*The
World
of
Marc
Chagall*

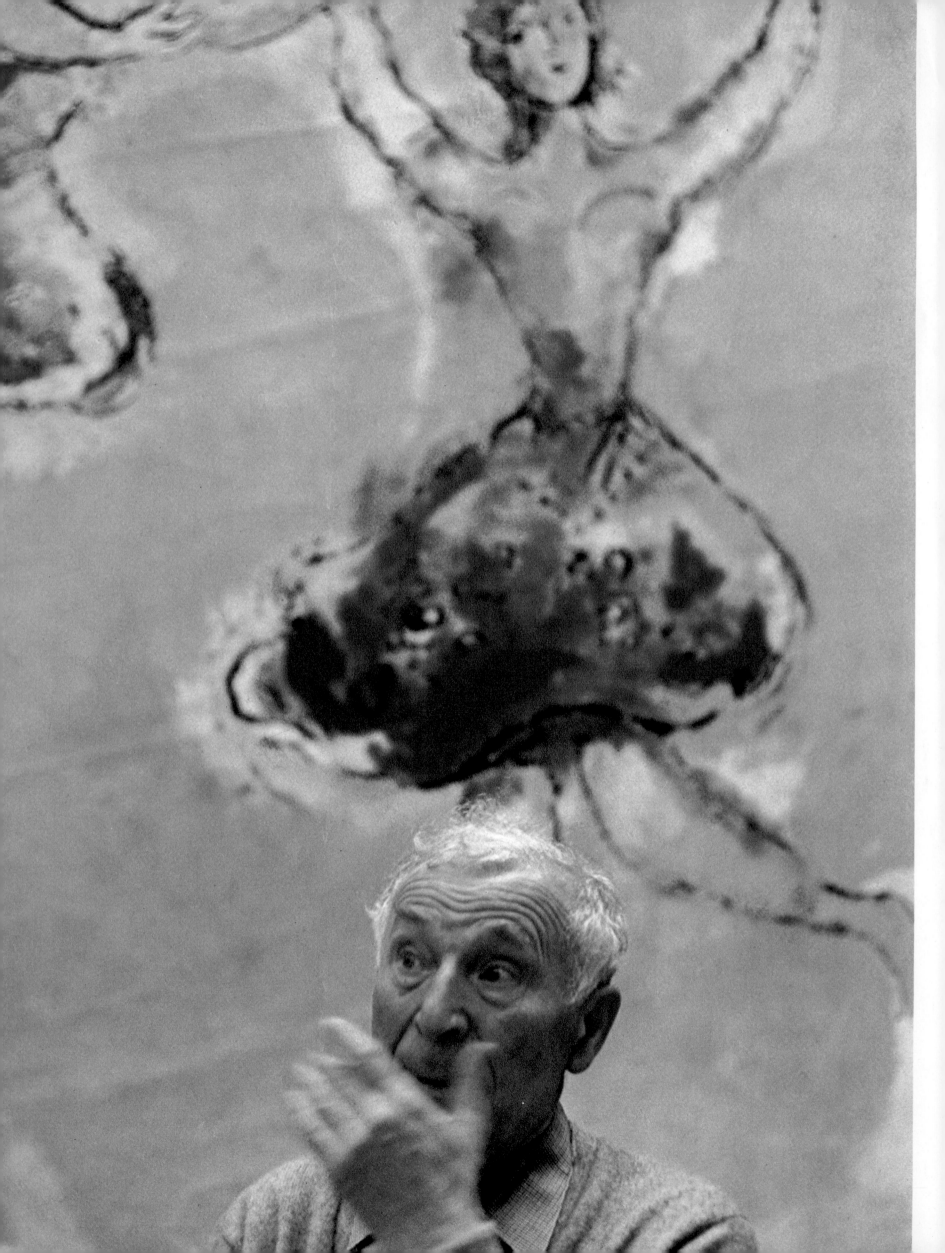

IZIS

The World of Marc Chagall

photographed
by IZIS BIDERMANAS

Text by
ROY McMULLEN

Doubleday & Co., Inc.
Garden City, New York

Aldus Editors: *Text* Jeremy Robson *Art* Felix Gluck
General Editor: Beverly Gordey

Library of Congress Catalog Card Number 68-20454

Copyright © 1968 by Aldus Books Limited,
Aldus House, Conway Street, Fitzroy Square, London, W. 1

Printed in Switzerland by Arts Graphiques Heliographia S. A., Lausanne
Bound in the Federal Republic of Germany by Hollmann K.G., Darmstadt

Contents

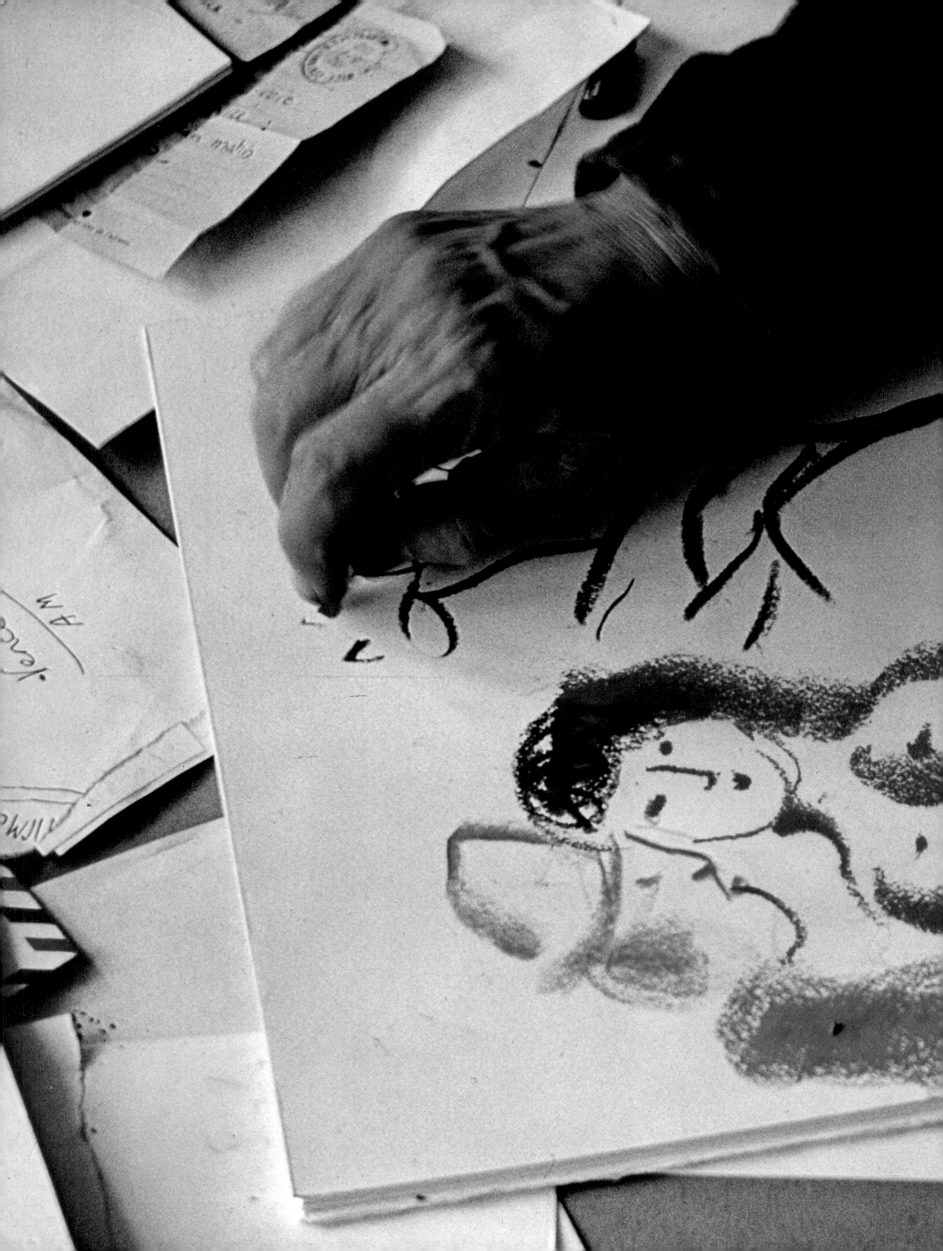

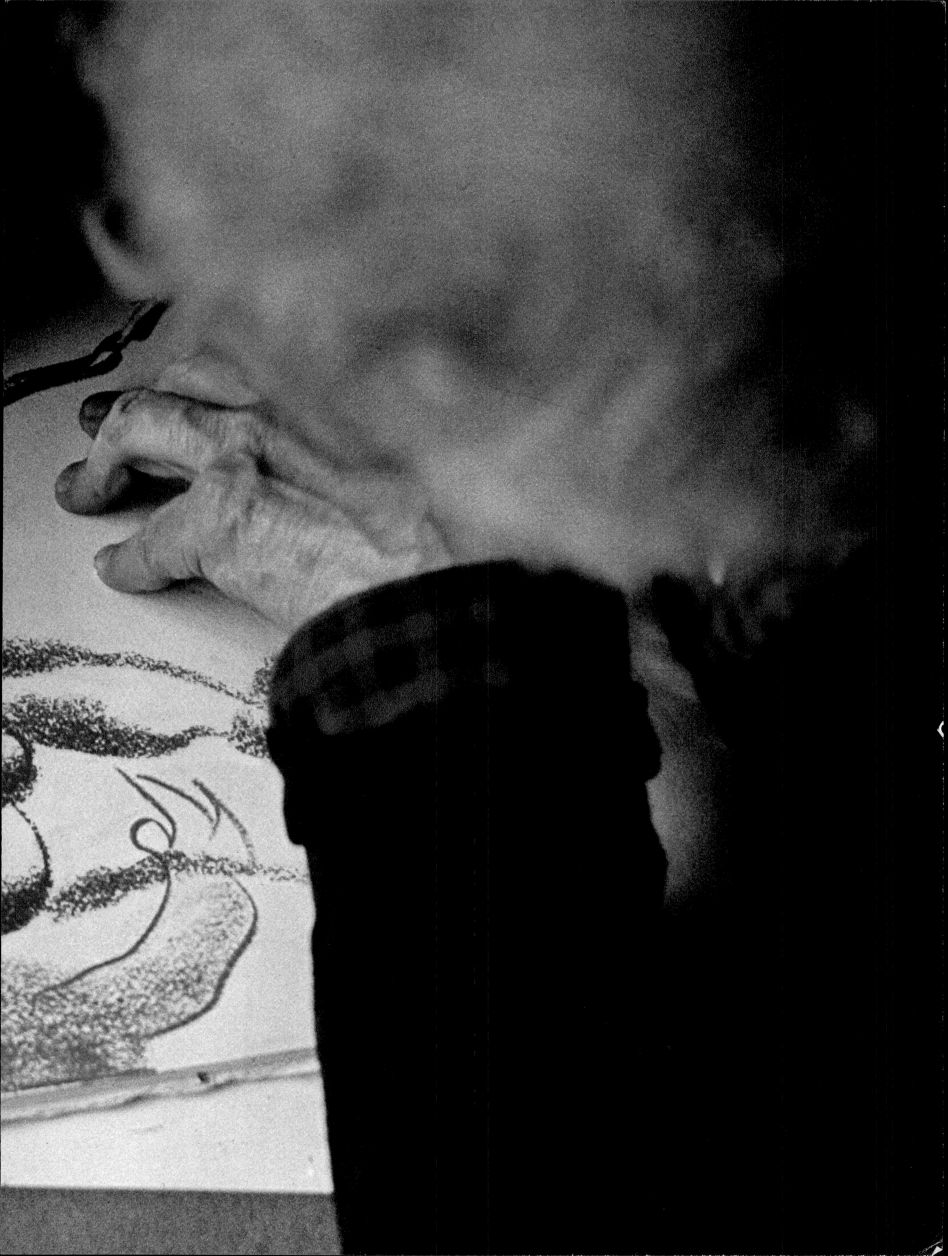

Preface

Marc Chagall is the poetic maverick among the major artists of the 20th century. None of the various labels—Fauvist, Cubist, Expressionist, Surrealist, Symbolist—that critics have applied to him during his long career has proved suitable. He has his own frame of aesthetic and spiritual reference, his own splendidly enigmatic world of discourse.

This book is a series of visual and verbal approaches to that world. Some of the approaches lead through artistic media, others through a unique creative process, others through an exotic cultural heritage, others through a half-ancient and half-modern philosophical outlook, and still others through an extremely personal life-style. All, however, are meant to converge finally in the mind of the viewer and reader in such a way as to increase understanding, and hence enjoyment, of the artist's actual works.

Explaining how the book grew into its present form may help to make the approaches come together. Izis, as he is known professionally in Europe, first met Chagall in 1949, in the course of a routine photographic assignment for a French magazine. The two men had in common a nostalgia for their East European background (Izis was brought up in Lithuania) and a bitter awareness, sharpened by personal loss, of the tragedy of the Nazi era. The first assignment was followed by others, and eventually Izis became both a friend and an unobtrusive Boswell. By last year he had in his files hundreds of unposed pictures of Chagall the hard-working artist and Chagall the relaxed citizen of the French Riviera; and from these he selected the sequences that appear here. Chagall contributed some recent sketches, paintings, and sculpture for reproduction, and approved a choice of relevant earlier work. Thus the project developed in an organic way, until with the addition of quotations and a critical essay—based in part on conversations with the painter—it became what it is now. It should be read and looked at with all this in mind: that is, with an awareness that the

photographs, reproductions, quotations, and essay are designed to complement and throw light on each other.

The photographs cover the period since 1956, during which time Chagall has produced, in addition to a steady flow of smaller items, such works as the ceiling for the Paris Opera, the murals for Lincoln Center in New York, stained-glass windows for Metz and Jerusalem, the cartoons for the large tapestries for Israel's new parliament, and the stage sets and costumes for productions of Ravel's *Daphnis and Chloe* in Paris and Mozart's *The Magic Flute* in New York. These achievements are major in terms of quality as well as size, and provide dozens of examples of the way the artist's imagination functions.

The quotations merit particular attention. Throughout his career, in St. Petersburg, Moscow, Berlin, Paris, New York, and southern France, Chagall has been the friend of men of letters. He is himself an occasional poet and the author of critical essays as well as of the famous early autobiography, *My Life*: indeed, it seems probable that if the unimaginable had occurred and he had not become a painter, he would have become a writer. As things are, he is an eloquent commentator on his own art, and therefore extensive use is made here of his remarks to the present writer, to other critics, and to the general public in speeches and printed memoirs. The quoted material on isolated pages is his.

The critical essay must speak for itself, but two of its assumptions should perhaps be emphasized. One is that Chagall is to be taken at his word when he insists, as he often does, that his art contains a serious "message." The other is that this message is to be found in his work as a whole. There is meaning as well as entertainment in his figurative midsummer night's dream of Vitebsk, Paris, blue moonlight, giant bouquets, weightless lovers, sad clowns, and fabulous beasts; and the same meaning emerges when we isolate for study what he calls his "abstract" colors, shapes, and structures.

9

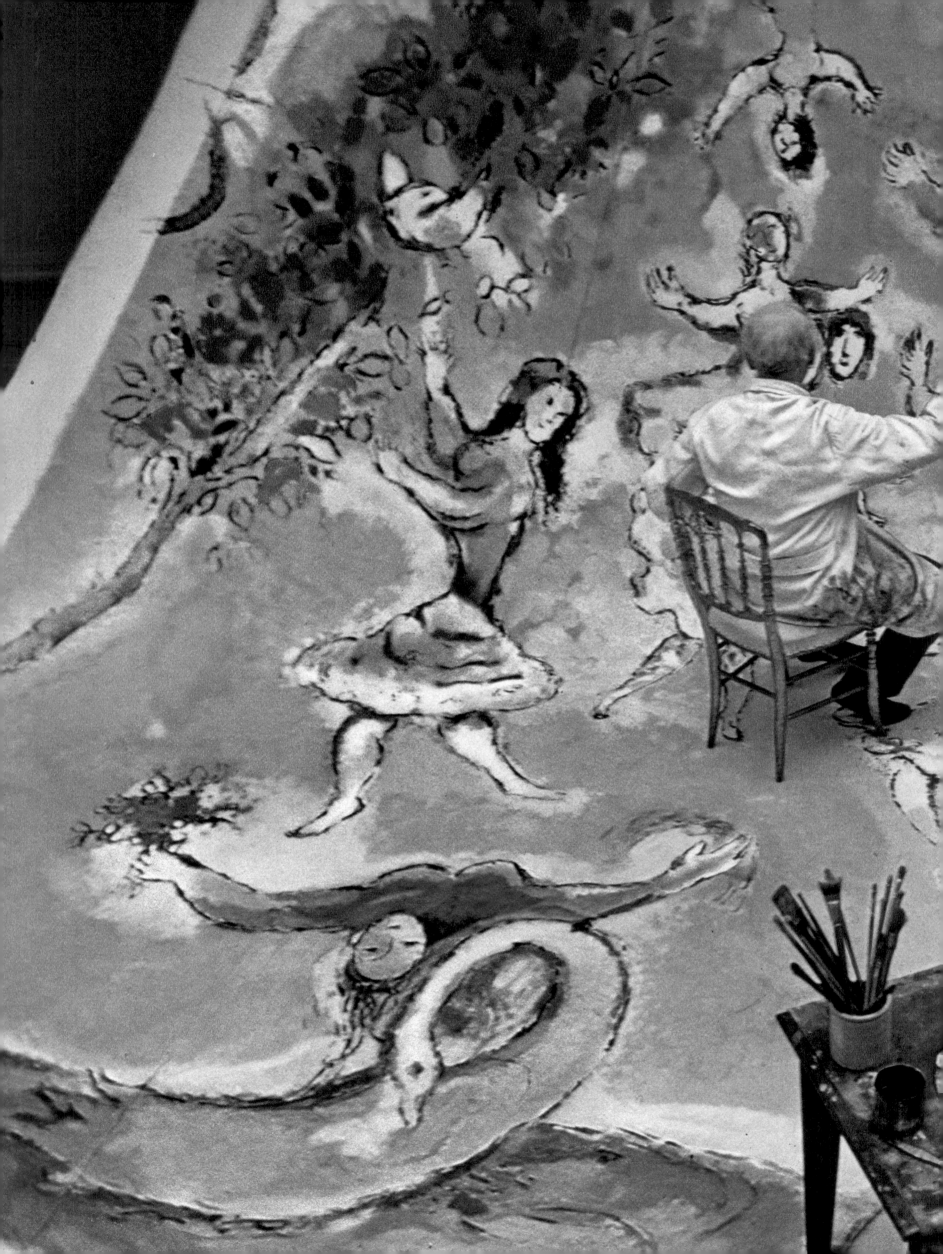

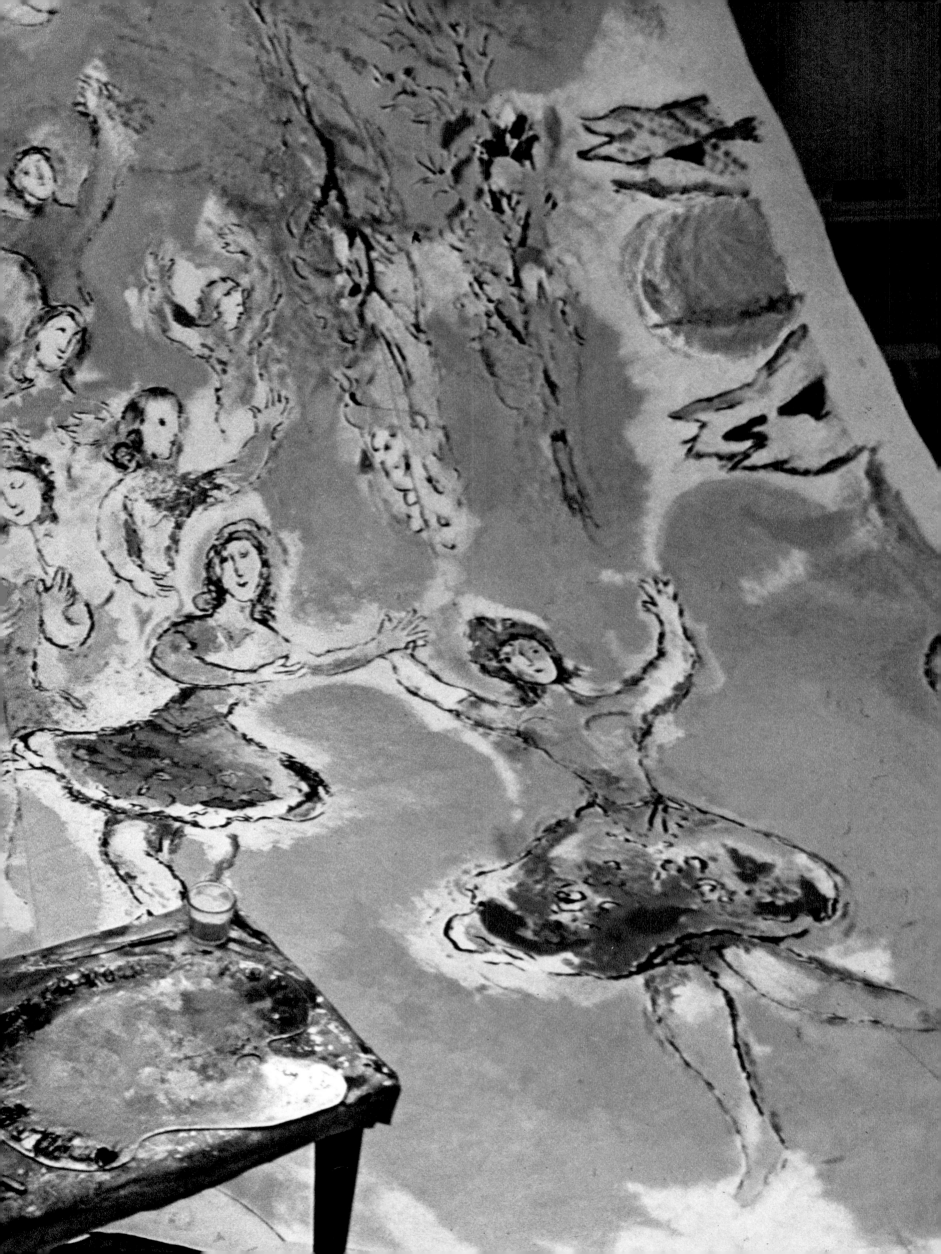

A Chagall Chronology

1887 Born in Vitebsk, Russia, July 7.

1907 Began studying painting: in Vitebsk, and then for 3 years in St. Petersburg.

1910 Began four-year stay in Paris.

1914 One-man show in Berlin. Returned to Vitebsk.

1915 Married Bella Rosenfeld.

1918 Named Commissar for Art in Vitebsk.

1919 Director of Vitebsk Academy.

1920 Resigned as Academy director. Theater sets and murals in Moscow.

1921 Taught painting to Russian war orphans.

1922 Wrote *My Life*. Went from Russia to Berlin.

1923 Returned to France with wife and daughter. Met Vollard.

1924 Illustrations for Gogol's *Dead Souls* commissioned.

1926 Began etchings for La Fontaine's *Fables*.

1931 Began etchings for the Bible. Invited to Palestine.

1939 Won Carnegie Prize.

1941 Left France—because of the war—for the United States.

1942 Trip to Mexico.

1944 Death of Bella.

1946 Exhibition, Museum of Modern Art, New York.

1947 Exhibition, Museum of Modern Art, Paris. Began color-lithography.

1948 Returned to Paris. Met Tériade.

1950 Moved to Vence, southern France. Started pottery work.

1951 First sculptures.

1952 Married Valentine (Vava) Brodsky. Trip to Greece.

1957 Began doing mosaics.

1958 Sets and costumes for *Daphnis and Chloe*.

1960 Stained glass for Metz.

1961 Stained glass for Jerusalem.

1963 Began tapestry design.

1964 Ceiling for the Paris Opera.

1966 Murals for Lincoln Center, New York. Moved to Saint-Paul.

1967 Sets and costumes for *The Magic Flute*. «Message Biblique» exhibition at Louvre.

I *Color and Substance*

During a recent conversation at his French Riviera home, with sunlit lawns and tropical flowers forming a frame of reference, Chagall issued what was apparently meant as a general warning to critics. "Remember," he said, "that my painting is not really European. It is partly Oriental. Color and substance are what count for me. I am not interested in the formal aspects of pictures."

The warning need not be taken literally: Chagall exercises a poetic license in his talk as well as in his painting, and he definitely is concerned with "the formal aspects of pictures" in his own way. But color and substance are certainly among the most important elements in his work, and they have been since the beginning of his career. Referring to the academic art that flourished under the czars and was officially adopted, after an interlude of modernism, by the Soviet regime, he has said: "I left Russia in 1910 because of the dead color of Russian painting, and I left again in 1922 for the same reason."

He has frequently insisted that he is an "abstract" colorist, and by this he means much more than the mere fact that he has always been willing to make a sky yellow, a face blue, and a tree red. A glance at pages 10 and 11, which show work in progress on the canvas of the *Swan Lake* section of the Paris Opera ceiling, can make his attitude clear: the vast pool of color, which in the complete work is combined with other pools, has its own—admittedly indefinable—significance. It could illustrate a symphonic movement, or even Rimbaud's vision in *Le Bateau ivre* of "the yellow and blue awakening of singing phosphorescences."

All this is not to say that Chagall's delineated elements should be ignored. A picture like *The Green Horse* (page 17), for instance, will repay careful and

The studio at Vence (1956), with Chagall reflected in the mirror. On the easel is The Green Horse.

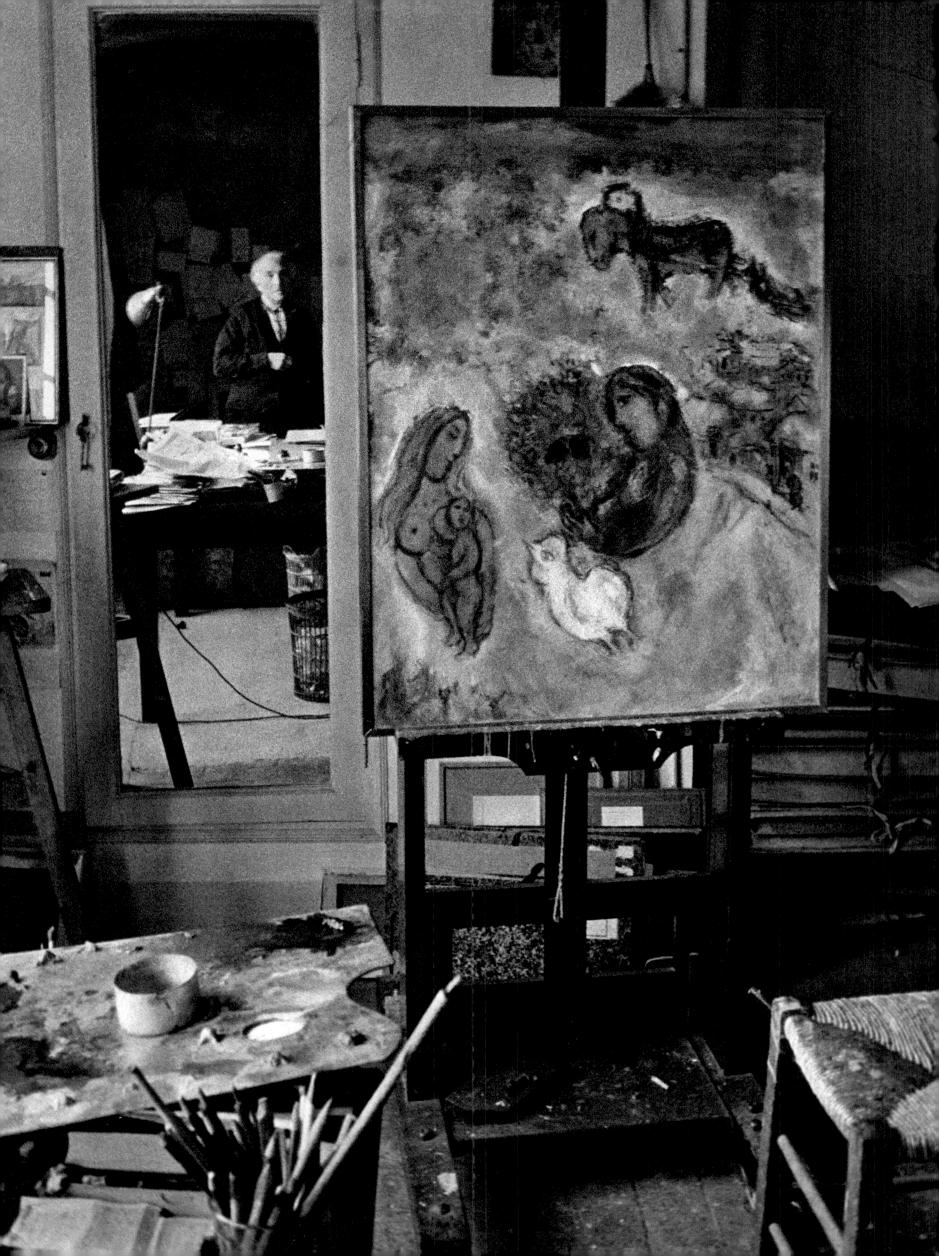

informed study of its figurative meanings. The mother and child, the young man with the flowers, the rooster, the earless horse, and the view of Vitebsk with the human violin on the sidewalk can all be assigned to significant places in Chagall's world. The creamlike cloud that covers most of the canvas can be interpreted as the remembered snow of Russia: it is definitely snow in some earlier and more detailed pictures in which the woman, the rooster, the Vitebsk street, and the same horse and sledge appear.

A representation of snow, however, is not likely to be uppermost in the mind of somebody seeing this picture for the first time. The creamlike cloud, long before it suggests any figurative reality, makes a vigorous sensuous appeal as sheer paint and as the substance in which are embedded the blue, purple, orange-red, and green motifs. It also functions as an abstract picture space, a nowhere irradiated partly by the warm colors in the center and partly by a cool light that, in one of the painter's favorite phrases, "comes from behind the canvas." And finally it functions as a strictly mental space, furnished with both wintry and springlike memories.

In sum, Chagall tries to persuade us to see and feel his world—first of all as iridescent matter infused with mind and spirit, and only later as a collection of images and a possible subject for literary paraphrase. Sometimes he begins a painting without any drawing at all, with simply a few zones of color spread over the entire surface in varying degrees of transparency. Even when this procedure is not followed, the effect is usually the same; one rarely has an impression of preexisting forms filled in with color, and nearly always an impression of color that is at once spatial and substantial, that is saturated with light and yet is solid enough to serve as the matter from which the forms are carved.

Remarkably, as the gouache *For Vava* (page 26) shows, this spatial and substantial effect is not limited to works having the advantage of oil painting's range from transparency to opacity. Nor is it limited to any particular mood. In *Jacob's Dream* (page 20) it is as apparent in the bright disk that reveals Jacob wrestling with the angel, as it is in the relatively dark tones of the sleeping earth. In *Clowns at Night* (pages 22 and 23) it lends an almost tragic resonance to the familiar theme of the sadness of the professionally gay. The strolling musicians are simply denser portions of the blue-green blackness of the night itself, through which winds an arabesque of broken patches of yellow, lavender, red, green, blue, and dead white.

The elements that go into the making of a colorist, particularly as fine a one as this, are mysterious. Chagall himself gives a great deal of the credit for the development of his talent to the influence of the light and color of Paris and the French countryside. "My Russian pictures," he has written, "were without

THE GREEN HORSE, *oil, 1956. Memories of Russian winters and of Vitebsk, where Chagall grew up, are blended with motifs of spring flowers and domestic happiness in this example of the artist's use of what he calls "abstract" color and "light from behind the canvas."*

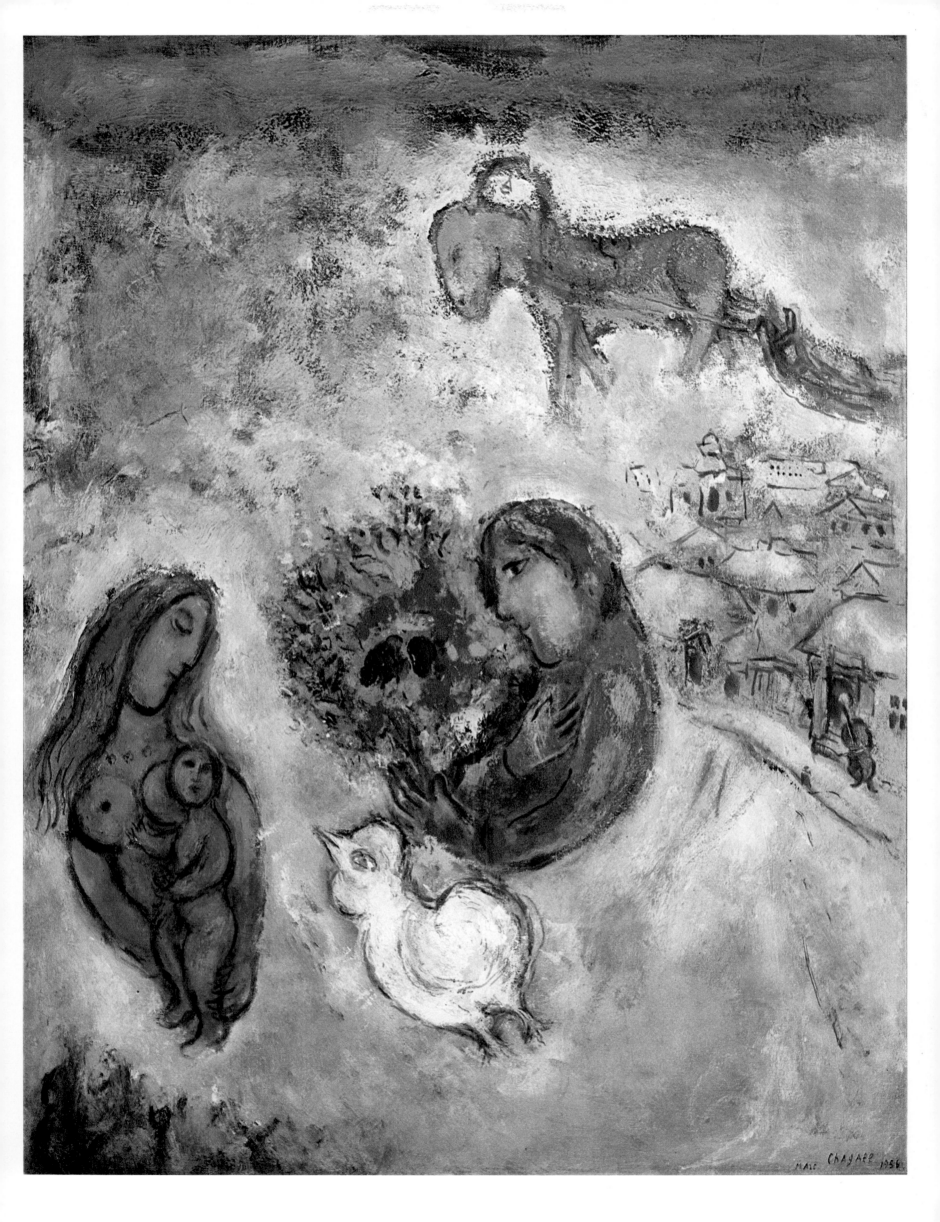

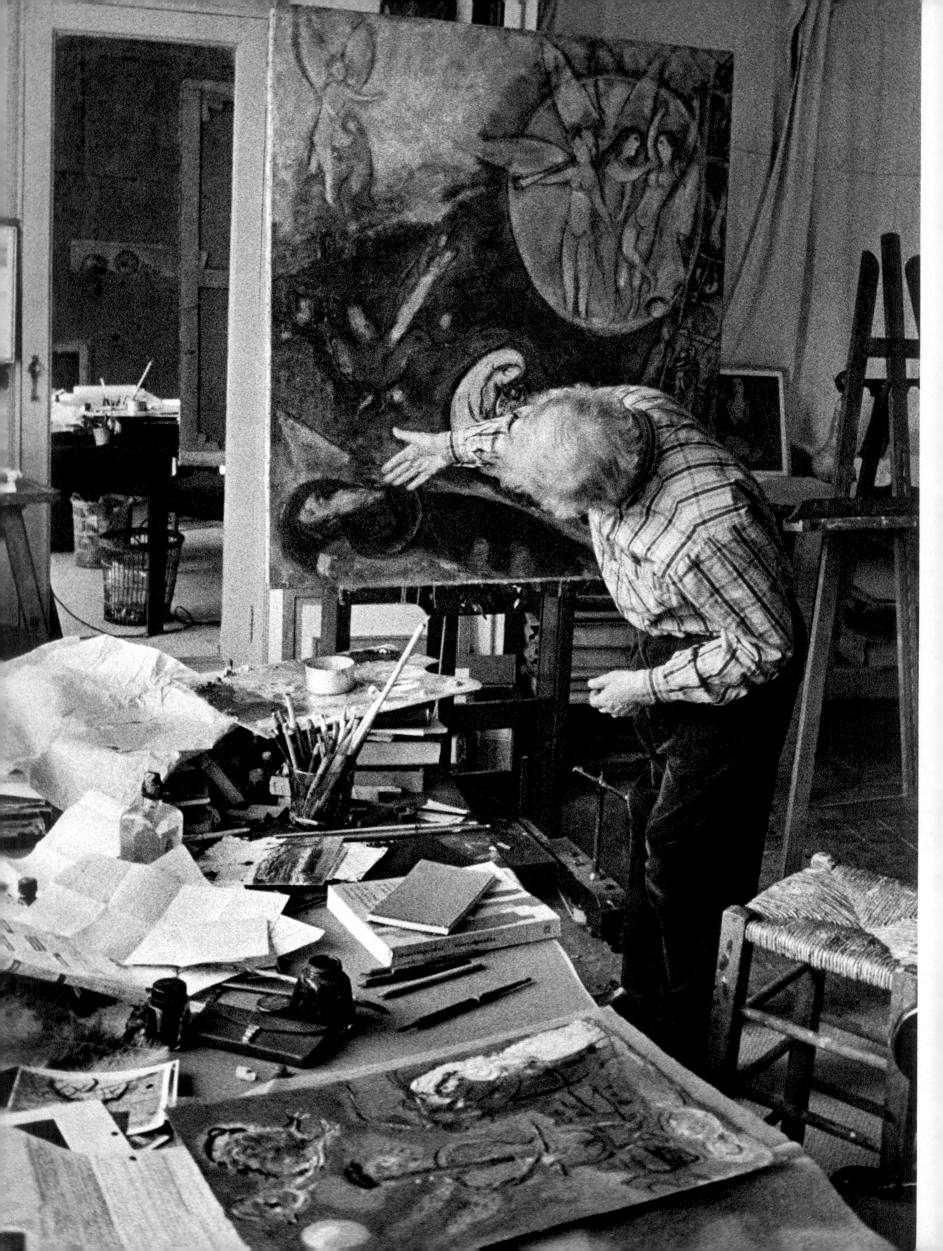

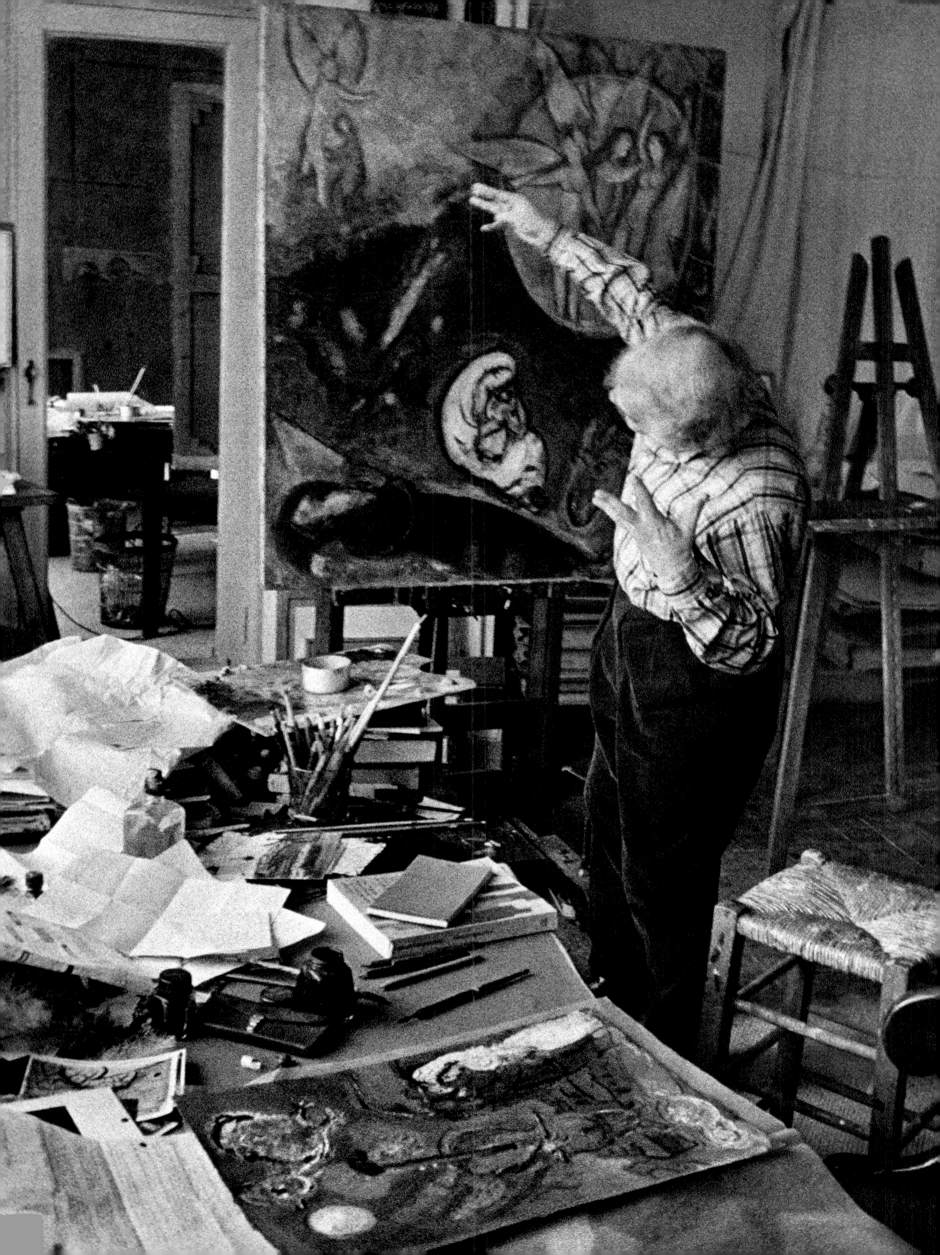

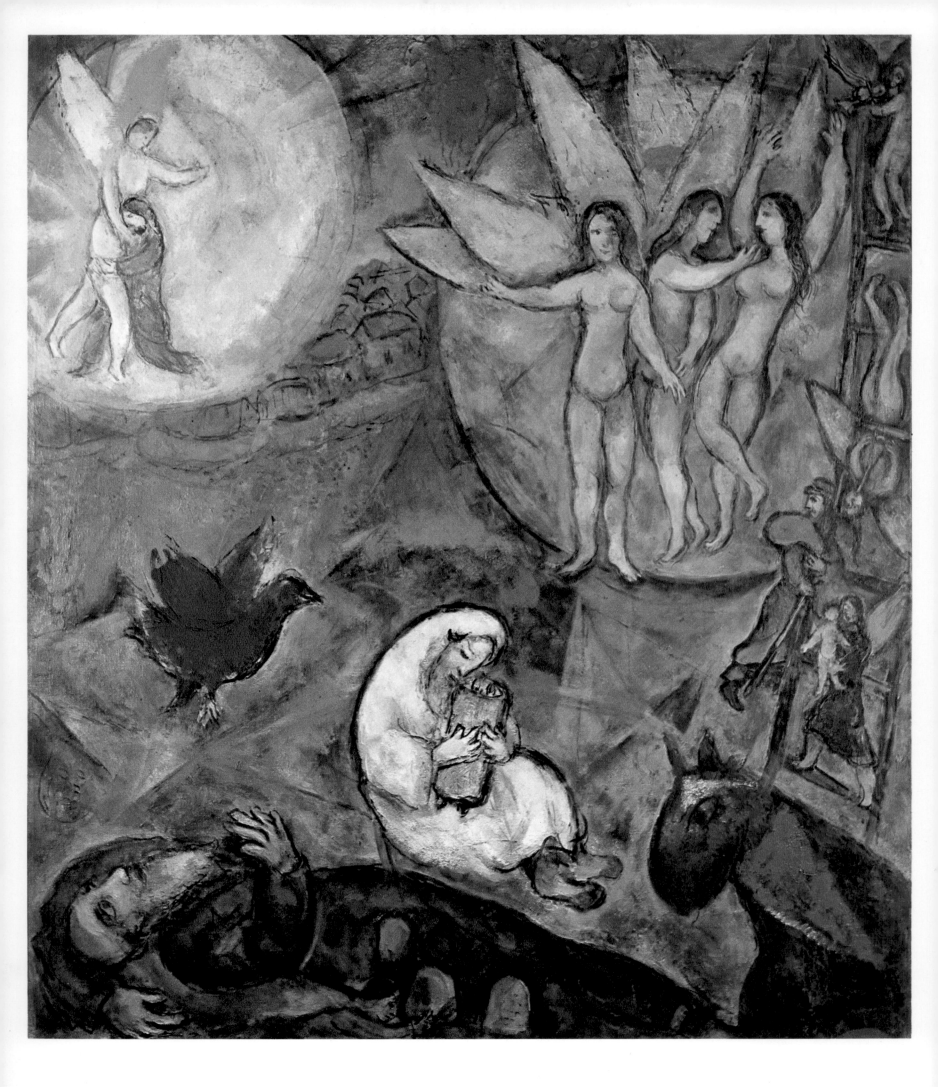

light. In Russia everything is somber, brown, gray. When I arrived in France I was struck by the shimmer of the color, the play of the light, and I found what I had been blindly seeking—a refinement of matter and of wild color. My familiar sources remained the same: I did not become a Parisian, but now the light came from the outside." There is some exaggeration here; the early Russian pictures are by no means entirely gloomy, and in 1906, four years before the journey to Paris, Chagall was already considered an eccentric by his teacher in Vitebsk because of a habit of painting in violet: "It seemed so daring that from then on I attended his school free of charge...." But it is true that his palette became brighter shortly after his arrival in France. Léon Bakst, his teacher in St. Petersburg, came to Paris in 1911 with Diaghilev's ballet company and noticed the brightness immediately: "Now," he said, "your colors sing." Three years later the poet Guillaume Apollinaire wrote of Chagall as "a gifted colorist who yields to every suggestion of his mystic, heathen fantasy."

In the decades since then Chagall has traveled widely, and has been stimulated by the extremely un-Russian light and color of such places as Palestine, Mexico, Spain, Italy, and the Greek islands. The exact effect, however, of geography and climate on his color has become increasingly hard to define, partly because he seldom paints directly from nature and partly because of what might be called his delayed-response creative process: he stores colors as well as forms in his imagination, allows them to be metamorphosed by memory and new emotional experience, and then, one day, suddenly puts them on canvas in contexts quite different from their original ones. The forms can often be identified almost immediately; the little house, for instance, in the upper right corner of *Clowns at Night* must surely have entered the world of the painter one evening in Russia some time before 1922, when he left his homeland for good. But we cannot say that the lavender of the crescent moon in the same picture is a memory of an evening in Mexico in 1942. The principal exception to this sort of difficulty is the

JACOB'S DREAM, *oil, 1967. An organic "tissue" of color, which the painter is comparing with his own flesh on pages 18 and 19, serves as the substance for images juxtaposed for emotional rather than logical reasons. A red chicken and a gentle donkey, partly in blue and white (the colors of Israel), guard the sleeping patriarch. Angels perform on the ladder like the acrobats of Chagall's many circus pictures and pose in the heavenly spotlight like his ballerinas. A wandering Russian Jew clings to the ladder. On the bottom rung an infant (who may be the Messiah) is presented to the world. A rabbi in the white vestment worn on the High Holy Days meditates over the scroll of the Torah. In the upper left corner, above a town that blends Vitebsk and Vence, Jacob wrestles with the angel that was to give him the name Israel.*

21

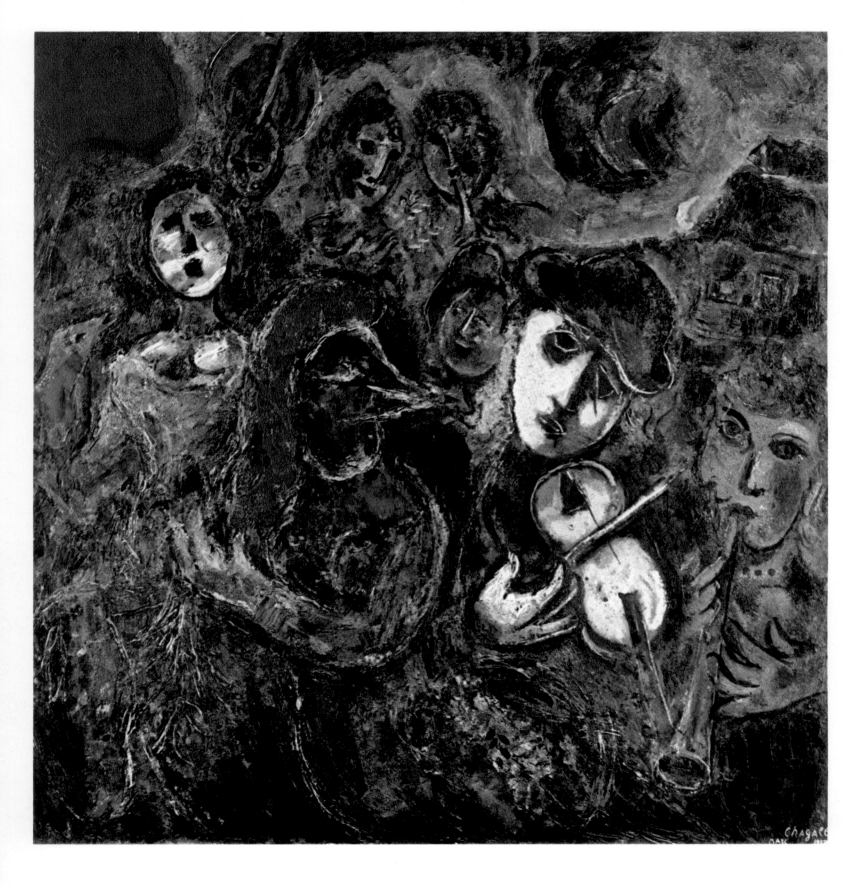

CLOWNS AT NIGHT, *oil, 1957. From the upper left corner the red muzzle of an unidentifiable animal looks out over a section of the Chagallian world, which combines a Russian hut with people one might meet on the streets of Nice during carnival time. For once, most of the light has been drained from the colored "tissue," leaving a substance that is in harmony with the melancholy theme. The enlarged detail (right) reveals that this substance is actually an architecture of dynamic brushwork and contrasting cells of hue and tone value. And here "brushwork" is merely a convenient general term: in fact the painter is likely to attack his canvas with anything available—a conventional brush, a palette knife, his fingers, an old rag, a pinch of dirt.*

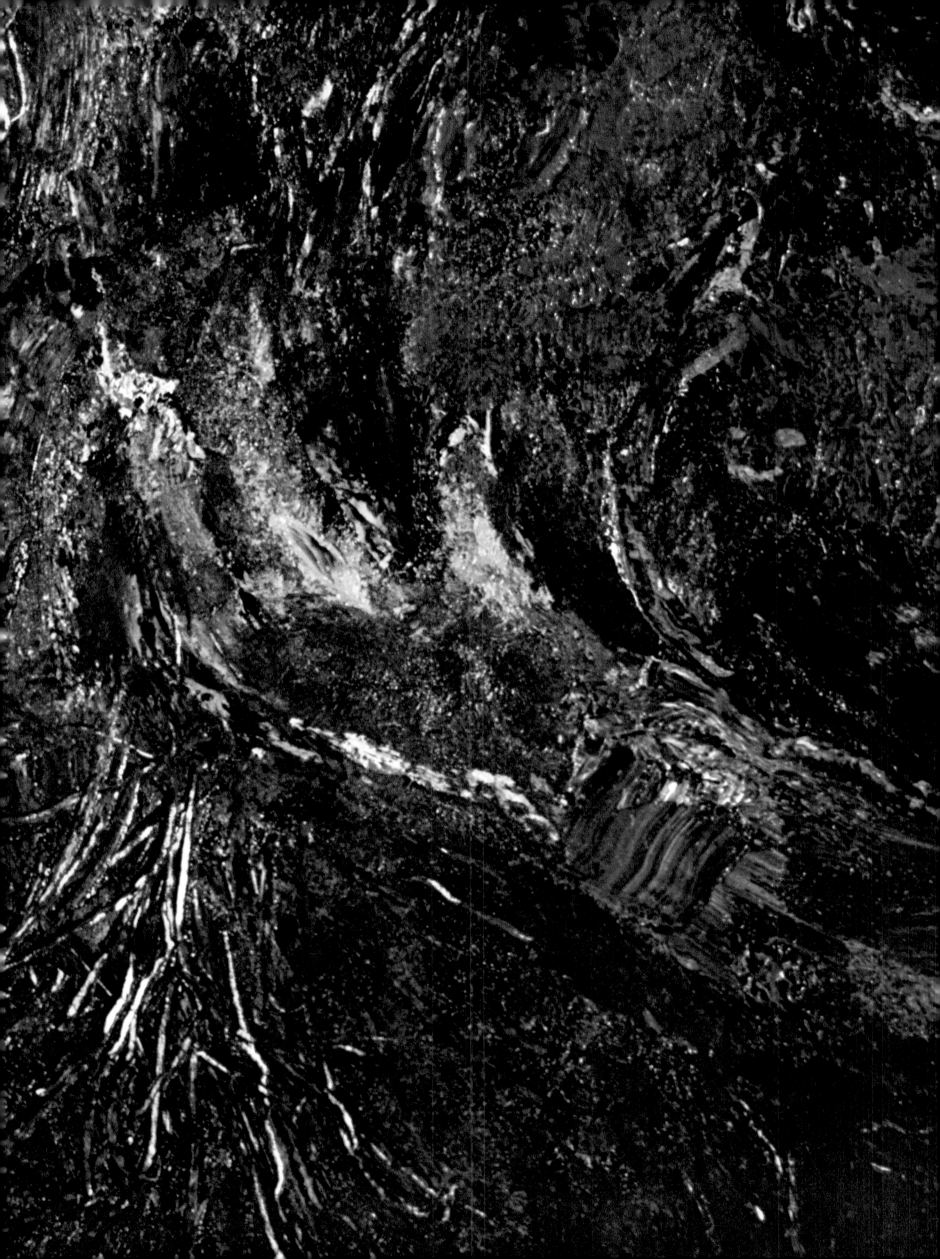

influence of the French Riviera since Chagall settled there in 1950; some of the recent paintings reflect, for me at least, exactly the density and radiance of the trees and flowers of Vence. Others, of course, do not; some, like *Jacob's Dream,* have a density and radiance that one can only assume to be pure products of the artist's imagination.

Chagall has acknowledged, with enthusiasm, that the awakening of his color sense in France before 1914 was due not only to the natural scene but also to what he found in museums and galleries. He was confronted by the reality of a modern pictorial chromaticism of which he had only dreamed in Vitebsk, with the help of poor reproductions: "... this circular motion of the colors which, as Cézanne wanted, mingle at once spontaneously and consciously in a ripple of lines, or rule freely, as Matisse shows. One couldn't see that in my town. At that time the sun of art shone in Paris alone, and even today it seems to me that there is no greater revolution of the eye than the one I came across on arriving in Paris in 1910. The landscapes, the figures of Cézanne, Manet, Seurat, Renoir, Van Gogh, the Fauvism of Matisse, and so many other things astonished me. They attracted me like a natural phenomenon." To this list one ought to add Gauguin, not only because of his color but also because of his insistence on the need for an art that went beyond realism and rationalism. The impact of this earlier generation of the School of Paris has long since been absorbed and transformed by Chagall's own highly distinctive style, but there was undoubtedly a time when it and its liberating effect were of decisive importance.

Decisive? The word may be too strong. There is always an awkward moment in an account of influences on artists when the explanations begin to seem circular, for finally only the influenceable are influenced. The palette of Van Gogh, for example, like that of Chagall, became lighter and brighter in Paris, and exploded into dramatic color in southern France. But nothing of the kind happened to the palette of Picasso. He remained primarily a draftsman throughout his revolutionary years in Paris, and one feels that no amount of time on the Riviera would have made him more than the ordinary, even perfunctory, colorist he became. On this line of thought one is apt to end up arguing that Chagall is a marvelous colorist simply because he is Chagall; and that is roughly what he himself, forgetting momentarily his account of the influence of Paris, has said: "You might say that in my mother's womb I had already noticed the purity of the colors of the flowers.... I don't know if color chose me or I chose color, but since childhood I've been married to color in its pure state...."

As that quotation may suggest, Chagall is an unabashed sensualist and even a sentimentalist about color, light, and substance in painting. He is also an ardent, indefatigable theorist on the general subject, and his theory is worth some attention both for its own sake and because it has clearly been affecting his practice more and more during the past decade. It lies behind a certain new note of intensity in many of his recent works, a note that at least one critic has labeled

Expressionist and that I think might be better described as metaphysical and ethical. In any event, that is how it might be described by Chagall, although he would use other terms.

The two key words in his theory are "tissue" and "chemistry." He is reluctant to define them with any great precision, and one can see why: they are evidently metaphors for something that he feels is of fundamental importance and ought to be recognized instantly by any art lover who is in a proper state of grace, but that he admits is as indefinable as poetry or music. If he were interested in jazz he might echo in this connection Fats Waller's famous "Man, if you got to ask you'll never know."

Nevertheless, it is possible to see, from the contexts in which he uses them, roughly what the words refer to. (I should add that one can see this without always accepting the judgments in his remarks, just as one can see what a man means by "beautiful" without agreeing that a particular object is indeed beautiful.) "Tissue" and "chemistry" are both life metaphors, just as "vivid" and "vital" were once upon a time, when derivations were fresh and art criticism was young. For Chagall, that is, "tissue" means organic tissue, and refers to whatever it is in pictorial color, light, and substance that can make a painting seem like flesh. "Chemistry" refers to essentially the same thing, regarded more as a process than as a collection of living microstructures. Both terms connote praise, of course, and so Chagall's use of them is sometimes inconsistently narrow and sometimes disconcertingly loose. He may, for instance, contrast "tissue" with "muscle," which is one of his terms for the structure or composition of a painting, and on such occasions he appears to ignore the fact that his "muscle" is also a life metaphor and ought therefore to indicate approval. He is especially apt to use "chemistry" simply to refer to the personal style of an artist he admires, and then the word appears to embrace the formal aspects of painting as well as the colored substance—the macrostructures as well as the microstructures. But always one can feel the pressure of his conviction that art must be emotional and organic rather than rational and mechanical. For him a good painting is never an inert object from which a ghostly lump of significance can be extracted for separate appraisal: mind and meaning are in every square inch of pigment, just as they are in every bar of a composition by Mozart.

How can we judge the quality of the "tissue" and "chemistry" in a painting? This question, raised during a conversation in Vence, brought from Chagall a demonstration that his metaphors are perhaps for him not so metaphorical after all (see the photographs on pages 18, 19, and 28–29). Holding his hand close to the surface of one picture, he said: "That is one test. The paint must stand comparison with the flesh of your hand, or with something else that is natural and alive—flowers, for example." He went on to say that he had long dreamed of organizing special exhibitions of masterpieces that would call attention to his theory. The pictures would be hung upside down, to avoid any

25

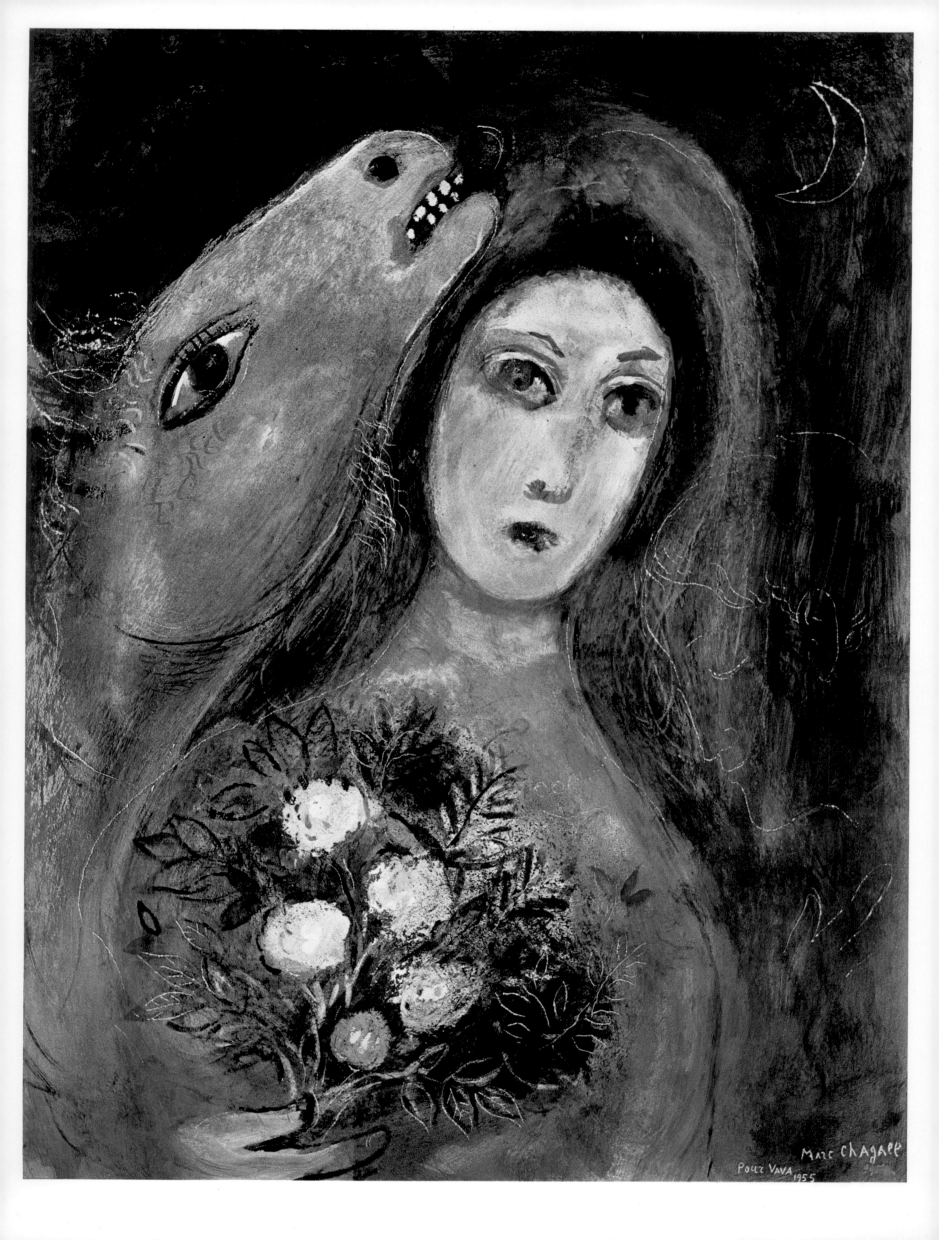

figurative meanings that might distract the literary-minded viewer from their "abstract" colors, and there would be potted plants everywhere to let people test the "tissue" and "chemistry" for themselves. He emphasizes that such tests should not be allowed to imply that a painting ought to be an imitation of nature —a piece of illusionism. The whole point should be rather that a good painting, like properly baked bread, is itself a part, or at least a continuation, of nature.

How can the ability to produce effective "tissue" and to make the "chemistry" work be acquired? The answer, strictly speaking, is that it cannot be acquired at all, and certainly not in any academy of painting. It is an aspect of an artist's personality and moral character: the "tissue" and "chemistry" of Renoir, for example, are Renoir himself. But Chagall does grant that a kind of ripening of sensibility may occur. "When you are young," he has said, "you are particularly sensible to form, to muscle. I had to wait until I was an old man, until after my return to Paris from the United States in 1948, to understand the importance of tissue." He thinks that what is essential is to be somehow in tune with nature, even with the cosmos: "You must feel the microbes of the universe in your belly." (It is characteristic of his thinking to prefer "microbes," in spite of the unpleasant connotations, to "atoms" or anything that would not imply living matter.) What these "microbes," these minute subdivisions of reality that, apparently, are at once matter and particles of psychic energy, happen to constitute in the outer universe is of little importance to the artist: "It can be manure or urine, no matter what, but you must feel it in your belly." Painters can be ranked according to their ability to resonate in this somewhat occult fashion: "The Douanier Rousseau really had the microbes in his belly. In this respect he was greater than even Cézanne or Monet."

FOR VAVA, *gouache, 1955. In this Shakespearean tribute to Madame Chagall, which could have been entitled "Bottom and Titania," the emphasis the painter gives to color, in his technique as well as in his theory, is evident. He has simply scratched the outlines of most of his forms (including the transparent self-portrait on the right) into pre-existing zones of purple, red, blue, yellow, and green.*

27

Overleaf: A detail of the 1962 oil PARADISE, *with the artist testing the quality of the colored "tissue" by comparison with his hand. The self-portrait discoverable in the lion's head can be read as a visual pun, playing with the traditional animal symbol of Mark the evangelist.* ▷

II *Space and Reality*

Next in importance to color as an "abstract" source of meaning, Chagall puts pictorial space, and in this aspect of his art he is even more independent than he is in his chromatic chemistry. In his theorizing about depicted space he is not, however, always precise. He maintains that "what is called perspective" does not necessarily add "depth" to a picture, but he leaves hanging the question of how metaphorically he wants the word "depth" to be taken. He denies that a Cubist "third dimension," obtained by warping the facets of represented objects into the plane of the canvas, can afford "a view of the subject from all sides," and again his terms can have more than one meaning. He speculates about the existence of pictorial space that is neither Euclidean nor, strictly speaking, visible, but he does not quite commit himself to such space:

"Perhaps another dimension exists—a fourth, a fifth, not only of the eye. And this dimension is by no means just 'literature,' 'symbolism,' or what is called 'poetry' in art. Maybe it is something more abstract, not in the sense of being unreal but of being more free. Maybe it is something that intuitively gives birth to a scale of plastic and psychic contrasts...."

Confronted by such a statement, which implies an almost impossible rejection not only of Renaissance optical naturalism but also of most of the spatial innovations adopted by 20th-century painters, we are obliged to turn to the actual works for clarification and qualification. And when we do we discover that the significance of "being more free" without "being unreal" is more controllable than might have been supposed. Chagall has not actually rejected all old and new spatial inventions; he has simply absorbed them into his own system, as he has the influence of such colorists as Van Gogh and Gauguin.

Moreover, his own system, although certainly idiosyncratic, is not "free" in the sense of being constantly improvised; it includes at least six kinds of spatial organization that recur with great regularity—great enough for them to

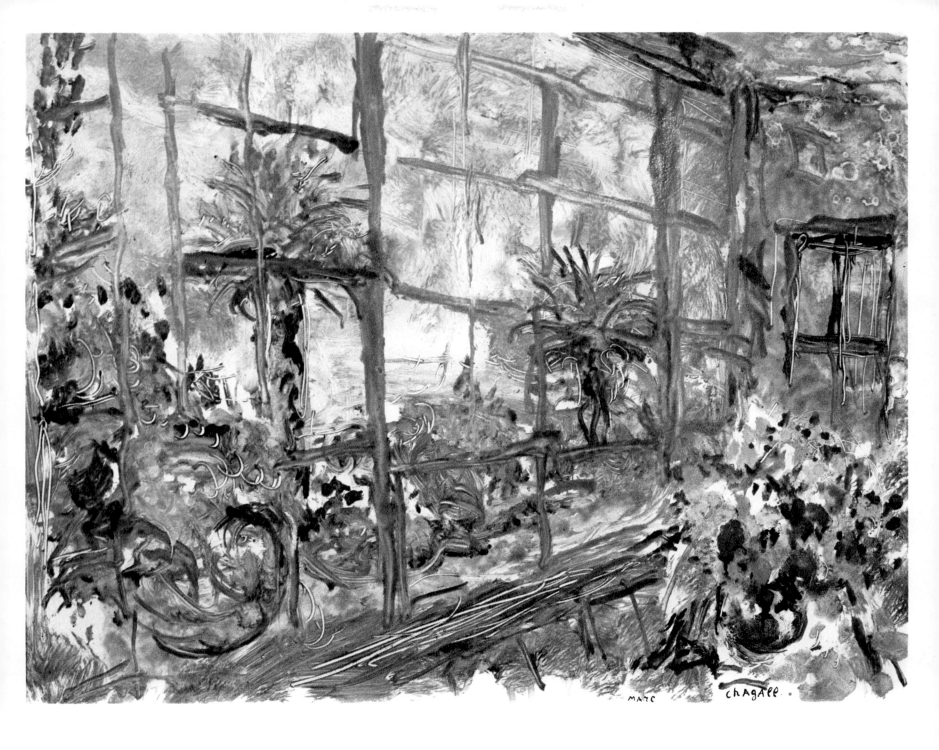

THE STUDIO WINDOW, *monotype, 1963. The palm trees and flowers are those of the painter's home at Vence, where he lived from 1950 to 1966.*

On the following page, Chagall gazes out of the window that appears in the above monotype; on the wall behind him hang pictures of his second wife, Vava (upper left corner), his granddaughter Meret (upper right), a view of Vence (lower left), a small work of his own, and reproductions of works by Bonnard, Van Gogh, Rembrandt, and Cézanne.▷

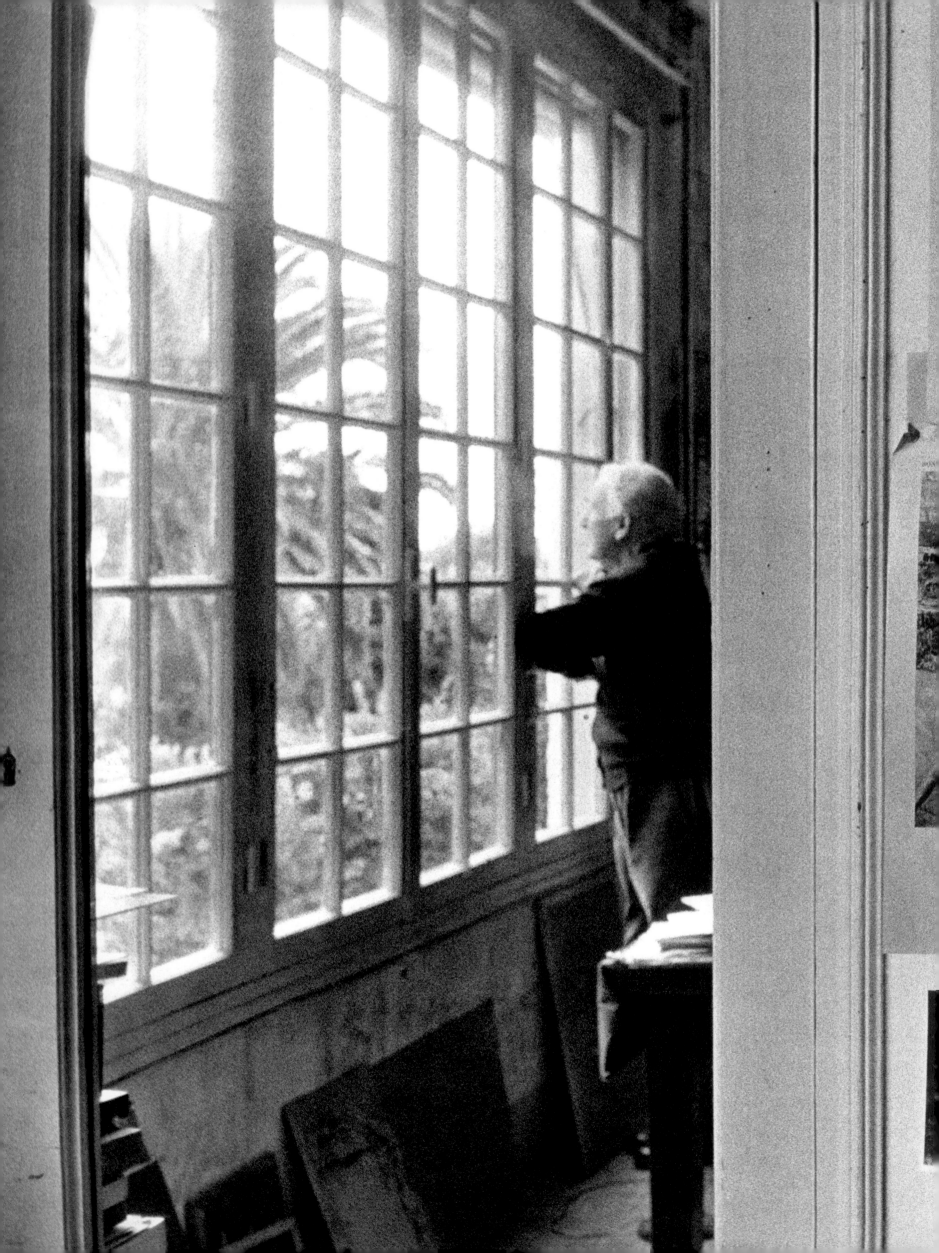

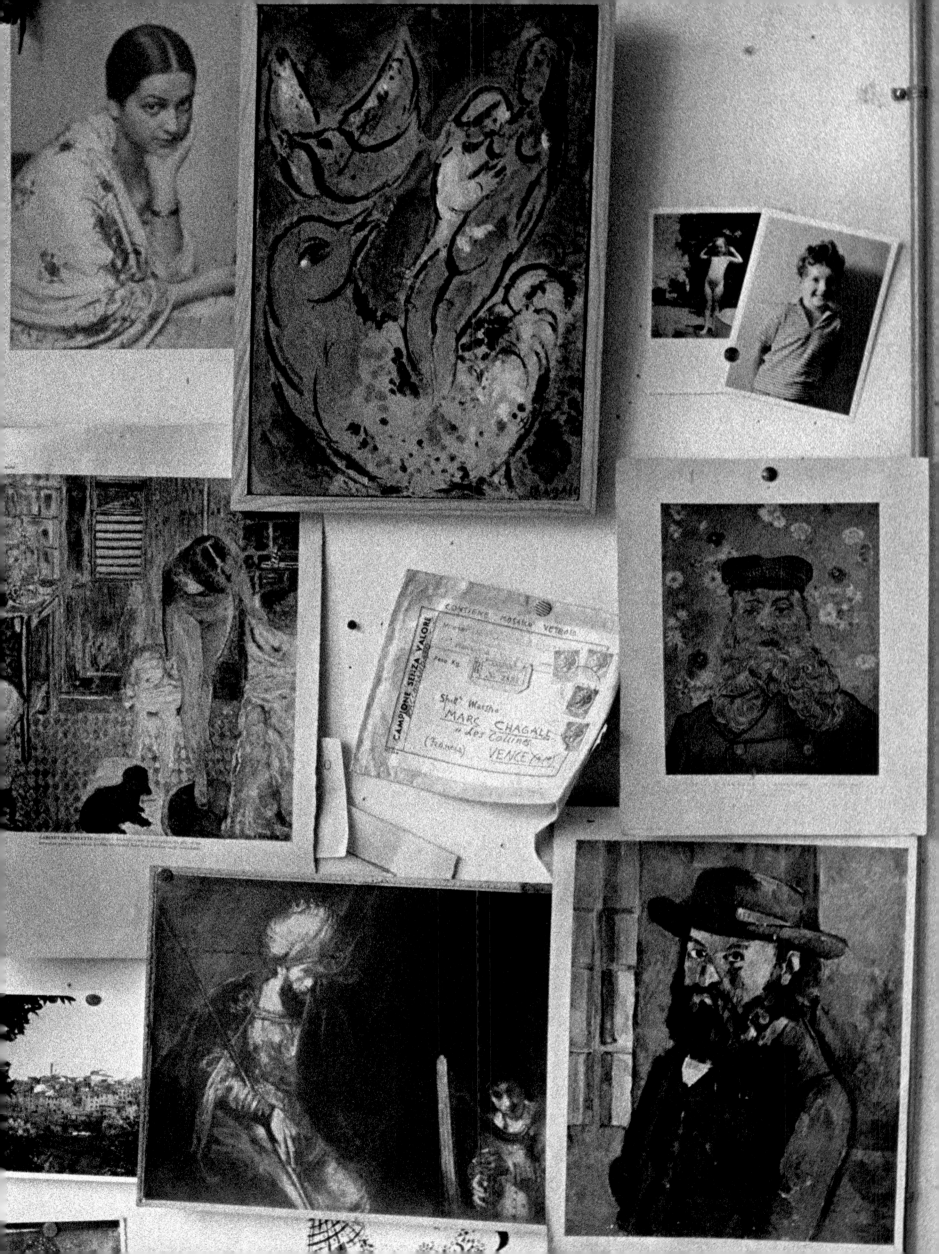

"People have reproached me for putting poetry into my pictures. It is true that there are other things to be required of the art of painting. But show me a single great work that does not have its portion of poetry! All this does not mean that I believe in the ability of inspiration, of an explosion, to dictate a painting. My whole life is identified with my work...."

During his 17 years at Vence, Chagall gradually transformed his studio into a small museum of personal souvenirs and reminders of the great artists of the past. On the opposite page are two photographs of his parents and three of his first wife, Bella. Below, his pottery creates a shrine for his daughter, Madame Ida Meyer-Chagall, and her son Piet.

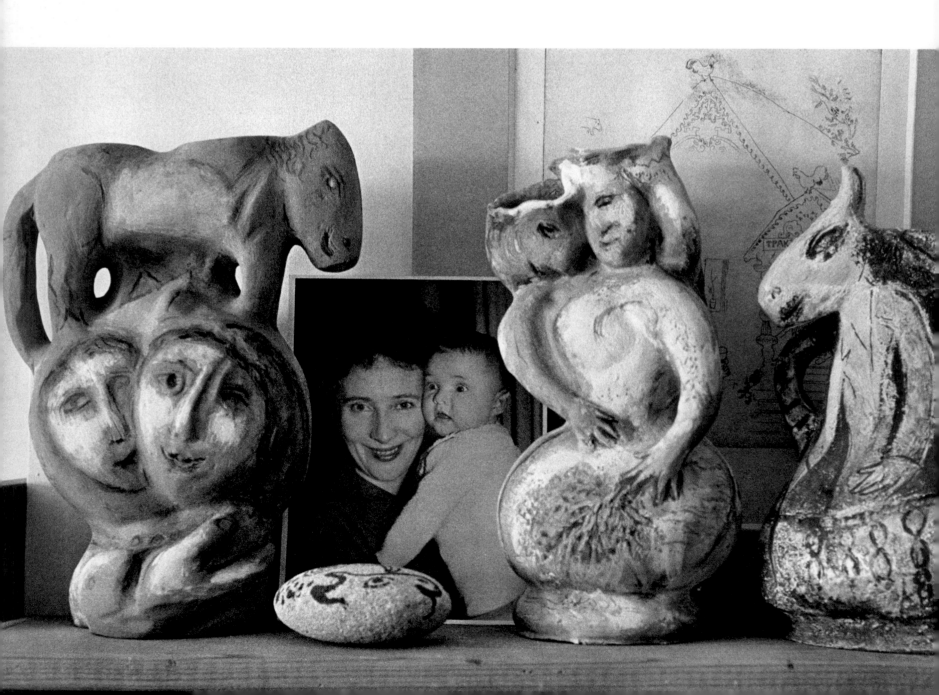

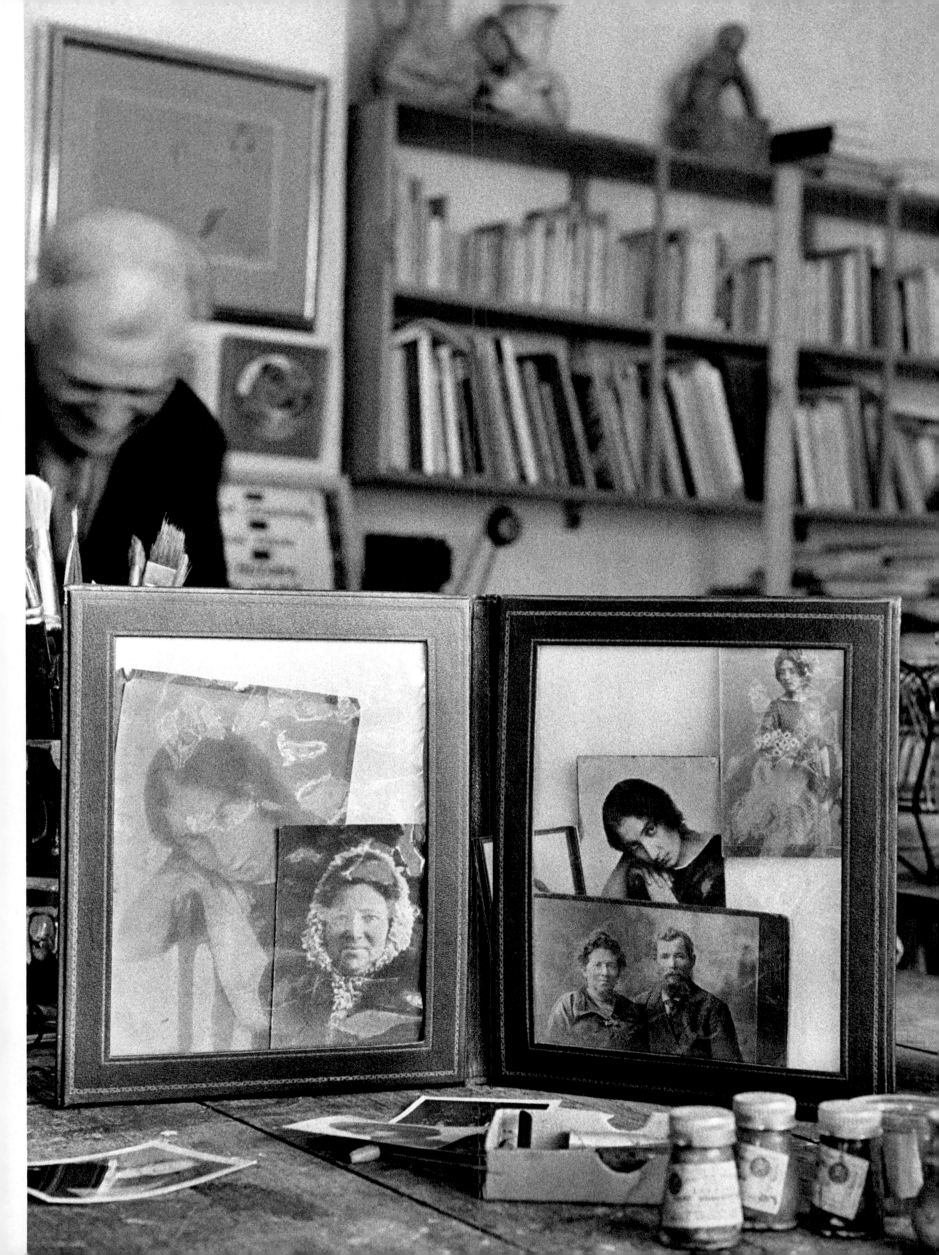

be considered a characteristic "scale of plastic and psychic contrasts." The six can be labeled (in some instances, admittedly, for the sake of reference more than of accurate description) Chagall's cinematic space, his dream space, his erotic space, his infantile space, his cosmic space, and his window space. All six may occur in a single work and thus create a kind of spatial counterpoint. All may be modulated by light and color. And all, of course, are apt to be distorted when written appreciation substitutes sequences of fragments for the wholeness and simultaneity of our experience of a picture.

Chagall's space is most evidently cinematic, although in a rather old-fashioned way, in the many pictures that juxtapose heterogeneous images and create "plastic and psychic contrasts" by means of a montage technique: the majority of the works reproduced in this book can serve as examples. But usually a second look at such paintings will disclose a more subtle and impressive analogy; the space—sometimes in concert with its fellow concept, time—can be seen flowing, jumping, coming, going, or spreading out in quiet lagoons (with the help of colored "tissue" and of light "from behind the canvas") as it does under the guidance of an Antonioni or a Resnais.

In *The Green Horse* (page 17) the creamlike cloud is not only the already-mentioned abstract colored matter and an allusion to Russian snow, but also a series of effective cinematic transitions between the motifs; the eye moves from a medium close-up of the young man with the flowers, who can be assumed to be in a filmic present tense, back through a kind of dissolve—the equivalent of the conventional filmic beginning of a flashback—into roughly the first decade of the 20th century and a long shot of the Vitebsk ghetto. In *Jacob's Dream* (page 20) the equivalent of a panning camera, combined with dissolves or cuts and what might be called associative film editing, produces a nicely varied and paced cinematic sequence—one that could easily be transformed into a short poetic documentary, perhaps with a commentary based on the Torah and read by the rabbi in the white vestment.

Here, as in many places in this essay, the question of sources is difficult. Although in conversation I have never heard Chagall mention a motion picture, he may have been influenced—even if unconsciously—by the then new cinematic art when he was a young avant-garde painter in Paris. He was befriended during the years before World War I by the pioneer film theorist Riciotto Canudo and was even given work for a day as an extra (his performance turning into a fiasco when he proved incapable of maneuvering a rowboat).

From a much earlier period, Russian icons, folk embroidery, and Haggadoth (the books containing the story of the exodus from Egypt, read at Passover) can be cited, for in all of them a Vitebsk boy frequently saw images juxtaposed in a spatiotemporal, vaguely cinematic way. Chagall has said that he was profoundly influenced as a child by the "mystique of the icons" and that during

Passover nothing, "not unleavened bread, nor horse radish," excited him as much as the pictures in the Haggadah. Today he still turns canvases around and paints from all sides in the manner of an embroiderer ("like a cobbler," in his own phrase): here is the most simple—and simplistic—explanation for his addiction to upside-down elements.

On the whole, however, it seems most probable that the fluid, "edited," cinematic kind of space in his work is just part of his intuitive method of apprehending and translating reality, like the colors he pretends to have become aware of in his mother's womb. It is constantly present, for instance, in the pages of *My Life,* which were almost certainly written without any thought of icon space, or of the camera-eye techniques that were about to become fashionable among American and European novelists. Here, with his own "filmic" paragraphing and arrangement of images, is part of his account of a boyhood visit to Lyozno, the village near Vitebsk where his grandfather lived:

"The clear, enchanted moon is turning behind the roofs, and I am left alone in the square, dreaming.

"A transparent pig stands in front of me, its feet ecstatically buried in the earth.

"I am in the street. The posts slant.

"The sky is grayish-blue. The solitary trees are bowed."

Further on in the book, some violent cinematic effects follow a prayer in Vitebsk for a chance to go to Paris:

"In answer, the town seems to snap like the strings of a violin, and all the inhabitants begin walking above the earth, leaving their usual places. Familiar figures install themselves on the roofs and settle down there.

"All the colors spill out, dissolve into wine, and liquor gushes out of my canvases."

As the above examples may have suggested, Chagall's cinematic space is also a kind of dream space. However, he has another and more explicitly oneiric kind of dream space. In this, the governing point of view for the depicted scene is emphatically that of a specific dreamer rather than that of an anonymous spectator in a museum or gallery; and the dreamer is always in the picture, just as a real-life dreamer—of either the day or night sort—is always present in his own dream.

In *Window in the Sky* (pages 38–39), for example, we do not quite see the airborne nude, the winged donkey, the rooster, and the inrushing quarter of Vitebsk through our own eyes, but rather through the imagination of the reclining personage in the foreground. In *For Vava* (page 26) we see the donkey and Madame Chagall (or Bottom and Titania, in which event the picture's space becomes an annex to the dream space of Shakespeare's play) through the closed eyes of the scratched-in Chagall. The situation in *Jacob's Dream,* where the sleeping patriarch and the meditating rabbi are personified dream points of view, may at

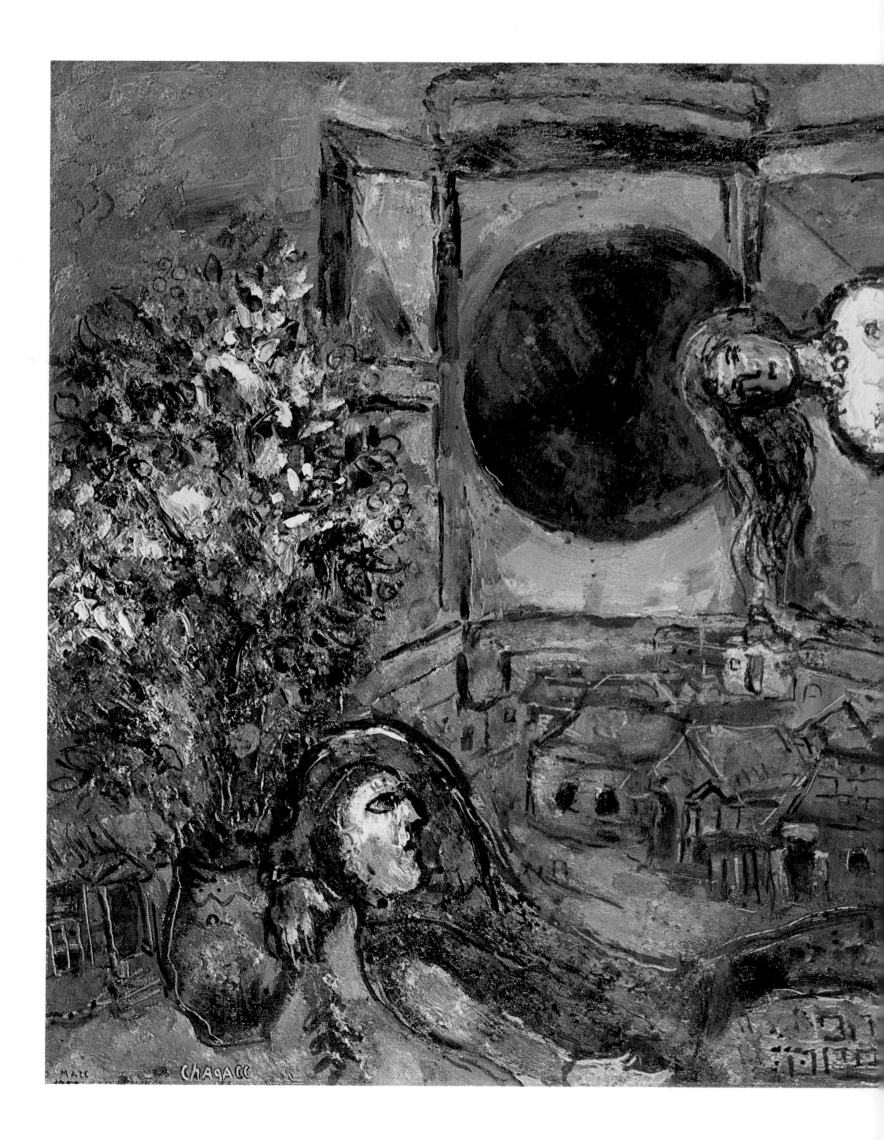

"*For my part, I have never liked realism.... My pictures were illogical and nonrealistic long before Surrealism. What I wanted was a kind of realism, if you wish, but a psychic kind, and hence a quite different thing from the realism of objects and of geometrical figures.*"

WINDOW IN THE SKY, *oil, 1957. A young man (identifiable as the painter himself) lies dreaming, with open eyes, of a woman and of his native Vitebsk. The organization of space is characteristic: an inner and an outer reality are simultaneously separated and united by the open window.*

first seem confusing, but I think that eventually we tend to see all the motifs, including Jacob and *his* dream space, through the rotating reverie of the rabbi (which can also, to return to my earlier analogy, be thought of as a motion-picture camera).

These considerations, incidentally, lead to an awareness of one of the several ways in which Chagall's methods are unlike those of the Surrealists, with whom he is frequently and mistakenly compared. The typically Surrealist picture space is not governed by the presence of a specific dreamer; it implies instead that it is intended to be perceived through the eyes—from the psychological point of view, that is—of a spectator out in front of the canvas. In other words, however many symbols of a presumed unconscious it may contain, in spatial terms it is more theatrical than dreamlike.

Possibly Chagall's authentic reconstructions of the dream process can be attributed to the fact that, unlike the average Surrealist, he relies on personal experience rather than general psychological theory. For instance, the space in many of his pictures has a prototype—again it would be hazardous to speak of a "source"—in an actual dream he had when he was an undernourished art student (to the point of fainting frequently) in St. Petersburg, and which so impressed him that he was able to describe it graphically some fifteen years later in *My Life*:

"A square, empty room. In one corner, a single bed, and me on it. It is getting dark.

"Suddenly, the ceiling opens and a winged being descends with a crash, filling the room with movement and clouds.

"A rustle of trailing wings.

"I think: An angel! I cannot open my eyes, it's too light, too bright.

"After rummaging about all over the place, he rises and passes through the opening in the ceiling, taking all the light and the blue air with him.

"Once again it is dark. I wake up."

This dream is evoked specifically in a Cubist-influenced work entitled *The Apparition,* which is now in a Moscow collection. But there is no need to refer to a particular painting in order to make my point; anyone who has visited a Chagall exhibition is likely to be familiar with the "blue air," the "winged being," and the room with an opening on the realm of the supernatural. In *Window in the Sky* all these elements appear, although in the fifty or so years since the original dream the blue air has congealed into a more dense colored

DE MAUVAIS SUJETS I, *colored etching, 1958. One of the series of illustrations for an essay of the same title (produced in a limited edition) by the French critic Jean Paulhan. The fish, the open window, and the tiny figure on the chair combine with the upside-down flyer to create a nightmarish Chagallian joke.*

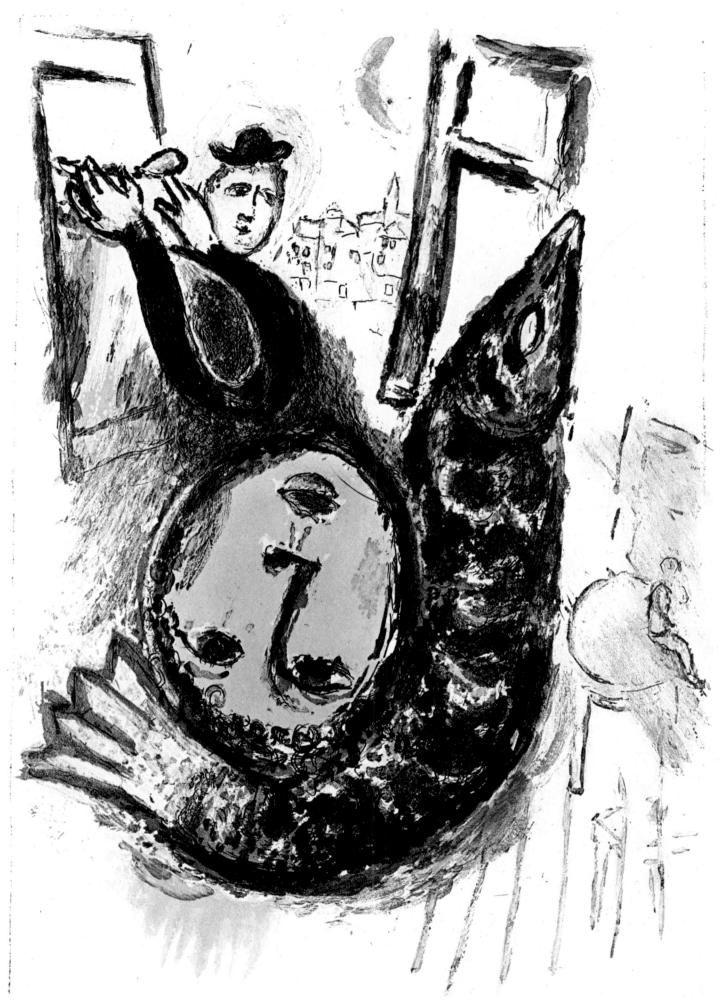

C/5 Marc Chagall

substance and the winged being has acquired a somewhat less than angelic form. One of this artist's many astonishing attributes is a type of memory that is not so much memory as a marvelous inability to forget. It scarcely ever suggests a Wordsworthian recollection in tranquillity or a sudden Proustian evocation of the past; it is instead a continuing emotional presence.

When the dreamer is a lover, as he frequently is in Chagall's work, the picture space, or at least part of it, becomes erotic as well as dreamlike and cinematic. It might be compared with one of the sexual "territories" professional bird and animal watchers have been studying in recent years, or perhaps with an area swept by a radar—an amorous radar. In plainer words, I am not referring here simply to the fact that a naked woman (Chagall's women are never just artistic "nudes") is likely to be present as the manifest object of the dreamer's desire (the dreamers, even when romanticized, are always definitely male). I mean rather that the point of view that determines the spatial organization is essentially erotic: the eyes of the young men in *The Green Horse* and *Window in the Sky* are points of departure for lines of pictorial force that inscribe definite zones of sexual interest. The system is of course variable; in *Jacob's Dream* the erotic space, which is occupied by naked female angels, is circled and thus set apart from the other zones in the picture. It can still, however, be regarded as energized sexually by lines of force—by "psychic" vectors—starting from Jacob's closed eyes. Evidently such lines are among the other dimensions the artist has suggested for painting.

Since infants are noticeably of little interest to Chagall except as props indicating motherhood, and occasionally as oddly adult-looking religious figures, the inclusion of "infantile space" in this analysis may be puzzling. But all I mean by this perhaps inadequate label is the kind of space an infant might imagine, not the kind he might occupy in real life. In some of Chagall's painting, including such recent works as the ceiling for the Paris Opera and the murals for Lincoln Center in New York, there is an utter lack of spatial sophistication, stubbornly preserved through the years of Russian academic training and those of Parisian avant-gardism, which ought to be mentioned as a corrective for too much concentration on cinematic concepts, psychic vectors, and the like. There are cases of nearness and distance that have no evident reason for existing except an infant's purely emotional one, supplied by a talent that has learned to trust its intuitions. The wanted is brought close, the unwanted pushed away.

Intuitions undoubtedly play a part also in the construction of Chagallian "cosmic" space, but in this instance one can point to the effects of calculation. Chagall is a master at handling the devices of scale, and he likes using them to create impressions of unearthly vastness. His skill has the most scope, of course, in his monumental works, but it is apparent in many easel paintings and even in etchings. The size of the wandering Russian Jew in *Jacob's Dream* converts the space he has apparently just traversed into the psychological equivalent of a

continent. In *Window in the Sky* the bigness of the universe beyond the open window is suggested by the size of the moon in relation to Vitebsk. In the illustrations (pages 41, 44, and 47) for Jean Paulhan's *De mauvais sujets,* an informal essay on the nature of literature, some scribbles representing distant buildings are enough to summon into existence an immense void.

What I have chosen to call the "window" kind of space is a phenomenon much more complex, and arguably more significant, than any of the kinds I have discussed so far, with the possible exception of the cinematic. In fact, it can be thought of as being really two complex phenomena, one involving painting techniques and the other involving subject matter.

Let me begin with some oversimplifications. One might say that the art of easel painting is rooted in an impulse to put a frame around part of a mural, and that artists can be classified according to their attitude toward the framed area. The anti-illusionists treat the area as the solid and flat thing it actually is—as a kind of small, portable wall that can be hung on an actual wall. They call attention to the surface of their pictures by such means as thick paint, rough brushwork, and an absence of perspective; and hence they often create a purely abstract kind of space. In all this they differ from the illusionists, who treat the framed area as an opening, as a portable window, and who therefore make use of mathematical perspective, thin coats of paint, and atmospheric effects. Typically "wall" painting (that of Abstract Expressionists, for example) can be called introverted, and typically "window" painting (realistic landscapes) extroverted.

Chagall, characteristically, often manages to work in both categories simultaneously. In *The Green Horse, Jacob's Dream,* and *Window in the Sky,* to take examples with which we are becoming properly familiar, he calls attention to the solid, flat surfaces by refusing to organize his material in its entirety according to the laws of perspective and by employing a dense colored substance that is obviously brushed-on paint. But he puts fragments in classical perspective, and obtains other effects of distance by means of light, color, and overlapping elements. The pictures are thus sections of opaque walls one moment and openings in walls the next, or both together: they are like beautifully smudged windows that may be looked either through or at. In strictly visual terms they are at once introverted and extroverted.

This ambiguity is often apparent also in subject matter, which may combine an inner world with an outer one in such a way as to suggest that the first is as real as the second and that the two are both separate and fused. *Window in the Sky* is just one of a long series of pictures on the open-window theme (the first ones were painted in Vitebsk), and its spatial arrangement is typical: the dreamer with the motifs of his inner world dominates a shallow foreground, while the outer world looms in the deep space beyond the window. Blue, the cool color of distance, floods both foreground and background. A patch of red, theoretically

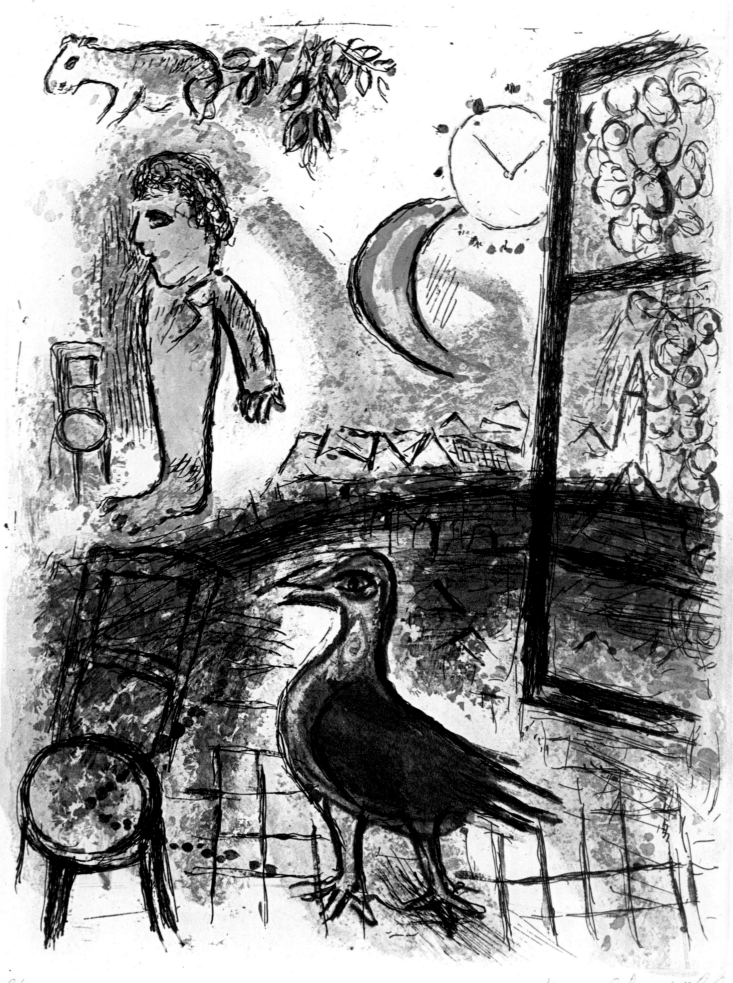

9/5 Marc Chagall

the warm color of nearness, helps to make the exact location of Vitebsk in the picture space uncertain and increases the impression of the town rushing from the outer world into the inner—or perhaps from the moonlit pre-World-War-I past into the vivid present of the dreamer's imagination, there being no rule that limits the discovery of meanings in these protean paintings.

The open-window theme should not, of course, be overloaded with sentiment and solemn significance, for Chagall would not be Chagall if he were deprived of his willingness to make fun of his own philosophizing and psychologizing. In *De mauvais sujets I* (page 41) it is the dreamer himself, accelerated by ferocious foreshortening and preceded by one of his fish motifs, who crashes from the outer world into the inner, like a Yiddish joke at the expense of the angelic apparition of St. Petersburg. In *De mauvais sujets IX* (page 47) the same comedian, as blissfully overconfident as Icarus, resolves to leave the cozy nest of his inner world for some experience of the deep space beyond the window. Nevertheless, the serious meaning is always there: even the grotesqueries are translations into pictorial space of their author's firm conviction that man's "psychic" or "fifth" dimension is as real as the other dimensions of the universe.

The conviction becomes even more apparent when we notice that the same kind of space occurs in dozens of pictures without windows. In these other works the window's paradoxical function of both separating and uniting the foreground and background, the inner and the outer worlds, may be performed instead by an arrangement that simply eliminates any suggestion of a middleground. Often such an arrangement takes the form of a half-implied terrace or platform in the foreground, from which the view plunges directly into the background (as it does in many late-medieval and early-Renaissance pictures, and almost invariably in classical Chinese landscapes). Sometimes there are spatial insertions —pictures within the picture—that eliminate the middleground. The patriarch in *Jacob's Dream* is provided both with such insertions, in the shape of disks, and with a hint of a platform for himself; and in *De mauvais sujets VIII* (page 44) there is an actual terrace, combined for good measure with an open window.

Chagall is by no means the only 20th-century painter fascinated by the open-window theme. It occurs in the work of many of his older contemporaries in the School of Paris—particularly in that of Bonnard, Matisse, and Delaunay— and also in the work of many German modernists. But usually these other artists turn out on examination to be more interested in the visual possibilities of the theme than in any metaphysical or psychological significance; they are

DE MAUVAIS SUJETS VIII, *colored etching, 1958. A mysterious red bird dominates a terrace that cuts off any view of the middleground and serves—in combination with the open window—both to unite and to separate the shallow "inner" space and the deep "outer" space of the moon and the distant city.*

45

the heirs of those Impressionists who continued to paint *sur le motif* in bad weather by looking through the window of a Normandy inn or a beachside villa. Quite apart, then, from the fact that Chagall was already painting open windows during his early Russian period, there cannot be much question here of influence, except in the sense of the encouragement of an existing predilection.

The window theme was favored also in Parisian literary circles toward the close of the 19th century and at the beginning of the 20th, particularly among the Symbolists and post-Symbolists. In this instance the question of influence is disposed of by Chagall's admission that he took a long time to learn French after his arrival in Paris. But convergences are often as enlightening as proved influences, and so it is worth noting that Mallarmé, a poet whom Chagall greatly admires, regarded the window as the supreme metaphor for "art and mysticism."

DE MAUVAIS SUJETS IX, *colored etching, 1958. Tired of indoor reverie and a confining local space, the dreamer sails through the window toward an undefined horizon.*

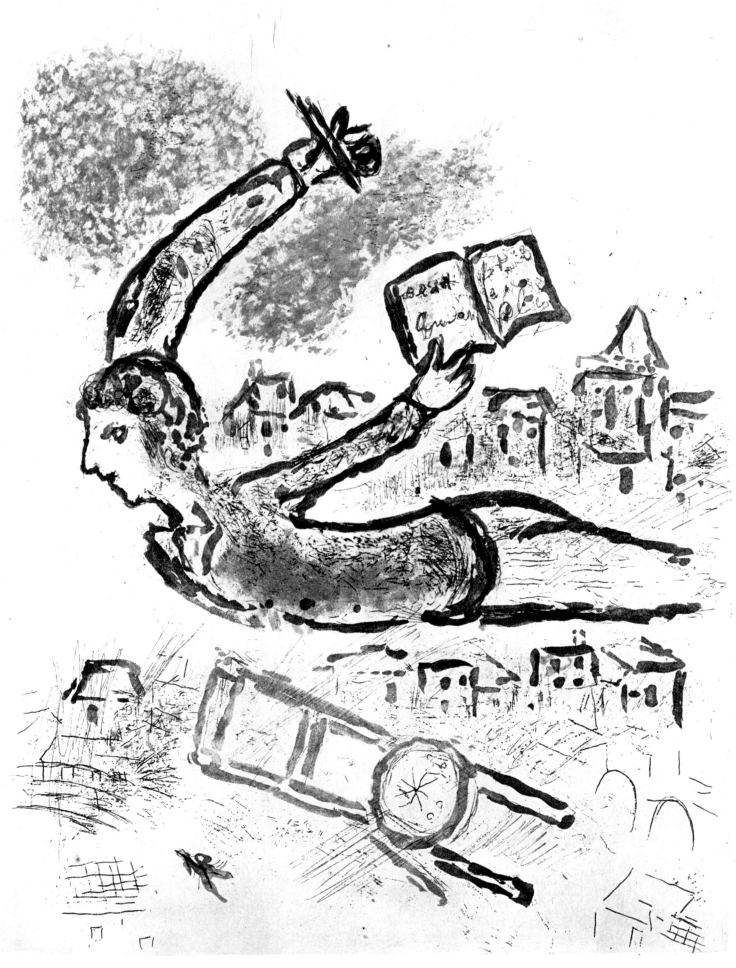

B/3 Marc Chagall

III *The Mystical Background*

Chagall is a profoundly Jewish painter—a rare phenomenon until about a hundred years ago. He might even be considered the first major Jewish painter, the other candidates for the honor being either not quite major or, as in the case of Pissarro and Modigliani, not recognizably Jewish in their work.

I am not, of course, suggesting that Chagall is dogmatically and exclusively a Jewish painter, for he has a right to feel unfairly diminished by such a classification. In his personal outlook he is firmly, sometimes humorously, nonsectarian, insisting that his only "religious rules" are to believe in the Prophets and to read the Bible and French poetry. His art functions often as nondenominational fantasy and often at an almost biological level of common humanity. And since he is today probably the most popular of the pioneer modernists (Picasso is better known, but not more widely liked) he can claim to have amply demonstrated his ability to appeal to people of all faiths and of none.

Every artist, however, inherits his ways of thinking and feeling partly from a group culture, and Chagall's are more than partly derived from the vibrant, mystical, largely Hasidic Judaism of the Vitebsk ghetto—a Judaism regarded, not without reason, as medieval by the enlightened and emancipated Jews of Western Europe. To be aware of this religious background is not, as some critics have implied, to possess the key to every Chagallian puzzle—group cultures do not paint pictures. But Chagall himself has described "the mystique of Hasidism" as one of the "principal elements" in his work, and so to neglect it is to risk missing a great deal of his significance and flavor.

Chagall usually begins and closes his working day with a walk through the sunlit landscape of the French Riviera. Here he descends the driveway of Les Collines *("The Hills"), his home on the outskirts of Vence until his recent move to the nearby village of St. Paul.*

48

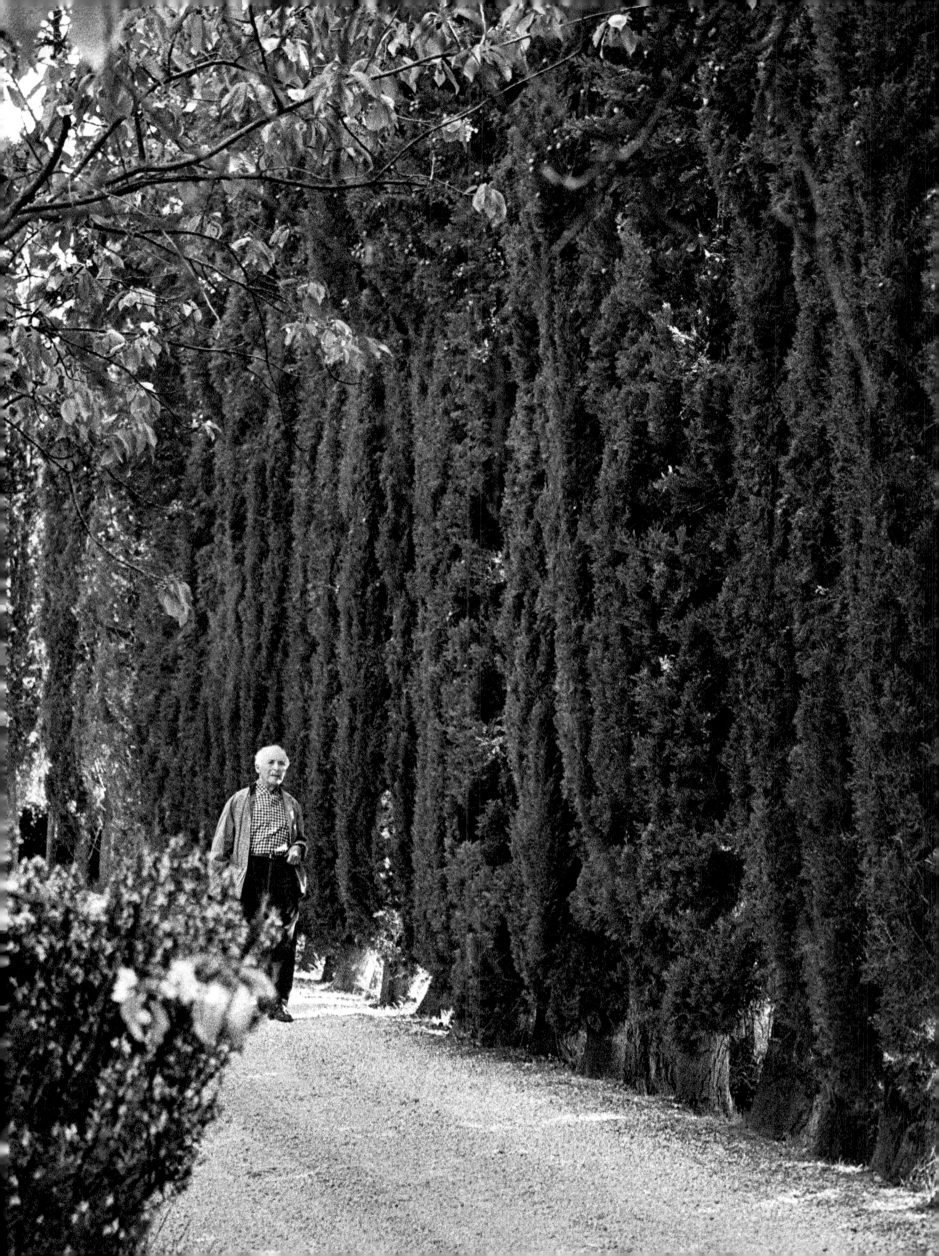

"*Personally, I do not think a scientific bent is good for art. Impressionism and Cubism are alien to me. Art seems to me to be a state of soul, more than anything else. The soul of all is sacred....*"

In the grounds of his home at Vence, the painter takes a townsman's—and also a mystical Hasid's—delight in the daily miracles of nature (Photo 1965).

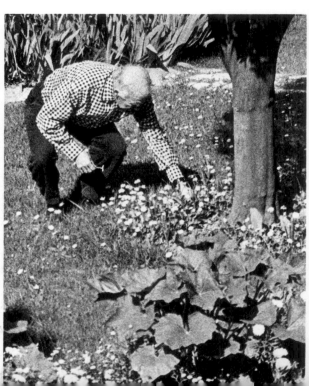

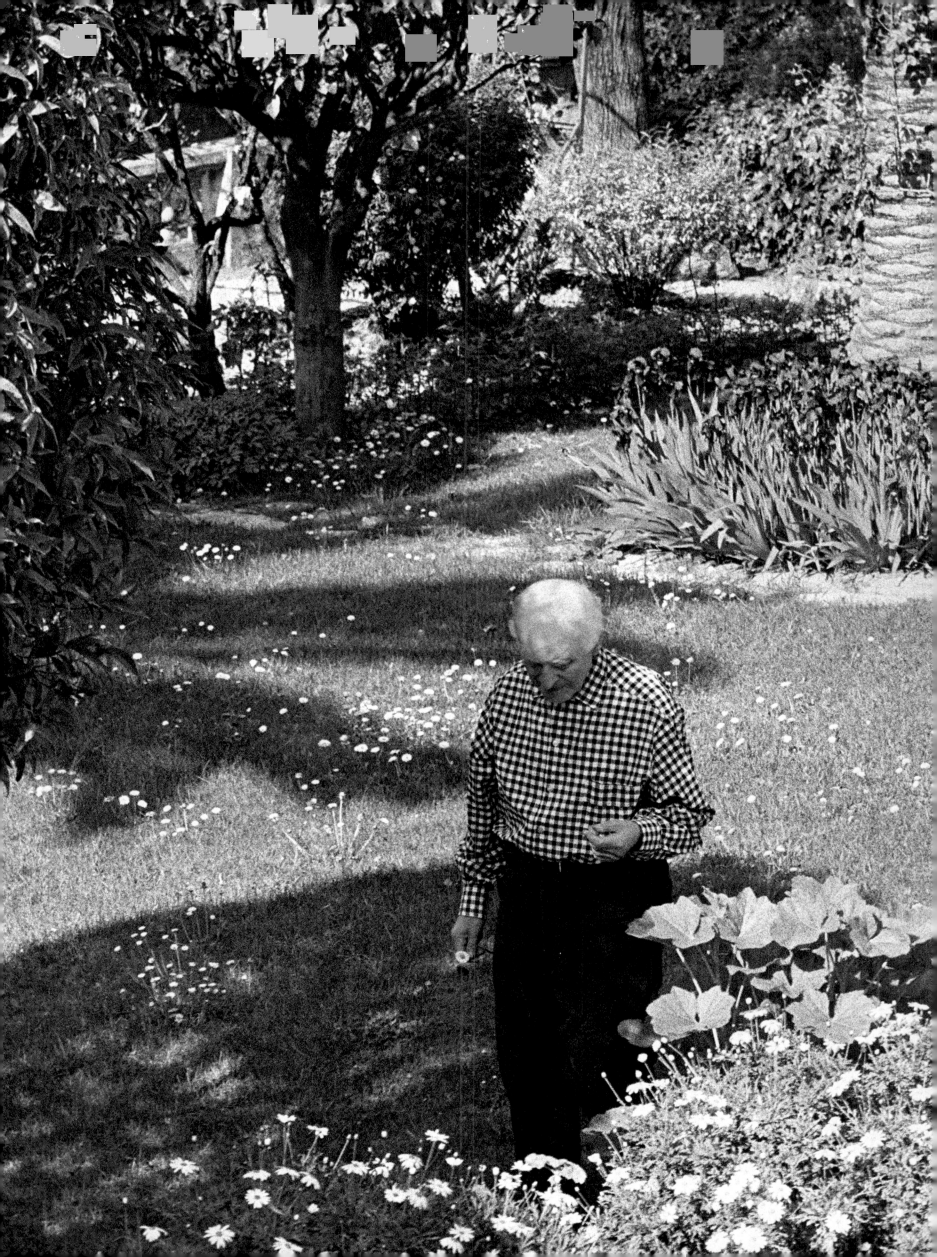

The revivalistic movement of the Hasidim (the plural of Hasid, the Hebrew word for "pious") had been under way for about a century and a half when Chagall was a boy, and although it still exists it is best described in the past tense, there being no modern equivalent for its context in the Russia of around 1900. The movement had started in Poland and the Ukraine, at a time when the Jews in these regions had become desperate and confused under the impact of pogroms, political oppression, economic disaster, bogus messiahs, and ersatz cults. Propagated by itinerant preachers, it had spread rapidly, especially in rural areas: at one point about half the Jews in Eastern Europe were Hasidim. During the 19th century a decline had set in, partly because of a lack of organization (since Hasidism was essentially conservative, there was never a definite break with the main body of Judaism) and partly because of the usual tendency of mystical sects either to harden into puritanism or to decay into superstition and charlatanry.

The decline, however, was not very noticeable in the Vitebsk of the young Chagall, to judge by his memoirs and by those that Bella, his first wife, wrote under the title *Burning Lights*—an allusion to the ritual candles lit on Jewish holidays. Both of their families were devout Hasidim. From Bella's book it appears that life in the more affluent Jewish circles of the town (her father was wealthy) was a perpetual round of fervent and often spectacular religious celebrations, interrupted only by the need to prepare for the next one. In Chagall's relatively poor household there was less festivity, but just as much fervor. He recalls his father, a laborer in a herring depot, going to the synagogue every morning at six, winter and summer; his Uncle Juda muttering prayers at the window; his Uncle Israel swaying and singing at the synagogue; his Uncle Neuch borrowing a tallith (prayer shawl), reading the Bible aloud, and then playing the rabbi's song on a violin; and himself singing with the cantor, praying to be hidden in the Holy Ark with the Torah, imagining tiny, ancient Jews in the depths of his father's Passover wine, waiting in a dark courtyard for the prophet Elijah and the white chariot to appear (only a beggar with a pack and stick appeared, a figure similar to the one clinging to the ladder in *Jacob's Dream*).

As he grew older and began to paint, he gradually lapsed into his present lack of commitment to any organized religion. But as late as 1915, when he was 28 and already married, he was still enough of a Hasid to ask the advice of the local rabbi—an old man who held court in feudal style—about moving to St. Petersburg (he was advised to do as he wished). And in the years since then the influence of Hasidism has been constant in his painting, his philosophizing, and —as the photographs in this chapter suggest—his everyday life.

Hasidic influence can be seen, for instance, in the tendency toward sentimentality that occasionally distresses even the most friendly critics of the Chagallian world. Seventy years ago a synagogue in Vitebsk, one gathers from *My Life*, was a showplace for sensibility, in the Jane Austen sense of the word.

Chagall says his grandfather's public praying was as sweet as "new honey," and speaks of Jews unfolding vestments "full of tears from the whole day's prayers." He tells how his father would prepare the prayer books for his mother:

"In one corner, he writes: 'Begin here.'

"Near one moving passage he notes: 'Weep.' In another place: 'Listen to the cantor.'

"And Mamma would go to the temple assured that she would not shed tears in vain, but only in the right places."

However, as the tone of this passage shows, a sense of humor accompanied the sentimentality and the self-dramatization—a sense of humor that is perhaps best known through the stories of such Yiddish authors as Sholem Aleichem and Isaac Bashevis Singer, but which is equally evident in many of Chagall's drawings and etchings. Saul Bellow, writing of the work of Aleichem, has described the religious roots of this East European Jewish humor in terms very applicable to the verve and irony of such creations as the *De mauvais sujets* illustrations and the sketches Chagall preserves in his notebooks (see pages 66–67):

"The Jews of the ghetto found themselves involved in an immense joke. They were divinely designated to be great and yet they were like mice. History was something that *happened* to them; they did not make it.... But when history had happened it belonged to them, inasmuch as it was the coming of the Messiah —*their* Messiah—that would give it meaning. Every male child was potentially the Messiah. The most ordinary Yiddish conversation is full of the grandest historical, mythological, and religious allusions. The Creation, the Fall, the Flood, Egypt, Alexander, Titus, Napoleon, the Rothschilds, the sages, and the Laws may get into the discussion of an egg, a clothes-line, or a pair of pants. This manner of living on terms of familiarity with all times and all greatness contributed, because of the poverty and powerlessness of the Chosen, to the ghetto's sense of the ridiculous."

The painter's deep distrust of rationalism and academicism, in both art and life, is also Hasidic, for the movement in one of its multiple aspects was a revolt of the relatively uneducated mass of village Jews against the rigid intellectualism that had been dominant in Judaism for centuries. The typical Hasid rejected the maxim in the Talmud (the compendium of Jewish law and tradition) that "an ignorant man cannot be a pious man" and stressed instead the other Talmudic principle that God "requires the heart." A Hasidic parable tells of a boy found reciting the Hebrew alphabet in the synagogue: he explains that since he cannot read the prayer book he is sending the letters up to heaven, where he is sure God will assemble them into a prayer for him.

This attitude toward learning helps to explain the ease with which, despite the traditional Jewish opposition to image-making, Chagall obtained his family's

53

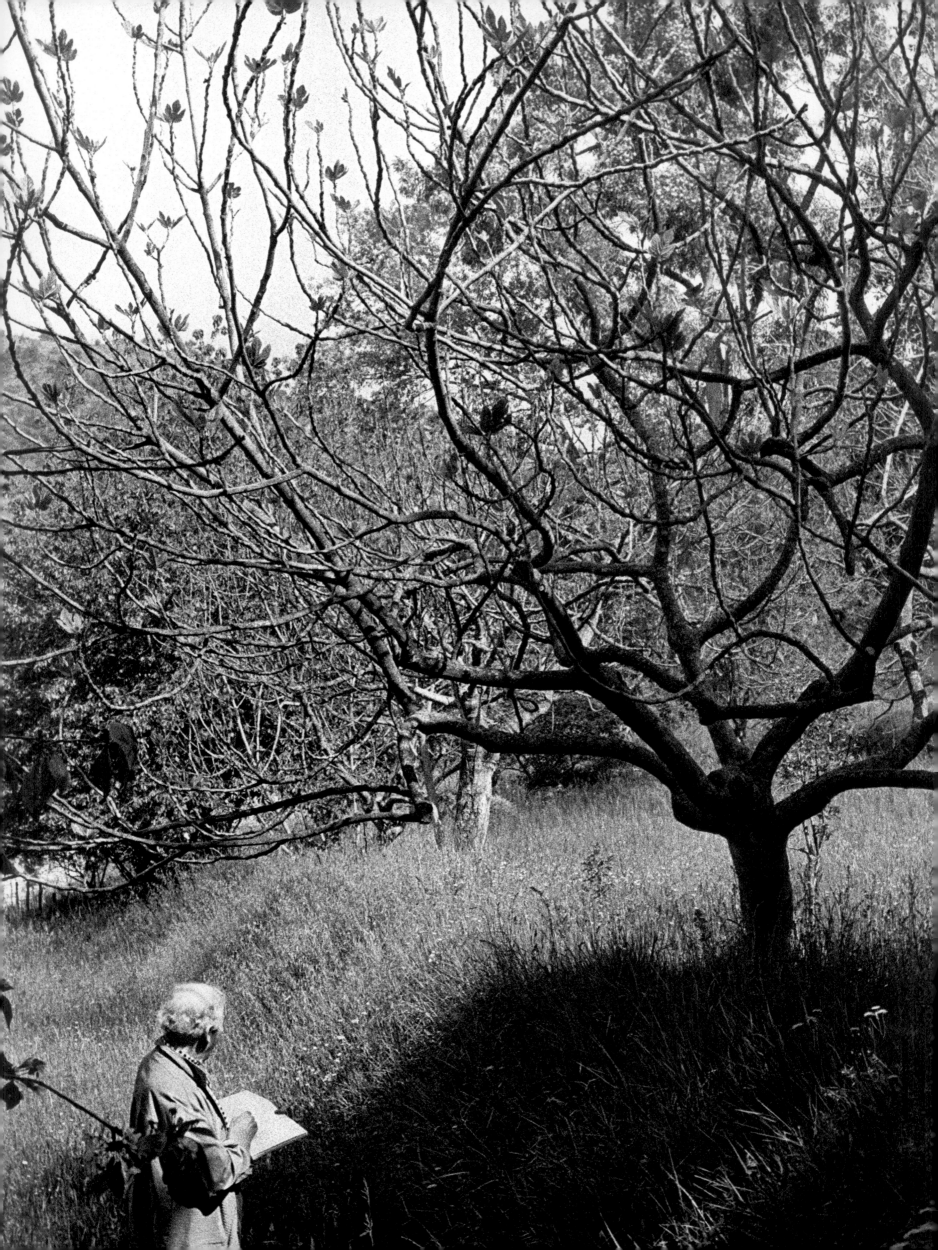

"Art picks up where nature ends."

"As I walked by this man at work, I felt enveloped in a Biblical atmosphere. It was as if he were purifying my heart and body. I silently thanked him."

Although Chagall insists, with justification, that his pictorial world is remote from that of folk and popular art, he takes pleasure in recalling that he is a working man's son, born "in a little house near the road behind the prison on the outskirts of Vitebsk... where the poor Jews lived." His daily walk—in Vence, on the opposite page—is for him a ritual of immersion not only in nature but also in "the people," whom he regards, quite in the spirit of Hasidic mystical democracy, as "the most sensitive class of society."

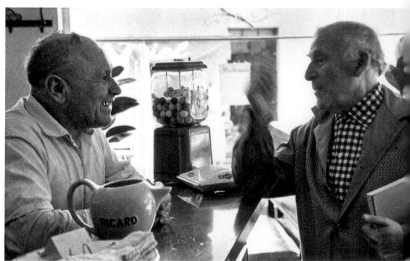

"I found my lessons in the city itself, at each step, in everything. I found them among the small traders in the weekly open-air markets, among the waiters in cafés, the concierges, peasants, and workers. Around them hovered that astonishing light of freedom which I had seen nowhere else."

The above enthusiastic remarks, with their typically Hasidic emphasis on a love of people and their mystical implications about light, are actually a reference to the painter's first months in Paris in 1910; but they are equally applicable to his years in Vence. The town, which normally has a population of less than 10,000, is flooded with visitors during the holiday season, and it is quite accustomed to celebrities: the chapel decorated by Matisse is in the suburbs, and Valéry used to try his hand at painting in the building that later became Chagall's studio. But during most of the year the place has the informality and the slow tempo of the other small towns in the hills behind Nice, and it has provided Chagall with the kind of friendliness—and light—he needs in order to work.

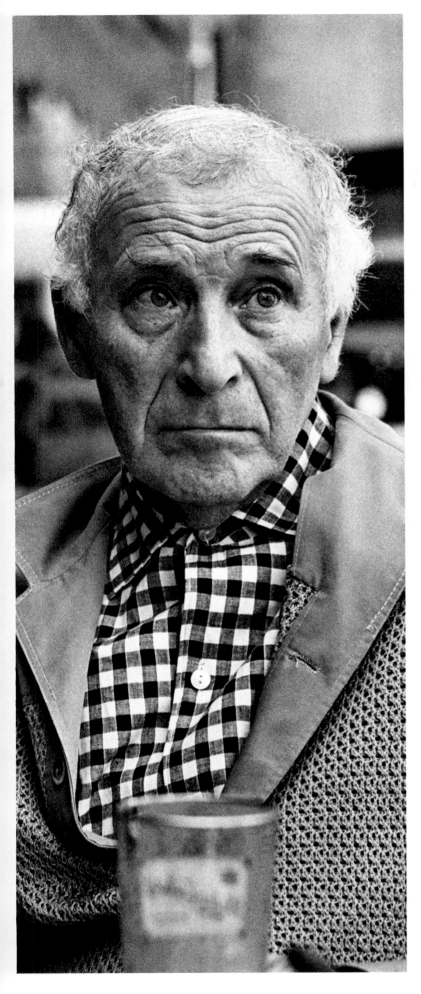
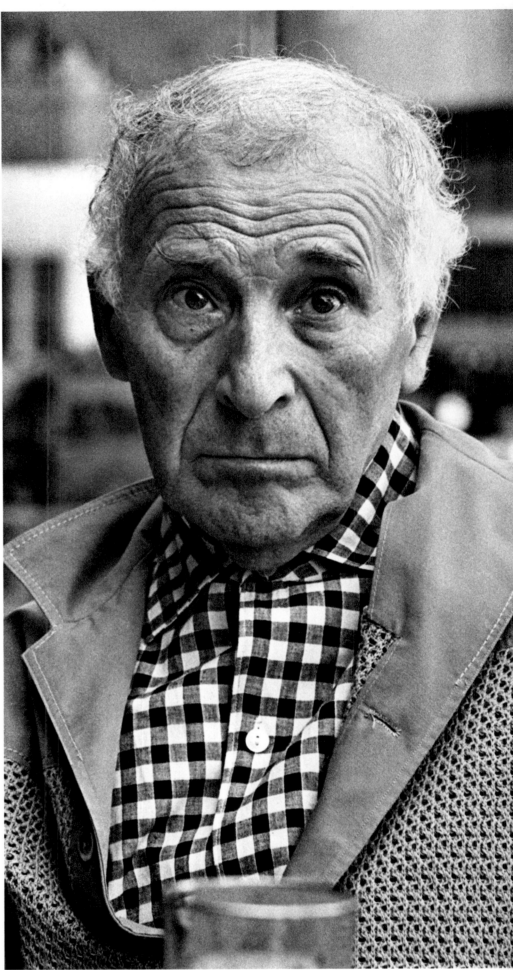

61

An air of trance-like solitude, which may envelope the artist at home in his garden, during one of his downtown walks, at lunch in a fashionable restaurant, or—as here—in one of Vence's cafés, is for his friends a familiar sign that he is ready to get back to work. A moment after these pictures were taken he produced a sketch pad and began to draw. His first sketches (on the following page) reflect vaguely the actual scene around him. But almost immediately his eyes are "turned toward the interior" (in his words) and toward images that have been part of the world of his imagination for more than 60 years.

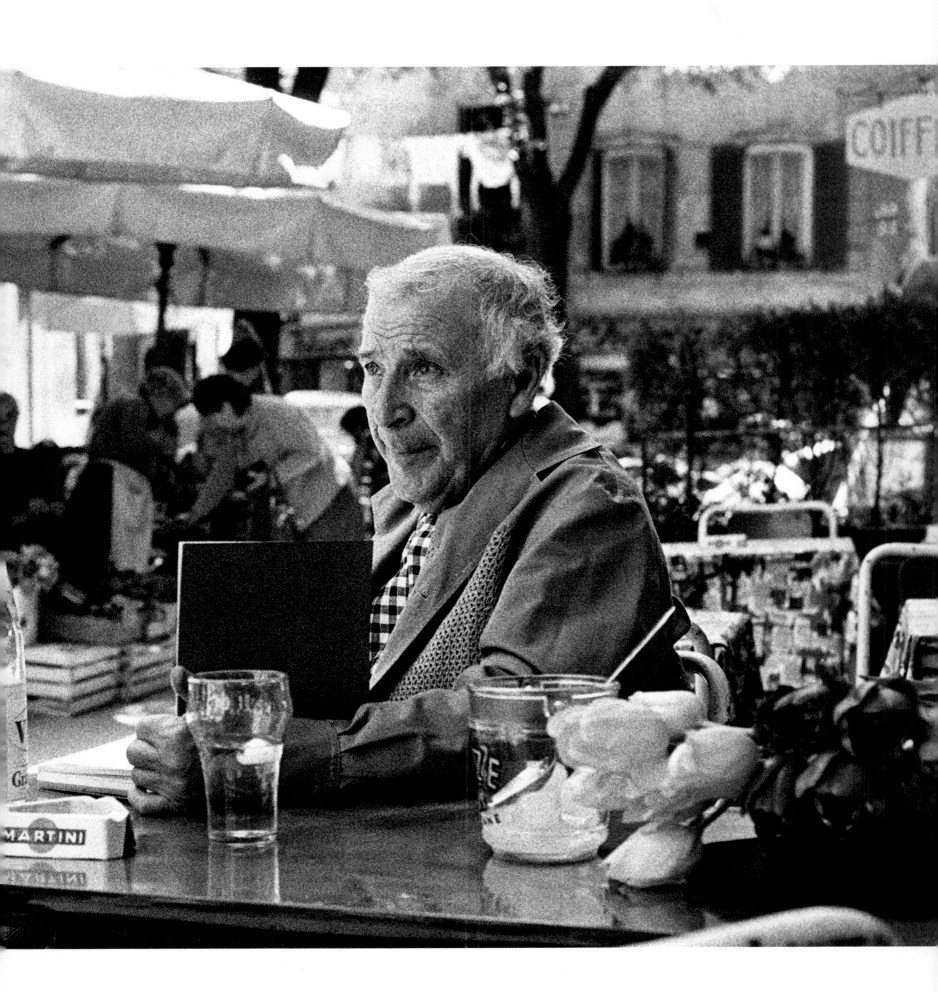

permission to become a painter. The pressure to become a scholar, which in a non-Hasidic community might have been irresistible for a gifted boy, was lacking in Vitebsk; and so the way was open to the nonliterary arts.

In fact, the way was open to a great deal of unconventional Jewish behavior, for the Hasidim believed in worshiping, as Chagall believes in painting, as joyously as possible. In Vitebsk the most pious Jews sang for God loudly and regularly, and whenever they could they danced for Him. Bella describes in *Burning Lights* the celebration at her home of the festival of Simchath Torah, which marks the completion of the year's weekly readings in the synagogue of the Five Books of Moses:

"The table is pushed to one side, the chairs are kicked away. The walls themselves seem to be swaying. The tablecloth slips. Pieces of cake and some glasses fall to the floor. The men begin to leap, to stamp in one spot. They turn the flaps of their coats, and they form little dance circles. Their shoulders are bent, their hands are interlocked.... With a shout, a tall, thin Jew bounces into the room. He turns a somersault and lands on his feet. He twists on the floor like a worm...."

It was during a celebration of Simchath Torah that Chagall's maternal grandfather climbed onto the roof "because of the fine weather we were having," sat down on a chimney-pot, began to munch carrots, and thereby became a motif in one of the painter's best-known pictures, *The Dead Man* (1908). Is it surprising that an artist who grew up in such an atmosphere should find it natural to turn his personages upside-down and to depict angels as acrobats and dancers? "Even today," he has said, "when I paint a Crucifixion or some other religious picture I have almost the same sensation as when painting circus people...."

But Hasidism was not only a stimulus for weeping, anti-intellectualism, singing, dancing, and roof-climbing. It was a doctrine of mystical love of all mankind and a theory of redemption of the universe from the evil of materialism. As such it must be considered a source (although certainly not the only one) of some of Chagall's most characteristic ideas, and also a link between those ideas and the medieval system of Jewish esoteric thought known as the cabala.

"Cabala" means "received tradition," and can designate the vague body of Jewish religious teachings handed down orally from generation to generation and presumably known only to the initiated. Since the Middle Ages, however, the word has usually meant an elaborately written and in outline fairly definite form of mysticism, much of which stems from the *Zohar,* a 13th-century book of occult lore and Jewish religious, philosophical, and scientific speculation.

The cabala in this restricted sense can be divided roughly into a cipher method of interpreting the Old Testament (usually for the sake of predicting, and then changing, the date of the coming of the Messiah) and a theory, or theories, of divine creation through emanation. The development of the cipher

method was facilitated by the fact that each letter of the Hebrew alphabet has a numerical equivalent, and also by the relative ease with which the letters can be regarded as ideograms. The theory of creation through emanation—through, that is, a series of descending radiations from the godhead by intermediate stages to matter—eventually existed in many versions, but the most influential was the one developed in the 16th century by the great scholar Isaac Luria at the cabalistic center of Safad, in Palestine. Luria maintained that matter and thought were the result of a cycle that began with the withdrawal of God to provide space for the world and ended with a synthesis brought about by the emanation of light.

Alongside this theoretical cabala there was always a practical one, a form of white magic that was often mixed with such occult sciences as astrology and alchemy. But the theoretical kind enjoyed an extraordinary prestige, among Christian as well as Jewish thinkers, throughout the early Renaissance and well into the 18th century. It existed in a popularized form when the leaders of the Hasidic movement felt the need for a mythical system that could replace in part the rationalism of the Talmud, and it was still current when Chagall was growing up in Vitebsk.

His familiarity with the system is shown in a number of playful sketches in which human beings are stretched and twisted into the shapes of Hebrew letters. Far more important, however, if less easy to define, is the evidence in his work and in his general life-style of the influence of the cabalistic theory of divine creation through emanation.

The version of the theory adopted by the Hasidim was Luria's, considerably modified in an optimistic direction. God's initial act of creation was represented as being not a withdrawal to make room for the world, but simply a diminishing of His light in certain areas, partly in order to adapt it to the capacity of endurance of His creatures. "Holy sparks" were therefore said to be still present in everything in nature, organic and inorganic, and in every person, good or bad. Evil in the world was merely a lower grade of good, and there was no real separation of the sacred and the profane.

In the Hasidic view, several conclusions could be drawn from this situation. Obviously, all men, whatever their defects in the eyes of their fellows, had to be loved, since all had in them the holy sparks. Obviously also, every man had to be humble; if he were not, he might not find in himself the proper willingness to love the wicked. On the other hand, nobody should waste too much time humbly regretting sins: instead he should strive harder to establish harmony with God—a happy harmony. And finally, every man had, without waiting for the Messiah, a role to play in the redemption of the world, for whenever he made use of matter in a holy way—by working with it honestly, for instance, or even by eating or drinking it joyously—he consecrated it and lifted it closer to the light of God; in the cabalistic phrase, he "caused the sparks to ascend."

65

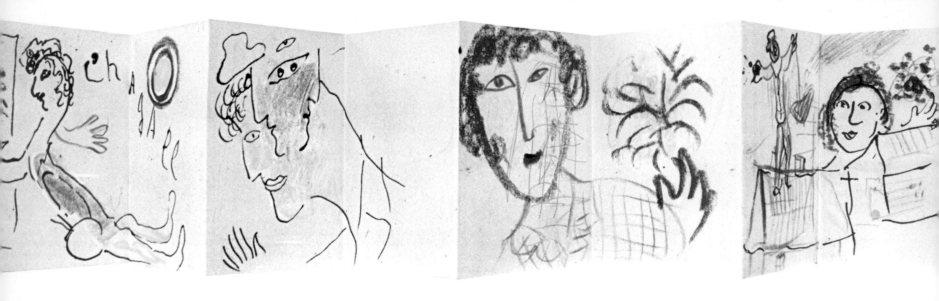

The artist assembles the leaves of his sketch pads into folders that provide records of the past and sources for the future. The sections above begin with self-portraits and continue through a typical selection from the Chagallian repertory. Less typical, because drawn from life, are the Vence personages at the bottom of the opposite page.

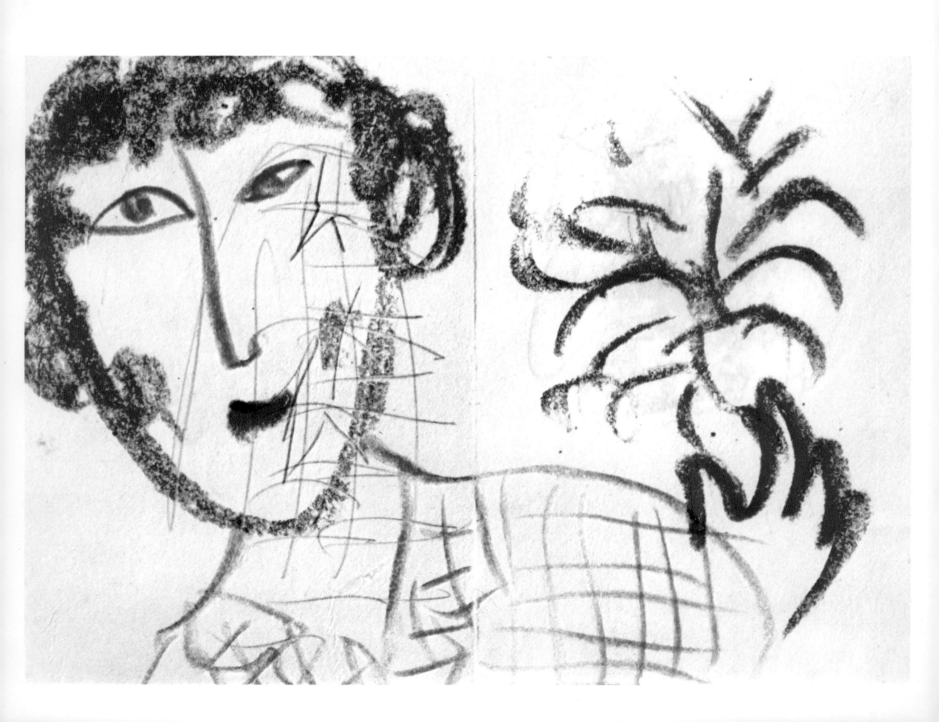

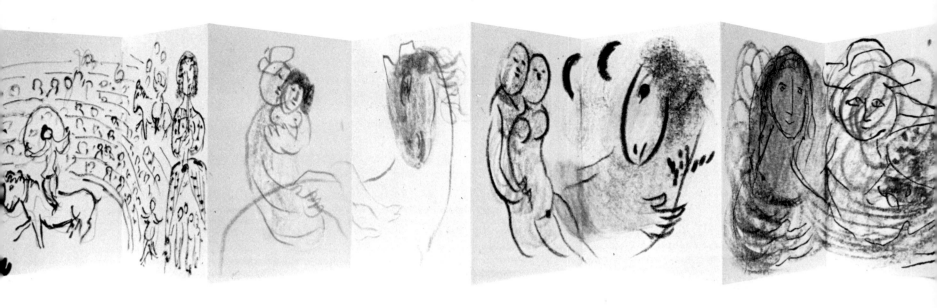

"*I am unable to see how I draw. My hand sees, but my eyes are often turned toward the interior and focused on other drawings and paintings I shall realize one day.*"

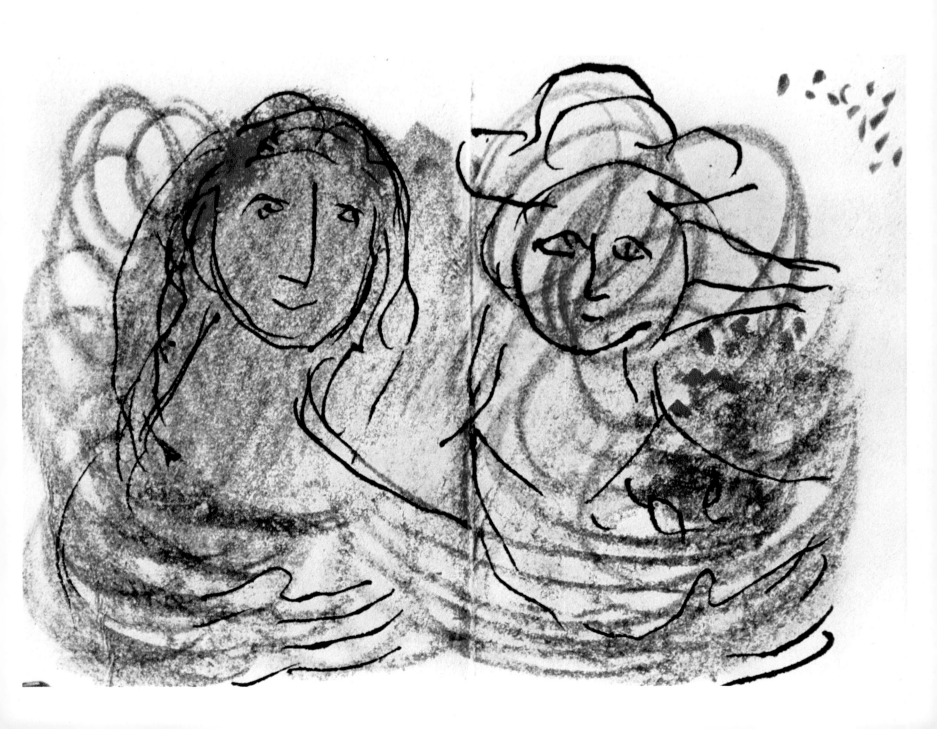

In the alleys and little squares of the old walled quarter of Vence, parts of which date back to medieval and late-Roman times, the children have a playground as free of automobiles as Vitebsk was 70 years ago. And they are too wrapped in their own world to notice the grandfatherly figure who is watching them—until (pages 70 and 71) he suddenly opens his sketch book and begins to draw. On such occasions one of the more puzzling aspects of the creative process Chagall has perfected over the years becomes apparent, for while he frequently sketches during his long daily walks he hardly ever sketches what he is looking at. Why then does he bother to look at something? The explanation, if such things can be explained at all, seems to be that in fact he usually creates from a reservoir of images—many of them dating back to his boyhood—in his imagination, but that he likes to have in front of his eyes a reasonably inspiring reality to act as what can be variously thought of as a trigger, a fuse, a primer, or a catalyst. And of course there is always the possibility that the reality being looked at will enter the reservoir and be sketched on some future occasion.

"You cannot walk among children without remembering your own childhood, your vanished Eden."

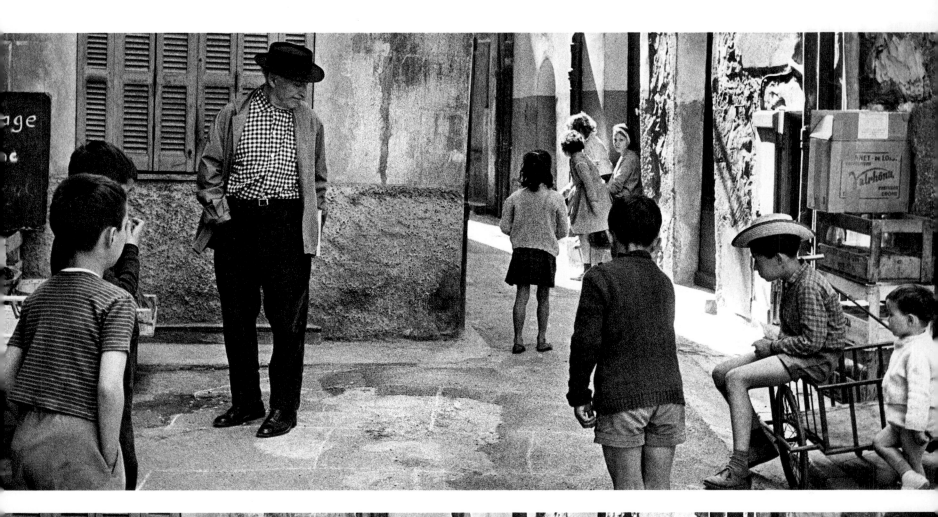
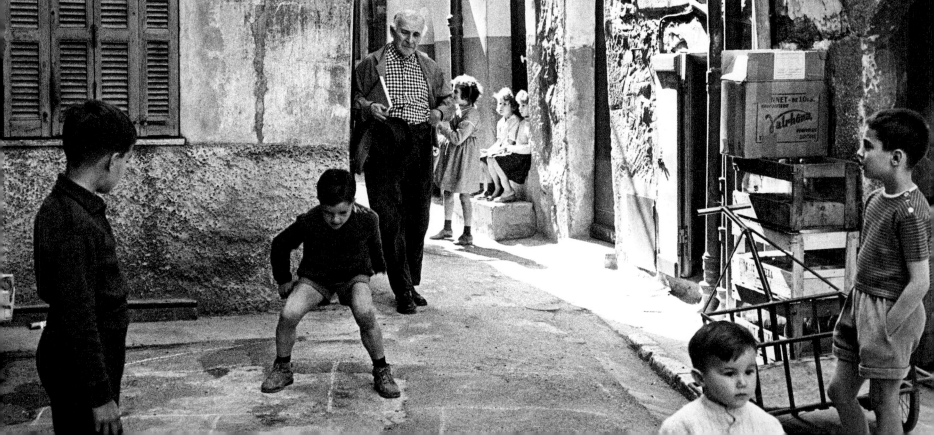

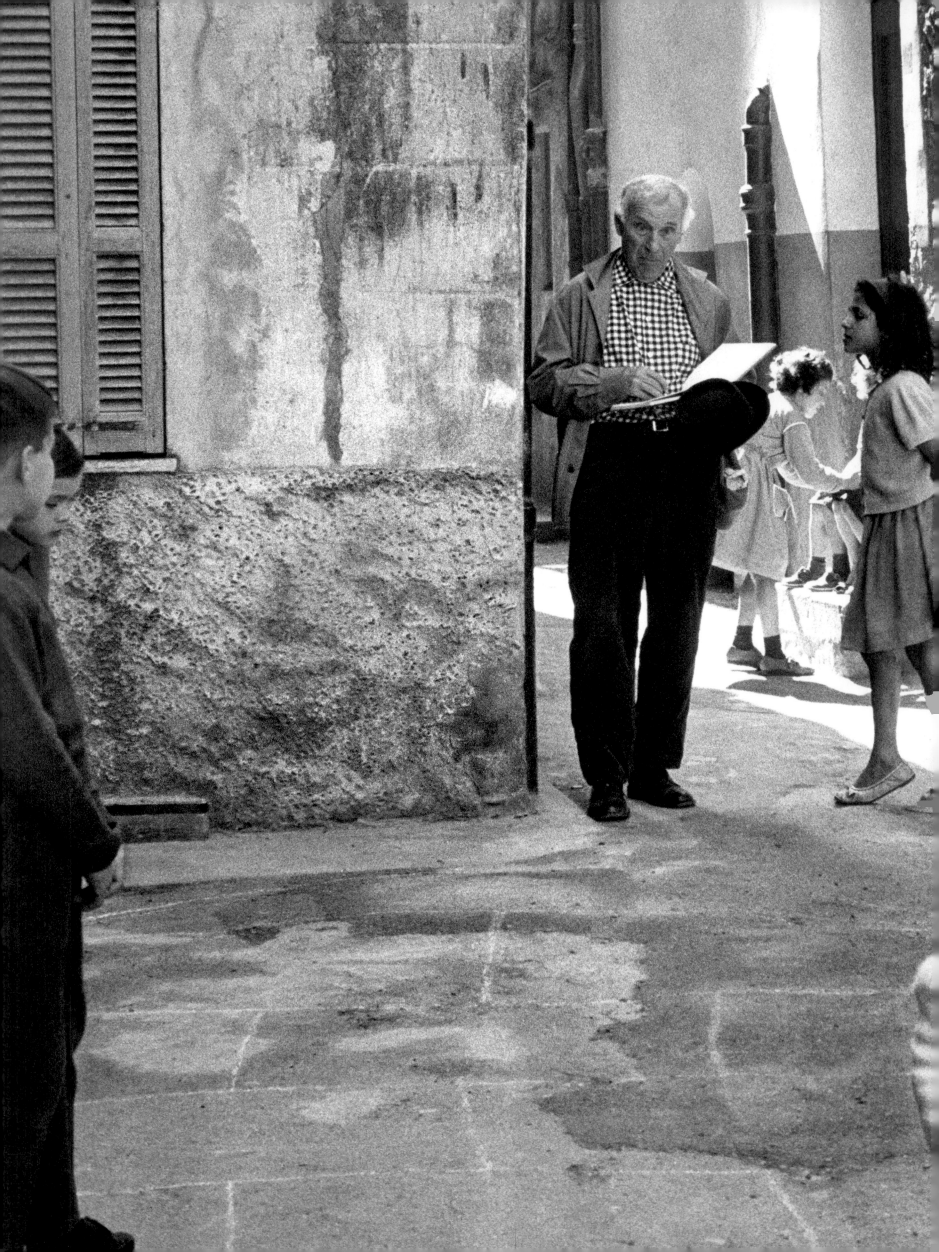

It should be noted that this doctrine is not a form of pantheism, although in practice it might often seem to be. It assumes that God is still the God of the ancient Hebrews—still a God whose ultimate nature is beyond the understanding of man.

The emotional and intellectual climate of Hasidism is here almost identical with the climate of the Chagallian world today. The patriarchal figure who in these pages can be seen taking his daily constitutional at Vence may indeed have lapsed from the details of the faith in which he was immersed for the first 20 years of his life. But one can scarcely doubt that he still adheres, in his own "psychic" fashion, to the Hasidic belief in the omnipresence of God in nature, that he still refuses to separate the sacred and the profane, and that he still feels what in *My Life* he describes as "that clamorous love that I have, in general, for mankind." He still feels, in other words, the imperative need to live hopefully which he felt as a boy in Vitebsk and which, much more than the persuasiveness of cabalistic cosmogony, was the basic reason for the acceptance of Hasidism by the Jews of czarist Russia.

An acquaintance with that cosmogony is not, however, entirely irrelevant to an appreciation of Chagall's art, for his strongly ethical notions about color, light, pictorial matter, and "the microbes of the universe" are clearly related, however remotely, to the esoteric tradition that produced Luria's theory of creation through emanation. They are, at least in part, the poetic residue of centuries of cabalistic ingenuity. They might even be regarded as just a slightly modernized and secularized version of the old commandment to cause the holy sparks to ascend.

"My worries disappear one by one when Vava is near me."

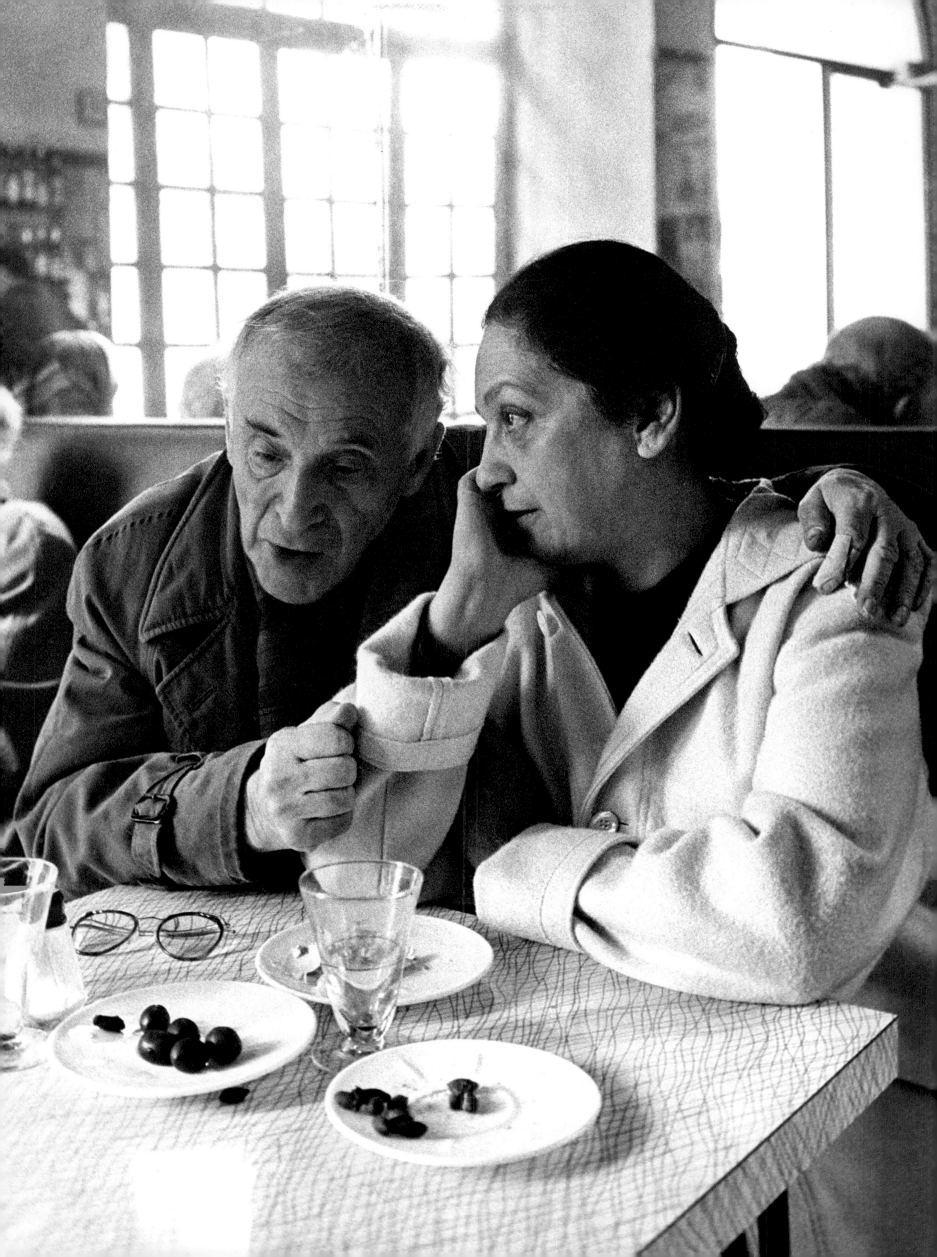

IV The Painter in the Mirror

The singing and dancing Hasidim of Vitebsk were clearly not interested in self-effacement, and they did not kindle any enthusiasm for it in Chagall. His work includes many straight self-portraits and a large number of compositions in which he is recognizable as one of the principal *dramatis personae,* often in association with painting equipment and visions of Russia. It would be hard to name another artist who has depicted himself, directly or indirectly, even half as often.

A certain youthful narcissism—of a kind quite normal among handsome people—can be detected in some of the pictures when they are combined with Chagall's candid comments on himself as a boy. In language that recalls Hebrew love poetry, he describes his face as a blend of "Passover wine, ivory-colored flour, and rose-pink petals," and he adds: "My closest friends caught me more than once in front of the glass. As a matter of fact, I was studying myself and thinking of the difficulties I should have if I ever wanted to paint my portrait. But there was a touch of admiration in it—why not? I admit, I did not hesitate to blacken my eyes a little, to redden my mouth slightly, although it did not need it...."

With the addition of the long hairstyle of a pre-1914 aesthete, an old Dutch master's white turnover collar, and a growing maturity, this good-looking adolescent became the complacently romantic subject of the early self-portraits; and eventually, so far as the image was concerned, he stopped growing older. He has remained, in a less individualized but still identifiable form, one of the basic reflections and projections of the Chagallian self—the ageless if sometimes rather jowly lover, bridegroom, dreamer, and artist who appears in a great many of the paintings.

There are, however, many other reflections and projections. There is the tousled anti-Narcissus, grimacing in the mirror. There is Chagall the Russian

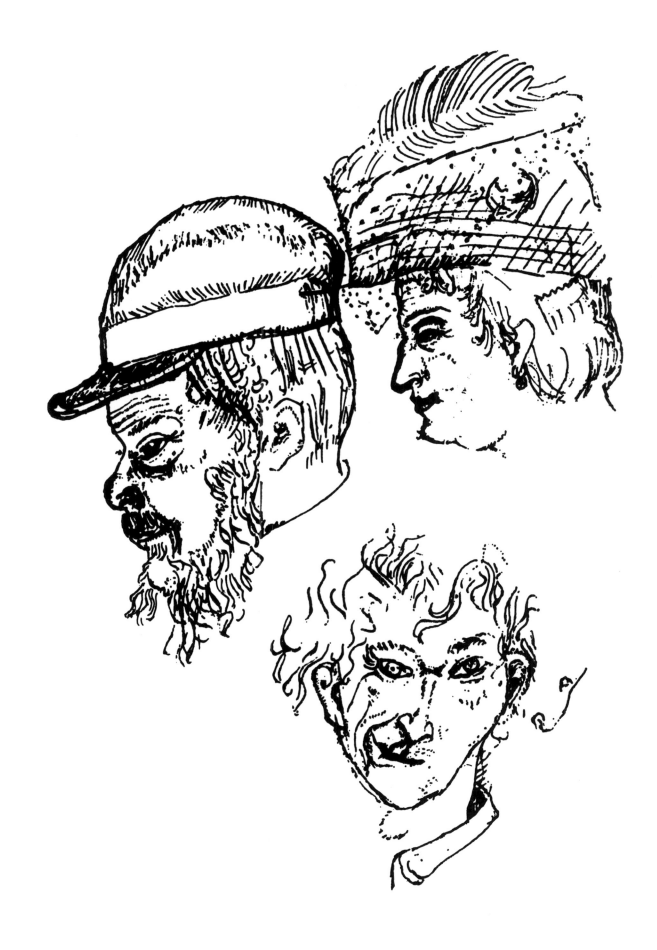

SELF-PORTRAIT WITH PARENTS IN PROFILE, *pen drawing, 1911. After a year of hard struggle in Paris, the homesick young artist sketched these memories—adding himself, grimacing in the mirror.*

faun, with exotically slanted eyes and nervous, sensual mouth. Recurring metamorphoses give us Chagall the Janus-faced, Chagall the green-faced, Chagall with an animal's head, Chagall with an upside-down head, Chagall with no head, and Chagall with the body of a beast, a bird, or a violin. In one otherwise quite realistic self-portrait the painter is represented as an angel—of at least the rank of the cherubim, to judge by the size of the wings. In one of the very indirect images he appears as a bearded Christlike figure, with one hand gripping his palette and the other nailed to a cross. At the opposite end of his scale of self-importance, he is often the innocent fool who has long been a character in Russian, Yiddish, and especially Hasidic popular literature; occasionally he is cast in the equally stock role of the Jewish chump, or urban schlemihl. One of the few deflating roles he has never forced himself to play is that of an old man; there is no trace of a Chagallian equivalent for the bitter self-caricatures created by the aging Picasso.

In short, youthfulness aside, Chagall images are not a consistent part of Chagall's world. Nor, it can be added, are they very remarkable when separated from their anecdotal contexts and looked at strictly as portraits. Even when they are not mythicized or satirized, they are usually flat characterizations: vivid and entertaining, but not complex enough to belong to the tradition of detailed self-scrutiny represented by Rembrandt, and not intense enough to belong to the Expressionist tradition represented by Van Gogh. We can ask, therefore, what purposes they serve that could not be served just as effectively by impersonal figures—by non-Chagalls.

One such purpose is undoubtedly compensation for past feelings of anonymity and inferiority. The boy in Vitebsk—who has always been, to a degree that cannot be exaggerated, the father of the man in the School of Paris—was not lavishly supplied with ego gratification, apart from his awareness of curly locks and handsome features. He was poor, and the occupations of the men in his family marked him as a member of the lower classes. For years he was afflicted with a bad stammer, which added to his natural timidity and made recitations at school a nightmare. He had spells of weeping, he says, "toward evening, as though someone were beating me." As a Jew he was frequently humiliated, and oppressed by the thought that he was growing up only to become a clerk or, worse, to be drafted into the army. All this makes more understandable his enduring disposition to give himself starring roles in his pictorial fantasies, and it illuminates in particular the evident and touching satisfaction he has always taken in depicting himself as a painter. In one of the early self-portraits he poses as Gauguin, in another he wears a beret in the Rembrandt manner, in another

THE SEVEN DEADLY SINS, *etching and drypoint, 1926. In this frontispiece for a collection of humorous essays by French writers, Chagall turns himself into a totem pole of all the traditional mortal vices.*

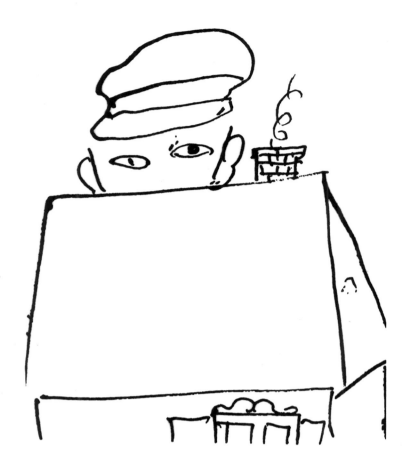

Roofs, chimneys, and old-fashioned Russian caps—symbols of shelter, the family hearth, and the homeland he has never forgotten—are recurring motifs in the work of Chagall. In the undated pen drawing above, entitled BEHIND THE HOUSE, *the boy Marc peers over a roof in his native Vitebsk. In* A GENTLEMAN *(opposite page), a pen drawing of 1920, a capped citizen of the new Soviet Union takes a stroll.*

he has a large hat that recalls Rubens. Although he has become more discreet, the palettes, brushes, and easels that appear in his paintings can still be read as symbols of the status he has acquired since the days when, according to *My Life,* he roamed the streets of the ghetto and prayed: "God, Thou who hidest in the clouds, or behind the cobbler's house, lay bare my soul, the aching soul of a stammering boy, show me my way. I do not want to be like all the others...."

But the compensatory function does not, of course, account for the many pictures in which Chagall mythicizes or satirizes himself, and even elsewhere it can usually, I think, be shown to be incidental in a larger and more properly artistic function. The latter can be described with the help of a literary analogy: whereas the average painter, like the average novelist, tends to use the third person, Chagall has a lyric poet's tendency to use the first person. His reflections and projections of himself are the visual equivalent of the "I" in verse, from

78

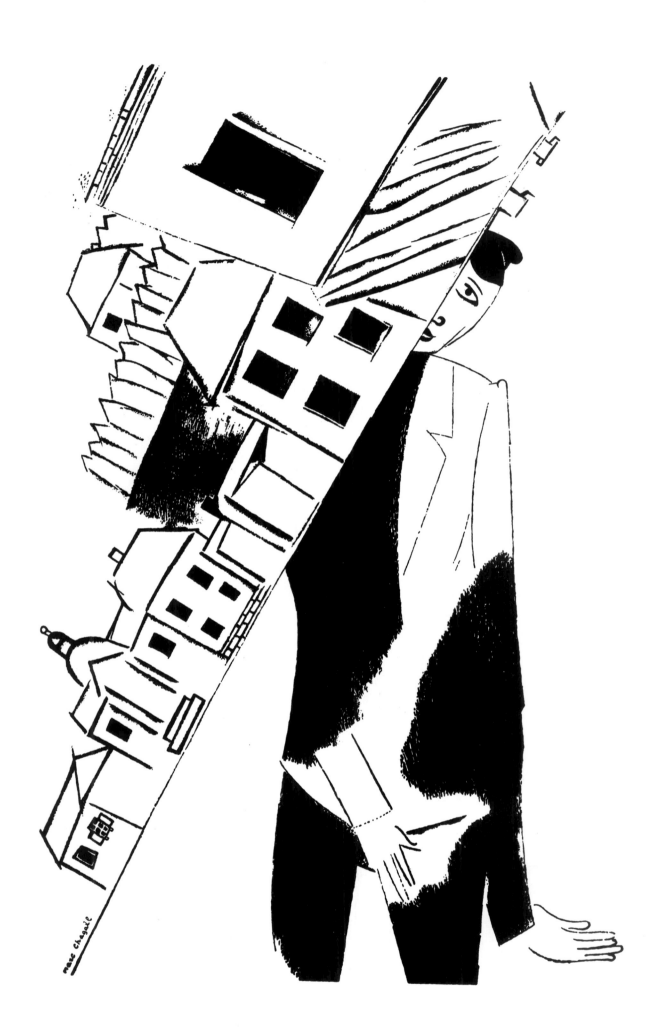

Above, in a vigorous pen drawing of 1920, textile impressions on the paper add a cheerful folk-art note to an amorous incident entitled ABDUCTION. *On the opposite page, in an undated ink work called* MAN CARRYING STREET, *a young Russian shoulders a sizeable section of Vitebsk.*

which custom long ago removed any taint of egocentricity. They are (as their success with a large public proves) simply ways of approaching the universal through the particular.

Since they are visual forms of the first person singular, they do sometimes produce effects that are normally absent from both prose and painting. They may add to what I have called Chagall's "window" space and "dream" space a mirror space in which the self becomes a part of its environment, the colored matter of the picture becomes the substance of the self, and the distinction between subject and object becomes difficult to maintain. But this universe of Narcissus does not destroy the analogy with lyric verse; in fact, it is another reminder of the resemblance of some of Chagall's ideas to those of French poets—to Mallarmé, for instance, who noted that in looking through the symbolic window of art and mysticism one saw one's reflection in the glass, or to Valéry, who made a philosophical principle out of the notion of seeing himself seeing himself.

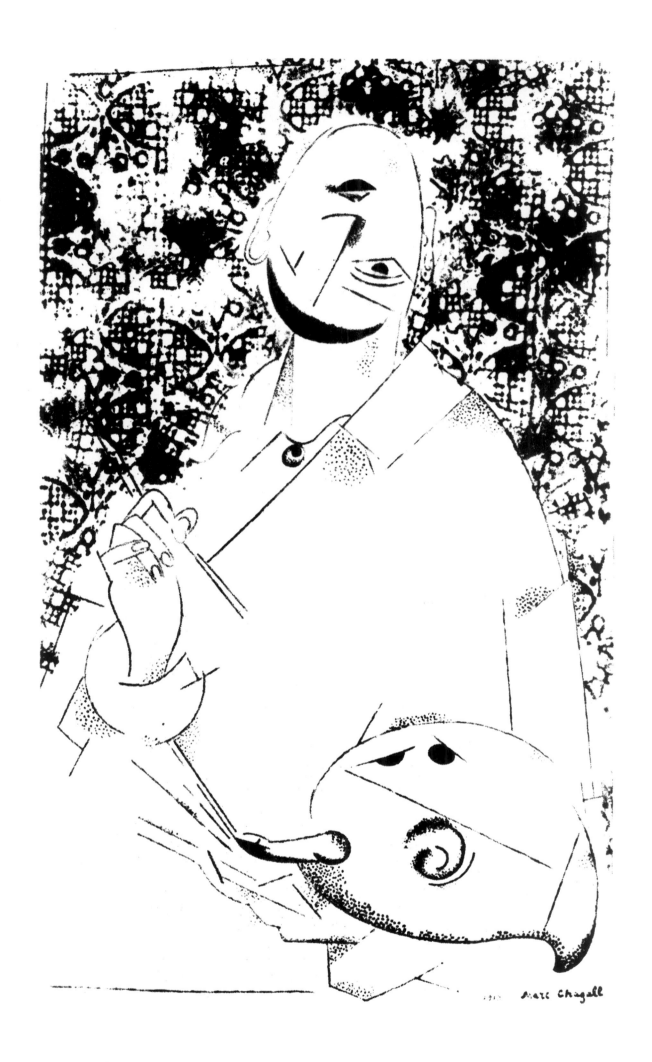

"It's not really my painting that's fantastic," Chagall once said to Izis, *"even when it represents flying donkeys and cows and girls in the form of flowers. What is really fantastic, for example, is that we should be sitting on the terrace of a sidewalk café. It's improbable. We ought to have our heads pointing downward, and be spinning, since the earth spins. But we don't. We ought to fly, and we don't fly."* In the ink self-portraits above and on the opposite page—executed respectively in 1915 and 1918 —the artist translates such half-serious banter into images. The background of the 1918 drawing is formed by impressions from the same piece of textile that was used in Abduction *(page 81)* two years later.

83

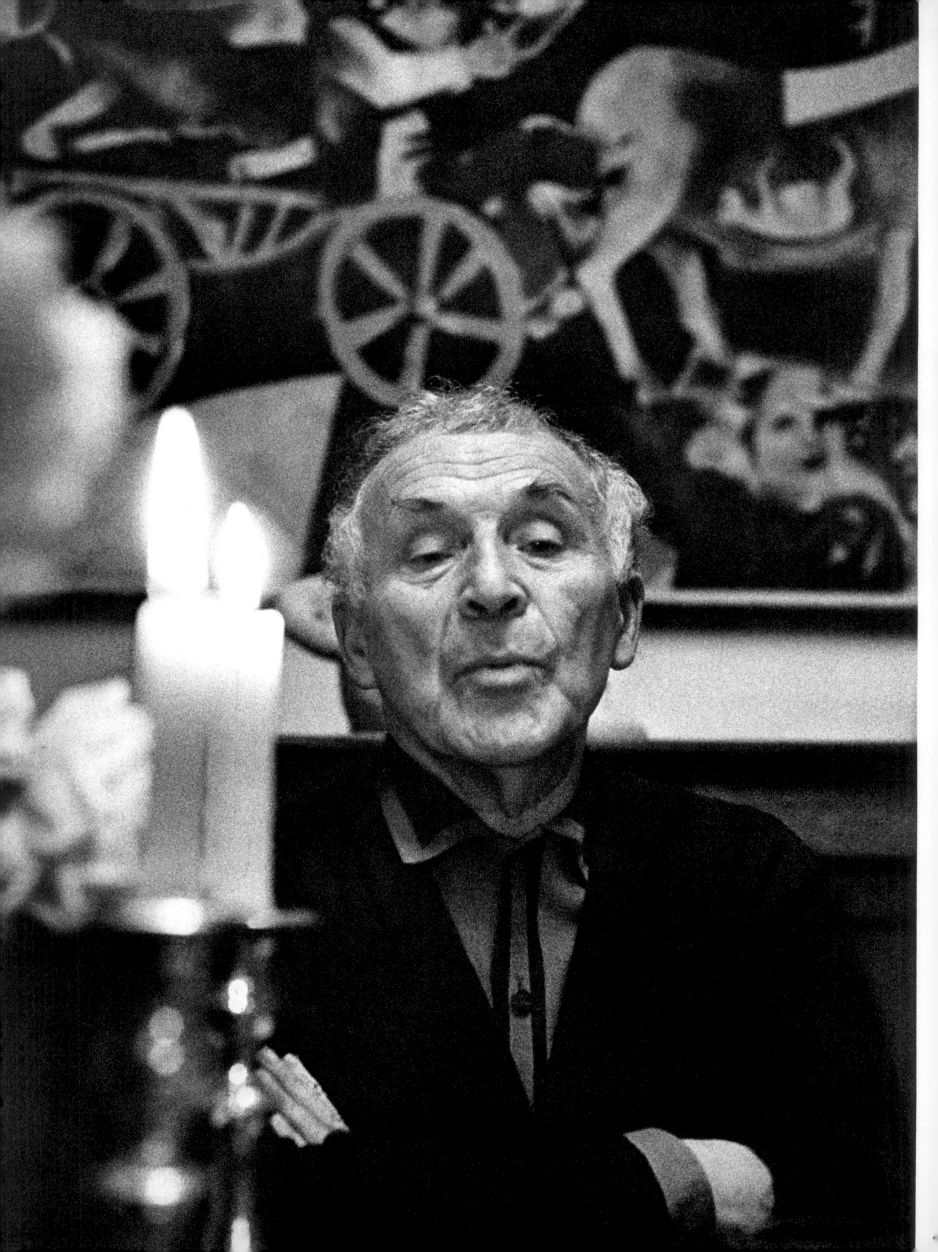

My only land
Is the land in my heart.
I enter it without passport
As if at home.
It sees my sadness
And my solitude.
It gives me sleep
And covers me with a fragrant stone.

There was a time when I had two heads,
There was a time when the doubled face
Would be covered with amorous dew
And would melt like the scent of a rose.

But now it seems
That even when retreating
I'm always marching forward
Toward a high gate
Beyond which stretch the walls
Behind which sleep extinct thunder
And broken lightning.

My only land
Is the land in my heart.

V *Structures and Shapes*

While Chagall has accepted on occasion the kind of analogy with poetry I have just proposed, he has never relaxed his hostility toward exclusively "literary" interpretations of his imagery. "Actually," he has said, "my first aim is to construct my paintings architecturally—exactly as the Impressionists and Cubists did in their fashion, and by using equally formal means. The Impressionists filled their canvases with patches of light and shadow; the Cubists filled them with cubes, triangles, and cones. I try to fill my canvases in some way with objects and figures treated as forms—resonant forms like sounds, passionate forms designed to add a new dimension which neither the geometry of the Cubists nor the patches of the Impressionists can achieve."

We are thus authorized to see in his pictures, in addition to the abstract colored matter and the abstract spatial patterns already mentioned, a set of "abstract" structures and shapes. Here the quotation marks are needed, for of course these structures and shapes usually have richly figurative aspects. Unlike more extreme modernists, Chagall allows the images that are "treated as forms" to continue to exist as recognizable "objects and figures"; for him a human head is a human head as well as an oval. But the underlying "resonant" and "passionate" abstractions are none the less worth noticing, for some of them occur often enough, and beneath a wide enough variety of figurative motifs, to be regarded as generators and unifiers of his style.

His emphasis on the word "architecturally" and his reference to "the geometry of the Cubists" raise the question of how much influence the Cubist revolution, which was under way when he arrived in Paris in 1910, had on the development of his characteristically Chagallian style. The answer, I think, is that it had a lot of influence, in spite of his frequently proclaimed scorn for its logic and for what he calls its "realism." It taught him to construct the gemlike facets of color and tone value and the subtle triangles of light that vibrate in the

THREE ACROBATS, *etching and aquatint, 1923. The calligraphic structures and rhythms, the strange play of light and shadow, the tattered circus costumes, a certain pathos in the desperate bid for public attention, and a general air of muscular happiness make this one of the most striking versions of a motif that has interested Chagall for many years. The same personages appear in the murals he did in 1920 for the Jewish Theater in Moscow, in a 1930 etching of a village fair, in an oil on the circus theme in 1944, and most recently in* Life *(pages 89, 100–101).*

backgrounds of such paintings as *Jacob's Dream* and *Life* (pages 20, 89, and 100-101). It encouraged him to dispose his motifs on the flat canvas as signs rather than as objects in naturalistic relationships; here *Life* again serves as an example. Above all, Cubism legitimatized, partly because of the prestige it had with literary intellectuals, his already existing tendency to paint what he knew and felt rather than what he saw. To realize the importance of this effect we have only to imagine a Chagall struggling to be himself in a Paris dominated by Impressionism or by the classicism of Ingres.

But what Cubism did not do for him, except briefly and very superficially, was to provide a repertory of basic structures and shapes. In other words, it did not provide any of the important "abstract" points of departure for the intricate system of "psychic" transformations and modulations that has always been his creative process.

A relatively minor but interesting part of that mysterious process can be glimpsed in the use—referred to in Chapter III—Chagall has made of the letters of the Hebrew alphabet. Sometimes this use is deliberate, in the manner (although too sportive to be quite in the spirit) of the mystical "lettrism" of the cabalists; and sometimes it recalls the initials designed by medieval Christian illuminators. But more often, I imagine, it is largely unconscious, in the way a Chinese artist's figurative use of the abstract structures and brush strokes of Chinese characters may be largely unconscious.

In judging it we ought to remember that education and travel have given Chagall an unusually "alphabetized" sensibility and many opportunities to be aware of the possibilities in letters treated as forms. In Vitebsk he spent seven years in the *heder*, the Jewish elementary school, studying the Hebrew characters, the Bible, and some of the Talmud. Then—after his dauntless and practical mother had bribed a teacher to ignore the rule against admitting Jews—he was enrolled in the local Russian public school, where he had six years of the Cyrillic alphabet. Then came the Roman alphabet in Paris, and a year of Gothic black-letter experience in Germany. Meanwhile, in order to have a permit to stay in St. Petersburg, he had apprenticed himself for a while to a sign painter and acquired what he has described as "a passionate interest in signs."

One result of this constantly renewed awareness of letters can be seen in the many pictures in which lettering is prominent: familiar examples are the studies of elderly Russian Jews posed against nearly solid backgrounds of carefully

At Vence in 1964, with an image of himself and palette on his right, the three acrobats on his left, and the great wheel of the sun above him, the painter contemplates his progress on the last stages of Life. *Like many visual artists, he has a tendency to go on retouching long after an outsider would consider a work finished.*

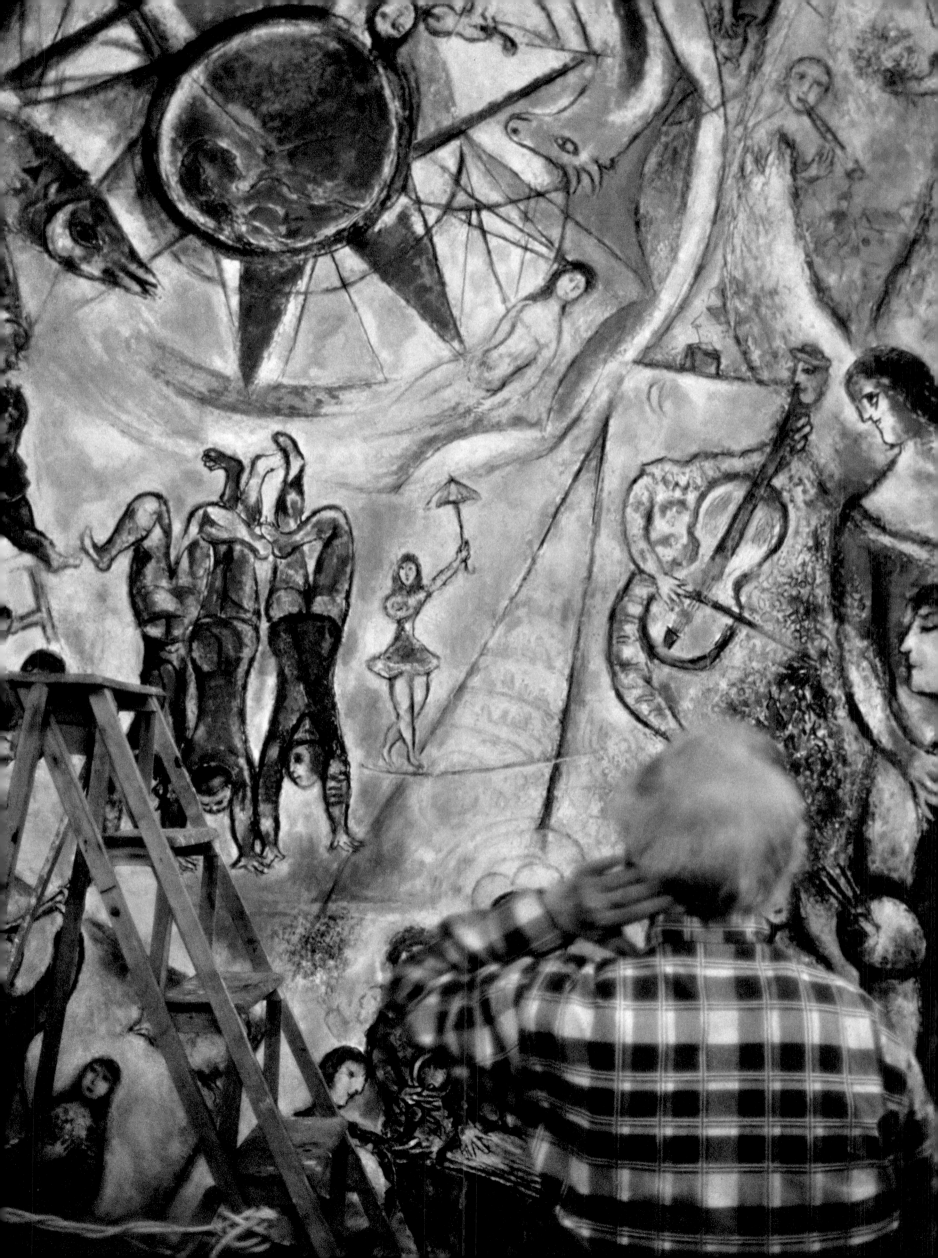

LANDSCAPE WITH BLUE FISH, *monotype, 1962. The landscape referred to in the title is in fact an imaginary townscape that blends the Eiffel Tower, the Cathedral of Notre Dame, and the little wooden houses of Vitebsk. The beaked blue fish with its human arms and incongruous bouquet can be interpreted as a dreamer's fusion, or condensation, of the familiar herring of Vitebsk with the artist himself, his palette, and the thick crescent that is one of his favorite "abstract" shapes. Floating in the sky is part of the Chagallian bestiary, a mother and child, and a young Russian with a book one can safely assume to be the Bible. The picture can thus be read as a representation of Chagall-the-fish offering his palette-bouquet in tribute to the sources of his artistic inspiration and to what he has loved in his life—much as he is doing, in a more easily recognizable form, in* The Green Horse *(page 17).*

90

painted text. But a more striking result can be seen in the graphic works in which the human figure is either an imitation or a metamorphosis—or shows the strong influence—of a Hebrew character. The drawing *A Gentleman* (page 79) resembles the Hebrew daleth (ד), or perhaps the resh (ר), turned upside down—a normal Chagallian predicament. *Abduction* (page 81) is very close indeed, in both shape and gait, to the aleph (א). Although in *Man Carrying Street* (page 80), *Self-portrait* (page 83), and *Three Acrobats* (page 87) there is scarcely any question of specific resemblances, the figures definitely have the angular structures, the heavy contrasts of light and shade, and the emphatic rhythm of Hebrew calligraphy.

These examples of the stylistic influence of letters are also examples of something far more important in the realm of abstractionism: a liking for diagonal structuring. This has been vividly and sometimes startlingly apparent in Chagall's work since the beginning of his career, so much so that it can be called a determining factor in the creation of his "world."

He avoids horizontal lines, noticeable horizons included, fairly consistently. Although he does not avoid vertical motifs, he is careful to counteract their effect. In the painting *Life* the extreme verticality of the wedding couple on the left and of the woman—identifiable as Bella—being lifted by Chagall on the far right is more than countered by the abstract diagonal lines embedded in the colored matter of the background and by such motifs as the tilted blue Paris at the bottom of the picture, the tilted Van Gogh-like room on the far left, the self-playing cello on the right, and the diving fish and leaning ladder at the top. In *Eiffel Tower* (page 93) one of the most vertical-looking structures on earth is turned on its point, given a wild lurch and a herringbone pattern of slanting lines, and accompanied by a donkey that is about as close to being a purely abstract diagonal as a donkey can get.

These are certainly, in Chagall's phrases, "resonant forms like sounds" and "passionate forms" that "add a new dimension." Those in *Life* echo each other across the picture space like the music one can imagine coming from the depicted cello, zither, shofar, flutes, violins, drums, and tambourines; and those in *Eiffel Tower* convert the whole composition into a visible bray at the universe. One could not ask for better symbols of a dynamic, happy, Hasidic confidence in the ways of God to man.

But it is always a dangerous critical practice to generalize about the expressiveness of abstract structures and shapes, for nearly everything depends on the context. In some figurative contexts Chagall's diagonals may suggest instead of dynamism a wild emotional instability, or the kind of anxiety we experience in dreams of falling through a vast space; such suggestions can be found in the slant-filled visions of crucifixions and holocausts painted just before and during World War II. And in many pictures the associations are with feelings of love and mutual dependence, perhaps as a result of some visual metaphor or pun

91

based on such universal verbal metaphors as "falling in love" and "inclined." (A similar plastic representation of words is said by Freudian psychoanalysts to account for the formation of many images in dreams). Chagallian sweethearts are frequently inclined, sometimes toward each other and sometimes, like the young couple in the cloud cocoon on the left of *Life,* in the same direction. *For Vava* (page 26) is one of two well-known portraits of Madame Chagall in which she leans, tenderly, gravely, and rather supernaturally, toward the right. In fact, Chagall's images of wedding ceremonies are among the few consistent exceptions to his habit of linking the idea of affection to a marked deviation from the vertical.

The wedding in *Life,* however, or at least the bride, does incorporate one of the artist's basic "abstractions": the elongate, rising sweep that is somewhat less a form than a movement, a gesture, an extension, or an ectoplasm. In the sketched montage of Parisian motifs on page 95 it is little more than a tendril that transforms itself at the last moment into the naked torso of the beloved. This shape, which in the two examples I have given clearly derives from 19th-century Romantic representations of specters and souls, has been prominent in Chagall's work since the death of Bella in 1944. It seems to be related, through the common denominator of elongation, to other forms that are linked by their figurative contexts to the idea of the return of the dead. In *Life,* for instance, the figure of Bella being lifted by the painter is preternaturally tall. One of the most elongate of the many elongate, icon-influenced Christ figures painted by Chagall is entitled *Resurrection,* although it actually represents Jesus on the cross. (A similar figure appears in the upper left corner of the monotype *Peace,* reproduced on page 98.)

Here let me repeat that Chagall can be inconsistent in what he associates with his basic structures and shapes; he has frequently used the elongate sweep in pictures without memories of Bella and thoughts of resurrection. But he can also be consistent in ways that commonsense criticism is not likely to discover, for his creative imagination often functions, as I have already suggested, much as everybody's unconscious does in dreams: it may, for instance, form symbols by the process called "condensation" in dream analysis—by leaving out some elements and fusing those that have common traits. Thus a picture like *Eiffel Tower* can be understood at a level deeper than, although not really contradicting, the level I used when talking about diagonals. The herringboned, elongate sweep

EIFFEL TOWER, *pastel and ink, 1954. Metamorphosed this time into the shape of a diagonal red donkey with a circular palette-bouquet, the artist again pays tribute to the sources of his inspiration and love. Here the sky is occupied by an outlined little horse of Vitebsk and a thick crescent that is simultaneously the moon, a dark-haired woman, and a rooster.*

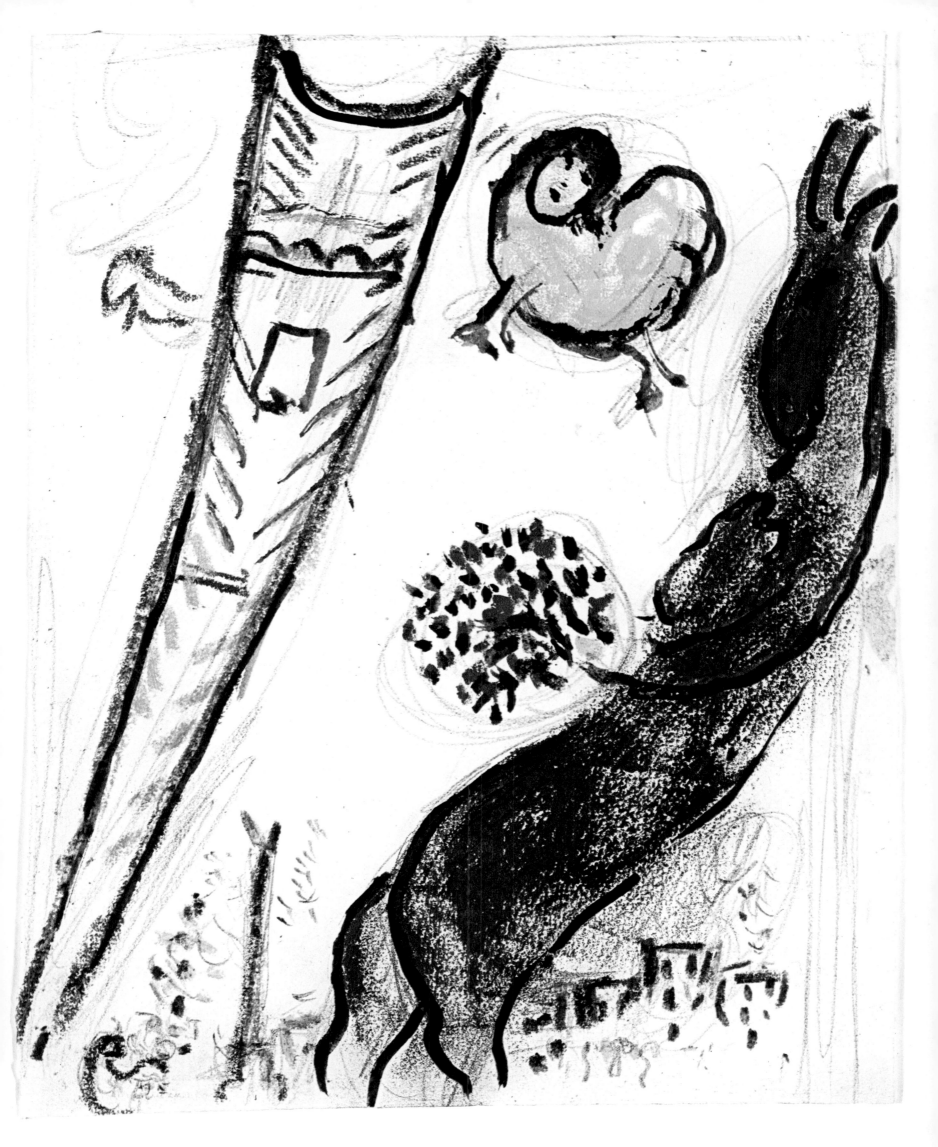

on the left can be read as a condensation of the wedding image and the Eiffel Tower, suitably upturned. The donkey with the flowers then becomes a condensation of Chagall with his palette, paying tribute to his phantom bride Bella exactly as he does in the more explicit imagery of *Life*.

The above remarks are particularly applicable to another of the painter's basic "resonant forms": the thick crescent. In *Life* this appears as the great blue rooster (merely a convenient term, I grant, for a thoroughly mythicized fowl) in the upper left corner, the red boat just above and to the right of the rooster, the small moon to the left of the fish, the red rabbi in the lower left corner, the blue equestrian acrobat to the right of Paris, and the small rooster above him. The same thick crescent appears as the anthropomorphized bird-beaked fish in *Landscape with Blue Fish* (page 90), as the meditating rabbi with the Torah in *Jacob's Dream* (page 20), as the young man with the flowers—as a projection of Chagall himself, that is—in *The Green Horse* (page 17), as the large fish that precedes the schlemihl who is crashing through the window in *De mauvais sujets I* (page 41), and as the animals, birds, fish, moon, and personages in scores of other pictures.

Clearly this is an abstract shape that the half-dreaming but always plastically alert inner self of Chagall has found congenial. It can be thought of, according to how one looks at the puzzle of artistic creation, as a personal archetype, as a handy mold for images, or simply as the final result of dozens of reductions and fusions—oneiric condensations—of symbolic content. It may on occasion facilitate for the artist, as does the elongate sweep in pictures referring to Bella, what psychoanalysts call "displacement": the dream process of partly concealing emotions by infusing them into seemingly inappropriate objects or actions.

In any event, it is an active source of coherence in Chagall's world. It not only causes the great blue rooster to "resonate" with the bird-beaked blue fish, the meditating rabbi, and the young man with the flowers; it also provokes a partial "condensation" of smaller, auxiliary images. While the spell is working, a viewer may have an intuition that beneath the figurative surface the tuft in the hollow of the blue-rooster crescent is essentially the same thing as the bird-beaked blue fish's bouquet, the meditating rabbi's Torah, and the young man's flowers—which are of course a transparent disguise for the painter's palette. The conclusion, already implicit in the larger shapes, that Chagall has somehow

RUE DE LA PAIX, *pencil sketch, 1953. Here the motif of the crescent rooster fills the Parisian sky and becomes Chagall and his palette—while the Eiffel Tower acquires the upside-down head of the self-portrait of 1918 (page 82). On the right, above the Paris opera house and the dome of Les Invalides, the ghost of Bella rises into the arms of her husband.*

The circle often has cosmic, personal, and religious associations for
Chagall. In THE SUN (above), a monotype of 1965, it is a solar disk to
which are attached a pair of lovers, the head of the little Vitebsk horse,
and a robed violinist; a large mosaic based on this composition is planned
for one of the exterior walls of the painter's new house at St. Paul. In
EZEKIEL'S VISION (opposite page), one of the etchings for the Bible
published in 1956, the "four living creatures" and the heavenly "wheels"
described by the prophet in Ezekiel I are evoked.

96

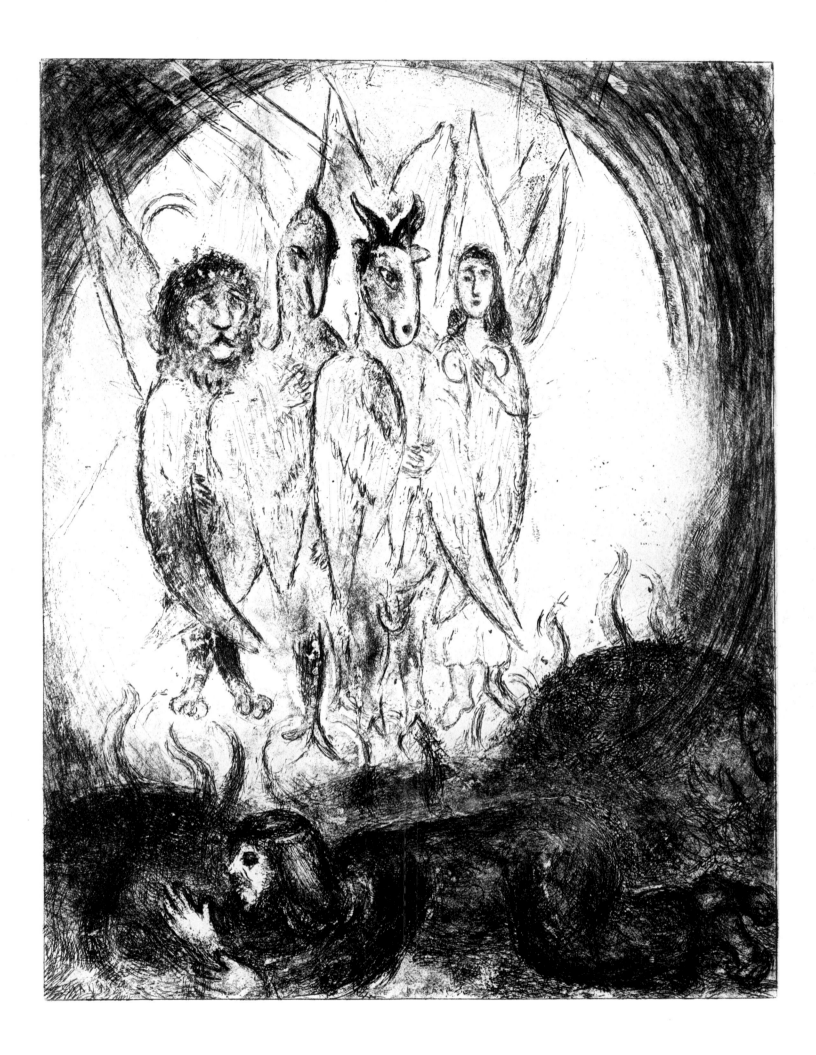

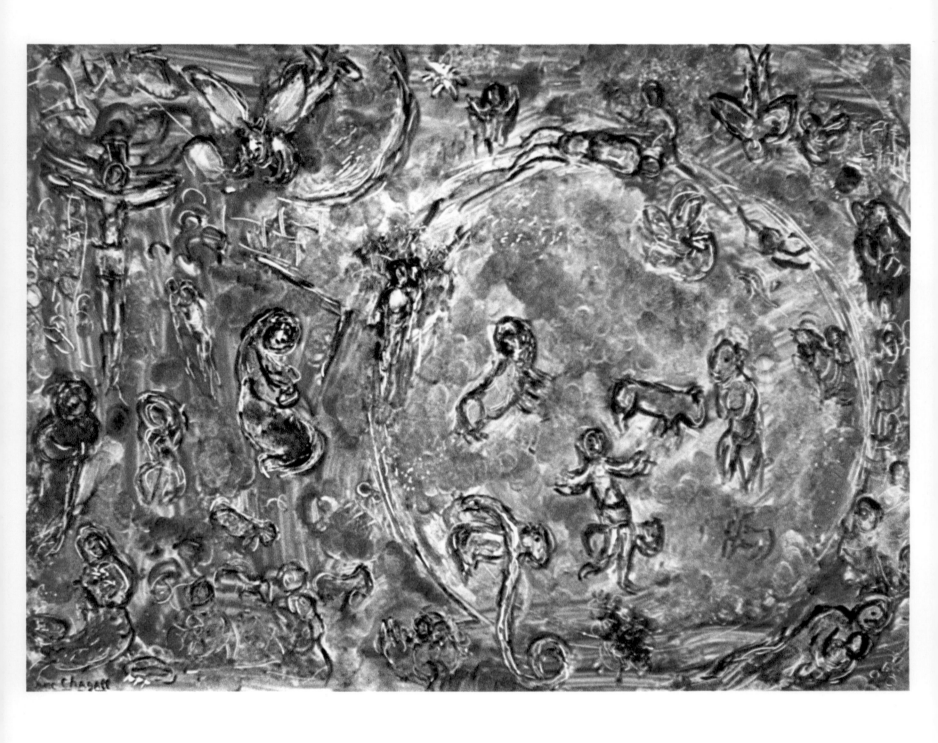

PEACE, *monotype, 1963. On a rotating blue background the prophecy in Isaiah* XI: *6, is recalled: "The wolf also shall dwell with the lamb, and the leopard shall lie down with the kid; and the calf and the young lion and the fatling together; and a little child shall lead them." In the upper left corner a crucifixion is a reminder of the martyrs for peace down through history, and also a reference to the passages in Isaiah* IX *that have been interpreted as foretelling the coming of the Messiah. This monotype served as a preliminary study for the stained-glass window in the United Nations building in New York, which Chagall dedicated to the memory of Dag Hammarskjold; and the composition reappears, under the title* The Creation, *in the tapestry for Israel's parliament.*

represented himself in the rooster-fish-rabbi crescent may thus be reinforced; and if the reasoning is disconcerting, one has only to recall that the spirit of Bella is somehow in the Eiffel Tower and that Chagall is also somehow a rampant donkey. With the help of abstract structures and shapes acting as common denominators, his creative imagination moves with dreamlike ease from one half-secret analogy to another.

The crescent is everybody's archetype; it is the fetal position, the new moon, and the centuries-old symbol of growth, night, and the female principle in the universe. However, it is probably less generally significant than another of the painter's basic shapes: the circle. With the help of this shape Chagall moves his personal myths into a broad public domain, where they pick up extra meanings from ancient traditions of symbolism and from the theories of modern depth psychologists. Does he intend to convey all these extra meanings? In specific terms he obviously does not. But in a general and intuitive way he does, for it is certainly not by chance that he favors so strongly one of mankind's primordial signifiers. He is like a gifted musician who knows the chord he wants, without consciously intending to sound every resultant overtone.

A few examples, out of the many possible, can make the point. In *Life* the circle is the great wheel of the sun, with overtones of primitive solar myths, of the wheel of fortune to which all creatures are bound, of Elijah's fiery chariot, and of the cabalistic theories of creation through emanation. In *Ezekiel's Vision* (page 97) and *Jacob's Dream* the circles are openings on the Beyond, reminiscent of the medallions in Russian icons and of the mystique of circular stained-glass windows. In the monotype *Peace* (page 98) the motifs rotate like constellations in a night sky, with perhaps an overtone of the signs of the zodiac. A similar rotation is implied in such compositions as *The Green Horse* and *Jacob's Dream*. All these circles are charged with at least some of the significance they would have had for our ancestors almost anywhere on earth; they are still readable as symbols of the round canopy of the heavens, of transcendence, of perfection, and of eternity—of the serpent Time with its tail in its mouth. And viewers who accept the fascinating, although scientifically questionable, concepts and wisdom of Jungian analytical psychologists can regard Chagall as a 20th-century master of the "mandala": the magic circle, historically a universal symbol of the nature of the deity, that is said to exist in the collective unconscious as an expression of the archetype of the self.

99

LIFE, *oil, 1964. This flying and swaying anthology of Chagallian images could well have been entitled* AUTOBIOGRAPHY—*or simply* NOSTALGIA. *It alludes to important events and phases of the painter's career and to many of the themes that have fascinated him. At the same time it illustrates one of Chagall's revealing remarks about himself, made during a refusal to explain his symbolism: ''My paintings are my reason for my existence, my life, and that's all.''*

In the upper left corner a tiny version of the familiar horse recalls the artist's birth in Vitebsk. Further down on the left appears a realistic scene in the house where he spent his boyhood. Next to it his wooing of Bella is evoked, and then their marriage in Russia and the birth of their daughter. The happy and successful years spent in between-the-wars Paris follow, amidst the ''blue air'' Chagall often uses to suggest love and a dreamlike bliss. On the far right he lifts Bella on his shoulder for a last backward look.

Other images refer to the illustrations for the Bible, to the circus, to the synagogue, to the fish, roosters, and cows of provincial Russia, to the dance, and especially to music. Underlying the whole composition is a large collection of characteristic diagonals, crescents, and circles.

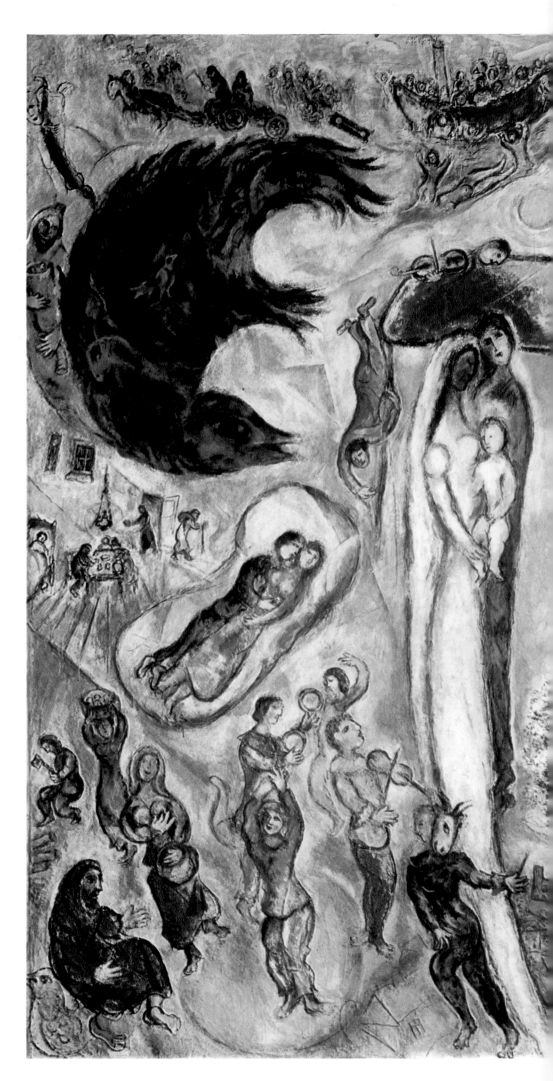

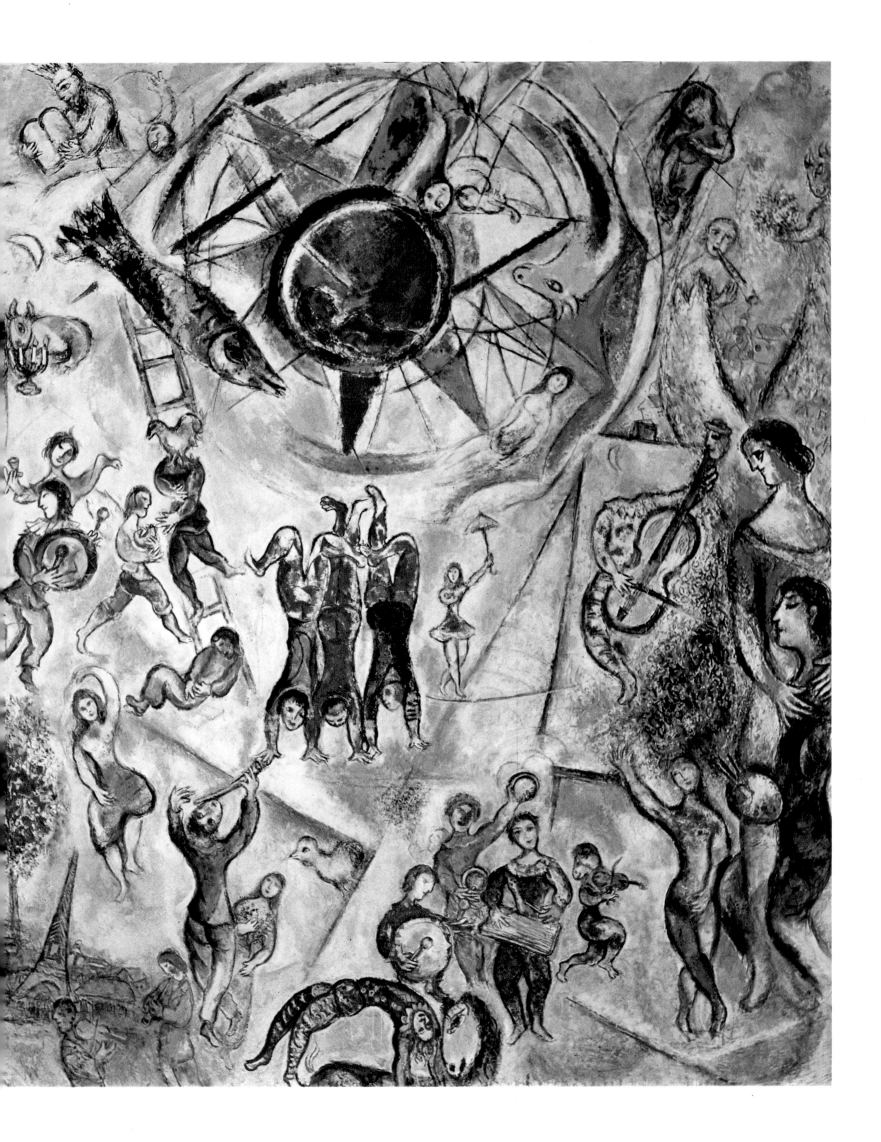

VI *The Printmaker*

After the ventures in the preceding pages into depth psychology, it may be well to surface with a reminder that Chagall is not only a dreamer, but a maker. He is such, of course, in the ancient sense in which every poet is a maker. And in particular he is a printmaker—one of the most gifted and prolific in the older School of Paris. To overlook this important fact, on the heretical assumption that only big and absolutely unique works of art are worth serious attention, would be like forgetting that Turner was a watercolorist, or Degas a pastelist.

There is, however, an element of paradox to be reckoned with. On the one hand, Chagall is certainly a natural printmaker. He has a style adaptable to small formats, a flair for storytelling, a set of universal themes, a liking for the work-and-ritual atmosphere of printing establishments, and a strong desire to communicate with as large an audience as possible while maintaining personal control of his creations. On the other hand, much of his finest print work has been published only since his post-World War II return to France from the United States—that is, since his 60th birthday. There are at least four reasons for this surprising situation: he was a late starter in the various techniques involved; he was, during one period, a slow worker much given to retouching his plates; for many years he was the victim as well as the beneficiary of the whims of the famous Paris art dealer Ambroise Vollard; and he was interested in color.

Although Chagall had tried his hand at printmaking in Russia, he did not master the techniques of engraving until 1922, when he was in Berlin and temporarily without a suitable place for painting. He put his new skills to use in a series of nostalgic and witty illustrations for a German edition of *My Life,* and these

In the Lacourière workshop in Paris in 1958, with master printer Jacques Frélaut assisting him, Chagall adds finishing touches to one of the colored etchings for the book De Mauvais Sujets. *Part of the hillside of Montmartre is visible through the window.*

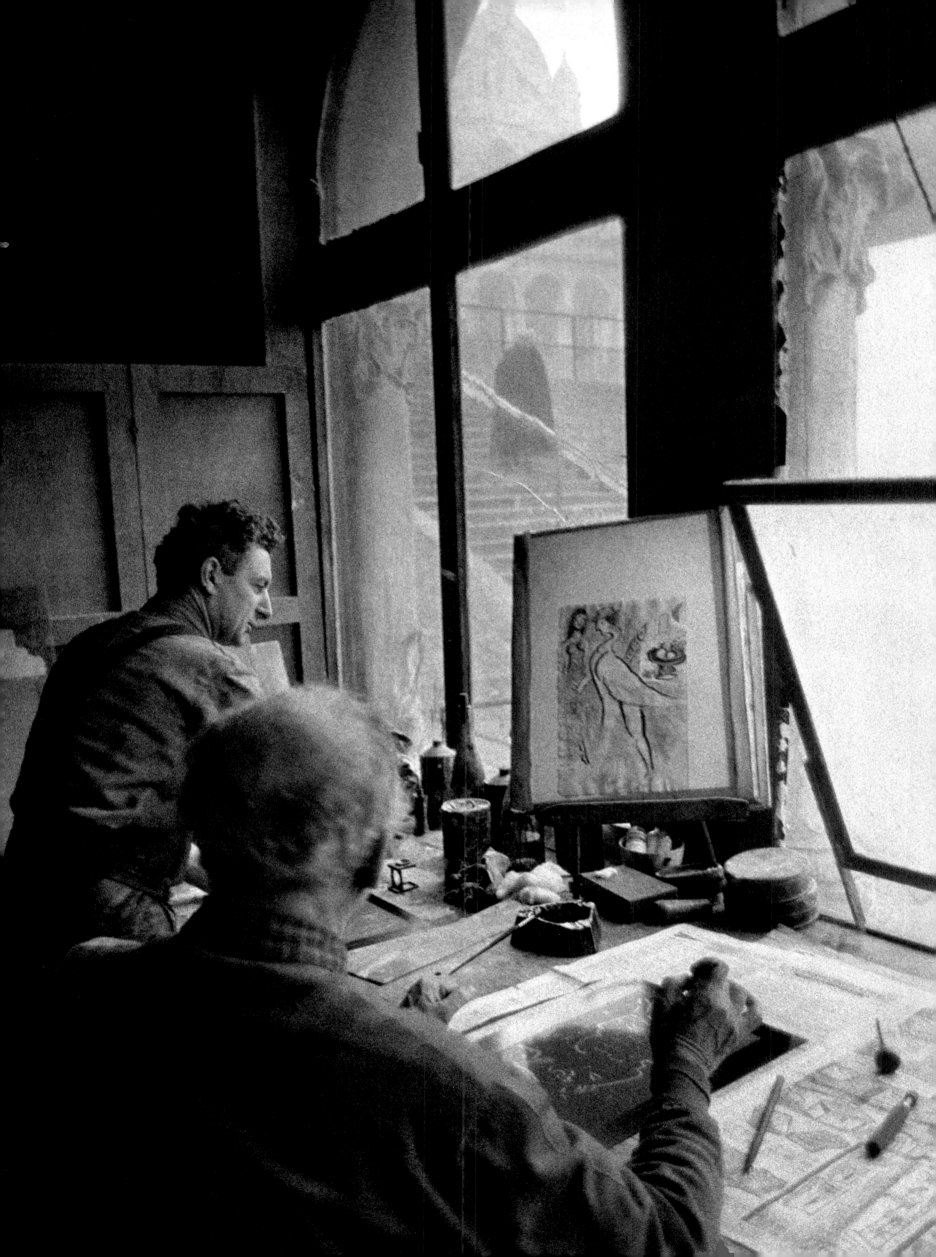

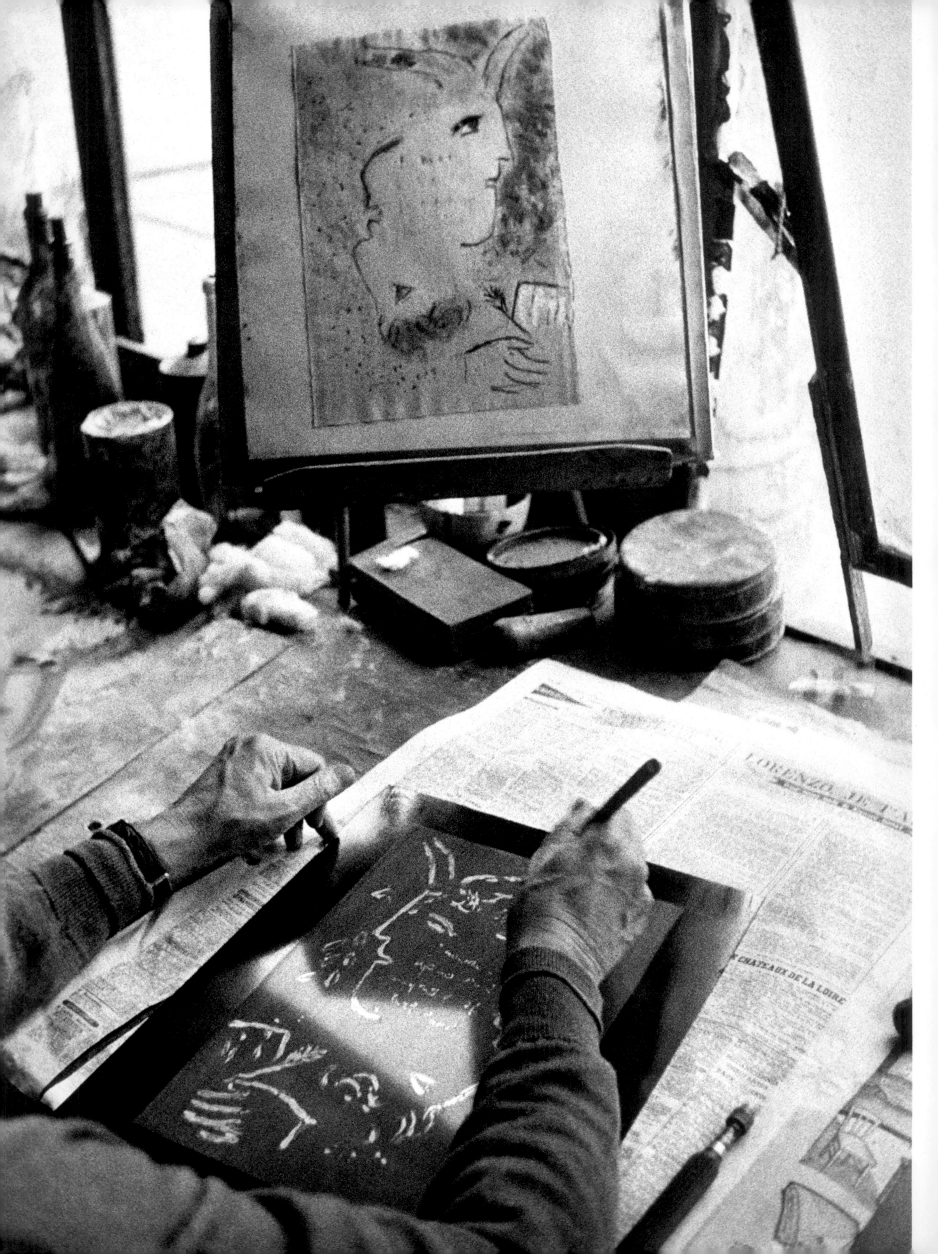

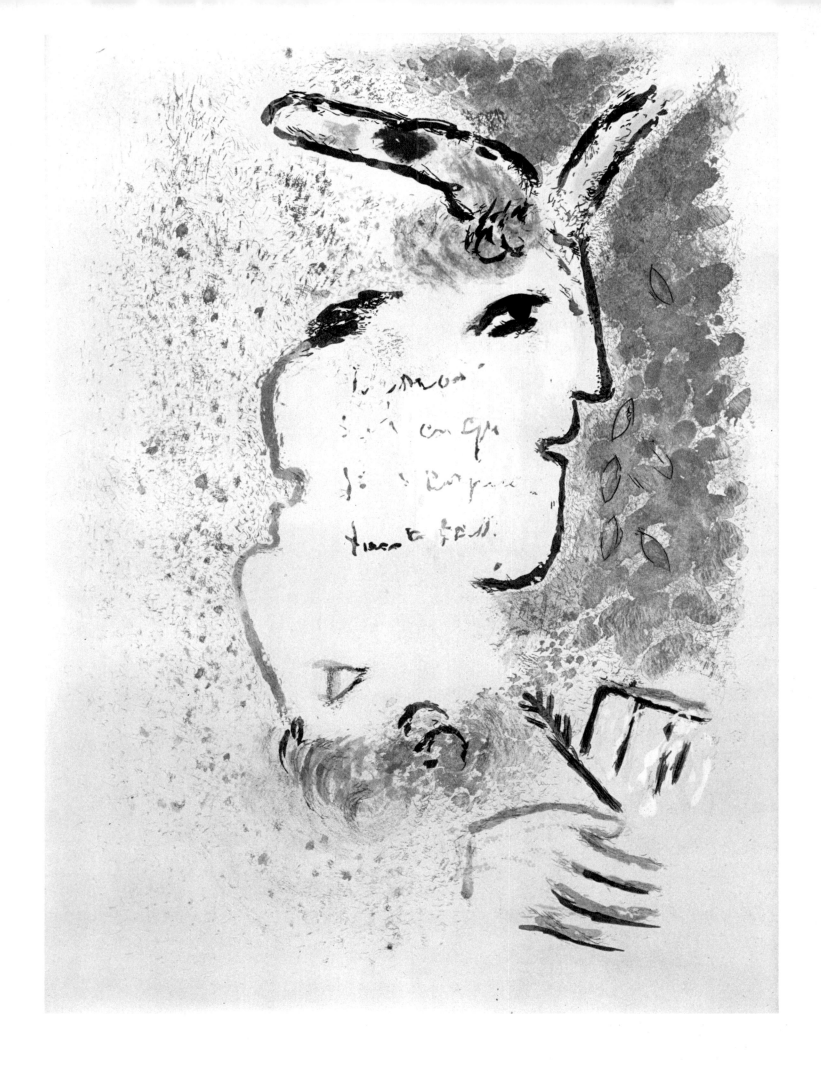

To a faun-like, double-headed creature for De Mauvais Sujets, *Chagall the etcher adds some personal, illegible graffiti and the spring colors favored by Chagall the painter.*

appeared as a separate portfolio of etchings and drypoints (engravings made with a needle instead of a burin, and without acid) when the translation of his Russian prose style proved so difficult that the book project was dropped. (*My Life* was finally published in Paris in 1931, in Bella's French translation and with drawings by Chagall. Some of the Berlin engravings have been reproduced, however, in a second French edition and in editions in other languages.) During these months in Germany he also did some woodcuts and black-and-white lithographs, the latter drawn on transfer paper instead of directly on the stone.

Following his return to France in 1923, he was put in touch with Vollard by the poet Blaise Cendrars, a close friend from the previous Paris period, and was immediately commissioned to do a series of etchings for a special edition of Gogol's *Dead Souls*. He was familiar both with the novel and with its setting in provincial Russia, and during the next three years he executed 107 full-page plates—a complete translation of the book into Chagallian visual language. But before the task was completed Vollard had another idea: an edition of La Fontaine's *Fables* with colored illustrations in the manner of 18th-century prints. For this he hired professional etchers, and instructed Chagall to prepare 100 gouaches for reproduction. When these were completed it became evident, as might have been predicted, that Chagallian color was too complex for the printing process envisaged, and so the artist decided to do the etchings himself, in black-and-white. The plates were ready in 1931, but they were not published, for by then Vollard had still another idea: a series of etchings by Chagall illustrating the Bible. Sixty-six plates were completed by 1939, when the death of Vollard halted work on the project, and the total was raised to 105 after the war. The Teriade firm in Paris, picking up where Vollard had left off, brought out *Dead Souls* in 1948 (with 11 more etchings for the chapter headings, making 118 in all), La Fontaine's *Fables* in 1952 (with 2 cover etchings, making 102 in all), and the Bible in 1956.

Along with these much-delayed monuments, which alone contain more print subjects than Rembrandt is known to have executed, Chagall has produced—with better luck in regard to publication—a number of smaller collections of engravings, and many single plates. The sense of affinity he has always aroused among Paris writers has led to his doing etched illustrations (the word has to be taken to include some free interpretations of texts) for the work of, among others, Marcel Arland, Jean Giraudoux, Paul Morand, Pierre MacOrlan, André Salmon, Max Jacob, Joseph Kessel, Paul Eluard, Louis Aragon, and Jean Paulhan.

In an output spanning so long a time and affected by such a variety of assignments there are of course exceptions to any critical generalization. However, it seems relatively safe to observe that as an engraver Chagall is essentially a pragmatist governed by the sensibility of a painter. He is willing to ignore craft traditions and do whatever he thinks will yield the effect he wants; and usually

the effect he wants is one that exists in his oils and gouaches. Printers in the shop shown on pages 103 and 104 tell of his coming in one morning, seating himself at the etcher's bench, drumming his fingers as is his habit, and then remarking: "I don't know what I'm going to do, but I suppose I'm going to do some Chagalls." Conservative connoisseurs have sometimes been startled by his readiness to color an individual print by hand, and even to alter the drawing with a pen.

But there are subtler examples of his attitude. The frontispiece (page 76) he did more than forty years ago for *Les sept péchés capitaux* shows how quick his painter's eye was to notice the rich, velvety look obtainable when drypoint is added to etching: he made the burr—the shavings turned up on each side of a line as the point bites into the copper—pronounced enough to produce, when it caught the ink during impression, an equivalent of brushwork and "tissue." In *Three Acrobats* (page 87), a slightly earlier work, he combined the usual etching technique with the aquatint tone process—in which a porous ground allows the acid to get through to the plate and form myriads of tiny dots—and emerged with a fine piece of pictorial "chemistry," in a literal as well as in his metaphorical and organic sense. More recently, in colored etchings like *De mauvais sujets V* (page 105), he has seemed intent on making a meaningful aesthetic distinction between painting and printmaking hard to entertain. Even in his relatively conventional black-and-white prints the distinction may be more a matter of words than of what we actually see, as can be discovered by comparing the textures and tone values of *Ezekiel's Vision* (page 97) with the equivalent elements in the upper left corner of *Jacob's Dream* (page 20).

From 1924 until after World War II Chagall ignored lithography, the black-and-white kind included. Then, as a logical sequel to the painterly emphasis in his etchings and to his growing interest in chromatic "chemistry" and "tissue," he tried colored lithography for the first time and seems to have undergone something like a conversion as a result. In 1948 he published 13 colored lithographs as illustrations for four tales from the *Arabian Nights,* and since then his production, in both color and black-and-white, has been abundant. It reached a particularly high level of magic hues and poetic sentiments in 1961 with the publication of 42 illustrations for Longus's romance *Daphnis and Chloe;* these, like many of the recent lithographs, were partly translations of earlier gouaches (see pages 184-185) and have in turn influenced the style of later gouaches.

In 1962 the artist had a small press installed on the ground floor below his studio at Vence, and began to turn out monotypes (pages 31, 90, 96, and 98). Since these are unique works, they are not prints in the way etchings and lithographs are: they are improvised oils subjected to the controlled accidents of impression. But for that very reason they can be cited as the ultimate evidence of Chagall's fascination with the painting-printmaking dialectic.

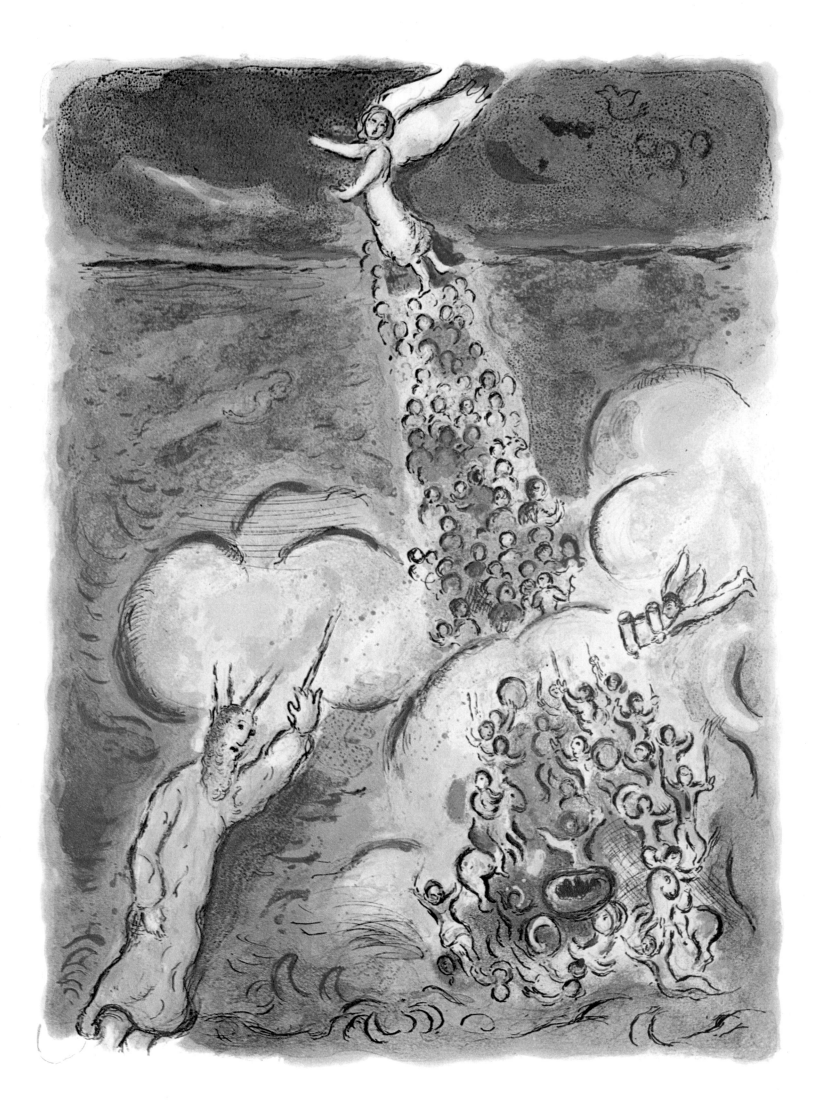

"When I held a lithographic stone or a copper plate in my hand I thought I was touching a talisman."

THE CROSSING OF THE RED SEA, *lithograph, 1966. The details adhere closely to the account in Exodus XIV. At the top of the picture, in the pose of the Victory of Samothrace on the prow of a ship, is "the angel of God, which went before the camp of Israel." The children of Israel follow "into the midst of the sea upon the dry ground," with the water "a wall unto them on their right hand, and on their left." In the foreground, separated from the Children of Israel by the cloud, Moses stretches forth his hand over the sea and the waters return to cover "the chariots, and the horsemen, and all the host of Pharaoh." As if to stress the faithfulness of the images to the sacred text, a small angel flies over the scene with the scroll of the Torah partly unrolled. Chagall has depicted the subject, as he has others in the Old Testament, in several media: in 1931 in a drawing tinted with water color, a few years later in an etching for the Vollard Bible, in 1955 in an oil painting, and in 1956 in a ceramic mural for the baptistery of the church of Assy, France.*

109

VII *Artist as Artisan*

Colored lithography, colored etching, and monotype-making are just three of the several ways in which Chagall has shown since World War II a surprising readiness to change his artistic materials and techniques and to become, at an age when he might have been forgiven for coasting on his reputation, the adventurous pupil of skilled artisans. He began doing pottery work in 1950, sculpture in 1951, mosaics in 1957, and tapestry cartoons in 1963. (Stained-glass windows, which should be added to the list, raise questions I shall discuss in a separate chapter.) In these extensions of his activity he has occasionally revealed that there are, after all, some limits both to his aptitudes and to his sensibility. He is manifestly not a born potter, sculptor, mosaicist, or tapestry-designer; and in everything he does his visible tendency is to feel and think primarily as a painter. But he has nevertheless produced many fine works in his new media, and in the process of translating his familiar pictorial motifs into clay, stone, or wool he has found fresh opportunities to emphasize and project his philosophy. An acquaintance with Chagall the wide-ranging artisan is essential to an appreciation of Chagall the artist.

He has said that what he calls his "experiments" in ceramics are "in a sense the outcome of my life in the South," and the remark is easy to document and expand. During his years on the French Riviera the ancient pottery industry of

In his pottery work Chagall avoids smooth, professional-looking shapes and surfaces much as he avoids academic correctness in his drawing, but he does not forgo elegance in other aspects of the craft. In this large piece, created at Vallauris in 1962, the juglike basic form is in deliberate contrast with the mannered eroticism of the personages and the delicate mauve, pink, yellow, and old-ivory shades in the scratched clay.

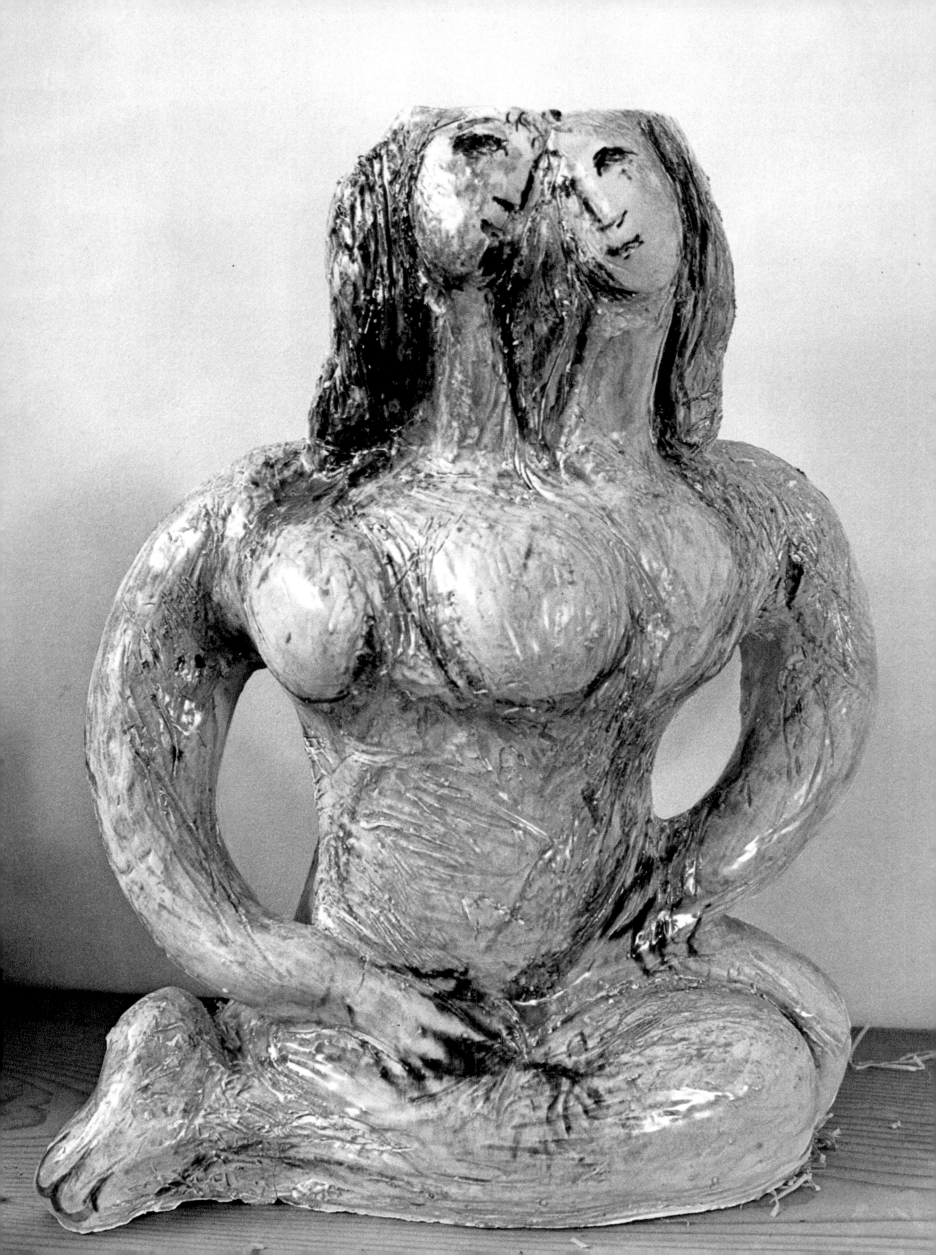

the region has been going through a spectacular period of growth and modernization. Today there are more than a hundred workshops in the small town of Vallauris alone, and others are flourishing in Antibes, Golfe Juan, and Vence. All are less than half an hour by automobile from *Les Collines,* the painter's home until 1966, or from *La Colline,* his new home in Saint Paul. And nearly all of them are managed by master potters eager to cooperate with modern artists—partly, to be sure, because of the fame, tourists, and prosperity that Picasso's work in ceramics brought to Vallauris, but also because of a genuine desire to rescue their craft from commercial patterns and raise it to its old level of a serious fine art.

However, since Chagall is always Chagall, the tempting nearness of the ateliers and the welcoming stance of their owners were only part of the attraction for him in the early 1950s. After his frequently unhappy years as a wartime exile in the United States, and his experience of the savagely dramatic and exotic landscape of Mexico, the country around Vence seemed to him warmly and humanly European. He fell in love with Provençal clay and Provençal light. In poetic prose, he has described the experience as essentially a mystical one: "Even the earth on which I walked was luminous. It looked at me tenderly, as though it wished to call me." He was somehow reminded, in spite of—or perhaps because of—the difference in light and color, of the soil of Vitebsk, which he had not seen for nearly thirty years and which had been a battleground of World War II: "I had the sudden feeling that this bright earth was calling awake the deaf earth of my far-off home town." Such sentiments were followed by a strong desire to see what would happen if Provençal clay and the traditional techniques of the local potters were combined with his personal artistic methods and vision: "I wanted to handle this earth as the old craftsmen did... and, while remaining within the bounds of ceramics, to breathe into it the echo of an art that is at once close and remote."

The art "at once close and remote" was of course painting, and one can fairly describe Chagall the potter as having been for several months primarily a painter who used clay instead of canvas or paper as a support for his pigments. He tried executing some of his pictures on wall tiles, hoping to integrate his motifs with the substance of the wall and to avoid the tendency in ceramics toward mere decoration. He did not actually make pots, preferring to paint on ready-made forms. During this period he seems—to judge his attitude by his works—to have regarded the various glazes, slips, and enamels of the professionals simply as new materials for continuing his attempts to create colored "tissue," although in his drawing he was ready to be inspired by the shapes of the pots.

However, he soon found himself drawn into the mystery of the medium. He began to model simple pieces with his own hands. The process of firing the painted clay involved him in a chromatic "chemistry" that was less metaphorical

112

than the kind he had long practiced in oil and gouache, and less remote from "the microbes of the universe" and the "holy sparks" of Hasidic doctrine. He was attracted also by the excitement of seeing what the heat would do to the forms he was learning to build up from the wet earth. What it did was not always agreeable: "The earth," he noted, "like the craft itself, does not yield up its secrets so easily. Sometimes the fire releases my children of sorrow from the kiln approvingly. Sometimes they come out in grotesque and ridiculous shapes. The ancient elements remind me only too well that my means are modest." But there were fascinating opportunities to produce the partly controlled "accidents" he had become familiar with when, as an etcher, he had waited to see what the acid would do with a design.

He became more and more proficient in the craft, and more sophisticated in his approach to it; eventually he developed a kind of colored-clay art in which basic pottery forms can be seen stimulating and serving his imagination in much the same way that underlying "abstract" structures and shapes—the crescents and circles discussed in Chapter V—stimulate and serve it in his painting. These basic pottery forms are metamorphosed by mental processes resembling the "condensation" of emotional symbols in dreams; they are then treated as surfaces that can be transformed by means of techniques similar to those the artist uses in his two-dimensional works; and finally they are submitted to the kiln for the metamorphosis brought about by heat—cabalistically speaking, by the outside universe summoned into creativity by the human artist.

In the large vase or jug shown on page 111—which is untitled but might be called *The Siamese Nudes*—all the aspects of this typically Chagallian exercise in mixed media, fantasy, and mysticism can be discerned. The underlying "abstract" shape was that of a thoroughly functional pot—a pot closer in spirit to the peasant's utility ware of Eastern Europe than to pottery and porcelain made for contemplation by connoisseurs. Through a process that, although much more simple and obvious, recalls the subtle way the Eiffel Tower was turned into a phantom of Bella (see page 93), the merely functional form was "condensed" into figuration. The pot's solid and stable base became the legs and buttocks of the fused women; the pot's ample belly and container's bulge became a human belly and a row of ripe breasts that would not be out of place on the facade of an Indian temple; the neck became a double human neck that

Overleaf and pages 116 and 117: Chagall at work in 1959 in the Madoura pottery workshop in Vallauris; assisting him is one of the professionals in the shop. The object of their concern is the vase that appears in its finished state on page 111. At this point in his career as a potter the painter has obviously added a craftsman's interest in modeled and fired clay to his existing interest in the organic "tissue" of color. ▷

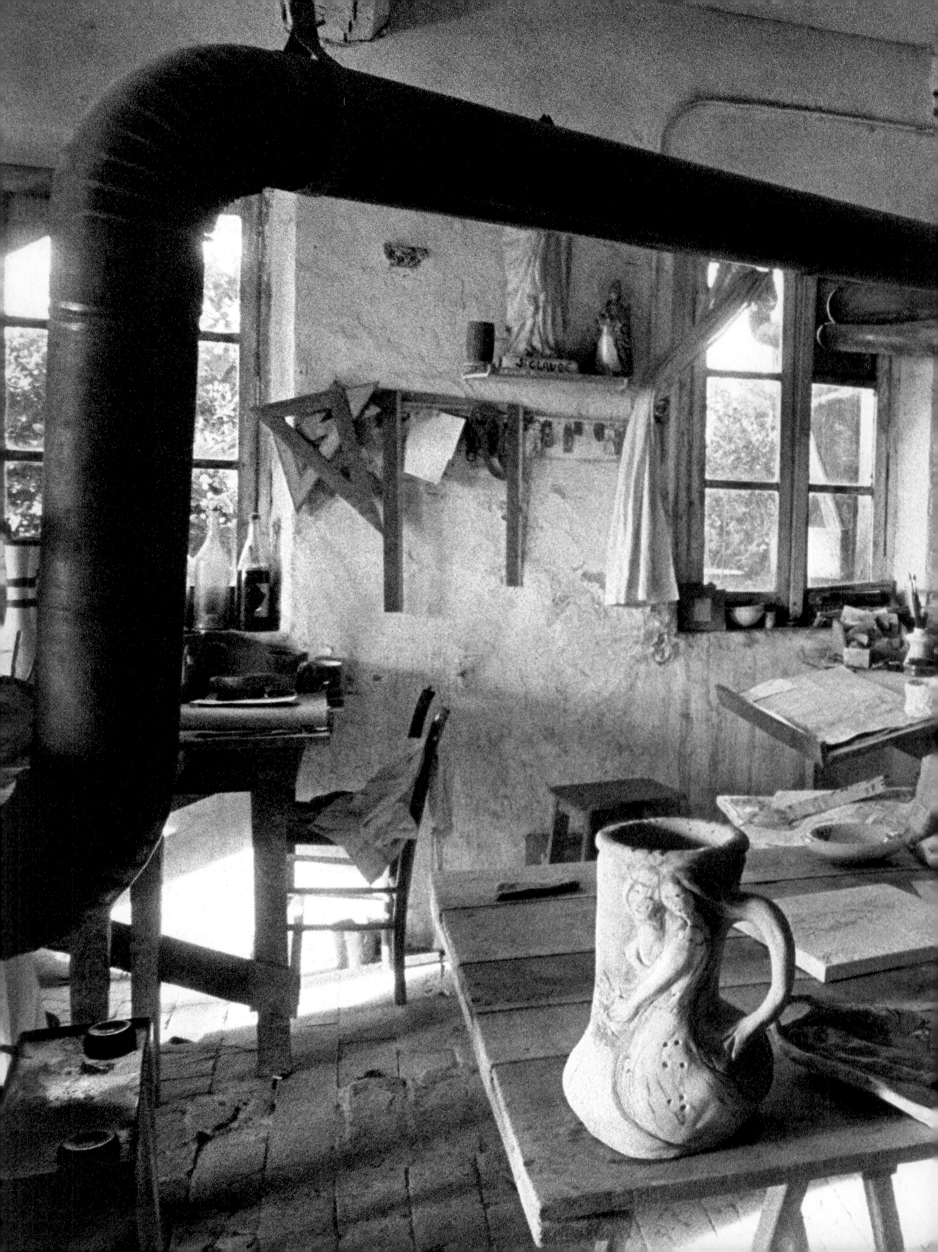

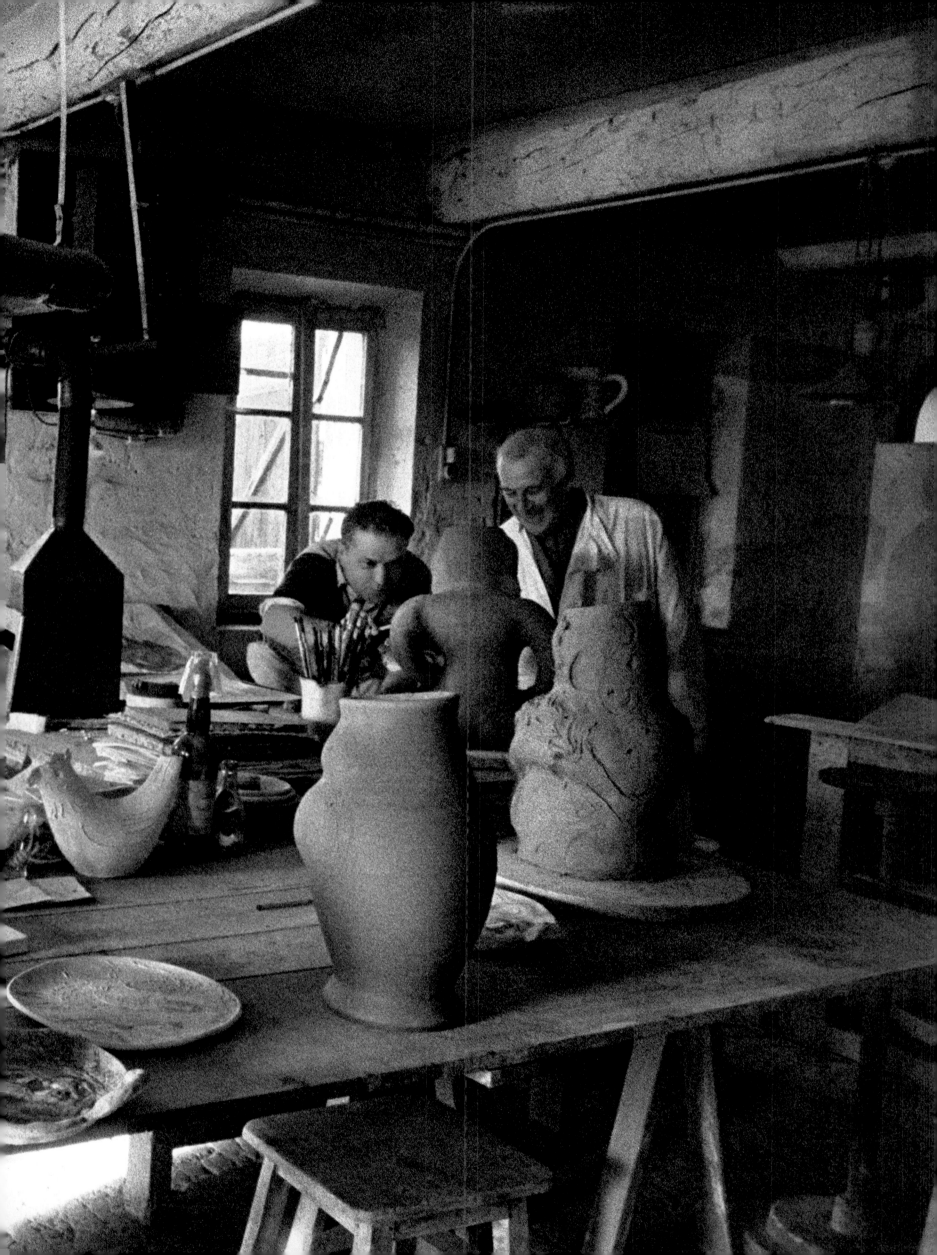

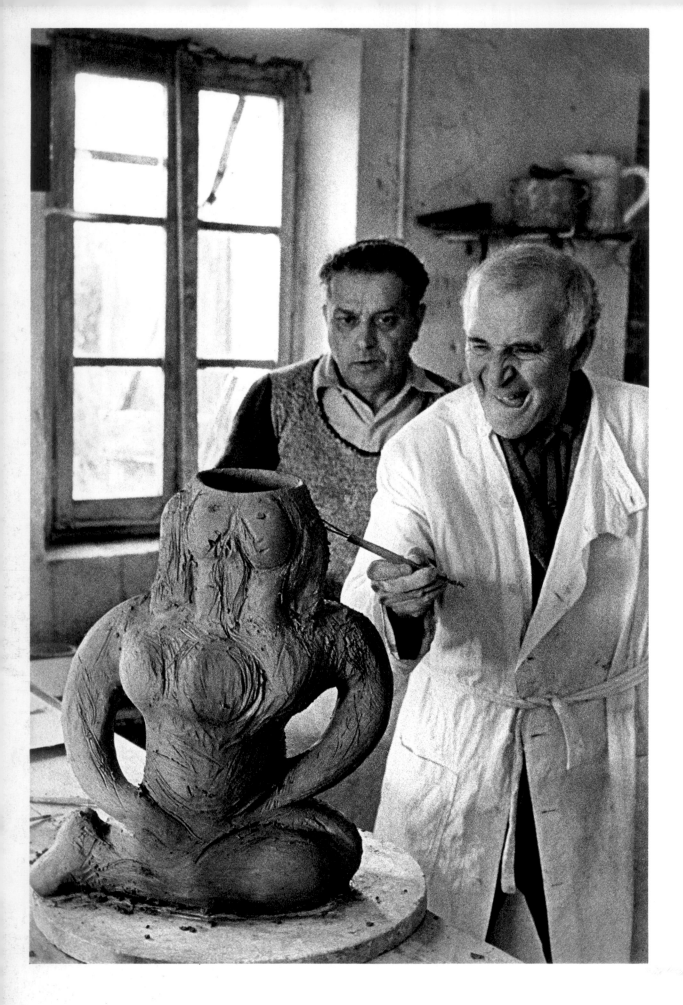

"*When I get excited in the atelier at Vallauris I call myself to order. I tell myself to get away from fabricating, to be integrated with the clay.*"

116

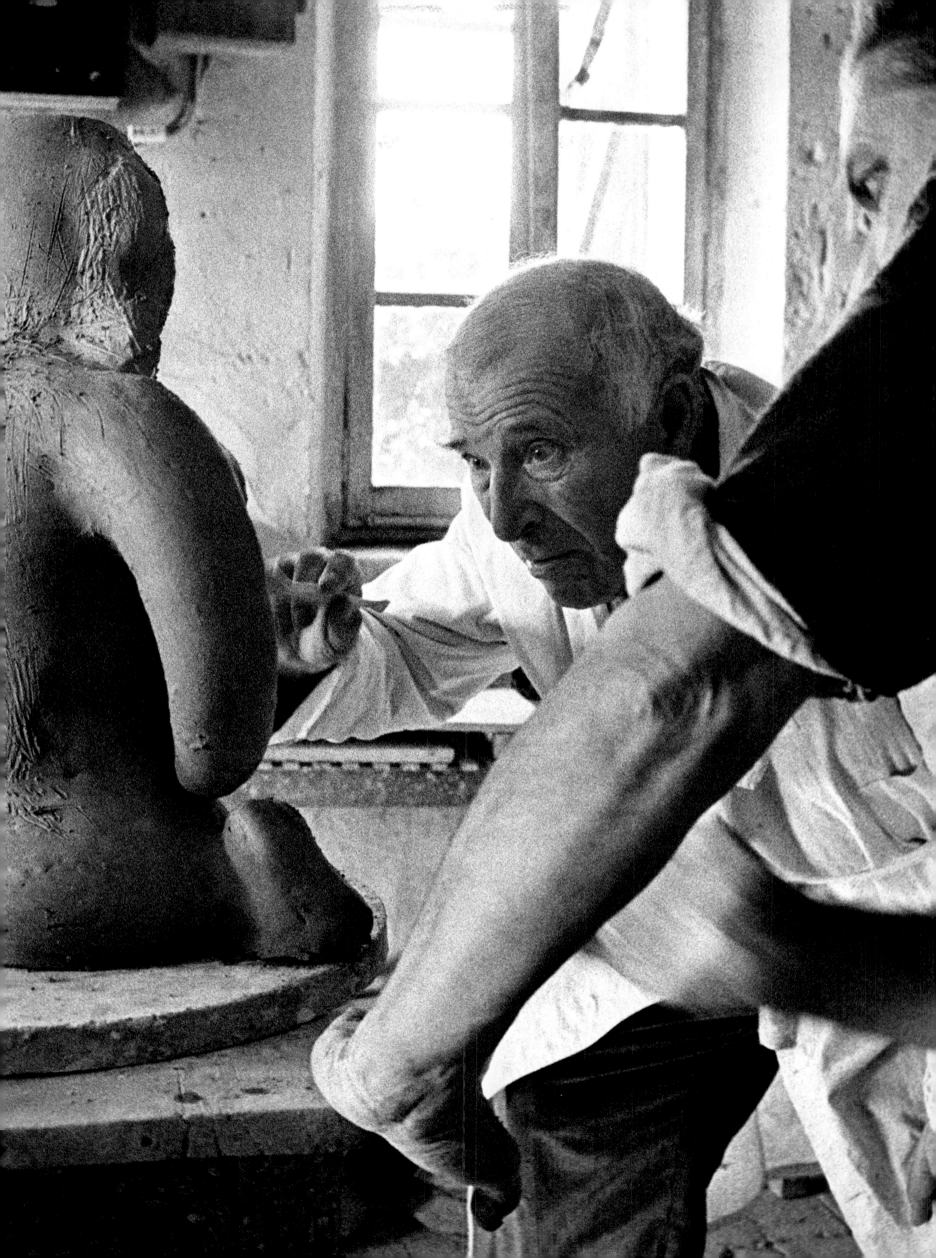

has a hint of Mannerism; and the handles became arms (here I think Chagall's inspiration flagged slightly). Or, to put all this another way, the verbal metaphors—body, belly, waist, neck—often used to describe pots were provided with plastic representation, much as the metaphor "falling in love" is in Chagall's images of inclined lovers. Then the clay was metamorphosed into Chagallian colored "tissue" by the addition of enamels and glazes (plus the judicious exposure here and there of the earth substance itself); and the surface was provided with pattern, texture, and tone values by means of a scratching technique that recalls the artist's etchings and drypoints, and also some of his gouaches (see again *For Vava,* page 26). Finally the shapes, structures, motifs, substances, colors, and patterns that had been fused imaginatively were fused physically by baking, and the result is an admirable object that looks at one moment like a 19th-century engraving, at another like a piece of folk art, and always like an extraordinarily natural product of the clay and sunlight of Provence.

Occasionally the first stages of this creative process are reversed. Chagall may begin, that is, with figurative forms derived from his repertory as a painter, and metamorphose them into the forms of more or less functional pottery. Most of his fantastic ceramic animals (see page 34) are the results of such an operation, and so, I would suggest, is the agreeably sentimental piece in the foreground on page 120: these symbolically fused personages are still Chagallian sweethearts first, and a container only very secondarily. But the order of imaginative priority in such works does not exclude them from the eclecticism (an eclecticism of techniques and media, not of styles) and the dialogues of shapes and motifs that are apparent in the piece I have labeled *The Siamese Nudes.*

One might conclude from a glance at the dates that three-dimensional work in clay led to three-dimensional work in stone, and the conclusion would be to some extent correct. However, a good deal more than the experience with pottery helped to interest Chagall in sculpture in 1951 and to keep him interested in the art during the years immediately following. Travel in France, Italy, and Greece increased the admiration he had long felt for Romanesque, Etruscan, and Archaic Greek statuary. During this period he seems to have had very much in mind the example of Gauguin, who in an effort to create art that broke through into a spiritual zone beyond the normal boundaries of art had experimented with primitivist carving (and also with ceramics). On a more modern and more purely aesthetic level, and quite near at hand on the French Riviera, there were the examples of Matisse and Picasso, both of whom had frequently branched out into sculpture, partly for its own sake and partly as a way of exploring problems that had appeared in their painting. In Chagall's own painting sculptural tendencies had been apparent for some time; the flat effects he had formerly favored had been modified by the use of stronger tone-value contrasts to throw figures into relief, by some thickening of the paint, and by the use of the palette knife

118

to carve motifs out of the colored background substance (the anthology *Life*, on pages 100-101, and *Jacob's Dream,* on page 20, are among the many relatively recent pictures that exhibit the results of all three of these techniques). In short, he was ready for the new medium, insofar as one can be ready in the imagination for a very concrete art that calls for the development of specific manual skills.

But it would be a mistake to underestimate the formidable number of philosophical, artistic, and technical problems he faced along with the need to learn the required manual skills. For the first time in his long career as an artist he had to create works without help from given points of departure. In his painting, in his printmaking, and even to some extent in his pottery, there had usually been something there at the beginning of an operation: the canvas or paper that had to be covered, the format of the work, the copper plate to be attacked with points and acid, the lithographer's stone, the rough idea of a functional pot, the clay surface to be scratched and colored. In sculpture he had to build up his forms almost from nothing by modeling them in clay, plaster, wax, and similar substances; or assume, in the manner of Michelangelo and primitive artists, that the forms were somehow hidden in blocks of stone or wood, waiting to be extracted by carving; or start from zero with one of the 20th-century methods of construction and assemblage. Whatever he chose to do would have implications he had not dealt with previously, for a piece of sculpture —more than a painting or a print—exists as a thing in itself as well as a representation: in addition to fostering an illusion it solicits attention for real matter, color, light, and space.

In selecting an artistic technique and material Chagall is usually very conservative; he likes the feel of an ancient tradition in his methods, even when the final effect he is aiming at violates traditional criteria. So he seems never to have considered experimenting with modern sculptural construction and assemblage—which is perhaps a pity, since these techniques might well suit some of his visual metaphors. Nor has he shown a great deal of interest in modeling, although some of his pieces have been cast in bronze (see page 122). It is mostly as a stonecutter that he has confronted the problems of translating his painter's vision into sculpture. Has he solved these problems? In my opinion he has not, but in the course of wrestling with them he has produced some remarkably interesting pieces of hybrid art.

He has been most attracted, as any painter would be, by the possibilities in low-relief sculpture (see page 123). In fact, several of his carvings are in such low relief, and make such cunning use of light and shade for pictorial effects, that even when seen fairly close to they look like gray monochrome paintings, or like plates incised for a batch of prints. They can be described as trompe-l'œil renderings of low-relief sculpture in which the surprise of trompe-l'œil painting—here it would be the discovery that what looked like carved stone was

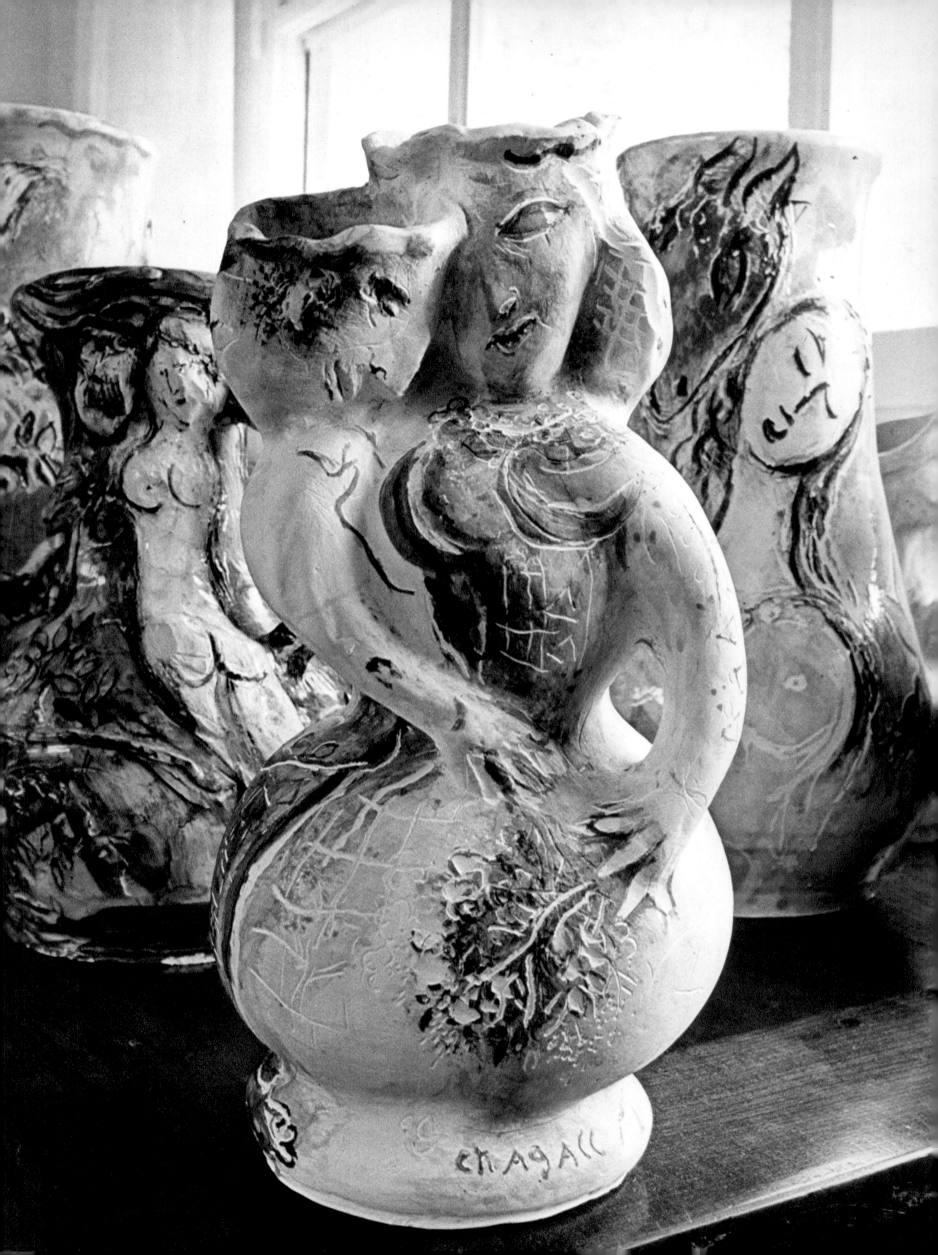

really pigment on canvas or paper—is replaced by the surprise of discovering that after all the carved stone is real and the painting is an illusion.

Some of the free-standing works are essentially blocks of stone covered with low relief on all sides; they are sculpture in the round only in the sense that a carved obelisk or a Romanesque capital is. Even pieces like the bronzes on page 122, which are true sculpture in the round, are likely to display low-relief images or to have patterns incised by means similar to the etching techniques Chagall often uses on his pottery. The general impression he gives is that while he prefers carving to modeling he does not have much faith in the Michelangelesque notion of preexisting sculptural forms expectantly awaiting the artist's hand, not so much to be created as simply to be released by a process of chiseling away, layer by layer, the imprisoning stone. Nor does he seem to have much faith in the expressive power of the third dimension: in this connection one can recall the remark, quoted at the start of Chapter II, that "what is called perspective" does not necessarily add "depth" to a picture. It is clear that for him a great deal, although by no means all, of the vitality to be found in a piece of sculpture lies on, or slightly in, the surface. This painterly attitude runs counter, of course, to orthodox contemporary thinking on the subject, and to the practice of some of the best modern sculptors. But before condemning it we should remember that a clean distinction between sculpture and painting is a relatively recent idea in the history of world art—and an idea that is being rejected today by many of the avant-garde mixers of media.

From what has been said above, certain other aspects of Chagall's venture into sculpture might be deduced. Although he often produces an effect of density and mass, a close look will usually reveal that he is not much concerned with the problem of articulating a mass into expressiveness: he is content to suggest solidity in the structure, and to rely on the surface to "say" something. Even his best pieces have almost no interior space—one can see why he was not tempted by the open-frame conceptions of the Constructivists, who were active in Russia just before his final departure. Nor do these pieces create around themselves the peculiar aura of fluid space that can be felt, for instance, around one of Henry Moore's personages. What they do manage to do, often with surprising force, is to project a kind of static space. The spectator who begins to walk around one

For the most part, the figures in Chagall's ceramic work resemble those in his painting; they are new only in their substance and in their integration with pottery forms. Occasionally, however, they seem to be imitating, as if they were his children, their creator's habitual gestures and postures. For example, the gently humorous piece in the foreground on the opposite page can be compared with the photograph on page 73 of the painter and his wife.

Two bronzes, entitled FANTASTIC ANIMAL *and* ROOSTER, *show Chagall retaining his painter's interest in texture and surface motifs when he turns to sculpture.*

"A thing has to be allusive to other things in order to acquire its true identity."

122

Cut in stone sent from Jerusalem, this relief is one of a pair in the wall at the entrance of the artist's new Provençal-style house above the village of St. Paul.

"If I create from the heart, nearly everything works; if from the head, almost nothing."

of them finds himself frequently halted and forced to adopt a single viewpoint, as he would if he were looking at the sides of a square building, at an Egyptian or Archaic Greek statue, or at a series of paintings.

The mosaics and tapestries for which Chagall supplies the cartoons do not raise the kinds of questions raised by his pottery and sculpture, partly because they are obviously in the same family of disciplines as his painting and print-making, and also because he leaves to other hands the actual cementing and weaving. In creating them he is rather in the position of an experienced composer who has been asked to arrange existing pieces for different sets of instruments—and who has to beware, for instance, of writing a score that requires a trombonist to play something only a violinist can play properly.

The outdoor mosaic (page 125) at the Maeght Foundation (a modern museum and center for the performing arts recently erected at Saint Paul, near Chagall's new house) does show, however, that one of these transcriptions may call for a combination of sensitivity and courage, and even for a ruthlessness, that not every artist possesses. In this composition many of the subtle shades of color that make up the characteristic Chagallian tissue in paintings had to be sacrificed for the sake of the bolder tones, coarser texture, and rhythmic swirls of tesserae proper to mosaics; and the painter himself, who supervised the execution closely, was the first to propose the sacrifice.

The tapestry triptych for the parliament of Israel (pages 126, 128-129, and 131), which was nearing completion when this book went to press, posed the problem of color in a particularly delicate and dangerous way; for in this instance the transcribing had to be largely entrusted to an executant, the Manufacture Nationale des Gobelins in Paris, whose desire to be faithful to Chagall's intentions was matched by a vivid awareness of its own style and traditions. Moreover, there was no chance of disguising a difficulty, for each of the three tapestries will be more than 15 feet high and their total length will be more than 66 feet. Every detail in the painted maquettes will be enlarged roughly five times.

The actual weaving got under way in February 1965, but work on the project began in 1963, when Chagall visited Israel, made some preliminary studies, and then went to Rome to examine the style and technique of Raphael's tapestries in the Vatican. When the cartoons were ready, Maurice Cauchy, the head of the Gobelins atelier, began a period of analysis and experimentation that lasted

In this mosaic at the Maeght Foundation in St. Paul, designed by Chagall in 1965 and executed under his supervision by Lino Melano, the painter's characteristic use of zones of color independent of the drawing acquires an unexpected emphasis.

124

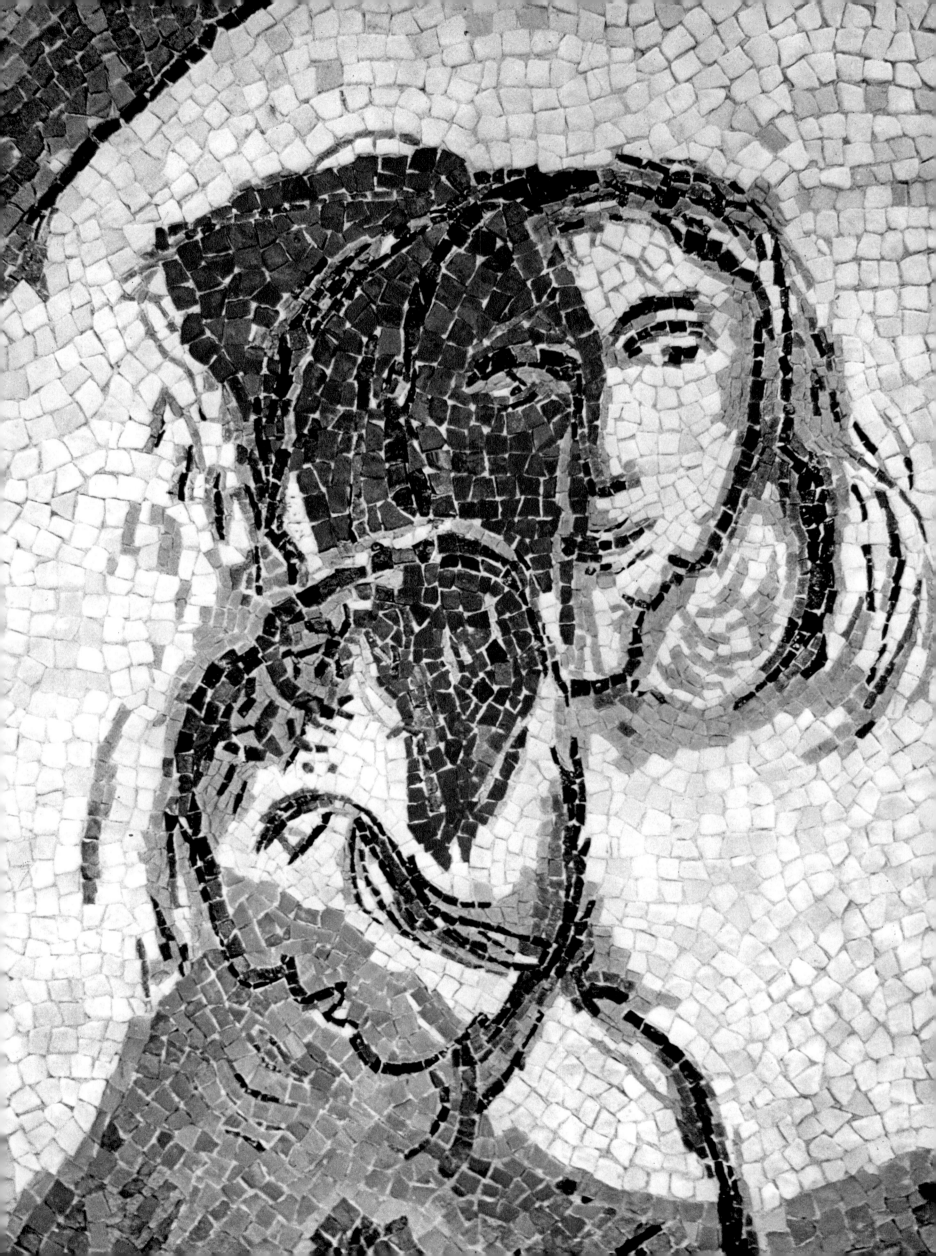

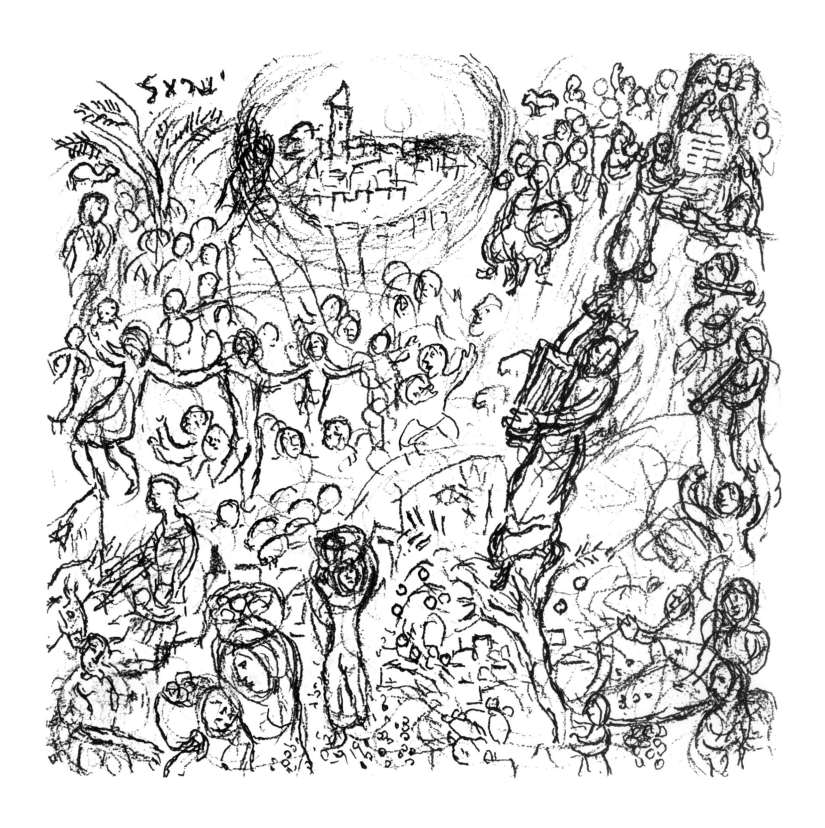

for nearly a year. He decided to produce the work in a modern equivalent of the classical Gobelins style, which meant a rejection of the Romantic notion of tapestry as an imitation of painting and an acceptance of the 17th-century practice of weaving with a relatively limited number of colors. A "color circle" was prepared by the weavers, and accepted by Chagall; it reduced his painter's palette to 160 tones of dyed yarn—a long way from the thousands of tones available to 19th-century weavers, and reasonably close to the classical total. More analysis followed, and for the first section of the triptych the number of tones was finally reduced to 110, of which less than half were used often enough to be termed "important" by Cauchy. In other words, we may feel sure that the Chagallian tissue on page 131 would have met with the approval of the imperious Charles Lebrun, director of the Gobelins factory under Louis XIV.

Color was not the only problem. Chagall discovered that his light and shade and his characteristically nonchalant drawing style—what he refers to as his "handwriting"—had to be modified slightly in order to create effects proper to the art of tapestry. He also found that the weavers who were enlarging and in some ways simplifying his cartoons tended to produce automatically, through no fault of their own, dramatic effects of contrast he had not intended, and that when the unwanted drama was eliminated, an equally unwanted lack of brilliance often resulted. In the course of finding solutions to such problems he became a familiar figure around the atelier and almost a weaver himself (see pages 128–129).

THE ENTRY INTO JERUSALEM, *pencil and pen, 1963. This is one of the early sketches for the third section of the tapestry triptych for the Israeli parliament; the first two sections are entitled* THE CREATION *and* THE EXODUS. *On the right is depicted the entry into Jerusalem of the Ark of the Covenant, as it is recounted in 2 Samuel* VI, 5: *"And David and all the house of Israel played before the Lord on all manner of instruments..." On the left, under the Hebrew for "Israel" and a medallion view of the city, modern Israelis join hands in a folk dance called the* horah. *Overleaf: At the Gobelins, Chagall checks the color of* The Creation.▷

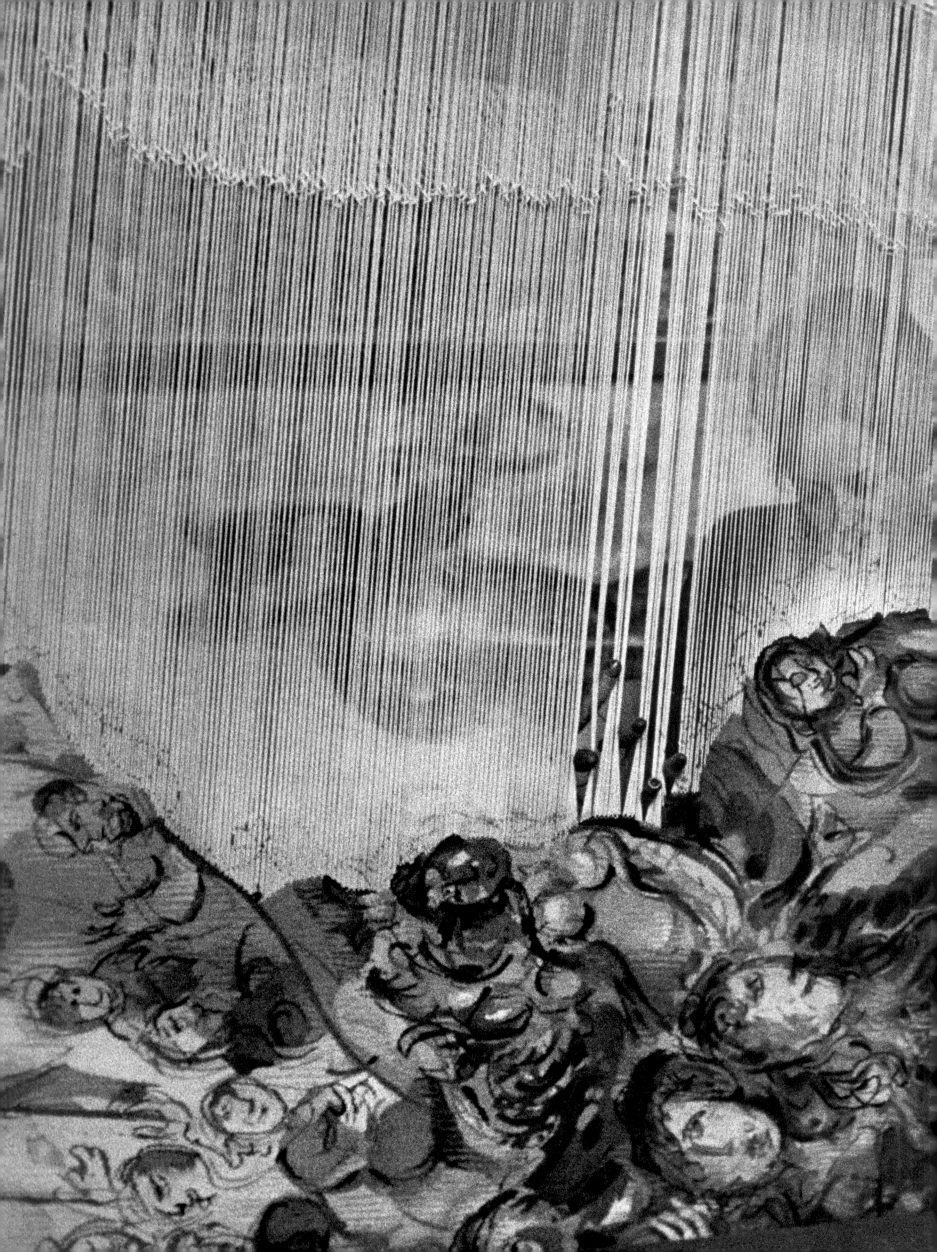

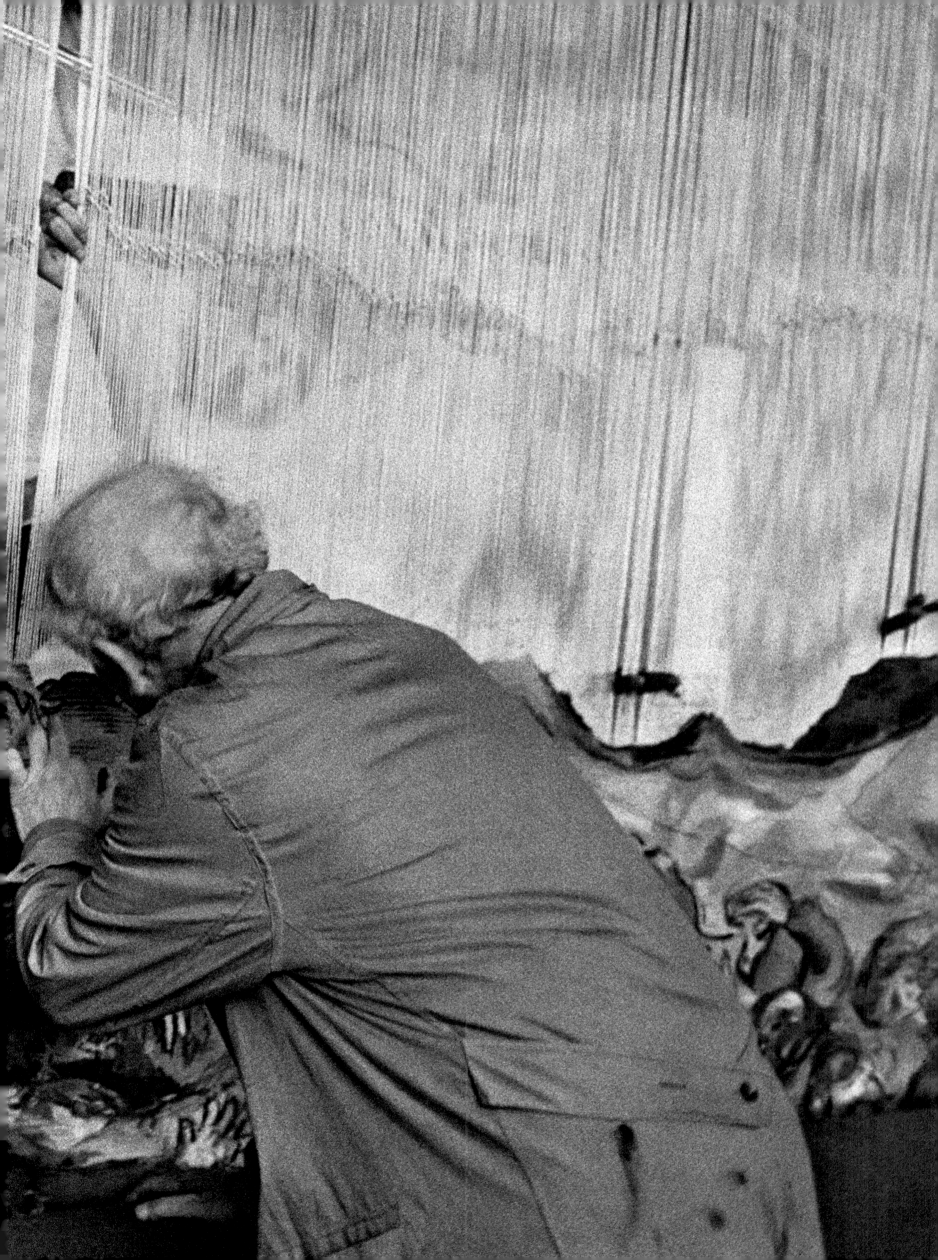

*"I've seen the mountains of Sodom and the Negev. From
their hollows spring the shades of our prophets, in robes
yellowish like dry bread. I've heard their ancient words."*

THE EXODUS, *tapestry, 1966. This incomplete detail from the middle
section of the triptych for the Israeli parliament offers a complex problem
in ambiguity. A royal harpist who is officially David fills the foreground.
In the upper right corner is Jerusalem, labeled in Hebrew. But behind
the king there is a bride in white, joined to a young violinist. Is she Bella?
A possible interpretation is that she is both Bella and the Shulamite, the
beloved in The Song of Solomon, for Chagall has made this association
the basis of a series of paintings in the past ten years. On that assumption
David is both David and Solomon (whom the artist has in fact represented
as a harpist in several recent works). A possible starting point for this
associative thinking is the fact that The Song of Solomon is read at
Passover, which celebrates the Exodus—the title of the tapestry.*

130

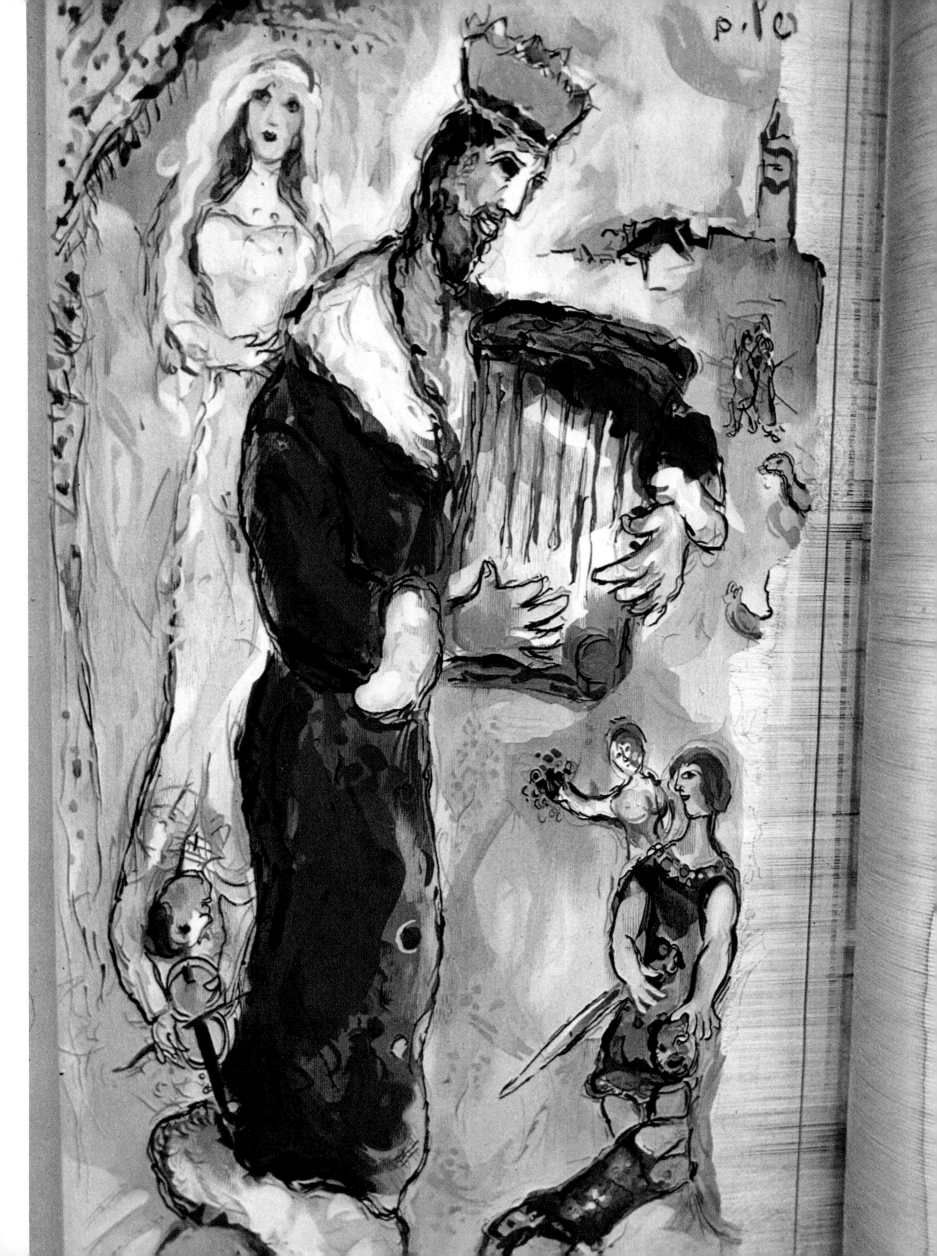

VIII *Memories of Places*

In the minds of countless viewers many of the world's real cities and landscapes have been more or less permanently "annexed" by particular painters: Toledo belongs to El Greco, Delft to Vermeer, Venice to Canaletto and Guardi, and the country around Aix-en-Provence to Cézanne. Few places, however, have been taken over by an artist in quite the fervent way Chagall has taken over both Vitebsk and—although not so exclusively—Paris. He has converted his home town not only into a trademarked townscape, but also into a kind of musical leitmotiv that calls to mind at each recurrence a web of personal facts: his working-class origins, his Jewishness, his Russianness, his life as an exile, his attachment to his childhood, his "separation anxiety," and his habit, unusual in the visual arts, of relying primarily on memory for inspiration. He has converted Paris into a symbol of his success and, more important, into what he himself has referred to as his "second Vitebsk"—his second source, especially since World War II, of emotional security and artistically productive memories. (Vence has shown signs of eventually becoming a third Vitebsk, but most of the imagery it has supplied to date has been charged with the sentiments of other places and an earlier period.)

A random glance through the reproductions in the earlier chapters of this book is enough to remind one how often the Vitebsk leitmotiv recurs, and in

Although Chagall (top center) has become a resident of the French Riviera, he works frequently in Paris and has kept his apartment on the Quai d'Anjou, from which he frequently descends to enjoy this leafy section of the banks of the Seine (from both above and below—see pages 136–137). These pictures were taken in 1962, when he was in the midst of a series of works too large for the Vence studio.

what a wide variety of contexts. The town looms out of the abstract colored substance, or remembered snow, in *The Green Horse* (page 17); it is mixed with a hint of Vence on the left side of *Jacob's Dream* (page 20); a Vitebsk house —a single chord from the leitmotiv—is inserted into the upper right corner of *Clowns at Night* (page 22); part of the town rushes into the dream space of *Window in the Sky* (pages 38-39); a Vitebsk street, with recognizable buildings and a stretch of the familiar wooden fence, is carried by the stroller (presumably Chagall himself) in the drawing on page 80. These works form a representative sample, and gain rather than lose significance from the fact that all except the "street-carrier" were conceived relatively recently, decades after the artist's last view of his town. But for good measure, and for the pleasure of looking at genuine exuberance, we can add *Over the City* (page 143), in which Vitebsk has not yet slipped from the status of a seen object to that of a memory image.

Paris occurs so often in Chagall's work, and is so easy to recognize, that it seems unnecessary to cite many examples. Notice, however, that as a rule the city in the pictures painted before World War II lacks the emotional density and the presence Vitebsk often has; indeed, in spite of the verve and the evidence of affection it contains, it is not so much a place as a collection of such familiar tourist landmarks as the Eiffel Tower and the Seine bridges. Then, in the 1950s, the mood changes. The city remains essentially a collection of symbols, it is still the Paris of a foreigner, but a new emotion agitates the symbols (see the drawings on pages 93 and 95). The idea of the "second Vitebsk" becomes visually explicit in 1953 with the deeply felt *Red Roofs* (page 145), in which a river that is both the Seine and Vitebsk's Dvina flows between the home town and a quite detailed view of the quarter of Paris around Notre Dame. The same idea is apparent in a series of oils painted during the following years, and a little later in the monotype *Landscape With Blue Fish* (page 90), which shows very clearly that the monuments of Paris and the humble houses of Vitebsk have become part of the same imaginary Chagallian city, and that the little Russian horse of *The Green Horse,* which is already floating in the background of *The Eiffel Tower* on page 95, can now gallop freely on the quays of the Seine.

What lies behind this long and extraordinarily consistent display of nostalgia? Why, to begin at the beginning, has Vitebsk been so important to Chagall?

THE SEINE BRIDGES, *lithograph, 1952. "Visions of Paris that are perhaps the same and that are not the same. Paris, reflection of my heart. I would like to dissolve myself in it, to not be alone with myself."*

Visions de Paris qui sont peut-être
les mêmes et qui ne sont pas
les mêmes
Paris reflet de mon cœur.
Je voudrais. m'y fondre, ne point être
seul avec moi-même
Marc Chagall
1952

The town of his boyhood certainly does not seem, at first glance, to have been the sort of place that an assimilated Jew of Western Europe and a successful, sophisticated painter of the School of Paris would remember with pleasure. It was a provincial center of western Russia not far from the Polish frontier (the past tense is appropriate, for the town that was has not existed since the Nazi invasion and subsequent rebuilding); but in many ways it was simply a large village, whose inhabitants were still rural enough to keep farm animals in the courtyards of their little wooden houses. The pre-1914 edition of the Encyclopaedia Britannica says that it had a population of slightly more than fifty thousand at the end of the 19th century, and adds: "It is an old town, with decaying mansions of the nobility and dirty Jewish quarters, half of its inhabitants being Jews.... The manufactures are insignificant." In sections of his autobiography (which we must remember was written just after the Russian Revolution and only slightly revised before publication in 1931) Chagall is not much more complimentary, although his love for the place is evident:

"Vitebsk is a place apart; a town unlike any other, an unhappy town, a boring town.

"A town full of girls, who, for lack of time or courage, I never even approached.

"Dozens, hundreds of synagogues, butcher's shops, passers-by.

"Was that Russia?

"It's only my town, mine...."

Because of his father's job in the herring warehouse, the whole place seemed to him to be permanently impregnated with the smell of fish. When the boy dreamed of going to France and becoming an artist, the smell appears to have motivated him almost as much as his vision of modern painting:

"... have you heard of traditions, of Aix, of the painter with the severed ear, of cubes, of squares, of Paris?

"Vitebsk, I am forsaking you.

"Stay on your own with your herring!"

Why should such a place have remained with him as a source of artistic inspiration during almost fifty years of living abroad? It has done so, of course, partly for the reasons that everyone has for remembering a home town with

The painter in 1960 in front of La Ruche ("The Beehive"), the ramshackle collection of artists' studios in Paris where he lived from the end of 1911 until his return to Russia in the spring of 1914. At various times the list of his fellow lodgers included Soutine, Modigliani, Archipenko, Laurens, and Léger, all then as unknown in the art world as he was. Today La Ruche is still occupied by young painters and sculptors.

139

"It was like this—and how much younger I was in the year 1911!—that I climbed up into the insides of the beehive. Behind me is the door to my studio."

At La Ruche Chagall was sometimes so short of money that he had to paint on sheets and tablecloths. His studio, according to his own account, was often a week-old litter of eggshells, bread crusts, empty cans, and the remnants of herring. But it was at La Ruche that he painted several of his famous early works and began the long process that was to make Paris his second home town. Here also, although the studios were reserved mostly for practitioners of the visual arts, he became the friend of the poets Blaise Cendrars, Guillaume Apollinaire, and Max Jacob.

pleasure: one was young and the future was still open. But Chagall clearly has other reasons.

The first of these reasons stems from the fact that he is a Jew. In Russia, certainly, anti-Semitism was strong: "There, although I was still a child, I felt at every step that I was a Jew—people made me feel it!" Nevertheless, in Vitebsk he belonged to a community, a community more closely knit than any he was ever to discover in France or the United States. Although his ghetto was indeed surrounded by Christian hostility and even by the occasional, distant threat of a renewal of the Russian pogroms of the 19th century, the Jews inside lived—to judge by the pages of *My Life* and Bella's *Burning Lights,* and the evidence in dozens of Chagall's paintings—in the last phase of the unique togetherness that had preserved the Chosen throughout the Middle Ages. The Chagall family was almost a clan: eight children and a rather indefinite number of grandparents, uncles, aunts, and cousins, who all seem to have been around the house a good deal of the time. They were all more or less poor, as was nearly everyone in the quarter (Bella's family was among the exceptions), and Marc's mother had to add to his father's small salary by running a shop where she sold spices, sugar, flour, and of course herring. But it is plain that nearly everyone loved nearly everyone, in keeping with the Hasidic commandments. Vitebsk was overflowing with love.

A second reason for Chagall's nostalgia can be found in the fact that although he has long been a French citizen, and clearly has no reason to be grateful or loyal toward the Soviet government, he has remained intensely Russian—and hence full of that love for the mother country that seems to fill all Russians, no matter how long they remain in exile. (A few years ago even the cosmopolitan Stravinsky astonished his close friends by dissolving into Russianness the moment he set foot on the sacred soil.) Those who think of the painter as one of the masters of the School of Paris ought to be reminded of a remark he made as long ago as 1934: "The title 'a Russian painter' means more to me than any international fame...."

Here I feel obliged to break a rule I have observed so far in this book, and to report, because of the circumstances, a personal conversation as such. One day in the summer of 1966 I called on Chagall at his new house in Saint Paul, which I had not seen since he had moved his furniture, books, painting equipment, and pictures over from Vence, about a month before. The walk up to the grounds, which form part of a wooded area above the walled village, was delightful, and so was the house, which is a large, white, cool, rambling structure in a modernized Provençal style. We inspected the printmaking room, the pottery room, the sketching room, and finally the main studio, which is equipped with a push-button device for raising and lowering large canvases (an eloquent reminder of Chagall's age), and a steel-encased annex for storing paintings (an equally eloquent reminder of the monetary value his works have now attained).

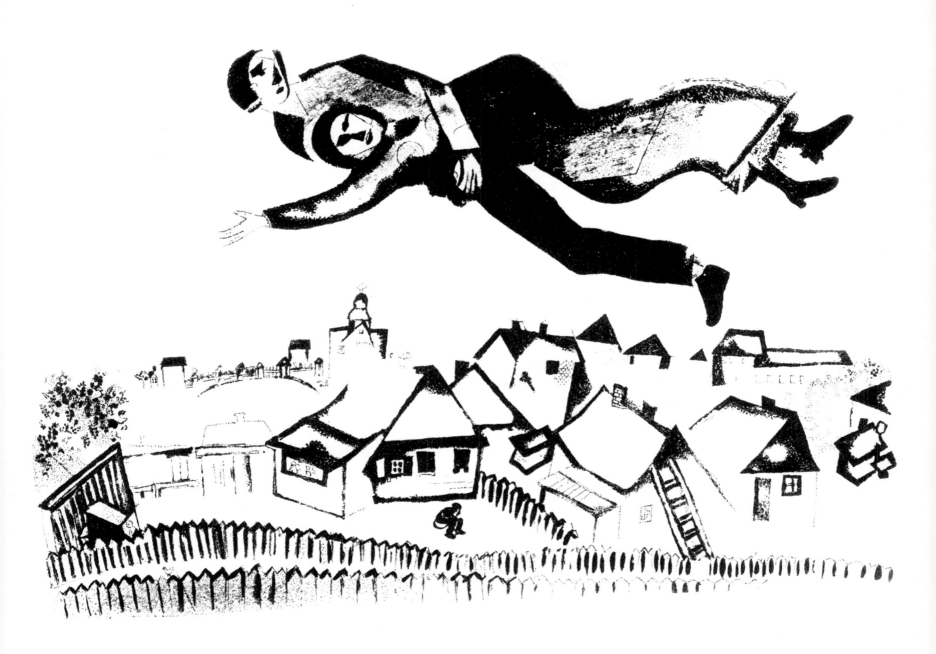

OVER THE CITY, *lithograph, 1922/1923. Marc and Bella soar over a relatively realistic version of Vitebsk, to which they never returned after the date of this picture.*

"In my pictures there is not one centimeter free from nostalgia for my native land."

"If only I could trace my way in the sky with my arms and legs, riding on the stone chimera of Notre Dame. There it is! Paris, you are my second Vitebsk!"

RED ROOFS, *oil, 1953. Four broad diagonal bands of rich colored "tissue," a large circle within a circle, and the crescent shape of the artist form the underlying "abstract" structures, but the picture itself is far from abstract. At the top is one of the most realistic views of Paris Chagall has painted: Notre Dame, the Seine bridges, and some apartment houses are visible. On the "Left Bank" the townscape changes to Vitebsk. Looking on from above is a man with the Torah; gazing pensively at the scene is Bella, with a bouquet. The painter, whose bare feet and pyjamalike costume suggest that he is a sleepwalker in a dream space, bows gravely over his memories. Meanwhile, the tiny citizens of Vitebsk, dimly visible through the red substance, go about their daily affairs.*

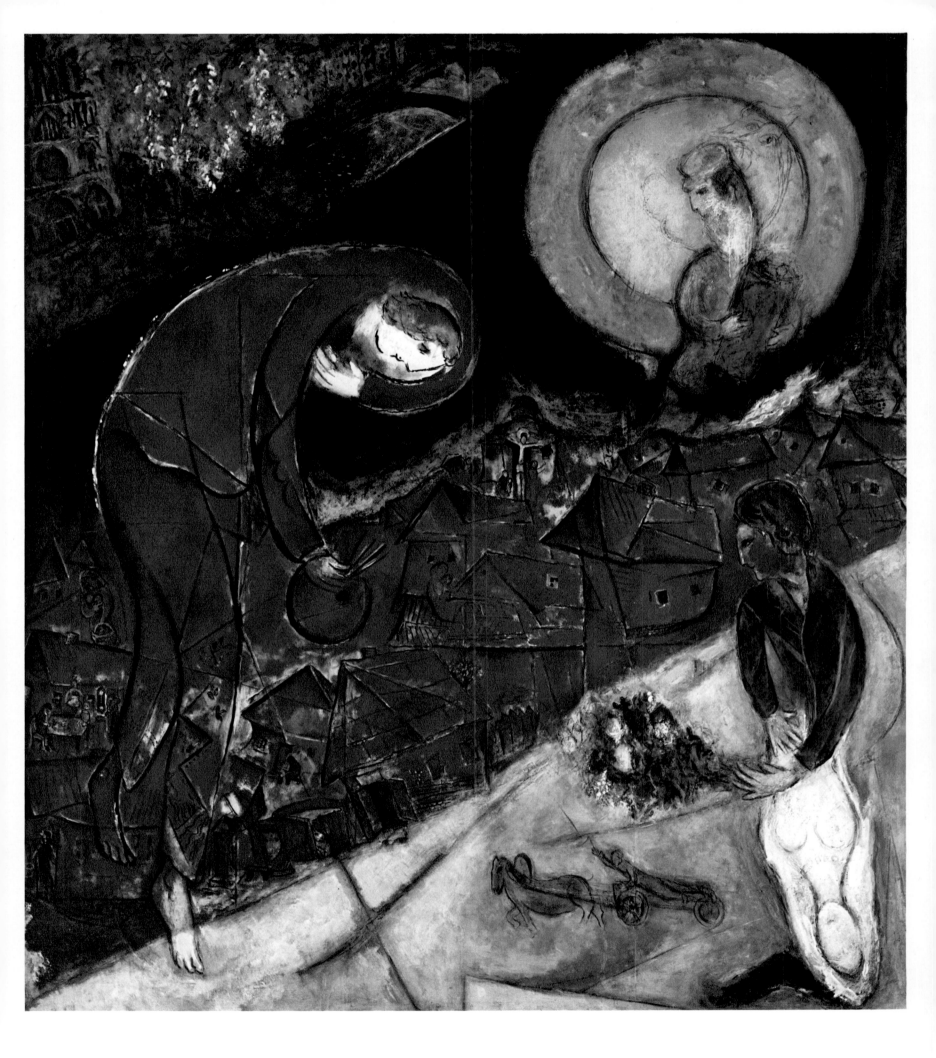

Then we moved on to the living room and sat down opposite a wall on which hung two pictures from the early Vitebsk period and the *Red Roofs* reproduced in this chapter. It was impossible not to think of all that had happened since the departure from Russia in 1910, and Chagall must have been thinking along similar lines, for he seemed depressed by the recent tour of his success symbols. I asked him how he thought his career would have developed in the Soviet Union, and he said, evidently referring to Hitler's massacres: "I'd be dead." Then, waving in the direction of the paintings, he asked: "What do you really think of all this?" I said nothing, since he knew I had seen the paintings many times and liked them. Then, as if in answer to my original question, he pointed at a potted plant and said: "That would not be the same thing if you put it in the earth of Vitebsk." After a long pause, he added, in a voice I won't attempt to describe: "All the others who came to Paris can go home if they want to, but I can't. You are looking at an unhappy man."

Before this conversation I was prepared to write that the Vitebsk leitmotiv was for Chagall a substitute for the original lost Vitebsk, another affirmation of his conviction that our "psychic" inner reality is just as real as the outer world, and in general a symbol of his optimistic belief in the power of art to heal the separation anxiety to which psychoanalysts say we are all subject from the moment we are separated from our mothers—in fact, from the moment we are born. I am still inclined to think that this analysis is essentially right. But evidently there are days when for Chagall himself the magic does not work, and then the painted Vitebsk becomes a symbol of the fact that he can never go back—or, to risk a sentimental generalization, of the fact that none of us can ever go back to the presumed moment when we were really emotionally secure.

How did Paris become the second Vitebsk? Chagall has given the following explanation:

"I came to France with soil still on the roots of my shoes. It took a long time for that soil to dry up and fall off. When it did, independently of my will, I had to find another reality. I found it in the landscapes of France, the flowers of the Midi, the horizons of Peira-Cava, the land of Gordes or the Roussillon, the deep reds of Mexico. When all the memories of Vitebsk had evaporated —and they were real, throbbing signs that had long nourished my soul—I had to find something else: Paris, of which I had dreamed in America and which I rediscovered enriched, re-lived. It was as if I had had to be born again, had had to dry my tears in order to weep again. There had to be absence, the war, and suffering, for all that to awaken in me and become the framework of my thoughts and my life. But that is possible only for someone who has been able to preserve his roots. To preserve the soil on your roots or to find another soil, that is a real miracle."

It would probably be a mistake to interpret this paragraph as a piece of straight prose, for the metaphors and allusions have apparently suffered a poetic

loss of exact referents, and the time sequence has been dislocated by strong emotions. But a number of facts do emerge fairly clearly. Apparently, before World War II, there was a period when the comfort of the painted Vitebsk leit-motiv failed utterly (although only temporarily, we now know) and Chagall felt himself to be an uprooted plant. He took root for a time in southern France and Mexico, but the "real miracle" occurred in the United States, as a result of "absence" and "suffering." Absence from France gave to Paris the dream quality that absence had once given to Vitebsk, and the French capital thus became material for Chagall's art in a way it had never been before—it suddenly had, so to speak, a new kind of aesthetic distance. Then "suffering," which is certainly an allusion to the death of Bella, had the effect of a conversion that it often has, a conversion that in this instance may have taken the turn it did because Bella had been the only part of the old, real Vitebsk to accompany him into exile. What he had, when he returned to France after the war, was Paris, with whose monuments, as we have already noted, the phantom of Bella soon became associated.

IX *Images and Meanings*

Somewhat in the vein of the pre-1914 Imagist poets, and of many of today's vanguard composers, painters, sculptors, and novelists, Chagall is inclined to argue that his works cannot be explained, not even by himself. "I don't understand them," he once remarked, "at all.... They are only pictorial arrangements of images that obsess.... The theories that I would make up to explain myself, and those that others elaborate in connection with my work, are nonsense." He detests the very word "symbolism" and if pressed may adopt something close to an art for art's sake position: "For me a picture is a surface covered with representations of things (objects, animals, human beings) in a certain order in which logic and illustration have no importance. The visual effect of the composition is what is paramount. Any other nonstructural consideration is secondary." He feels singled out by exegetes: "They don't interpret the images of Braque and Picasso. Why should they interpret mine?"

One can sympathize with his purpose in such remarks. He has a right to object to criticism that overlooks the fact that he is a painter who uses the specific language of painting—and uses it as brilliantly and tellingly as the abstractionists and near-abstractionists do. But in the long run he cannot make his more extreme objections stick. He is a figurative painter who plainly invites interpretation as such. Vitebsk, the Eiffel Tower, the open window, and the phantom of Bella are not mere "representations of things" arranged in a certain order on a flat surface; nor are dozens of other typically Chagallian images. These "objects, animals, human beings" are not symbols, of course, in the sense of being signs with fixed significances; no computer will ever be able to read a Chagall painting. They are not transparent to meaning in the way prose can be; they have their share of the mysterious opacity of real things in nature, of things that do not signify, but simply exist. In brief, they do not denote. They do, however, connote; they have reflected and associated meanings that can be legitimately discussed

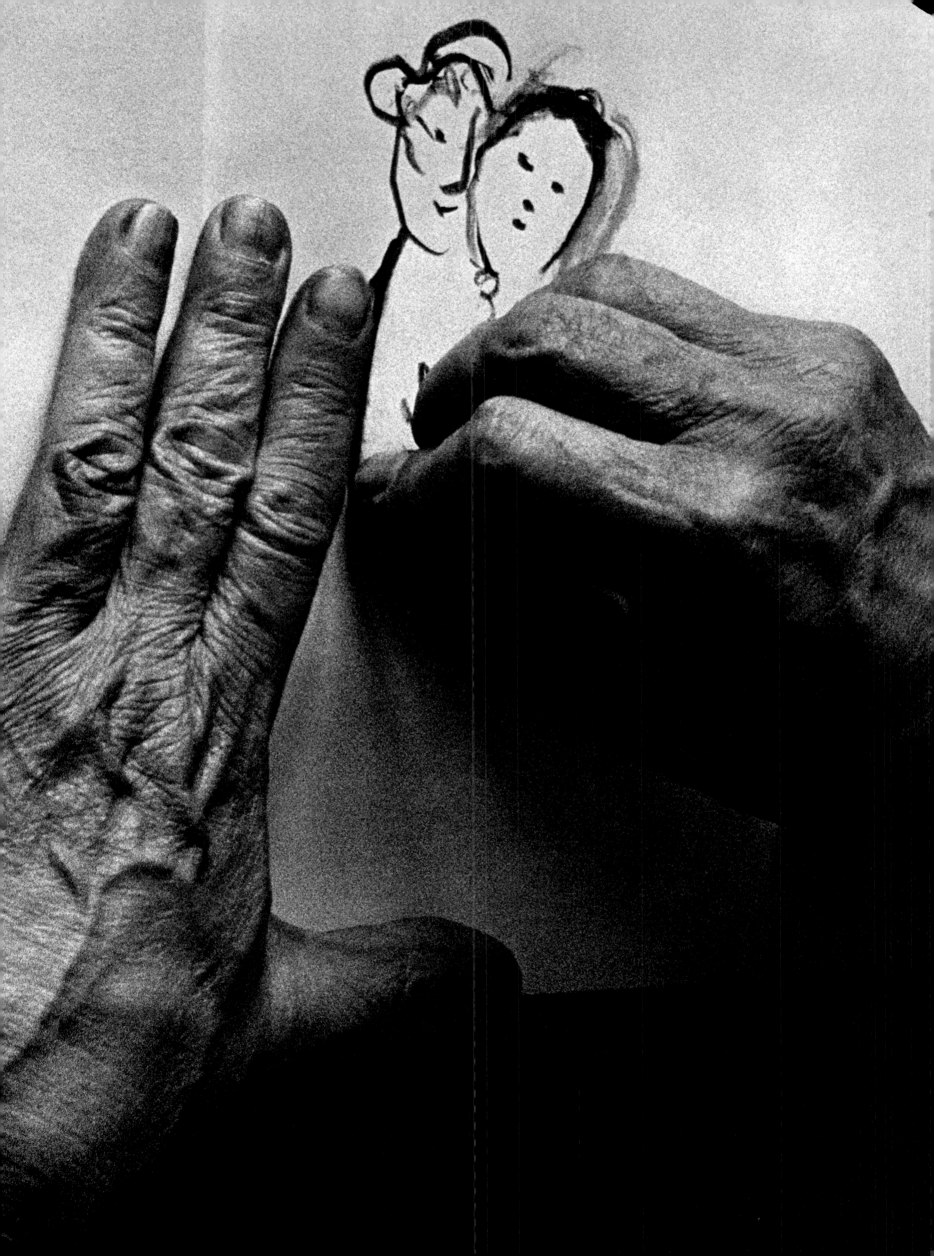

in the light of religious symbolism, of Chagall's background and career, of modern psychology, and of every viewer's personal experience. Moreover, they are indeed "images that obsess"; some of them occur frequently enough to constitute an image system—a small mythology, or what an art historian would call an iconographic program.

Most of the specifically Jewish images have complex connotations operating on more than one level. Thus the great candelabrum in *Obsession* (pages 156-157) is both a ritual object and a symbol of Judaism's defiance of the forces of destruction, or perhaps a symbol of the failure of that defiance, since one of the candles is dark and ready to fall. The blue Torah carried by the bearded figure in the upper right corner of *Red Roofs* (page 145) is a real Torah, a scroll of the Five Books of Moses; and it can also be read as a symbol of suffering, exile, and the destruction of Vitebsk, for throughout history Jews have carried the Torah with them when forced to flee. Sometimes the ritual object becomes a deeply personal symbol; thus the yellow-splashed red canopy, or *chupah,* above the bride and groom in *Life* (pages 100-101) is not only a sign that the wedding ceremony is Jewish (the *chupah* is said to symbolize the idea of a royal occasion) but also a reminder, for a reader of Chagall's autobiography, that half a century before the picture was painted Marc and Bella were married "against the yellow background of the wall, without stars and without sky, under a red canopy."

Sometimes the meaning remains religious, but not in a conventional way; here the etching on page 87 can be cited. One of the acrobats has put on phylacteries, or *tefillin,* the small leather boxes (containing slips inscribed with scriptural passages) traditionally strapped to the left arm and to the forehead by Jewish men during morning weekday prayers. In other words, these energetic figures are Hasidim communicating with God in their own confident, joyous fashion. And that Chagall intended this meaning is evident from the fact that he kept the phylacteries in several versions of the motif, executed over a period of more than forty years (the straps can still be made out on the left arm of the acrobat on the right of the trio in *Life*).

Crucifixions, which began to appear in Chagall's work as early as his first Vitebsk period and became particularly numerous and intense during the Nazi era, might almost be classified as Jewish images, although stylistically they show

PREGNANT WOMAN, *pen drawing, 1913. The sky shows the influence of Cubism; the X-ray manner of revealing the infant derives in part from the medallions worn by Madonnas in Byzantine and Russian icons; and the skirt has echoes of Russian folk art. However, the combination of all these elements in a single figure whose head has a man's and a woman's face is unmistakably Chagallian.*

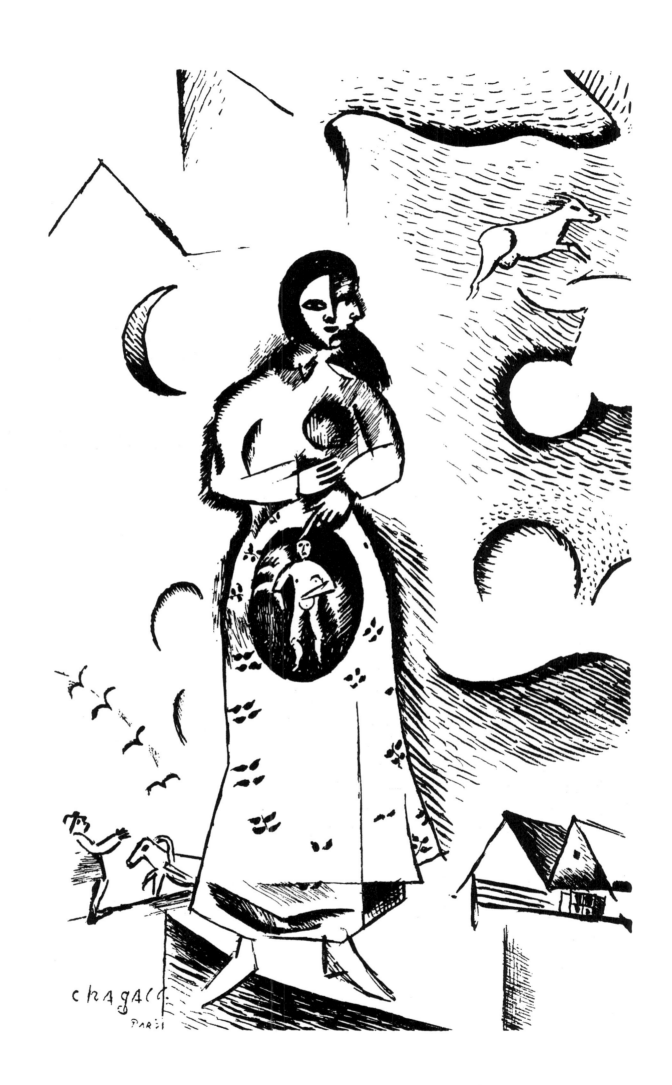

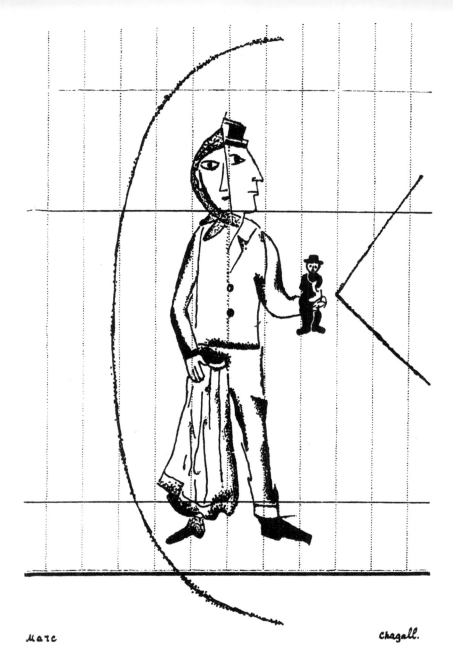

THE ACTOR, *pen drawing, 1916. On a sheet of bookkeeping paper that produces the effect of a cage for a circus sideshow, Chagall plays the role of a fantastic marriage broker.*

HOMMAGE À APOLLINAIRE, *oil, 1911/1912. The dedication around the pierced heart is not only to Guillaume Apollinaire but also to the painter's close friend Blaise Cendrars (whose name is misspelled), to the Paris motion-picture theorist and avant-garde editor Riciotto Canudo, and to Herwarth Walden, editor of the review* Der Sturm *and organizer, in Berlin in 1914, of Chagall's first important one-man show—the show that marked the beginning of his international reputation. In addition to being a piece of strange and striking symbolism, the painting is thus a significant document for an understanding of its creator's career.* ▷

the influence of Russian icons and of Gauguin's *Yellow Christ*. Sometimes the figure on the cross seems to be Jesus, or partly so, but he is never the Christian Messiah. More often than not, he is a Jewish martyr; he may wear a Russian cap, or a set of phylacteries, or the *tallith,* the prayer shawl worn by Jewish men during most synagogue services—and which they take with them to their graves. He is often associated with Vitebsk; he can be made out, for example, as a tiny yellow motif in roughly the center of *Red Roofs*. At least once, as I have already noted, he is Chagall himself. One may, of course, see him as an exemplary figure, a tragic hero whose suffering benefits all mankind, but the atmosphere of terror that usually surrounds him makes such an interpretation difficult to accept. Certainly there is no suggestion of salvation in *Obsession*.

This entire painting is an example of Chagall's ability to lift his personal experience to a level of general significance. One cannot doubt that the subject of the picture is a catastrophe of vast, possibly cosmic, dimensions: the whole canvas resembles a sheet of flame, and a ghostly army marches across the horizon

152

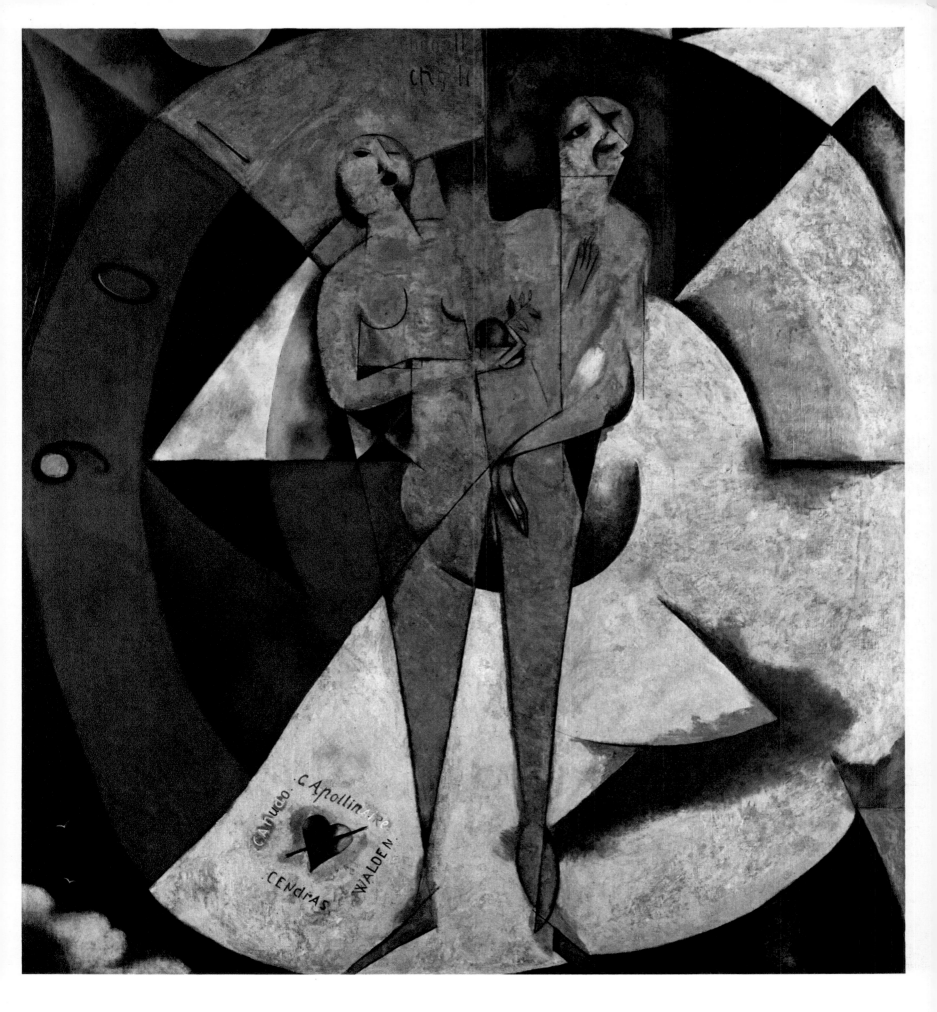

in the upper right corner. But the town is Vitebsk; the green crucifix has apparently just been blasted away from the front of the church depicted in the upper right corner (which is where, in its yellow version, it stands in *Red Roofs*). And, as can be seen from the passage from *My Life* quoted on page 157, the burning house in the foreground is the painter's birthplace, from which he and his mother—with the help of the ubiquitous little horse—had to be rescued just after he was born. With this picture as a point of departure, an entire essay could be written on Chagall's sensitivity to the birth trauma (several of his early works are extremely, even disagreeably, realistic depictions of births), his separation anxiety, and his search for emotional security in memory and art. He was already an exile and a refugee in the first moments of his life.

One of his favorite, presumably compensatory, symbols of wholeness in the life of the emotions is the image of a man and a woman who are physically one person. They may simply have two faces on the same head, as in *Self-portrait in Checked Jacket* (page 159), but often they are joined bodily, either at the lower extremities, as the bride and groom are in *Red Roofs,* or in vertical halves, as in *The Actor* (page 152), or by a branching of the torso, as in *Hommage à Apollinaire* (page 153) and the vase shown on page 120.

Probably the best comment on the two faces as a symbol of young love—as a visual metaphor—is this stanza from the poem by Chagall that appears on page 85:

> There was a time when I had two heads,
> There was a time when the doubled face
> Would be covered with amorous dew
> And would melt like the scent of a rose.

In other words, one can safely assume that the two faces are usually (some obvious exceptions will be noticed in a later chapter) those of Marc and Bella, and the same assumption can be made about the bodies of the brides and grooms joined at the lower extremities. In these images we have more examples of the painter's tendency to produce, by mental processes analogous to those we go through unconsciously in dreams, plastic representations of words; and the original verbal form of the meaning may be nothing more complicated than the phrase "in perfect union" from the Jewish marriage ritual.

However, the branching torso calls for more explanations, as indeed does all the mysterious *Hommage à Apollinaire* in which the motif appears for the first time. The initial thing to notice about this masterpiece is that the subject has nothing whatever to do with the poetry of Guillaume Apollinaire; the title, which is actually just a dedication, was added more than a year after the work was finished. The blue apple makes it clear that the double creature holding it is a merged Adam and Eve, and the numbers suggest that the circle is partly a clock. The subject of the painting might therefore be summarized—in words that

convey none of the primitive magic and mana in the gold, red, green, blue, yellow, and white geometrical forms—as numbered time emerging from the great wheel of eternity simultaneously with the beginning of human history. But the more one looks at the central motif the more one feels a need to qualify such a summary. A first impression that the depicted event is the creation of Eve related in Genesis II: 21-25, does not hold up, for Adam is not in a deep sleep and Eve's trunk springs, not from his side, but from common hips. In fact, both she and he are emerging from a single body, the neck of which is visible between their heads; and their anguished expressions, their gesture of shame at their nakedness, and the apple of sin suggest that the emergence is nothing to rejoice over. Once again, Chagall is protesting emotionally against separateness. In our ideal state, he seems to be saying in this modification of the biblical myth, man and woman are united as a single being.

There is no need to look very far for the verbal form of a metaphor that has been commonplace in love poetry and wedding ceremonies for centuries, but there is a curiously appropriate parallel for this particular Chagallian image in Genesis I: 27, in which singular and plural are nicely mixed: "So God created man in his own image, in the image of God created he him; male and female created he them." According to an ancient Jewish-Platonic mystical tradition this passage means that the first man was androgynous and that when the Many are at last gathered into the divine One the division of the sexes into different bodies will be healed. That *Hommage à Apollinaire* is an allusion, perhaps indirectly or unconsciously, to this tradition is not improbable. Chagall has been an attentive reader of the Bible all his life.

Clocks, treated as symbols of cosmic history, as souvenirs of a lost childhood, or simply, in Chagall's own words, as "extraordinary, mystical objects," hang, float, or fly in a large number of paintings. Nearly all of them are the same clock—the tall, rectangular wall model, with baroque columns on the sides and a round pendulum almost as large as the face, which dominated the living room at Vitebsk. Chagall painted it in affectionate detail in 1914 when he returned from Paris (the hour shown on the clock, 10.10, has remained the same in most of the subsequent versions that have visible hands); and he used it, with a flying fish, 16 years later in one of his best-known pictures, *Time is a River Without Banks*. It can be seen in miniature on the wall of the stage-like room on the left side of *Red Roofs,* from a different angle in the room on the left of *Life,* and again in *Life* floating above the tip of the blue rooster's tail. Confronted by the persistent appearance of this object in paintings done over a period of 50 years, one understands what Chagall means by "images that obsess."

Ladders obsess him only a little less than the family clock. Apparently they were prominent in the Vitebsk of his childhood as farmyard equipment, as precautions against fire in the wooden houses, and as facilities for roof-climbing grandfathers. One of these utility ladders stands out in the foreground of *Over*

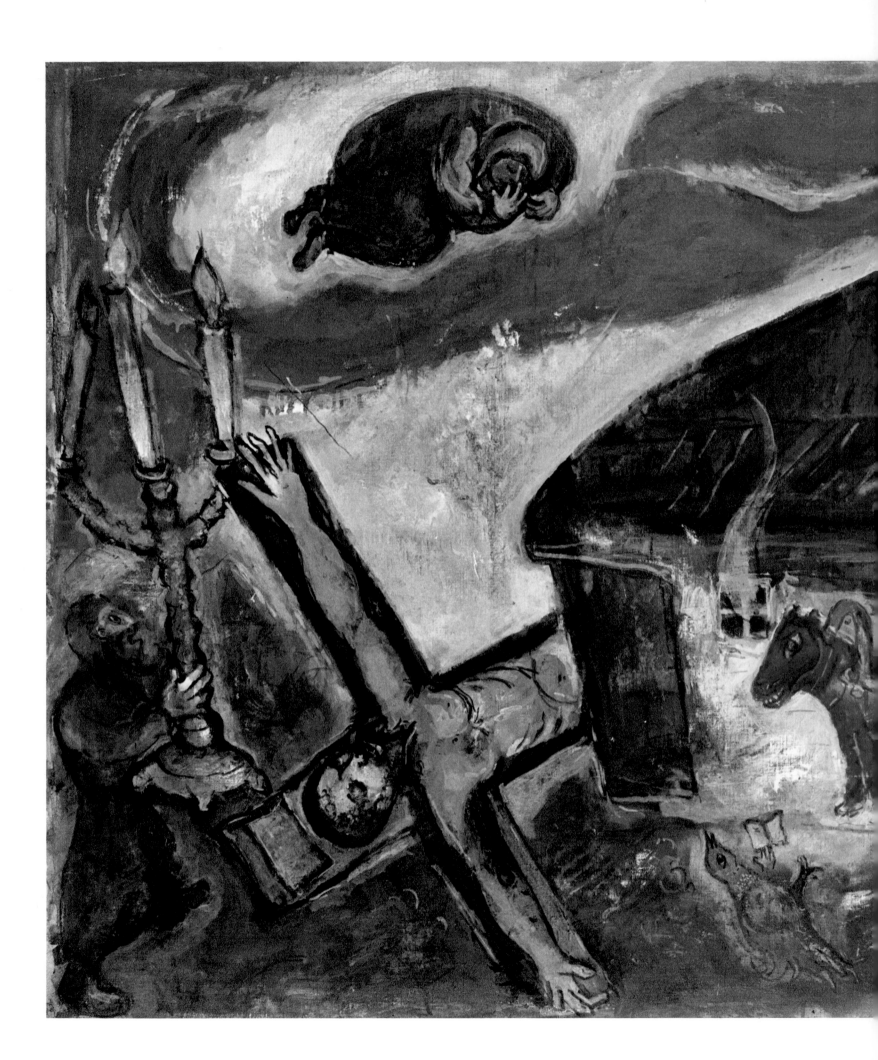

La ville était en feu. Le quartier
de pauvres juifs

on a transporté le lit et le
matelas, la mère et le fils à ses
pieds dans un lieu sûr, à l'autre
bout de la ville

Mais, avant tout, je suis
mort-né.

"The town was ablaze, the quarter where
the poor Jews lived.
"They carried the bed and mattress, the
mother and the baby at her feet, to a safe
place at the other end of the town.
"But, most important of all, I was still-
born."

OBSESSION, *oil, 1943. The central incident is
derived from the circumstances of Chagall's
birth, sketched and described in the above
autographical passage from* My Life.

the City (page 143). They become symbols of man's cruelty to man in the cruci-fixion pictures, and of man's closeness to the angels in pictures of Jacob's dream. Sometimes, as in the center of *Life,* they appear to have no purpose at all. They can then be interpreted as general symbols of aspiration, or of the possibility of reaching an ideal realm from a dream world, or of the possibility of rising from the id to the ego. But it may be safer simply to say that Chagall likes ladders. They are ready-made satisfactions for his preoccupation with diagonal shapes and structures.

Very obviously, he also likes musical instruments, flowers, and animals; and here again I think there is some danger of drawing interpretations to too fine a point. But there are associations of which a spectator—a conscientious "reader" of the pictures—ought to be aware. And sometimes there are symbolic overtones at which one can legitimately guess, even though one cannot advance proof that Chagall was thinking of them while painting. As I emphasized in the chapter on underlying "abstract" elements, one of the most remarkable qualities in his art is a constant allusiveness to the universal symbols studied by modern mythologists and depth psychologists.

The musical instruments seldom look modern. The flutes or horns (Chagall does not differentiate very clearly) in *Clowns at Night* (page 22) have a pastoral shape—and, one imagines, sound—that would not be out of place in a Greek or Etruscan painting. Many of the percussion, string, and wind instruments in *Life* vaguely evoke Romanesque murals and Gothic manuscripts; and the horn that is being blown ecstatically just below the three Hasidic acrobats could be, if curved a little more, the shofar, or ram's horn, blown by the ancient Hebrews in battle and today in synagogues before and during Rosh Hashanah (the Jewish New Year) and at the end of Yom Kippur (the Day of Atonement). The harp and other instruments in the tapestries for Israel (pages 126 and 131) are definitely biblical. In fact, only violins seem relatively up-to-date in Chagall's pictures, and they encompass memories of Vitebsk, and Uncle Neuch:

"He played the violin, like a cobbler.

"Grandfather listened and dreamed.

"Only Rembrandt could have known what the old grandfather, butcher, tradesman, and cantor thought while his son played the violin beside the window, beside the dirty windowpanes covered with raindrops and finger marks.

"Behind the window, the night."

SELF-PORTRAIT IN CHECKED JACKET, *lithograph, 1957. The painter is at work, with the town of Vence and a large Provençal sun visible in the "real" space beyond the window. In his own interior, or "psychic," space the tutelary horse and fowl of Vitebsk appear, and an angel brings flowers to his studio just as Bella did at the beginning of his career. Suddenly it is the face of his bride of 1915 that is examining his canvas.*

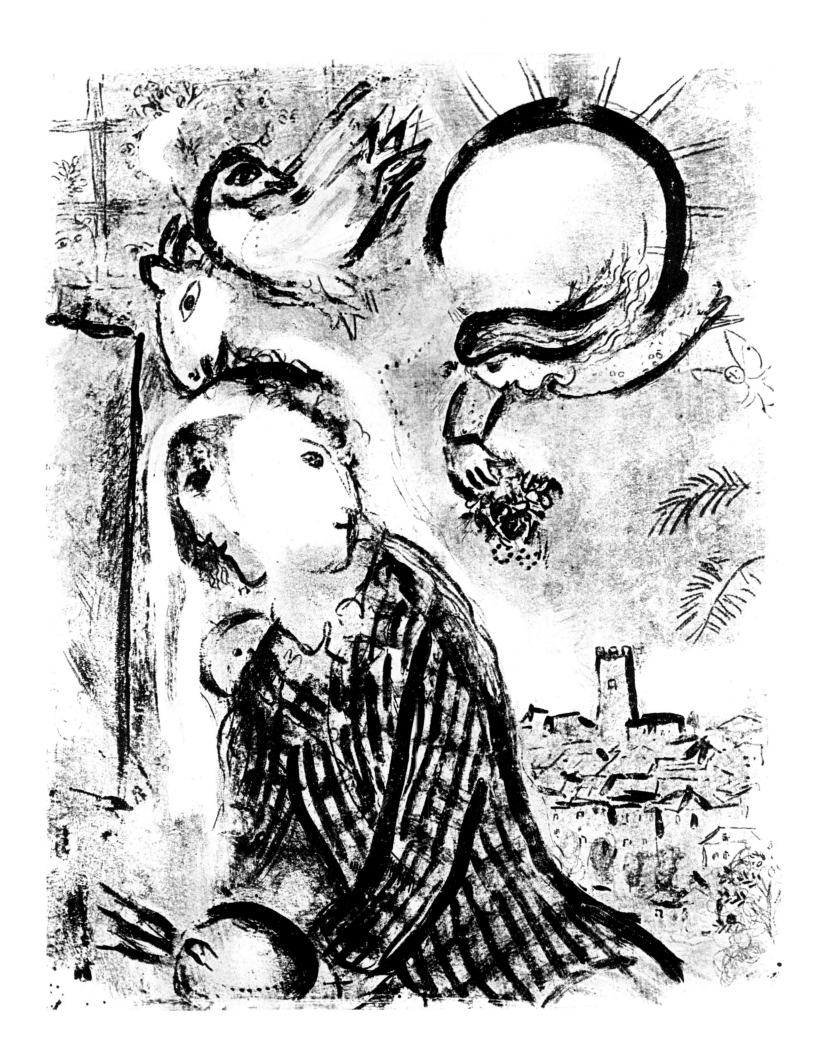

Specific memories are also present in Chagall's flowers, which are almost never conventional still-life subjects, even though they are often identifiable as the products of particular countrysides in France or elsewhere. The bouquets in *Window in the Sky* (pages 38-39), *Self-Portrait in Checked Jacket* (page 159), and *The Painter With the Blue Bouquet* (page 161) might all be traced back to 1915, when the artist, freshly returned to Vitebsk from Paris and working hard to justify his choice of career, was receiving daily encouragement from Bella.

"... morning and night, she brought sweet cakes to my studio from her house, broiled fish, boiled milk, all sorts of decorative materials, and even some boards which I used for an easel.

"I had only to open my window, and blue air, love, and flowers entered with her."

As for Chagallian fish, beasts, and birds, I am inclined to feel, in view of all that has been written about them, that it is now important to avoid burying the poor creatures in explication. So let me begin by stressing the fact that nearly all of them were really there in Vitebsk once upon a time, existing in a fashion no more symbolic than Whistler's mother or Van Gogh's sunflowers. The fish were there, in the father's warehouse and the Chagall home: "When my eldest sister, Aniouta, came back from a walk, she would go into our shop, which was on the way in, to fetch a herring, and carry it in by the tail." The little horse was out in the street, the cow was in the grandfather's small slaughterhouse at Lyozno, and the rooster was in the courtyard.

Moreover, although the exact relevance of the fact to a particular painting would be hard to demonstrate, historically Chagall is not at all unique in his visual bestiary. There was, and still is, a strong animal-art tradition in Eastern Europe and Western Asia, dating back at least to Scythian times. Jewish artists in many countries and for many centuries have depicted animals, sometimes in the spirit of folk decoration, sometimes in response to rules against representing the human face, and often in an effort to symbolize. There are Jewish animal allegories in medieval European manuscripts, and fish motifs in Tunisian Jewish decoration, that one would swear—mistakenly—the boy from Vitebsk had seen. And surely the lions in *Paradise* (pages 28-29) and *Peace* (page 98) are cousins of the heraldic lion of Judah one sees in ancient synagogue mosaics.

However, none of this quite explains the donkey in *For Vava* (page 26), the winged donkey in *Window in the Sky,* the fish in *Landscape With Blue Fish*

THE PAINTER WITH THE BLUE BOUQUET, *oil, 1964. Without taking into account the influence of the warm and color-filled French Riviera, it would be hard to imagine Chagall painting flowers like these. But the diagonal lovers and Uncle Neuch's violin are from another country.*

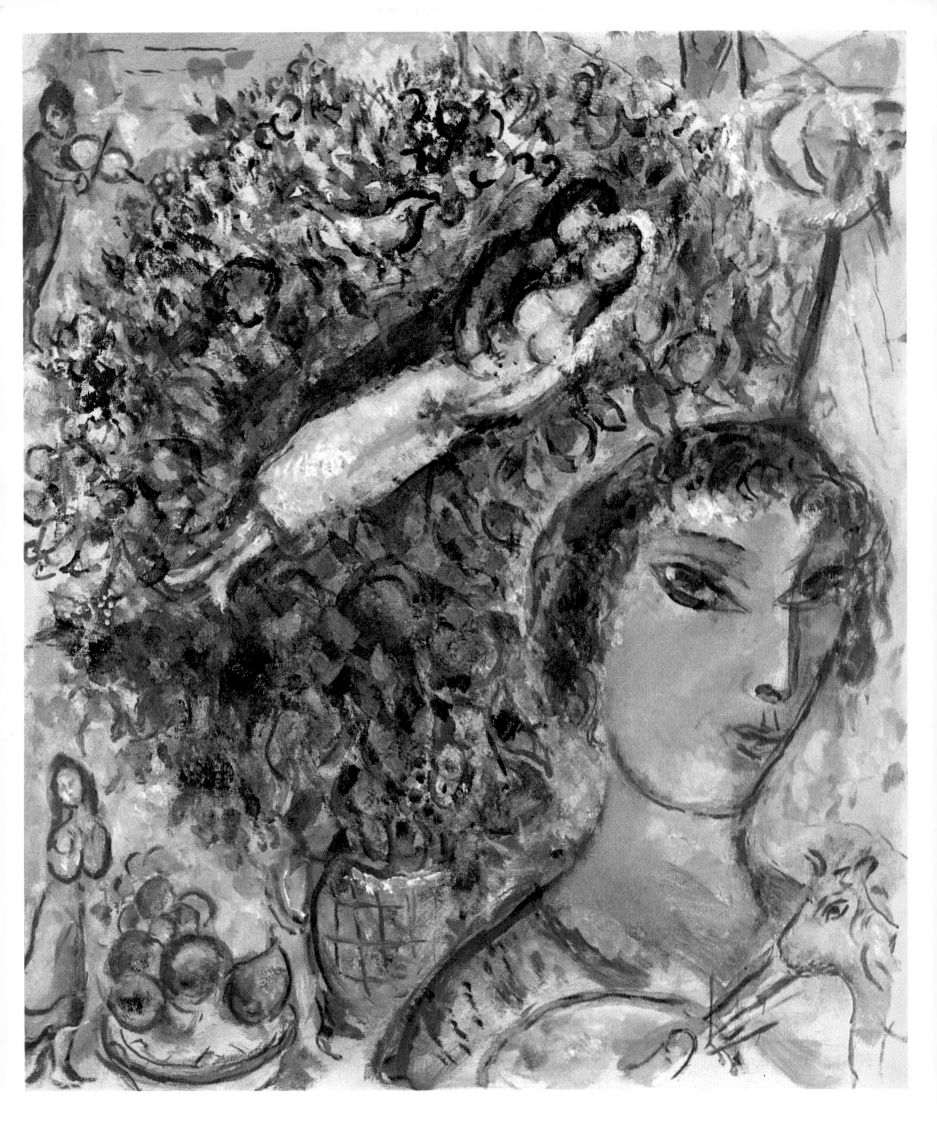

(page 90), the rooster-headed man on the ladder in *Life,* and many other creations in the same category of zoomorphism. One can interpret these pleasant monsters as allegories of animal passion triumphing over human reason, of the unconscious ruling the conscious, of a typically Chagallian refusal to separate two kinds of being, and much else. One can imagine, according to the pictorial context, that they are witch doctors, masked dancers, or the gods of a private religion. But one should avoid adopting a single interpretation for any of them.

A painting cannot be psychoanalyzed. However, modern psychological theory, if it is not used exclusively, can perhaps help toward an understanding of two special categories of Chagall's "images that obsess": his visions of women and his visions of flying.

The women can often be identified as individuals; they are Bella, Vava, the painter's mother, or his sisters. They may also play parts in the dream "condensations" of symbols and plastic representations of words I have attempted to describe. But in addition to having these and other kinds of significance, a number of them strikingly resemble, when grouped, what Jungian psychologists call an *anima* and define as an inherited collective image of woman, presumably present in every man's unconscious and ready to be projected into the outer world of actual women. Chagall's images fit the clinical description admirably: he projects the sexually exciting mistress into *Window in the Sky* (with a flying donkey that can symbolize animal passion), the bride into *For Vava,* and the mother into *Life.* There is scarcely a need to cite other examples, for the entire anima—naked Aphrodite, loyal wife, and protective Madonna—is projected as a single figure in *The Green Horse.*

The images of flying may be interpreted in most instances as evidence of a desire to surprise the viewer and hold his attention, and almost as often as plastic representations of such verbal metaphors for good spirits as "walking on air," "up in the clouds," and "flying high." But I feel obliged to add Freud's theory that the flight motif in dreams symbolizes the sexual act. Plastic representation of words is again involved, for at the lower levels of usage in many languages the term for a bird, especially a fowl, is also a term for the male organ.

While we consider this theory in the light of Chagall's pictures of flying roosters and flying lovers (*Life, Over the City,* and *Self-Portrait in Checked Jacket* are three obvious examples), it may be as well to consider also one of the artist's frequently quoted remarks: "As far as I am concerned, I have always slept perfectly well without Freud."

DONKEY WITH FLOWERS, *pastel, 1960. A comment on this sketch can be found in some remarks made in a slightly different context: "For my birthday in 1915, Bella came with a bouquet. This reality was immediately transformed in me; a chemical reaction took place. Memory and souvenirs do the same thing... I begin with an initial concrete or mental shock, something precise, and move into something more abstract."*

162

X *Stained-glass Windows*

Looking at the photograph on the opposite page, Chagall remarked: "When I climbed that ladder I was not so much interested in finishing a detail as in spying out something that might be hidden up there. For it seems to me that destiny obliges you to undertake certain kinds of work in your life, and that I *had* to make stained-glass windows. I had to get myself into daylight."

Some of the reasons for the mysterious obligation he felt can be guessed at. After World War II the creation of stained-glass windows gradually became a logical outcome for his preoccupation with colored substance and "light from behind the canvas," his fresh interest in colored etching, his experiments in pottery, and his attachment to religious subject matter—an attachment which had existed since his Hasidic childhood, but which had been strengthened by the Nazi holocaust, the death of Bella, and the long hours devoted to completing the illustrations for the Vollard Bible.

In 1952 he visited the Cathedral of Chartres, studied all the windows with growing fascination, and discovered a pleasant sign of his vocation—a green, thoroughly Chagallian donkey in one of the medieval medallions. But he had to wait for destiny to provide a building, and so five years elapsed before he completed his first commission: two relatively clear windows for the baptistery of Notre Dame de Toute Grâce, a church on France's Plateau d'Assy, for which he also provided two marble reliefs and a ceramic mural (among the other modern

Chagall at work in 1961, in the Simon atelier at Reims, on his stained glass for the synagogue of the Hadassah Medical Center in Jerusalem. The window represents the tribe of Dan and was inspired in part by Jacob's prophecy in Genesis XIIX: 16, "Dan shall judge his people, as one of the tribes of Israel." The passage is inscribed in Hebrew at the top and down the left of the composition.

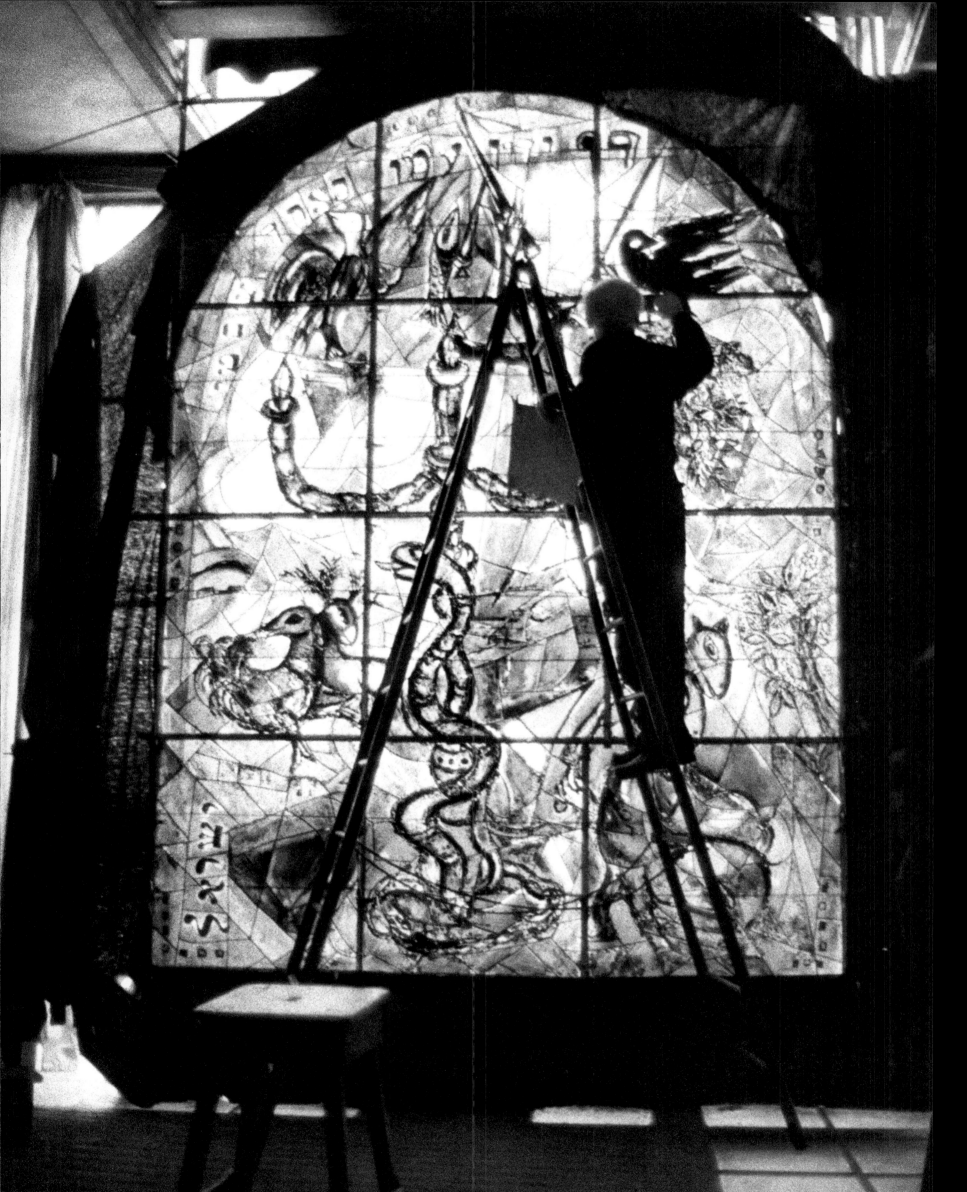

artists represented in this extraordinary museum-like building are Bonnard, Braque, Léger, Matisse, and Rouault). Since then his work in glass—in "daylight"—has been appearing at an accelerating rate on both sides of the Atlantic and, most spectacularly, in Israel. In 1960 the first of three windows for the Cathedral of Metz was installed (pages 172 and 176). In 1961 came the second Metz window (pages 174-175) and the completion of twelve for the synagogue of the Hadassah Medical Center in Jerusalem (pages 165 and 168); the latter were installed the following year, after being exhibited in Paris and New York. In 1964 the United Nations Secretariat in New York inaugurated the window entitled *Homage to Dag Hammarskjöld,* for which the monotype *Peace* (page 98) is a preliminary sketch. In 1965 came the third Metz creation, and in 1966 eight windows for the Union Church in Pocantico Hills, New York, and in 1967 a window for the village church of Tudely, in Britain. As this is being written studies are under way for replacements in parts of the Metz triforium, which lost its Gothic glass long ago.

Chagall has not, of course, done all this with his own hands; he works with Charles and Brigitte Marq, the experts who manage the internationally known Simon workshop at Rheims. But his achievement is nonetheless prodigious, and its personal nature is evident in the characteristically Chagallian solutions the windows offer for technical and iconographic problems.

His general approach to technical problems, which was developed for him by the Marqs and modified in the light of his experience as a painter, etcher, and potter, has raised objections among purists, who feel that "painting on glass" is sinful and that the only aesthetically right way to make a window is to enclose fragments of virgin "pot-metal" (the craft term for glass colored throughout its substance) in an improvised lead framework. So let me riposte immediately that similar objections can be made to the techniques displayed in some of the finest of the surviving Gothic and Renaissance windows and that we are really under no obligation to be more old-masterly in our criteria than the old masters were. Chagall does indeed, as I have already observed, tend to think and feel in all media primarily as a painter, but it does not follow that in his windows he is nothing but a painter. In fact, he is an eclectic who uses, according to his inspiration, various perfectly orthodox stained-glass techniques, all of which date back to the centuries before the traditional art had decayed into the reproducing of pictures on panes.

The details of the second window for Metz (pages 174-175) can help to make the point. But perhaps it can be made more effectively by reviewing the technical phases of the creation of the cycle for Jerusalem and noticing how traditional the methods really are—even when they resemble those of painters.

Chagall began his work on these windows by doing a series of small black and white drawings; in these he adapted his motifs to the round-arched

Romanesque format, indicated the distribution of zones of light and shade, and suggested the patterns of the leads. The drawings gave way to watercolors, then to combinations of gouache and collage, and then to the actual maquettes. After much research, samples of glass corresponding to the Chagallian spectrum were prepared at the Saint-Just-sur-Loire factory, which specializes in the manufacture by hand of colored plaques of the Gothic and Renaissance kinds. Since the glare of Israeli sunshine has an effect on color that could not be anticipated in the soft light of the Loire valley, the samples were taken to Jerusalem and tested at the site of the synagogue. The patterns for the leads were modified by the Marqs for the sake of stability and rhythm. Finally the windows, in a relatively crude first state, were mounted in the workshop at Rheims, and Chagall spent the next six months modifying and refining them.

His methods, the materials that made the methods possible, and the brilliant results he achieved can be seen in the window representing the tribe of Levi (page 168). Here he allowed the pattern of the leading to influence his imagery in much the way that his underlying abstract structures and shapes do in his painting. He turned to grisaille, a technique that dates back to the late 13th century in France, wherever he felt that the brown, black, or gray enamel would throw motifs into proper relief. For some particularly vivid touches he resorted to the technique of painting with colored enamel that was developed in the 16th century. In order to avoid the inert effect of glass that is yellow all the way through, he used for nearly the entire window a yellow stain derived from a silver solution invented in the 14th century; after the firing of the plaques it forms a thin film that varies from a pale lemon to a luminous orange on clear glass and yields a bright green on blue glass. Finally, utilizing another 16th-century invention, he added nuances of daylight to the composition by scratching the colored plaques and thinning them here and there by the application of acid. The operation was made feasible by the fact that each plaque was fused with a supporting layer of clear glass, which is detectable, of course, only from outside the synagogue.

In most of his work in stained glass Chagall has not had to worry about subject matter. At the cathedral of Metz, for example, he had only to continue his etched illustrations for the Bible in the new medium, and at the United Nations the idea of peace was inherent in the assignment. The windows for Jerusalem, however, posed a delicate problem, partly because of their location in the new state of Israel and partly because in accepting the commission from Hadassah (the American Zionist women's organization that helped to equip the medical center) he agreed to abstain from his habitual representation of human beings. How, in view of this prohibition and of the relative scarcity of Jewish religious symbols, was he to proceed?

He found inspiration in an aspect of Judaism that has no counterpart in the other great religions of the world. It appears variously as Jewish tribalism,

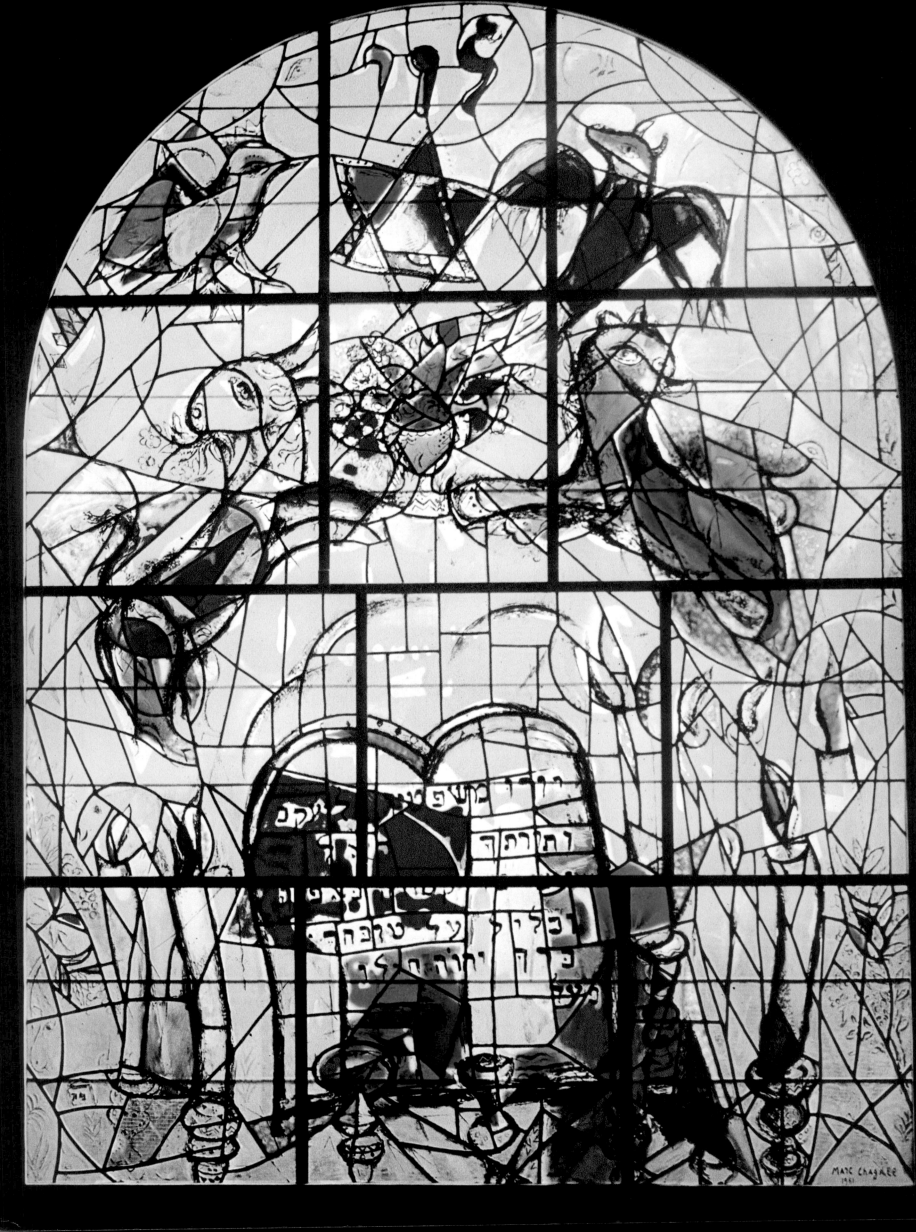

Jewish messianism, Jewish prophetism, and a kind of Jewish socialism; and it comes down to a conviction that the righteousness and justice of God are in the long run made manifest to Jews in the historical process right here on earth. This conviction—this special feeling for history—is strong even among Jews who do not regard themselves as being particularly religious, and it has given Israeli patriotism a recognizably biblical and archaeological flavor. Chagall's twelve windows symbolize it in heraldic fashion. More specifically, they are the imaginary armorial bearings of the twelve sons of Jacob—Reuben, Simeon, Levi, Judah, Zebulun, Isachar, Dan, Gad, Asher, Naphtali, Joseph, and Benjamin— who became the eponyms of the Twelve Tribes and thus the legendary point of departure for a historical process that was to lead eventually to the creation of the modern state of Israel.

Much of the imagery, which evokes at the same time a biblical personage and a biblical tribe living in its assigned part of Palestine, was suggested to Chagall by Genesis XLIX and Deuteronomy XXXIII. In the first passage Jacob, old and blind, realizes that his death is near and that the time has come to think about the continuation of the Jewish historical process: "And Jacob called unto his sons, and said, Gather yourselves together, that I may tell you that which shall befall you in the last days." The sons—and future patriarchs—are summoned in the order of birth and treated to a mixture of wild poetry, curses, prophecies, and blessings. They are compared to lions, wolves, hinds, asses, serpents, water, and fruit trees. Sometimes the old man is tender and prolix; then he becomes gnomic and cryptic. He recalls bitterly the sins committed by his sons long ago. Did not Reuben, the eldest, once lie with one of his father's concubines? Did not Simeon and Levi once make their father "stink among the inhabitants of the land" (Genesis XXXIV, 30) by mounting a murderous raid on a neighboring city? The curse follows: "I will divide them in Jacob, and scatter them in Israel." Then comes a vision of the future in the Promised Land, for the chronicler does not let us forget that the twelve sons are eponyms: "All these are the twelve tribes of Israel." But neither does he let us forget that we are witnessing an actual event: "And when Jacob had made an end of commanding his sons, he gathered up his feet into the bed, and yielded up the ghost, and was gathered unto his people."

In the passage in Deuteronomy it is Moses about to die in the land of Moab without crossing over into the Promised Land, who gives a last, prophetic blessing

The Levi window for Jerusalem is bathed in solar yellow and animated by a spiritual breeze that causes the candles to flicker and sway like Hasidic folk dancers. A tracery of blue and red flowers and transparent leaves—some of which are being eaten by one of the heraldic animals— adds a springlike note to the gamboling imagery.

to the children of Israel. And here again, although the total effect is blurred and fragmented, the poetic images are of a sort Chagall has enjoyed all his life. In the apparently feverish mind of Moses the thought of the tribes stirs visions of skies, suns, moons, ancient mountains, enduring hills, the deep sea, nomads' tents, morning dew, and bullocks with horns like the horns of unicorns. The final vision is of the future: "Israel then shall dwell in safety alone: the fountain of Jacob shall be upon a land of corn and wine...."

Chagall did not attempt to translate into stained glass all the images he found, for his intention was not to illustrate in any conventional way the biblical passages. Thus he utilized in the window representing the tribe of Dan (page 165) Jacob's prophecy in Genesis XLIX, 17: "Dan shall be a serpent by the way, an adder in the path...." But in the Levi window (page 168) he ignored the curse pronounced by Jacob on both Levi and Simeon in Genesis XLIX, 5-7, and painted into the tablets of the Law in the lower part of the composition some of the words of Moses in Deuteronomy XXXIII, 10, that refer to the fact that the Levites were dedicated to the care of the tabernacle, the sacred vessels, and the temple: "They shall teach Jacob thy judgments, and Israel thy law: they shall put incense before thee, and whole burnt sacrifice upon thine altar...." Around the tablets he placed the burning candles of a Jewish holy day, and above them the two rampant beasts and two strange birds that sometimes appear in synagogue decorations.

Four of the windows are dominated by blue, three by yellow, three by green, and two by red. Embedded in these basic colored substances are gemlike hues that recall Aaron's "breastplate of judgment," which was inlaid with brilliantly colored precious stones (Exodus XXVIII, 21) bearing "the names of the children of Israel, twelve, according to their names, like the engravings of a signet; every one with his name shall they be according to the twelve tribes."

The presence of the Shield of David, or *Magen David,* in the Levi composition is proof that Chagall did not intend the windows as evocations merely of Old Testament history, for this symbolic six-pointed star, or double triangle, did not exist in biblical times. In fact, although it was the object of speculation among the mystical cabalists in the Middle Ages, and has been used in the decoration of modern synagogues, it has no generally accepted religious significance. But it does have an immense historical significance for the world Jewish community. Since the 17th century it has been a popular symbol of Jewish solidarity in Central Europe and, since the end of the 19th century, a symbol of Zionism and Jewish nationalism. Everywhere in Nazi-occupied Europe it was the "badge of shame" the surviving Jews were forced to wear. And today, as part of the flag of the victorious new Jewish state, it is a stirring reminder of the fulfillment of the last prophecy of Moses (Deuteronomy XXXIII, 28): "Israel then shall dwell in safety alone...."

It is also a reminder of some interesting questions raised by the three windows for Metz and the 12 for Jerusalem—questions that reach beyond matters

170

of technique and iconography into what we nowadays call "commitment" in art and what our Romantic ancestors called "sincerity." Admittedly, the actual beliefs of an artist are not always relevant in a discussion of his work; what counts is his persuasiveness. But Chagall is an unusually committed artist; his paintings, prints, pottery, and sculpture are informed by a strongly personal mysticism and by private memories. How well do the mysticism and the memories consort with the official Christianity represented by a great medieval cathedral? With the official Judaism and Zionism represented by a new synagogue in Palestine? How well do the Chagallian "images that obsess" go with the fact that stained glass is a more public art than painting, for example, usually is?

With regard to Metz, the answers are comparatively easy. Chagall has never found it difficult to reconcile his personal beliefs and private imagery with the general truths of Christianity, and he simply ignores the specific doctrines that he cannot accept. "I am," he has said, "something of a Christian—in the fashion of Saint Francis of Assisi. I have an unconditional love for other beings. I give love and I demand love, like a child."

He gets along with official Judaism on much the same—essentially Hasidic—basis and also by concentrating on the Bible instead of the Talmud. His attitude toward Zionism, however, and hence toward the state of Israel, is a mixture of profound sympathy and vague worry; it cannot quite be called the attitude of a man who has reconciled his private values with a set of public ones. He has often expressed his awareness of the terrible events that justified the creation of Israel as a place of refuge for the Jews of the world. Long ago, when he began his illustrations for the Vollard Bible, he was stirred by a mere sight of the Holy Land: "Nowhere else will you see so much despair, so much joy; nowhere else can you be so desolate and so happy as you are when you see these ancient encrusted stones, and the dust of Jerusalem, of Safad, of the mountains where prophets are buried on prophets." But he is troubled by the idea of nationalism and by the wars the new nation has been forced to fight with its Arab neighbors. In the speech he gave at the Hadassah Medical Center when his windows were inaugurated he pointedly referred to "the other Semitic peoples," and added: "The more our era refuses to see the whole face of the world for the sake of looking at a very small part of its skin, the more worried I become...."

I am not suggesting that his celebration in stained glass of the historical cycle that brought the Jews back to the Promised Land is in any way insincere. But it does seem to derive its emotional force largely from its relation to the general Chagallian theme of departure and return—metamorphosed into an allusion to contemporary Israeli patriotism. To say that the imagery in the windows is just another example of the artist's dream process transferring feelings from one form to another would be to go too far. And yet the inaugural speech from which I have just quoted begins: "How did the air, how did the soil of Vitebsk, my home town... happen to merge with the air and the soil of Jerusalem?"

171

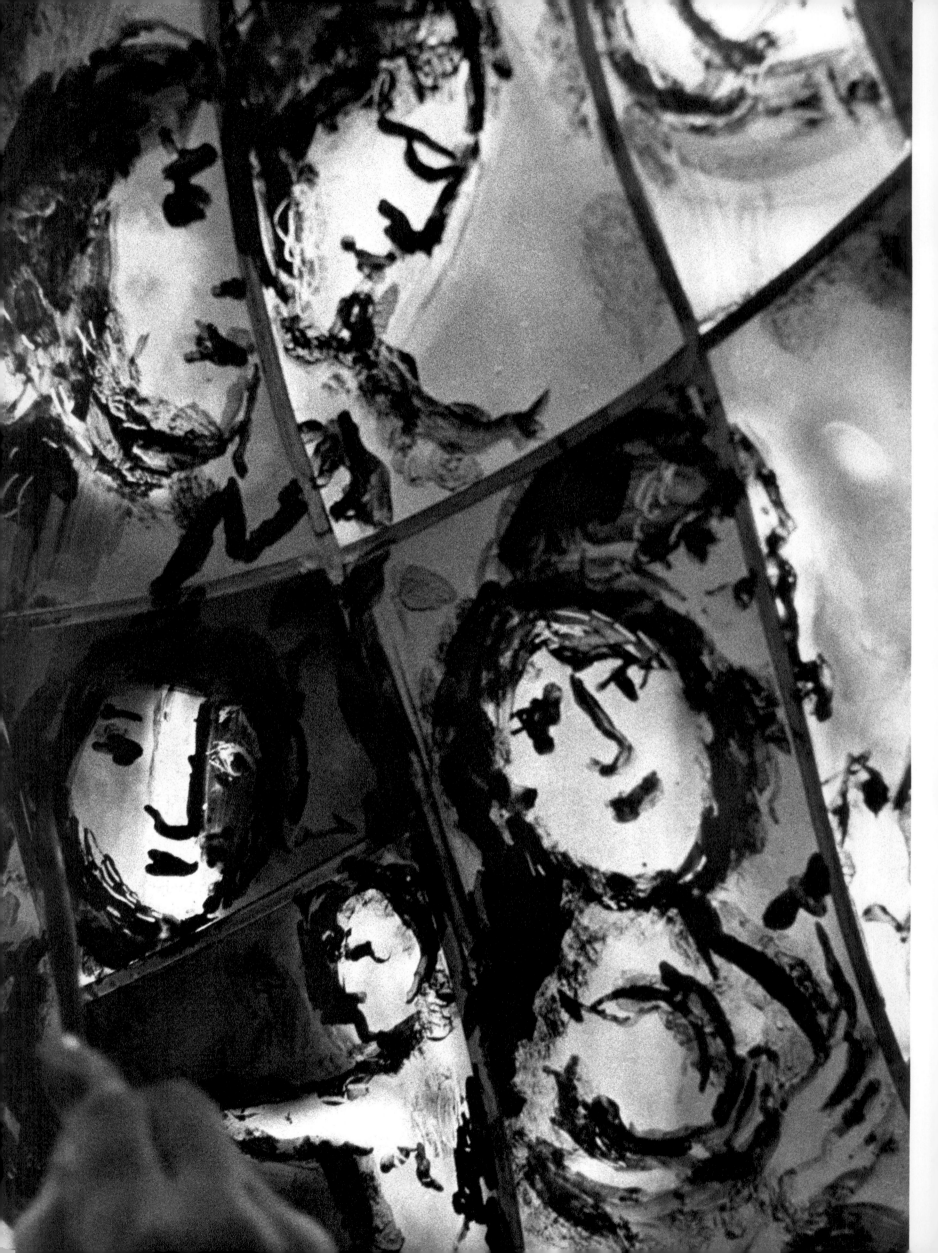

"I am a mystic. I don't go to a church or the synagogue. For me, working is praying."

Left: the worshipers of the golden calf, in a detail of the first Metz window, being retouched by the hand of the artist. Below: Chagall pauses to reflect during his work on the Metz project in the atelier at Reims. Overleaf: part of the second Metz window showing Noah and the dove.

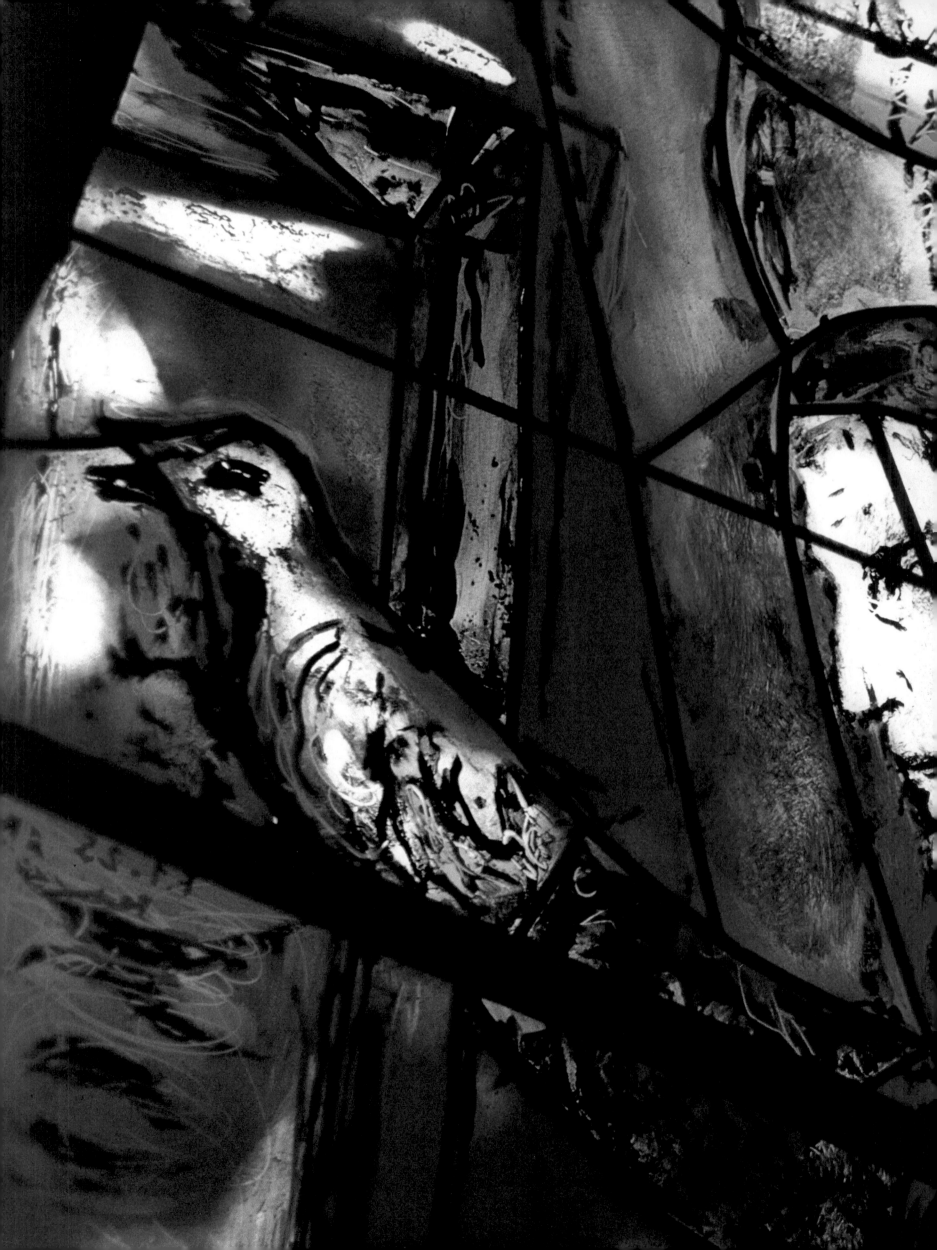

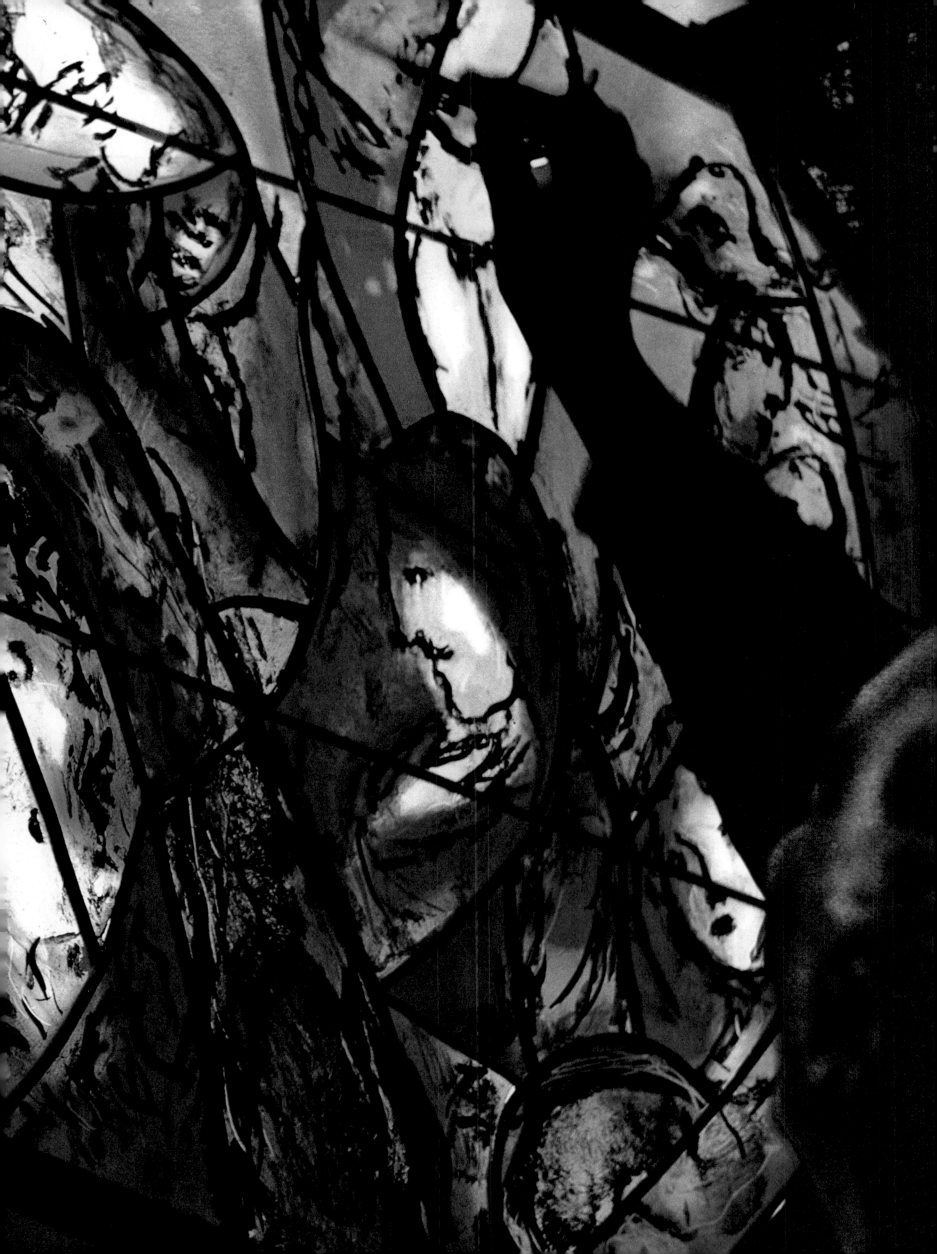

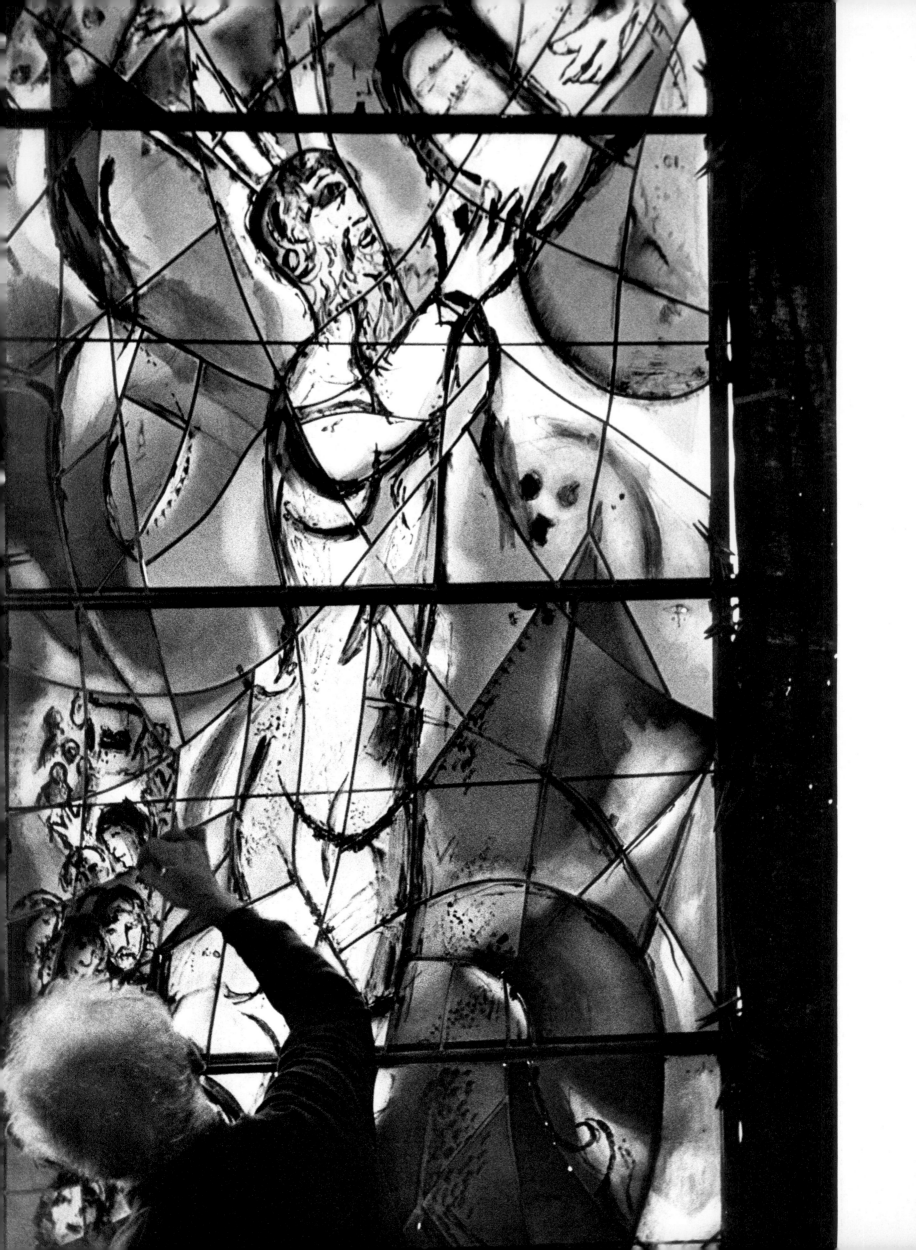

"I'm not afraid of death. But I would like to have time to do what I want to do."

Left: Chagall works on the section of the first Metz window that shows Moses receiving the Tablets. Below and overleaf: he judges the results.

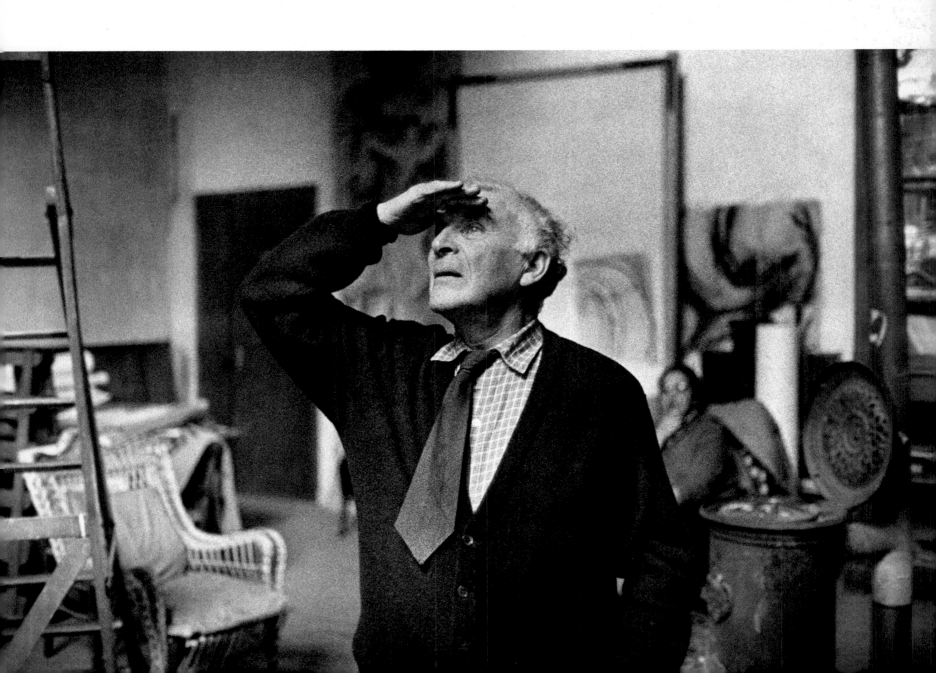

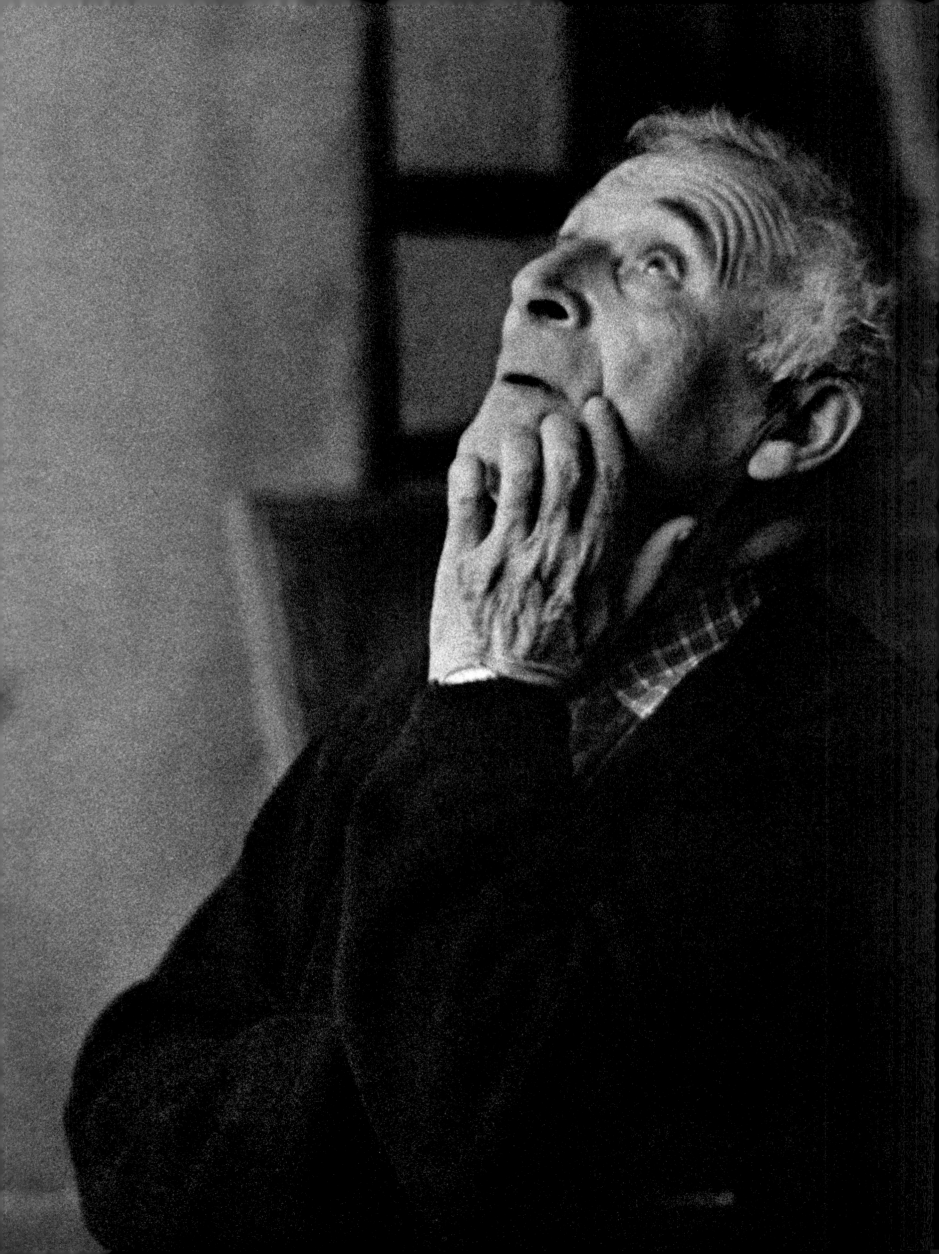

XI *Music, Ballet, Theater*

While noticing how unusual Chagall is among painters, one ought not to forget what he has in common with other kinds of artists. I have already remarked that he shares with lyric poets a fondness for the first person singular and a habit of thinking in unexplained metaphors, with architects and potters a dependence on underlying "abstract" structures and shapes, with storytellers a flair for finding the meaningful incident, and with film directors a facility for handling apparently irrational space and time. Such similarities in outlook and method are not, however, as evident, nor perhaps as significant, as those he has with certain composers, and with some ballet and theatrical creators.

"In addition," he says of himself as a boy, "to my skill at playing games with sticks and feathers, bathing, and standing on roofs during fires, I had other talents." His "sonorous soprano" produced such a gratifying effect in the synagogue that he dreamed: "I'll be a singer, a cantor, I'll go to the Conservatory." He took violin lessons in the evening from a teacher who during the day was "an ironmonger's clerk" and who cried, "Admirable!" during every performance, beating time with his foot: "And I thought: 'I'll be a violinist, I'll go to the Conservatory.'" When he visited his grandfather at Lyozno he was encouraged to dance: "I thought: 'I'll be a dancer, I'll go to...' I didn't know where." As he grew older what he calls "a sort of Russian stubbornness about painting" seized him and drove out of his dreams all other ambitions; but he continued, as a glance at almost any of his pictures will show, to think of music and the dance as arts that were somehow within his field of activity.

Chagall working in Paris in 1958 on his sets for Daphnis and Chloe. *In a comment on this photograph he has evoked his mystical, cabalistic feeling for letters: "When I get close to the ground this way and trace out letters, I feel I may discover something beneath the earth's crust—unveil and know our secret. Through how much time and distance, and through what depths of truth, does our existence project itself?"*

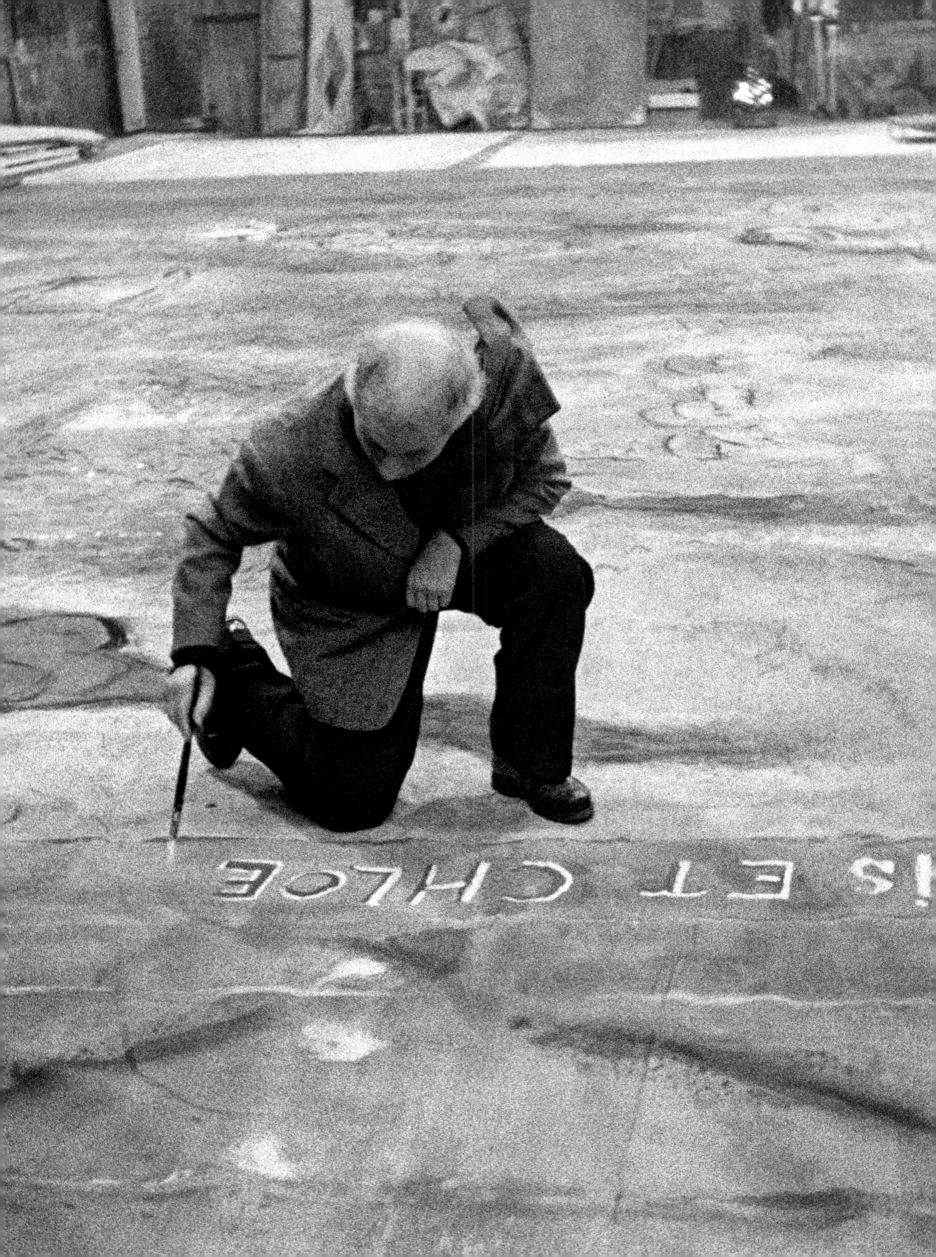

Today he spends a good deal of his time at home listening to music, and he goes to the concerts given during the summer on the Riviera. His favorite composer by far is Mozart, with Bach possibly in second place. "Although Bach," he says, "is a god, Mozart is a miracle." When working he makes a conscious effort, often with the help of a portable record player in the studio, to achieve an equivalent in paint on canvas of the Mozartian effects he admires: "the touch, the chemistry, the translucent color." But he also enjoys the music of the great Russians, and one can argue that his unconscious affinities with them have been more important than his conscious attachment to Mozart. In any event, it is easy to feel the closeness of the Chagallian world to the unashamed pathos of Tchaikovsky, the mysticism of Scriabin, the tender folk realism of Mussorgsky (especially of the songs), the "oriental" orchestral colors of Borodin and Rimsky-Korsakov, and the exotic rhythms and fantasy of Stravinsky. In the works of most of these composers, as in those of Chagall, one can catch something of the peculiar cultural climate of pre-Revolutionary Russia—a compound formed by the atmosphere of city salons and that of a rural society.

The compound is apparent also in Russian ballet, which was going through the most brilliant period in its history during the painter's years as a student in St. Petersburg and his first stay in Paris. He was fairly close to the Diaghilev circle for a time in Russia, with the scenery and costume designer Bakst as his teacher and Nijinsky as a fellow student working at the easel next to his. In 1910, hoping to accompany Bakst to France, he tried his hand—very unsuccessfully— at designing the sets for the ballet *Narcissus;* the very title of the work calls to mind the post-Symbolist and post-Art-Nouveau excitement in which were produced such Diaghilev sensations as *Les Sylphides, The Firebird, Scheherazade, Petrouchka,* and eventually *The Rite of Spring*. It would be wrong, of course, even to hint that this balletic rage had a decisive influence on the art of the young man from Vitebsk, which was already going its own way. But again some affinities are evident: the Diaghilev realm of moonlit reverie, glittering magical bird-women, Asian bacchanales, street fairs, tragic puppets, sad clowns, and spring-time sensuality, is a neighboring province in the same Russian imagination of which many of the pictures in this book are a part. And Chagall has recently reaffirmed his special Russian feeling for the dance: "I experience something unique when I listen to the music and watch the movements of a ballet. The purity and the high-altitude atmosphere can remind us of some paradise we have lost."

He also has a special feeling for the theater in general, conditioned by the Russian cultural climate in the first decades of this century, by his Jewish background, and by some early personal experience that went much further than his early experience with ballet. During the years he spent in his homeland after his first trip to Paris, the modern movement in the theater—a movement marked by a shift in emphasis from the texts of plays to the actual stage productions—was

182

gathering speed. Many directors, following the leads given by Vsevolog Meyerhold and Alexander Tairov, were reacting against the naturalism that had been practiced and taught at the Moscow Art Theater by Konstantin Stanislavski since 1898. Unrealistic scenery, sometimes in the gaunt, machinelike style of constructivist sculpture, was being experimented with, and actors were being disguised in fantastic costumes and masklike makeup. In St. Petersburg (Petrograd after 1914), and later in Moscow, Chagall joined the movement with enthusiasm, as might have been predicted from the lack of naturalism in his painting; but he joined on his own terms, as might also have been predicted. Among other projects, he designed scenery and costumes for plays by Gogol and for Synge's *The Playboy of the Western World* (page 200). He outdid the most daring among the innovators by proposing sets that defied the law of gravity and by insisting, for instance, that the actors have green faces and blue hands. For backdrops he sometimes used motifs from his most completely irrational paintings. None of these projects, unfortunately, was realized. His career as a stage designer did not actually begin until 1921, with the appearance in the Kamerny State Jewish Theater of his sets and costumes for three "miniature" plays by Sholem Aleichem: *The Agents, The Lie,* and *Mazel Tov.*

This debut was followed in 1942 by scenery and costumes for the ballet *Aleko,* produced by the Ballet Theatre during the summer in Mexico City and that fall in New York. In 1945 came the production of *The Firebird* in New York (see page 202), in 1958 *Daphnis and Chloe* at the Paris Opera, and in 1967 *The Magic Flute* at the Metropolitan Opera's new building at Lincoln Center.

On each occasion, including the first in Moscow, newspaper and magazine comment has followed much the same pattern. Nearly all the critics have agreed on the quality of the scenery and costumes as pure painting, and a few have praised the productions without qualification. The majority, however, have felt that Chagall has repeatedly displayed a lack of the humility proper in a member of a theatrical team. In Moscow it was said that he made excellent drawings and paintings but no actual sketches for scenery and costumes, and that he transformed the personages and the spectacle invented by Aleichem into straight pictorial art. In New York it was said that the backdrops and curtains for *Aleko* and *The Firebird* were not integrated with the music and the choreography, and in Paris that Claude Bessy and George Skibine, who danced the roles of Chloe and Daphnis, were dwarfed by the splendor of the painting behind them. After an evening of *The Magic Flute* at the Metropolitan one critic complained that the huge, busy, beautiful sets made it impossible to close one's eyes and just listen to Mozart's music—a disaster from the critic's point of view, since he considered the libretto of the opera intolerable nonsense. Other critics declared bluntly that Chagall had simply forced the composer off the stage and appropriated the work as his own. However, there was strong dissent on this point.

DAPHNIS AND CHLOE, *gouache and water-color sketch for a backdrop, 1958. Ravel thought of the ballet as "a vast musical fresco" infused with lyricism and punctuated by sudden dramatic effects. Here Chagall translates the long, arching phrases of the music into ebbing and flowing zones of yellow, blue, green, and mauve, punctuated by explosions of red and white flowers.*

At the top of the composition a blue fish hovers like a dirigible above an intensely blue sea that recalls the abduction of the nymph Chloe by pirates. A partly human rabbit, a satyr, and a nude waving her robe in the breeze float above a Greek temple. Silhouetted against the sky is a shepherd tending his flock.

Along the lower section, behind a bank of flowers, the mauve becomes a pool of light that dissolves the forms of the lovers. They reappear—Chloe with a large bouquet and Daphnis with a lyre—in the lower right corner. Above them a tree grows into the picture space from the right side and repeats the motif of the hovering blue fish.

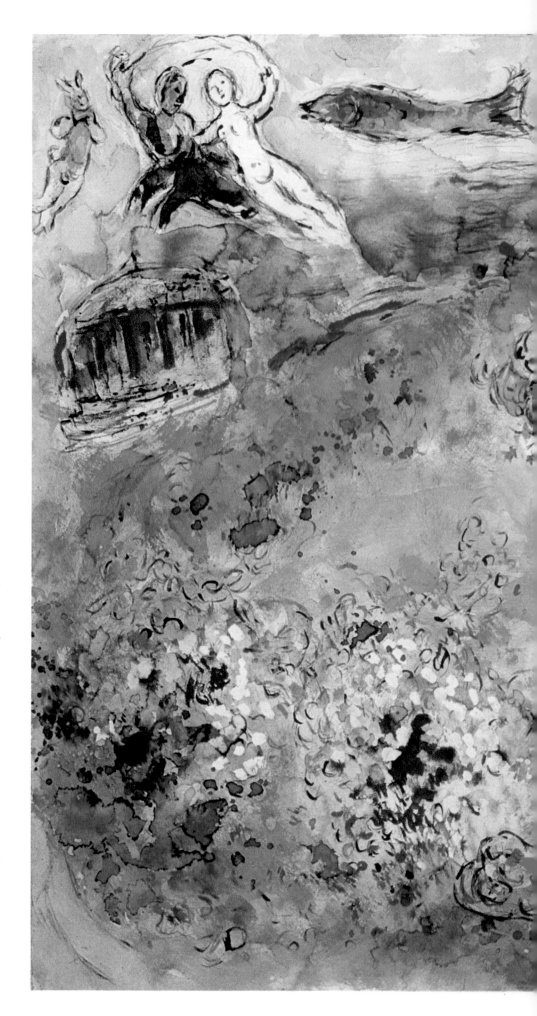

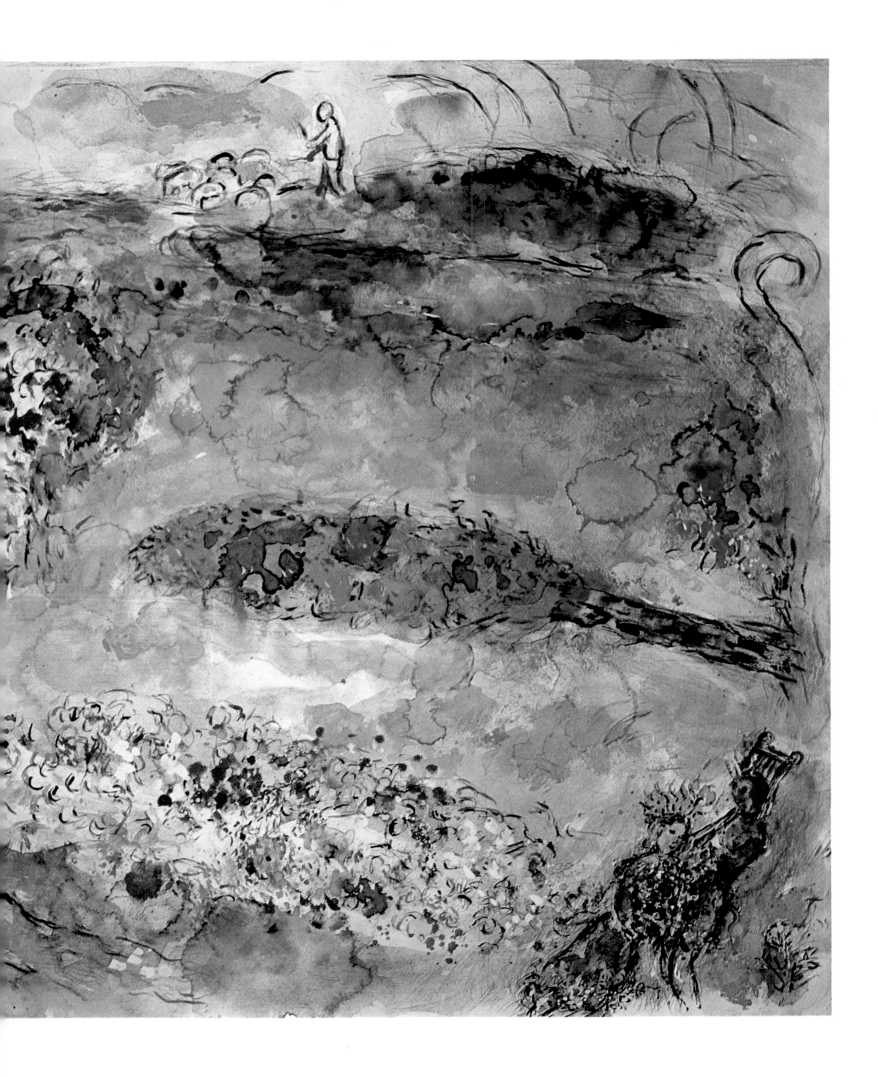

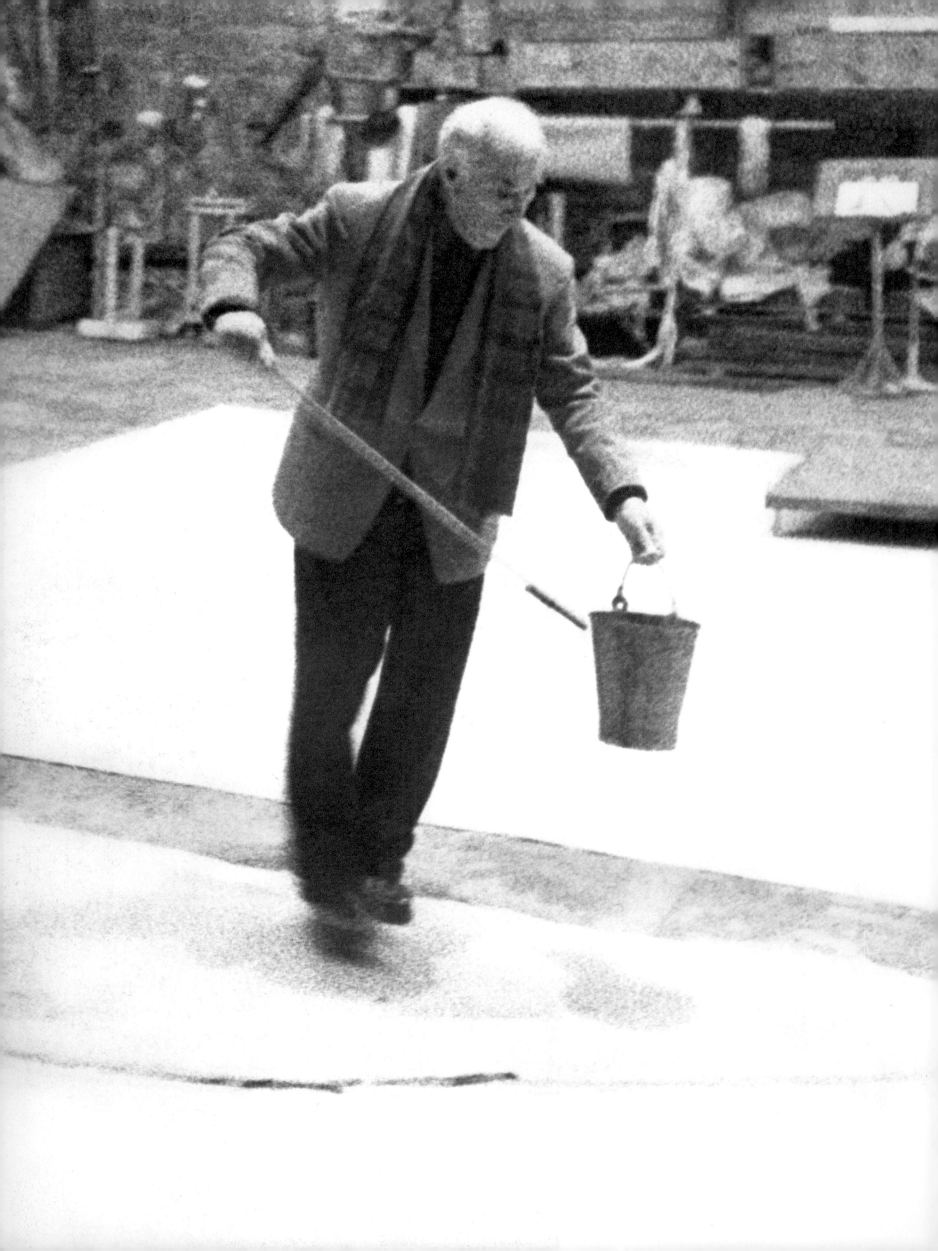

One day in 1910 Chagall stammered a question to Léon Bakst, his St. Petersburg teacher who later became one of Diaghilev's principal designers. The story is in My Life:

"'Léon Samuelevitch, could you...? You know, Léon Samuelevitch, I would like to... go to Paris.'

"'Ah! If you like. Tell me, can you paint scenery?'

"'Certainly.' (I hadn't the faintest idea.)

"'Here's a hundred francs then. Learn the job properly, and I'll take you.'"

The student failed in his demonstration, and had to find another way of getting to Paris; but he has since shown that he can indeed paint scenery, and do so with the equipment of the professionals. Here, in the workshop that serves the Paris Opera, he helps to prepare his settings for Daphnis and Chloe.

Overleaf: The artist becomes a character in the partly classical, partly romantic balletic world he is creating. ▷

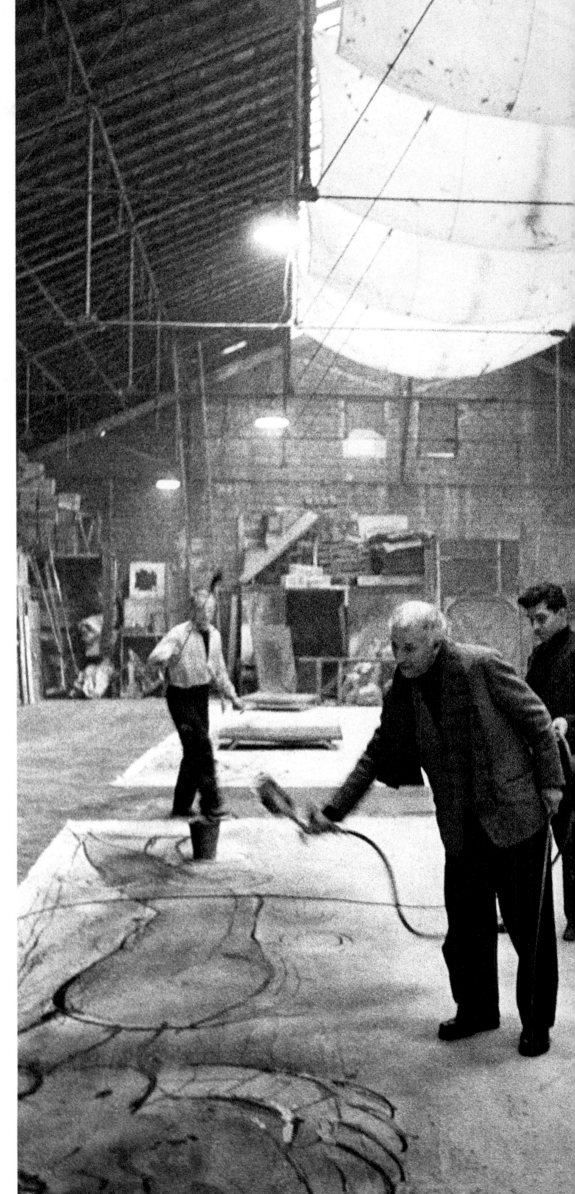

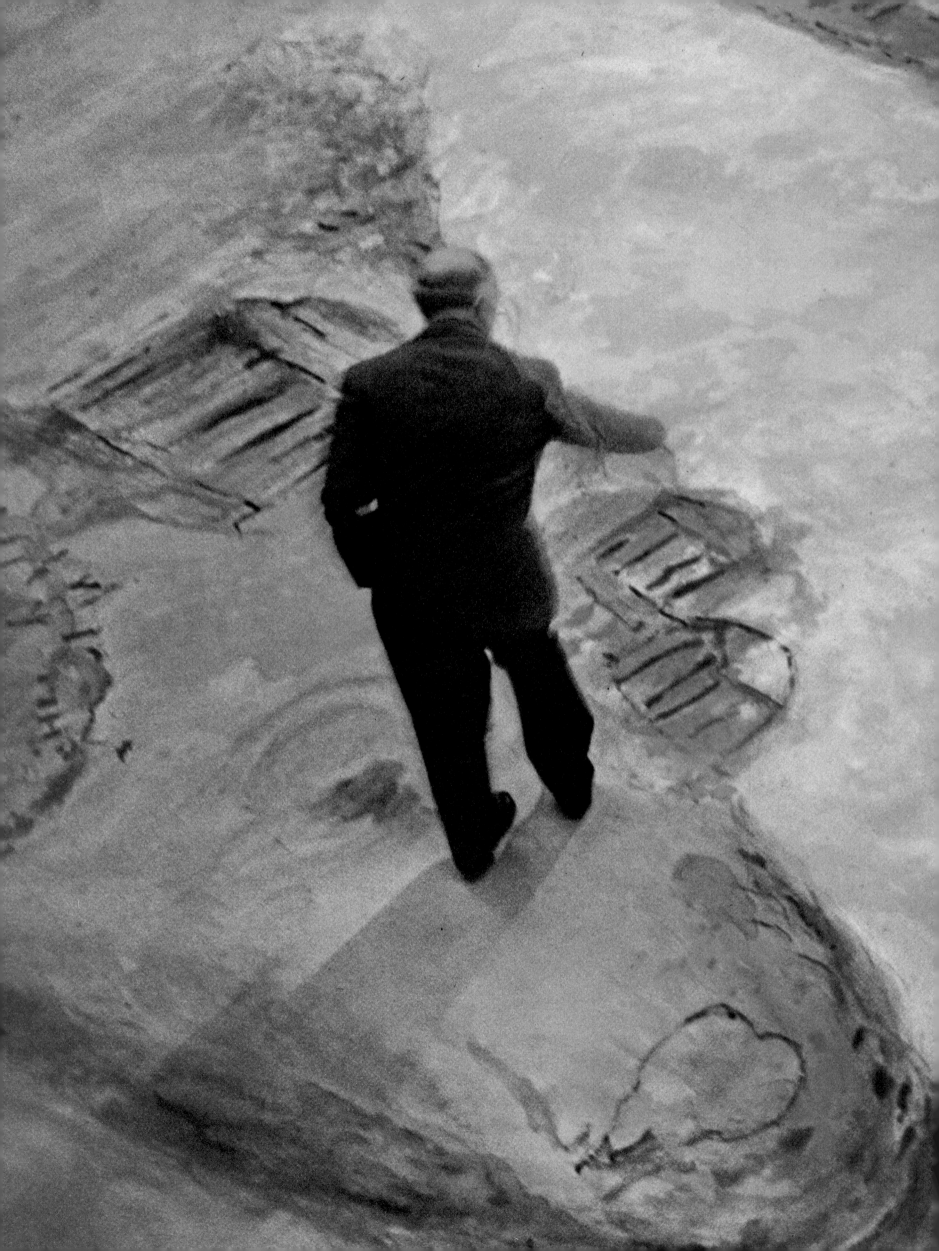

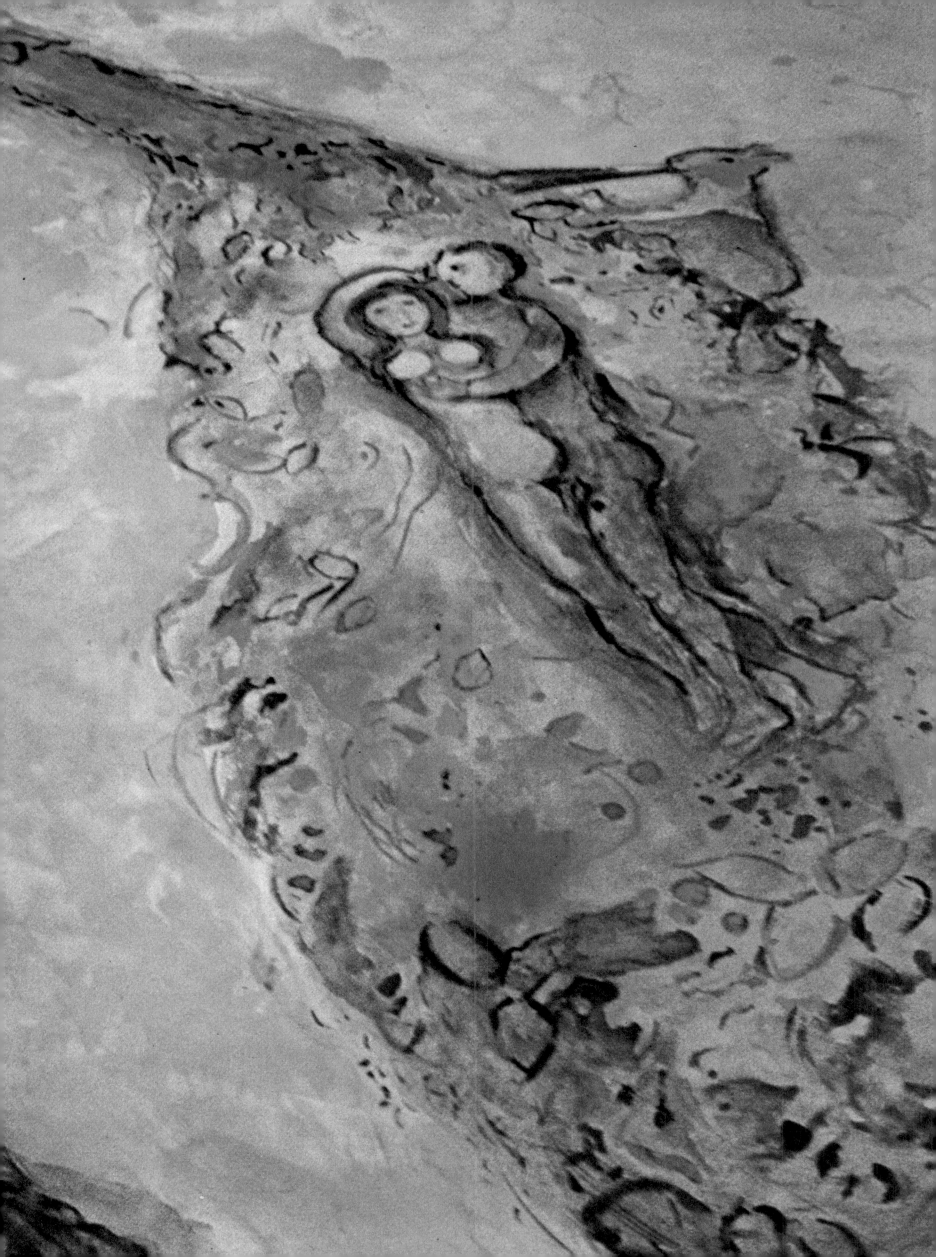

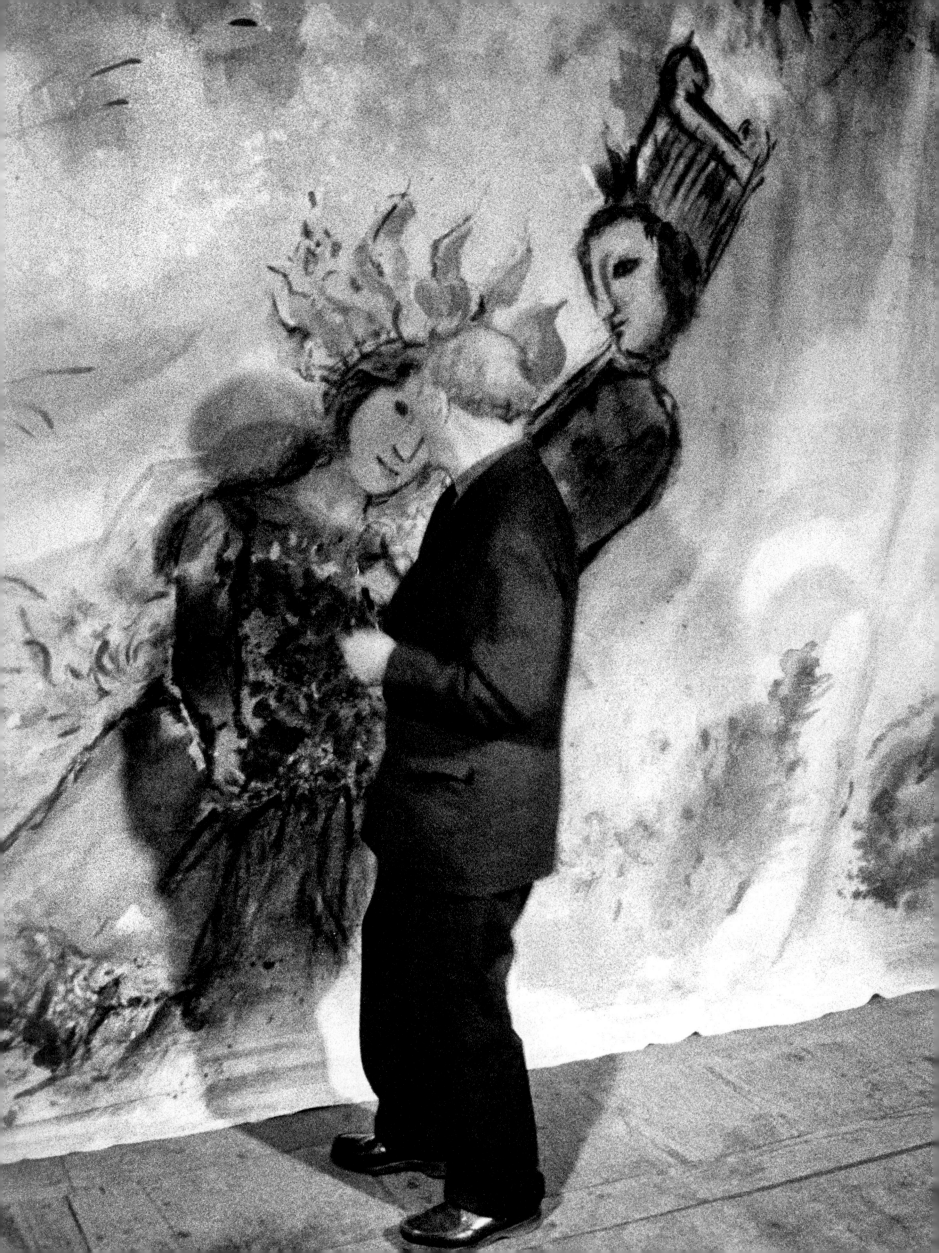

"If there were a hiding place in my pictures, I would slip into it...."

191

At the Paris Opera for a rehearsal, Chagall merges with his Daphnis and engages in a dialogue with his Chloe. The composition that was a gouache and watercolor sketch a few months earlier (pages 184–185) has become a huge backdrop without any apparent loss of its original meadow-like freshness—thanks in part to a steady and personal attention to "tissue" and "chemistry" at each stage of the process of enlargement. Now the task is to make certain that the painting, which began its existence as a reflection of Ravel's music and of the spirit of the Greek story, is integrated with the choreography and theatrical lighting.

DAPHNIS AND CHLOE, *costume sketch, 1958. The painter is willing to become a dressmaker to ensure that his conceptions do not remain merely ideas on paper. On the opposite page he improvises a detail in the costume of Chloe, with ballerina Claude Bessy (who danced the role in the Paris production of 1958) serving as his model.*

192

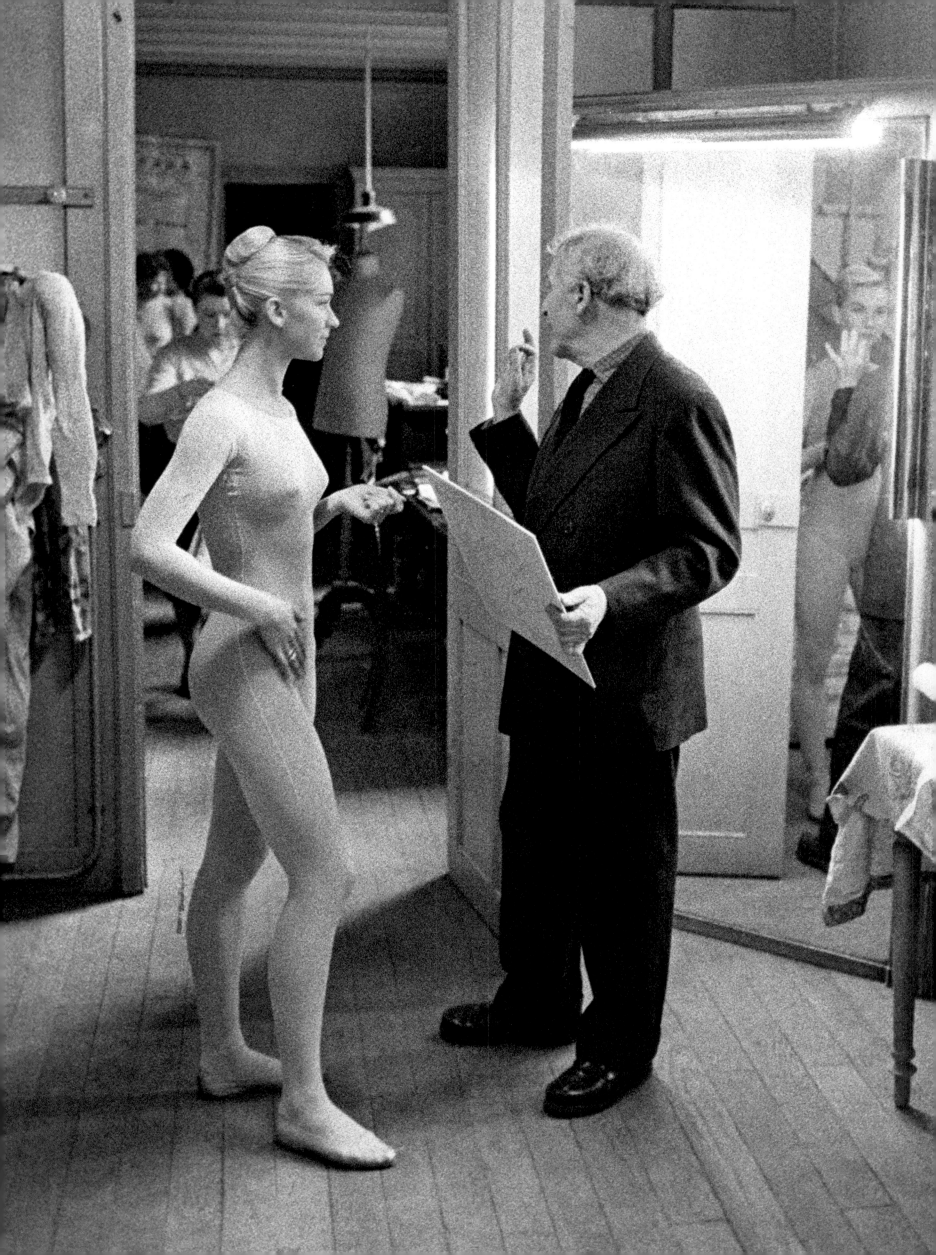

*"All that mattered to me was to solve a plastic problem:
construct an arabesque in the form of a personage—
with real means to construct another reality,
a sign of a personage.... Too bad if for 50 years
critics have sought more seductive and more limited
explanations. My reality is elsewhere."*

Dancer Claude Bessy tries on her Chloe costume at the Paris Opera, with the artist on hand to get her opinion and make adjustments. His experience as a designer for three ballets has taught him that what is satisfactory from a painter's point of view may be a disaster from the point of view of a performer who has to think in terms of freedom of body movements. A floral crown has to stay in place during acrobatics, a flowing robe has to be manageable, and a tunic has to stretch. Chagall's costume designs are very carefully worked out on paper, however, even to the point of specifying the fabrics to be used.

194

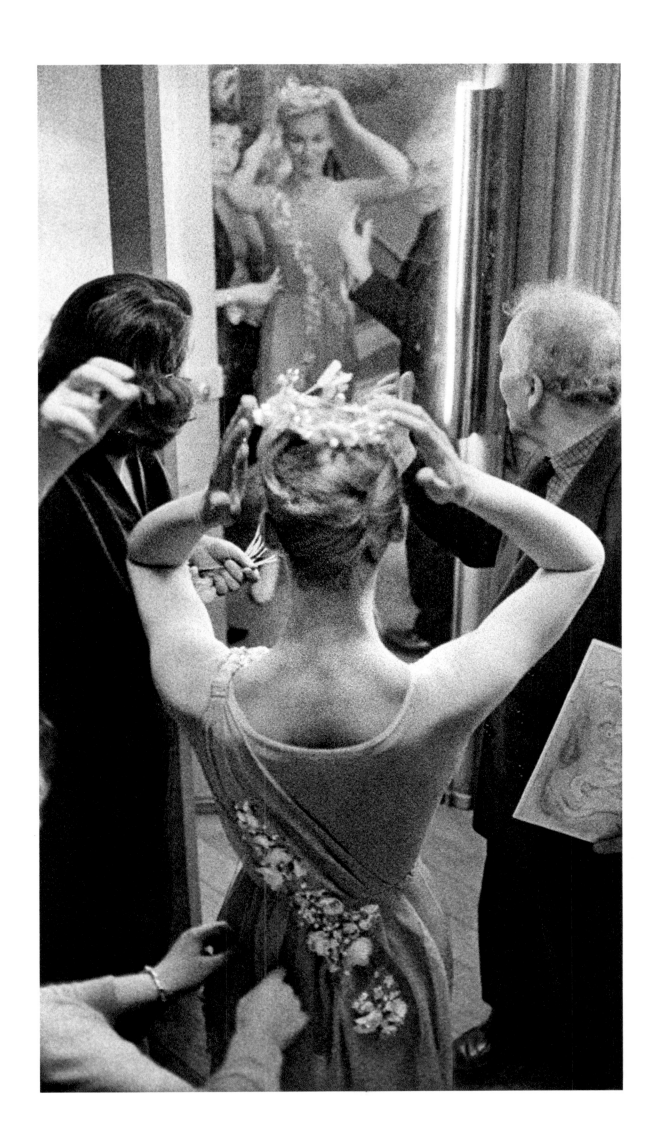

What should an admirer of Chagall say in reply to such criticism? One might try to score points at the expense of other members of theatrical teams. After all, Schikaneder, the librettist of part of *The Magic Flute* and the first man to sing the role of Papageno, did not hesitate to distract attention from the music, nor has any other Papageno whose performance has been noticed. Dancers and choreographers are notoriously willing to mutilate and turn into mere accompaniments the masterpieces of famous composers. Actors and directors often seem to feel that to ignore the intentions of a dramatist is an aesthetic duty in the modern theater. In short, what usually preserves the integrity of such multiart creations as operas, ballets, and plays is not the readiness of one kind of artist to defer to another, but simply the ability of each of the constituent arts to stand up against the attention-distracting power of the others; and it is hard to worry very seriously about the ability of the music of Mozart, Ravel, Stravinsky, and Tchaikovsky, when properly performed, to stand up against painting.

In fact, it is easy to see behind much of the criticism of Chagall's scenery and costumes some assumptions that amount to denials of the right of multiart works to exist. One can guess that what many of the objecting balletomanes really want is not fully elaborated ballet, but merely the choreography of *The Firebird* or of *Daphnis and Chloe* danced in rehearsal clothes without scenery. In any event, it is clear that what the critic with the closed eyes really wants is a record album, not *The Magic Flute* in an opera house.

However, having said this much for the defense, I feel obliged to grant that Chagall is indeed too strong an artistic personality to be completely successful as a team artist and a conventional decorator. He always has something to say on his own, and he cannot refrain from saying it with all the forces at his command—including powerful color. He clearly regards his scenery and costumes as works on the same level of importance as his easel paintings, his etchings, his stained-glass windows, his murals, and all the rest. It follows that one must go to see his stage productions in the same frame of mind that one adopts when going to any Chagall exhibition; and this, of course, is precisely what most people—those who are not professional critics—actually do.

Since the works are his in the sense of not being dependent on the inspiration of writers, composers, and choreographers, he insists when he can that they be his in the sense of being executed under his close supervision and sometimes even by his own hand: he is not the kind of decorator who stops when the sketch is finished. On the opening night of the Aleichem "miniatures" in Moscow he was so spattered with paint that he could not enter the auditorium. For the production of *Aleko* in Mexico City he painted the large backdrops himself,

At the Paris Opera the fittings for Chloe continue. By the opening night of the ballet's new production Chagall had made changes in the costumes of all the principal dancers.

196

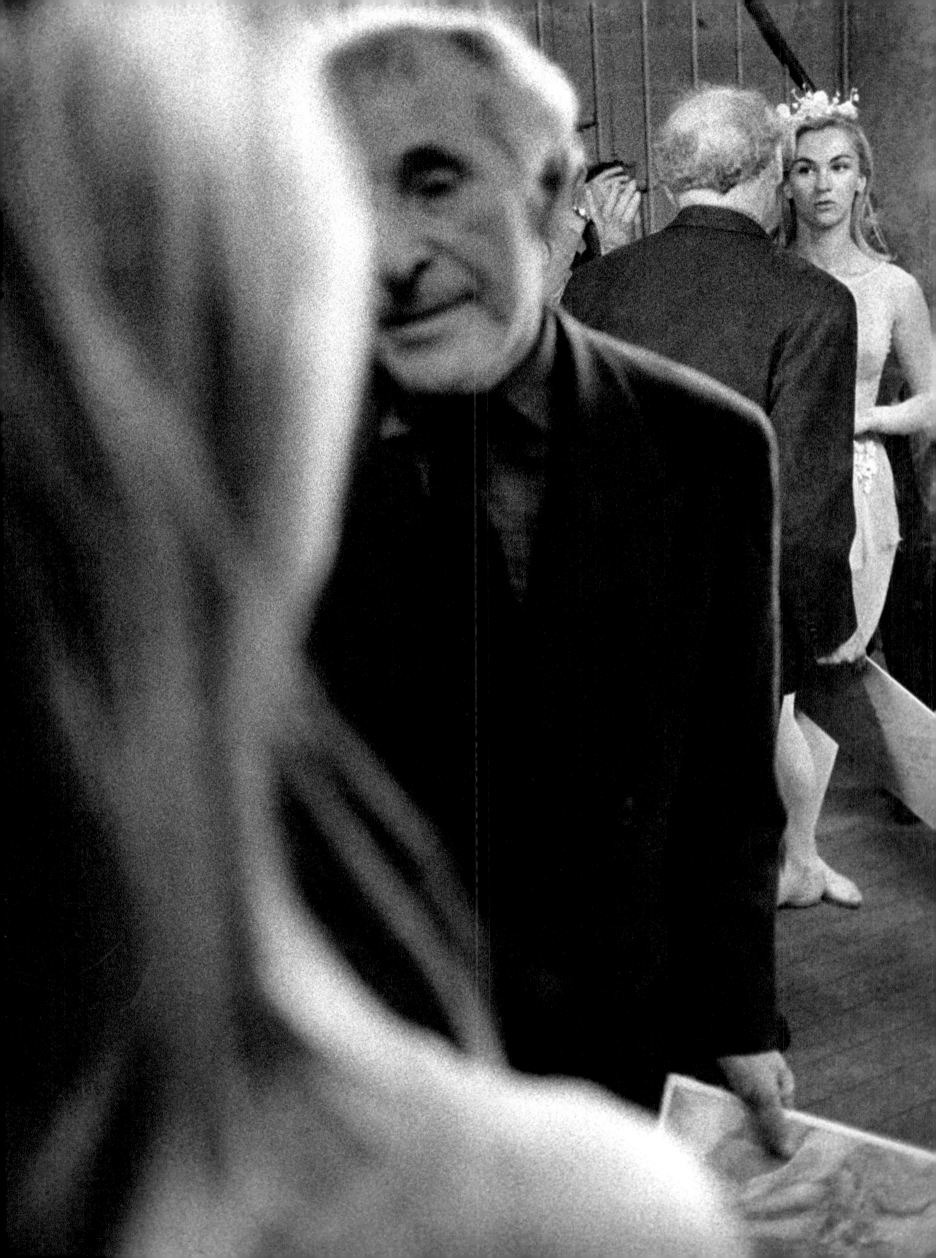

"Our whole inner world is reality, perhaps even more real than the apparent world. To call everything that seems to be illogical a fantasy or a fairy tale is to admit that one does not understand nature."

THE SOURCES OF MUSIC, *detail, oil, 1966. This celestial instrumentalist, a member of the chamber orchestra that appears on the right side of one of the Lincoln Center murals (see page 242), is a manifestation of Chagall's preoccupation with the music of* The Magic Flute.

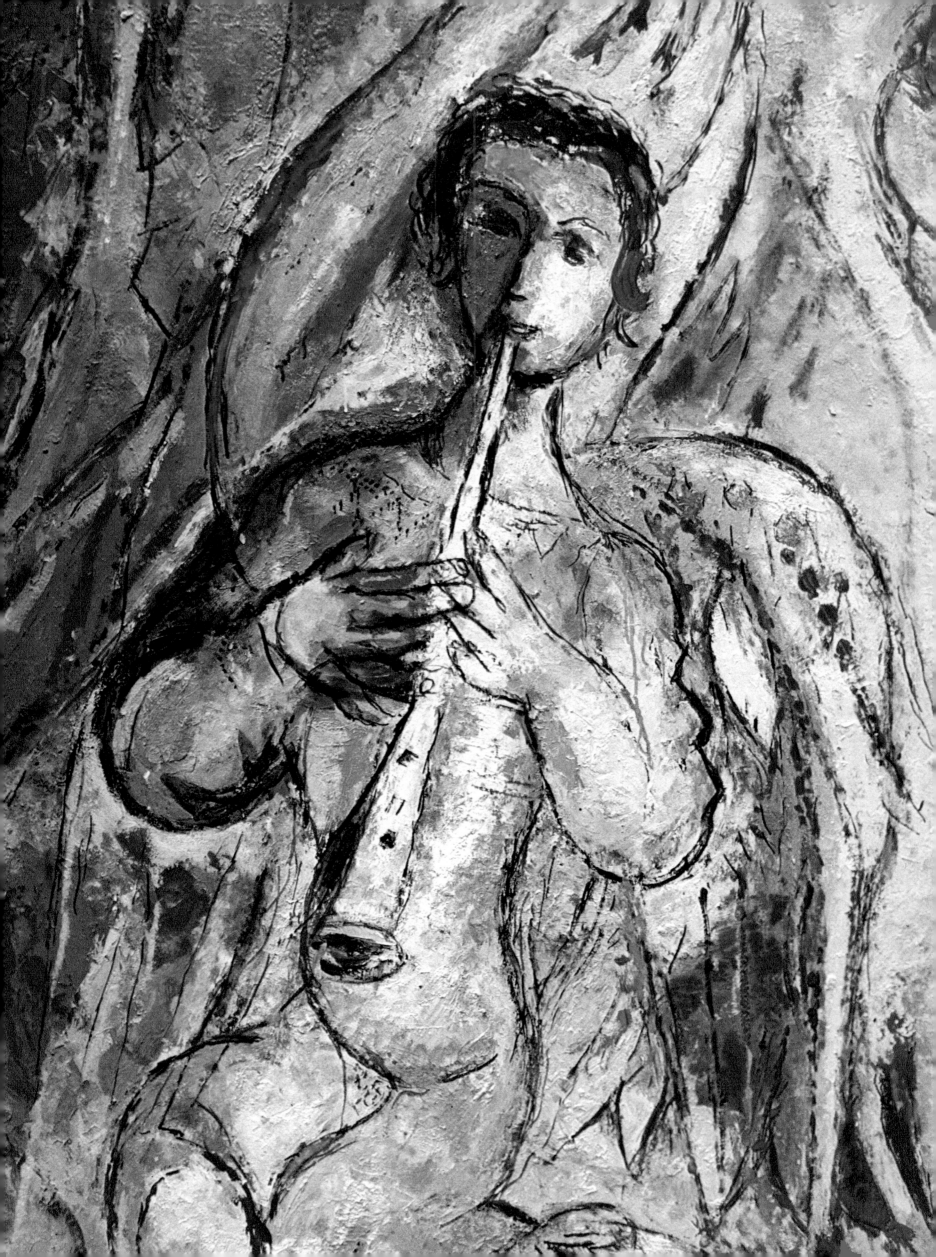

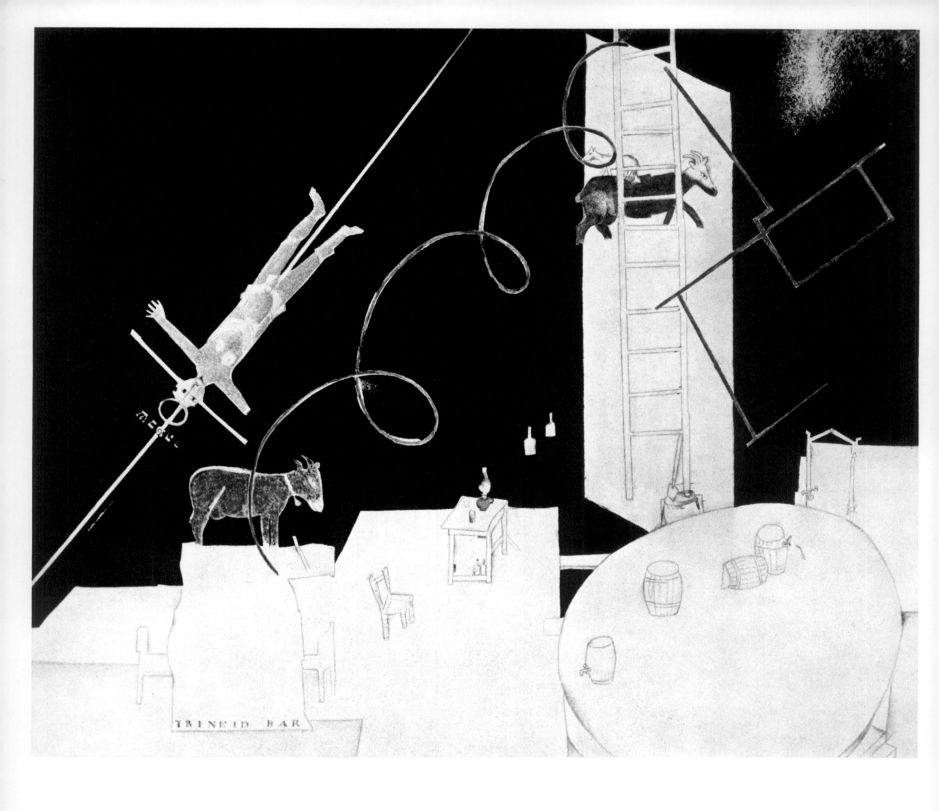

Sketch for a stage set of Synge's The Playboy of the Western World,
*pencil and gouache, 1920. Those who think of Chagall as a gentle dreamer
of village love affairs and a spinner of fairy tales may be confounded by
this fiercely unsentimental project, which was rejected by a director of
Stanislavsky's theater in Moscow because of its lack of naturalism. In a
Bauhaus geometrical world of steel wires and white slabs against a black
sky, a mutilated puppet figure of Christ is impaled head down on a cable.
The only recognizably Chagallian elements are the ladder and the
livestock, and the latter are strangely disinclined to fly.*

200

while Bella looked after the making of the costumes, which he refused to accept unless they were handpainted and therefore part of the total painting. For *The Firebird* he again did the backdrops himself, and also the curtain (page 202). For the Paris production of *Daphnis and Chloe* he worked as part of the crew in the atelier that serves the opera house, and was on hand for the costume-fitting sessions with the dancers. He found it impossible to stay as close as that to the New York preparations for *The Magic Flute,* but he stayed as close as he could. Vladimir Odinokov, the chief scenic artist at the Metropolitan, spent a week with him at the Vence studio, learning the correct brushwork and studying the color in the sketches before enlarging them with the help of the regular staff at the opera house. Then, long before the dress rehearsal, Chagall came to the United States to participate, brush in hand, in the final preparations.

But to grant that the scenery and costumes for these productions are Chagall works on the same level of importance as other Chagall works is not to assert that they are unrelated to the dramas, the music, and the choreography they accompany. They simply have a relationship that is unlike the conventional relationship of interpretative decoration to what is interpreted and decorated. They are parallel, rather than dependent, works of art—works in which the painter expresses what he has in common with other artists without deferring to them. The proof of this is that he has never chosen to do the decors for a theatrical piece with which he was not already in a relationship of affinity.

Thus long before he was commissioned to design the sets and costumes for the plays at the Kamerny State Jewish Theater in Moscow he had seen the works of Aleichem performed in Vitebsk and had felt that they were being wrongly treated as ordinary farces. He wanted to see the sly Yiddish humor in them brought out in a poetic—Chagallian, that is—and nonnaturalistic style. In order to carry out his wish he was willing to become not only the painter of the decors, but practically the director of the pieces. He coached the actors himself, and on the opening night he came close to provoking a crisis when he discovered Alexis Granovsky, the manager of the theater, in the act of hanging up a real duster in the unrealistic set. The passage in *My Life* rings with an Aleichem-like immediacy:

> "I sigh and shout:
> "'A real duster?'
> "'Who's stage manager here, you or me?' retorts Granovsky.
> "My poor heart!
> "Papa, Mama!'"

In his work on *Aleko* he had at the start the advantage of a triple sympathy—with choreographer Leonide Massine; with Tchaikovsky, whose *Trio in A Minor* provided the music; and with Pushkin, whose poem *Gypsies* provided the story of the young man from the city who joins a Gypsy tribe, falls in love with a

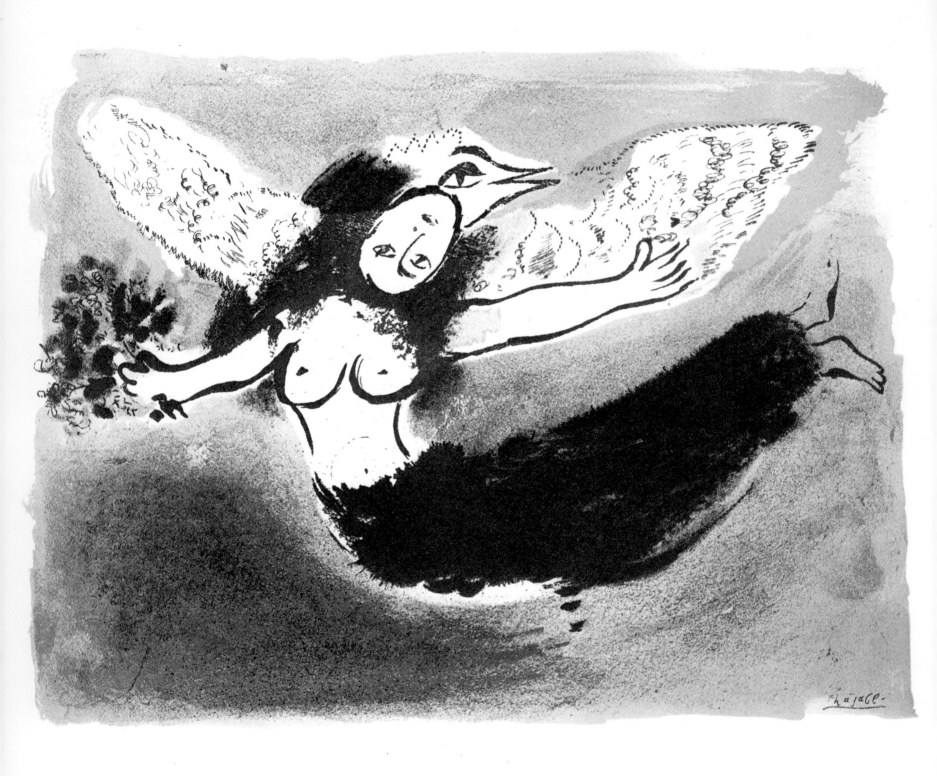

Sketch for the curtain for Stravinsky's ballet The Firebird, *pen drawing and watercolor, 1945. The magical being, part royal fowl and part naked woman with an inverted head, flies through the stormy night in the form of a crescent. The scenery and costumes designed by Chagall were used in the 1945 production by Ballet Theatre in New York, with choreography by Adolph Bolm, and again four years later in the production by the New York City Ballet, with new choreography by George Balanchine.*

202

Gypsy girl, and kills her when she proves unfaithful. In this instance the painter was also collaborating with himself, for he and Massine worked out the book of the ballet together.

The marvelous *Firebird* of Stravinsky and choreographer Michel Fokine was first produced in Paris by Diaghilev's Ballets Russes in the summer of 1910; it was thus part of the same Russian cultural invasion that brought Chagall himself to the French capital. And one can easily imagine that the principal elements in the ballet—a shining, soaring, apparently weightless human bird, a golden light that comes and goes, a collection of monsters rendered harmless by love and magic, a Russian round dance, a Russian marriage, and a mysterious Russian forest—were also part of the baggage of dreams that the young Russian painter carried with him. At least he had no difficulty in finding Chagallian equivalents for them 35 years later, when he was asked to design the scenery and costumes for the new production in New York.

His relationship to *Daphnis and Chloe* and some of its creators was already ancient, complex, and intimate when he began work on the production of 1958. His former teacher Bakst had been the creator of the scenery and costumes for the original version, performed by the Diaghilev company in Paris in 1912 with Nijinsky in the role of Daphnis. For the new production at the Paris Opera the choreographer—and the Daphnis—was George Skibine, who had danced the title role in Chagall's *Aleko* in Mexico City and New York. But more important than these connections was the fact that the painter was thoroughly familiar with the spirit and the setting of the story behind the story told in the music of Ravel and in the choreography; he was thus in an excellent position for creating in his scenery and costumes what I have called a parallel work of art. Six years previously he had been commissioned by the publisher Tériade to do a series of color lithographs illustrating the *Daphnis and Chloe* of Longus; he had been delighted with the tale, which within the limits of the Greek pastoral convention of the second and third centuries analyzes the simple, mutual passion of two abandoned children who are raised by a shepherd, are protected by nymphs and the god Pan, and finally marry after being cruelly separated for a time because of the abduction of the maiden by a pirate. The work on the preliminary sketches and gouaches for the series had involved him in trips to Athens, Delphi, Olympia, Nauplia, and Poros; in the course of these, he had fallen in love with the Greek landscape, archaic sculpture, the Greek sea, and especially Greek light. Out of this experience he designed decors for the ballet that are neither quite the classical Greece envisaged by Bakst in 1912 nor quite the French 18th-century Greece avowedly envisaged by Ravel; they are perhaps best described as the Greece of a romantic colorist dreaming of what was dreamed during the last phase of pagan antiquity (see page 184).

To appreciate fully the importance of the New York production of *The Magic Flute* in the career of Chagall one ought to bear in mind that it is one

of a series of monumental works, having been immediately preceded by the Lincoln Center murals, the Paris Opera ceiling (these two undertakings will be discussed in the next two chapters), and the stained-glass windows for Metz and Jerusalem. One ought to bear in mind also that the painter is a fervent admirer of the *Jupiter Symphony*. In other words, there is good reason to suppose that the Mozartian chromatic "chemistry" he wished to parallel visually on the stage was not so much that of the graceful little Wolfgang Amadeus as that of the profoundly ethical composer who was in many ways the predecessor of Beethoven. On this assumption the extraordinarily powerful color of the scenery and costumes can be related to the second, or Masonic, part of the opera; it is the Chagallian equivalent of the humanitarian ideas and bass voice of Sarastro, who announces at the end that the kingdom of error is yielding the day to truth. It is the moral climax to the painter's series of big public manifestations.

But to say this and then say no more would be to forget that Chagall is a happy sensualist who enjoys Mozart's music simply because of its sound, and who has shown in several ways in recent years that he associates *The Magic Flute* with fairly specific erotic reverie. He is also a painter who enjoys precisely the sort of comic extravaganza that more than half of the opera really is. He has a large set of equivalents in his own work for Papageno the bird-catcher, for the three Genii in their flying boat, for the animals that are entranced by the sound of Tamino's flute, and for the lovely daughter of the Queen of Night. In fact, he has his affinities with Schikaneder as well as with Mozart. The only surprising fact about his staging of *The Magic Flute* is that he should have had to wait until he was almost 80 for the opportunity.

The costume of Papageno in the Metropolitan Opera production of The Magic Flute, *watercolor sketch with fabric collage, 1965. With a cage on his back and a Panpipe in his hand for attracting his prey, the bird-catcher is fully equipped for his profession; from his tail and posture one might guess that he is about to be metamorphosed into a bird himself.*

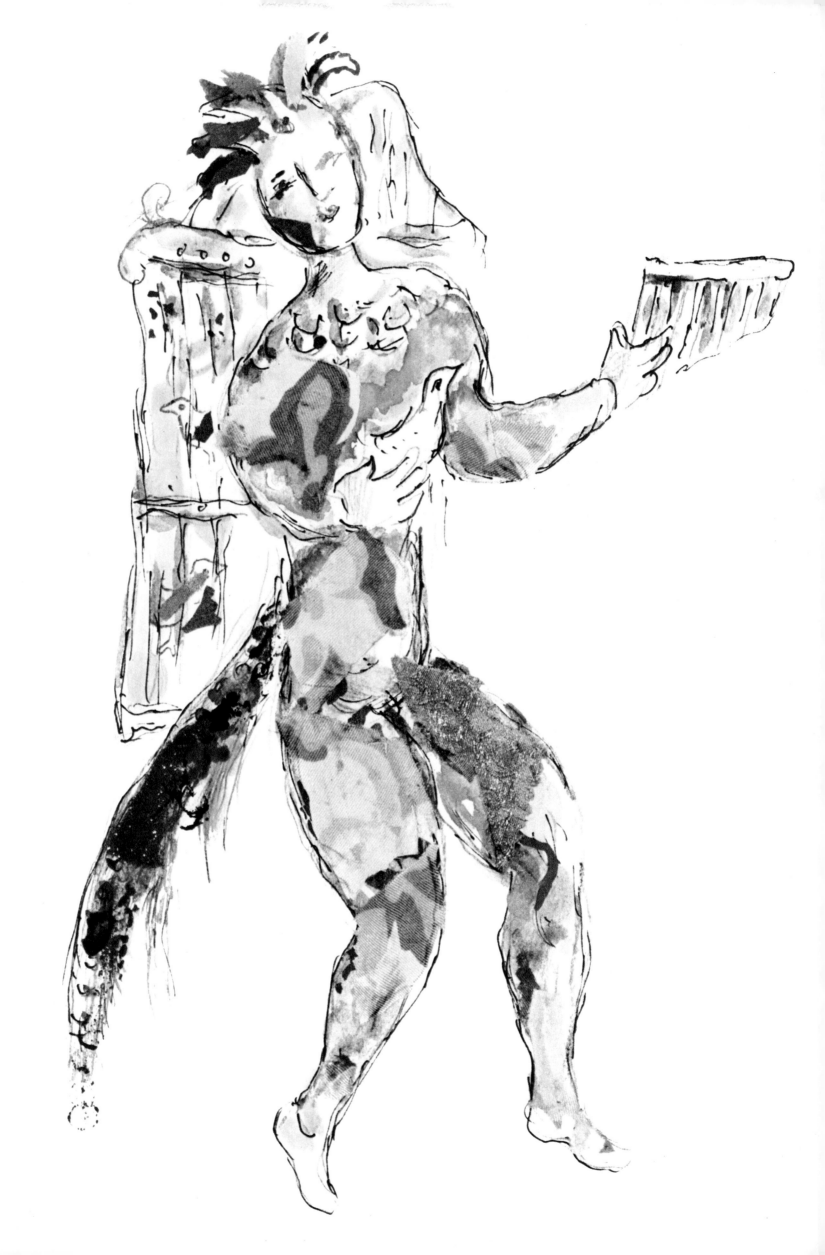

XII *The Paris Opera Ceiling*

Chagall has represented himself as a dreamer, lover, mystic, and clown often enough to obscure his record as a person with a taste for dangerous, paradoxical, and even scandalous projects. The stammering schoolboy did, after all, become a painter in a conservative Jewish ghetto and then make his way to St. Petersburg and Paris. The timid lover from the wrong side of town did marry the beautiful daughter of the local jeweler. The impractical non-Marxist became a Soviet commissar, and the Left-Bank Bohemian the director of the Vitebsk Academy. The Yiddish humorist and Russian expressionist invited the fury of French traditionalists by illustrating the classical *Fables* of La Fontaine. The anguished Jew reacted to the menace of Hitler by producing a series of crucifixions. More recently, the born painter has risked becoming a potter, sculptor, and eclectic artisan; the Hasidic mystic has adapted his vision of God to the iconography and architecture of a Roman Catholic cathedral; and the internationalist has celebrated in stained glass and tapestry the success of the national state of Israel.

Few of these exploits, however, required quite as much coolness under fire as the creation of the new ceiling for the Paris Opera, for at the start of this project Chagall seemed to have against him nearly everybody in the French art world except his friend André Malraux, who as Minister for Cultural Affairs commissioned the work. Although nobody was warm in defense of the old ceiling, which was a pale allegory executed in 1870 by the academic Jules-Eugène Lenepveu, the majority of critics felt that at least it had the negative virtue of not clashing with the Second Empire neo-baroque style of the rest of the building.

At the Gobelins atelier in Paris in 1964, Chagall works on the section of his ceiling that depicts the opera house itself, with the sculptured Dance of Carpeaux *in the foreground. Overleaf: In the studio at Vence in 1963, the whole composition emerges in its initial form as a nearly abstract "bouquet" of contrasting colors.*

206

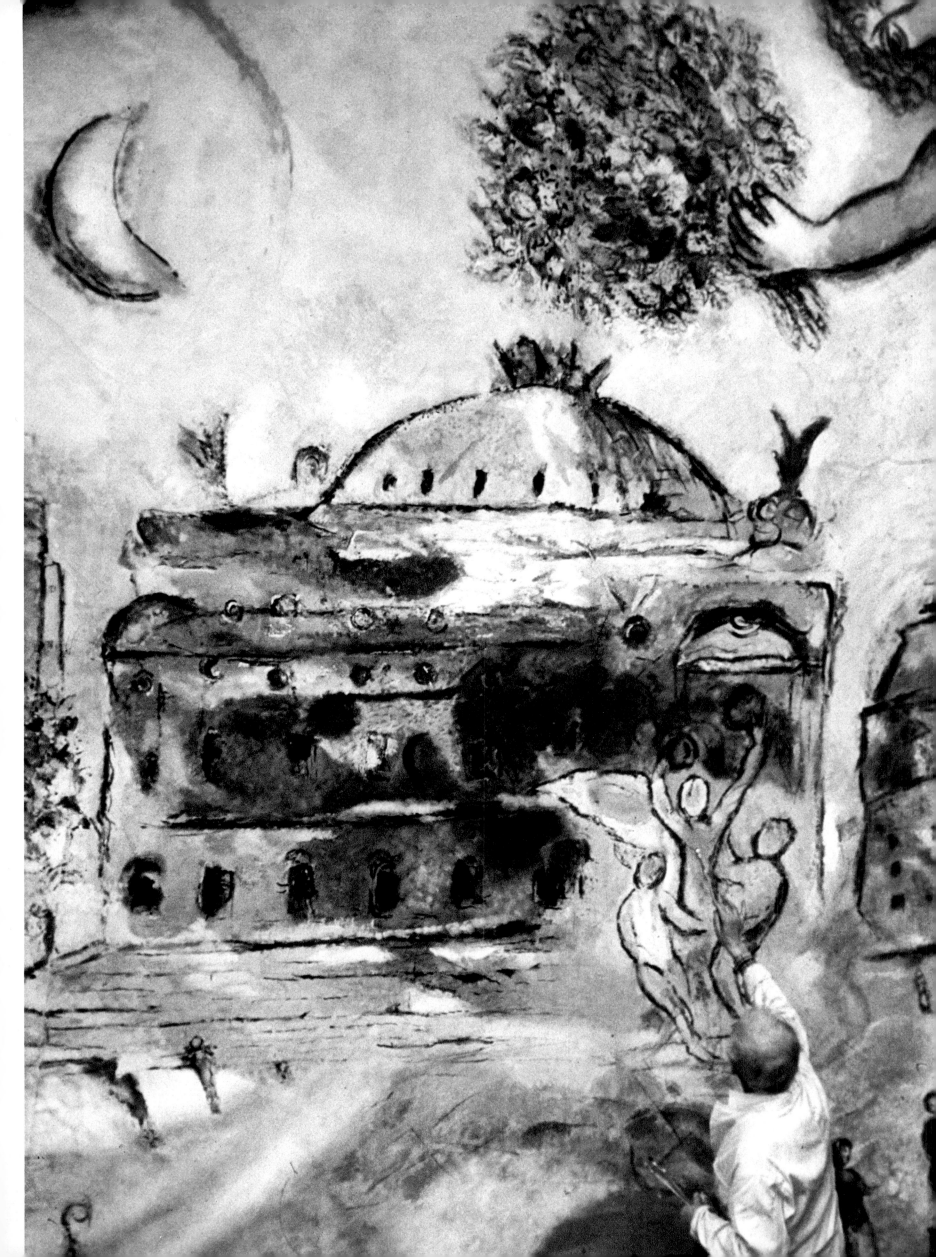

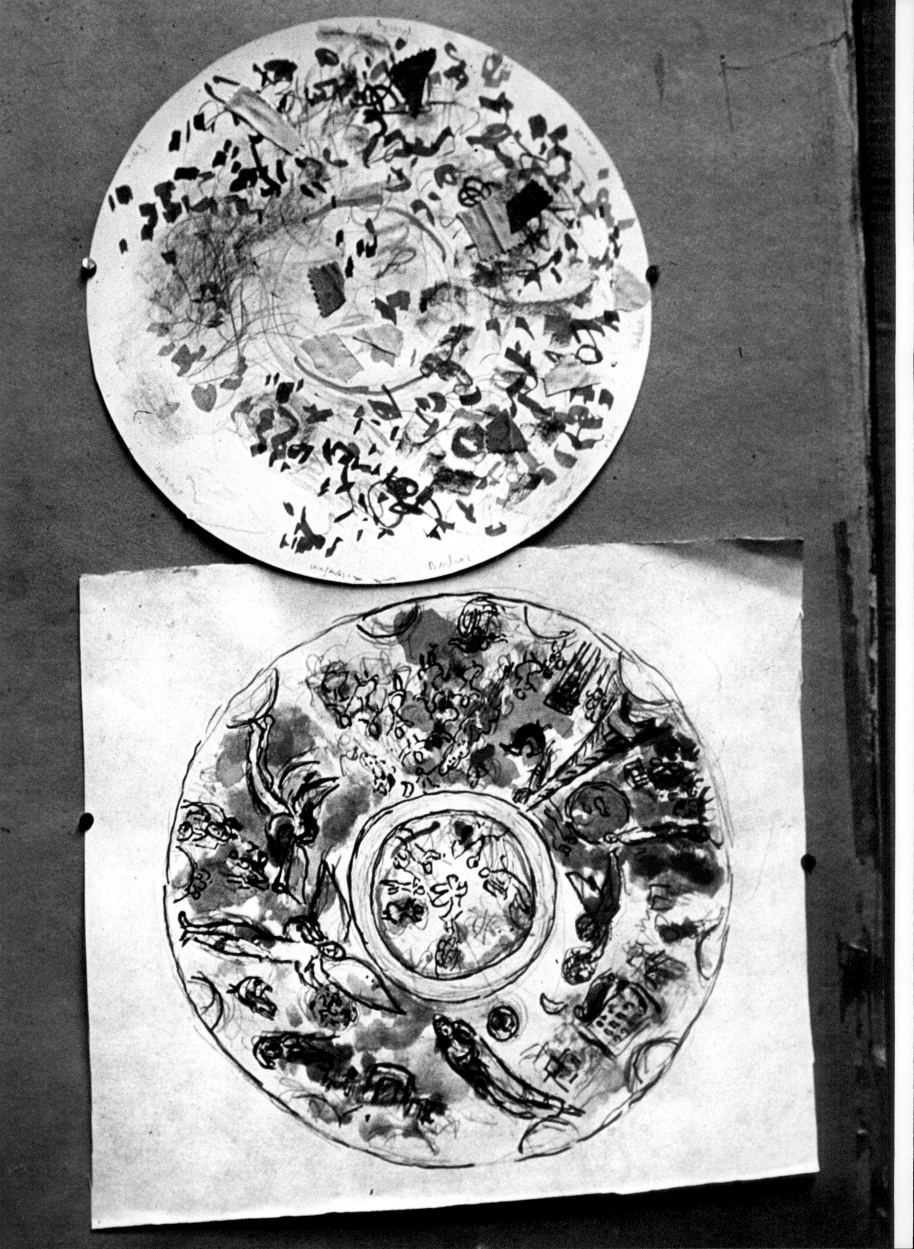

How could a painting by Chagall, even if it turned out to be a masterpiece, possibly have such a virtue? In any event, would it not constitute a flagrant violation of the principle that a historic monument, whatever the merits of its details, ought to be preserved in its original state? What would Charles Garnier, the designer of the whole edifice, have thought about such an attack on the integrity of his life work? These were legitimate questions, and they were asked with unrelenting vigor by the political opponents of Malraux.

Chagall did not attempt to answer them directly. He agreed to the use of a plastic shell that would leave the Lenepveu ceiling intact beneath his own, and he let it be known that he would accept no payment for the commission. Then, with all journalists except the trusted Izis excluded, he went to work, first at his home in Vence, then in the ateliers provided for him at the Gobelins tapestry establishment, then—as the need to keep the whole vast composition in view became imperative—in an old hangar in the Paris suburb of Meudon, and finally, for the last deepening and adjusting of tones, on a scaffold at the opera house. On September 23, 1964, to the sound of Mozart's *Jupiter Symphony,* the long-secret work was officially unveiled, and within minutes the controversy began to die. Today, even the more violent of the hostile critics are willing to concede that, whatever doubts one may still have about the wisdom of Malraux's decision to alter the interior of a Parisian landmark, the result achieved by Chagall is a fine example of artistic tact and respect for predecessors. Other viewers, myself included, would add that it is one of the best examples of monumental decorative painting our era has produced.

"The problem," Chagall remarked when the arguments had at last subsided, "was to work somehow with the architect Garnier and at the same time with the people of our own century." Hence at his studio in Vence (pages 208-209) the ceiling took shape first simply as an arrangement of zones of color—a "bouquet," to use his word for it, of hues rich enough to harmonize with the gold, bronze, and red of Garnier's decorative scheme, transparent enough to suggest the old ceiling's effect of an open, if rather heavily populated, sky, and varied enough to seem to reflect the glitter and color of a first-night audience. Figurative motifs were added (page 210) in order to provide the colored substance with basic shapes, structures, and "muscle"; and a small plaster model of the ceiling (pages 212-213) was used to test the patterns on a curved surface and in conjunction with the large sculptured heads Garnier had distributed around his frame (see page 236 for a close-up of two of them).

The nearly abstract bouquet acquires its principal shapes and structures, and the shapes and structures turn into the images Chagall associates with his chosen composers. Overleaf: The composition is tested on a plastic model of the ceiling.

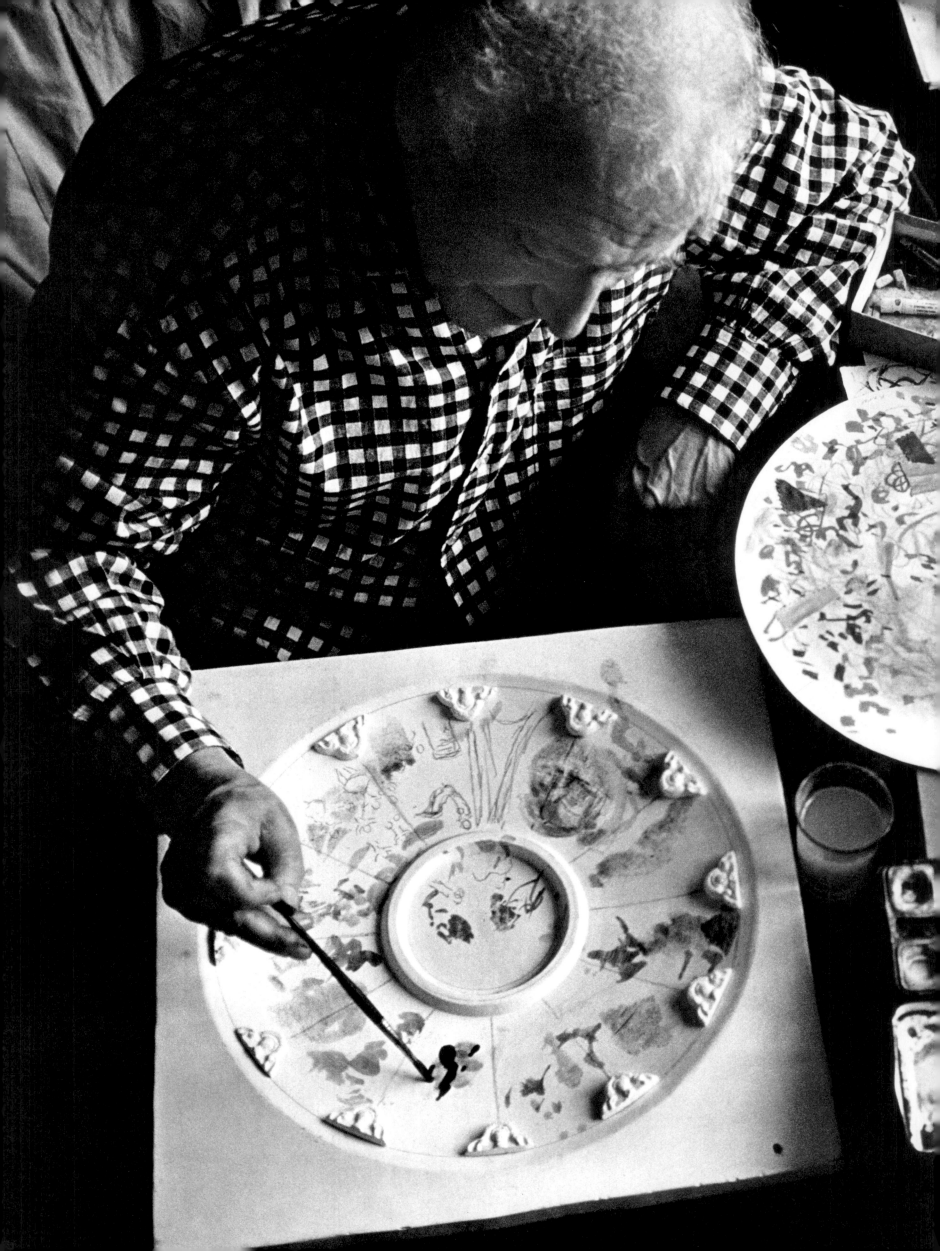

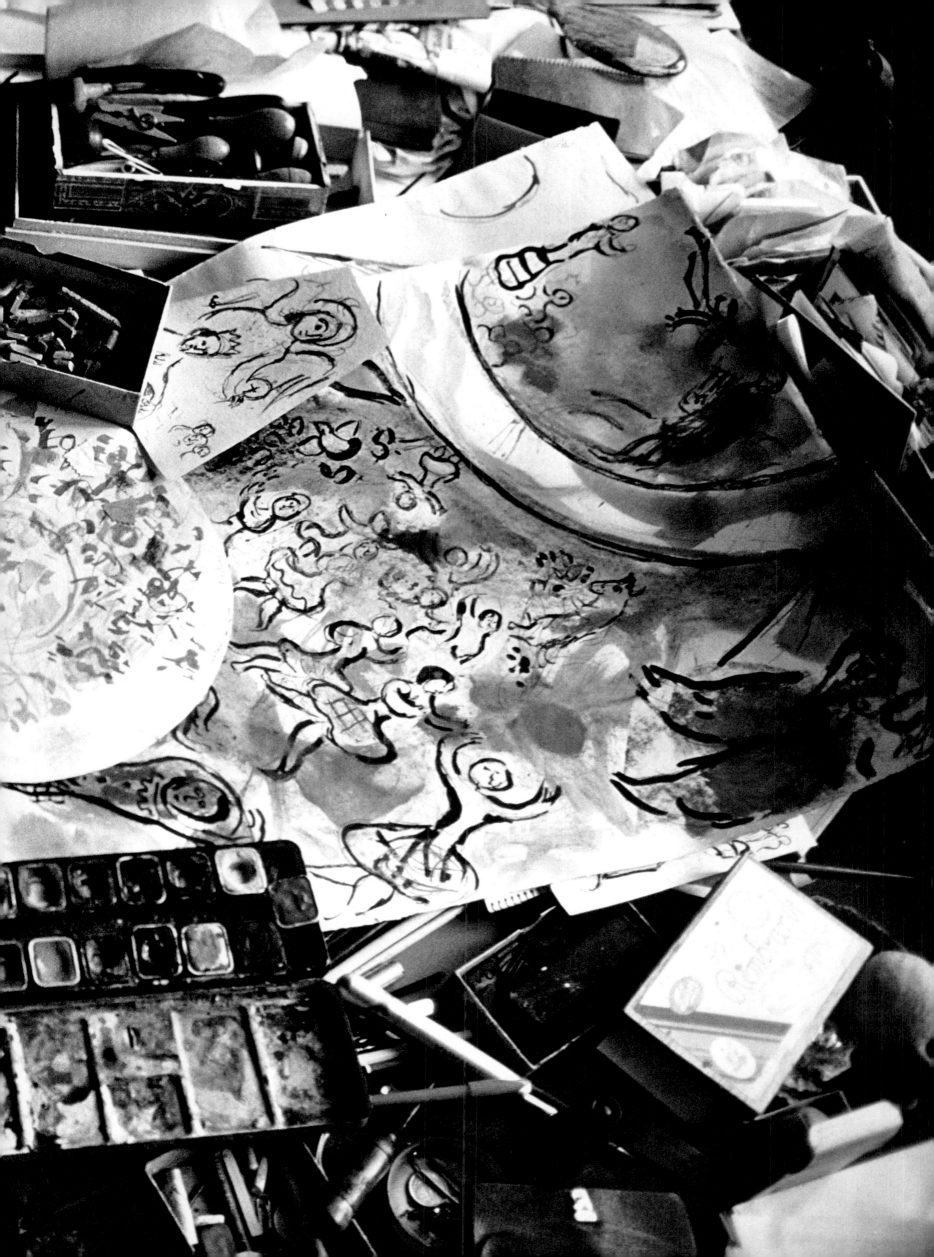

MOZART

BIZET

WAGNER

VERDI

BERLIOZ

RAMEAU

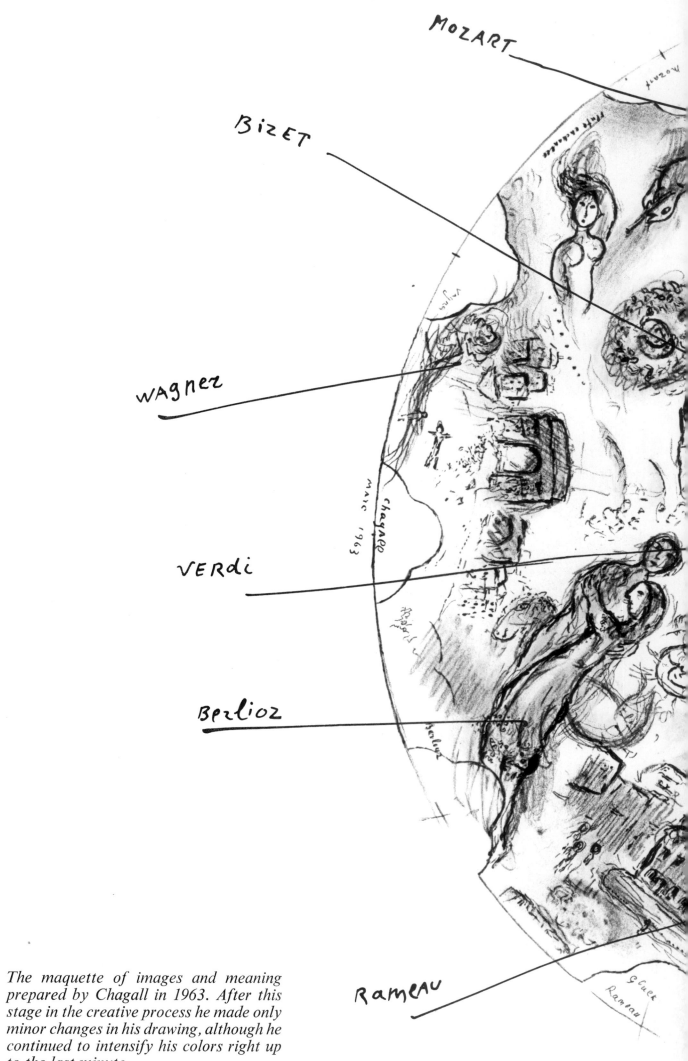

The maquette of images and meaning prepared by Chagall in 1963. After this stage in the creative process he made only minor changes in his drawing, although he continued to intensify his colors right up to the last minute.

214

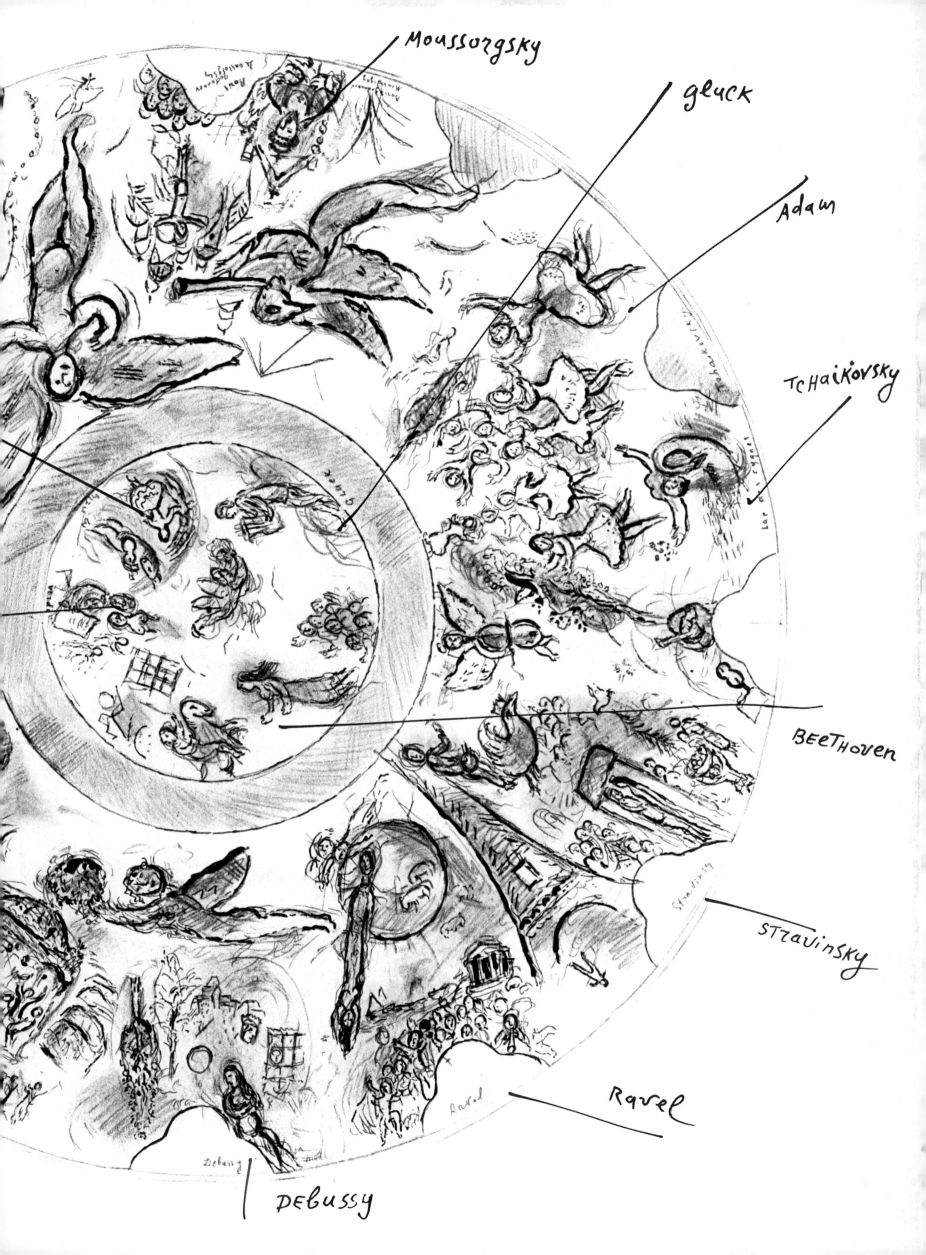

Moussorgsky

gluck

Adam

Tchaikovsky

BEeThoven

STravinsky

Ravel

DEbussy

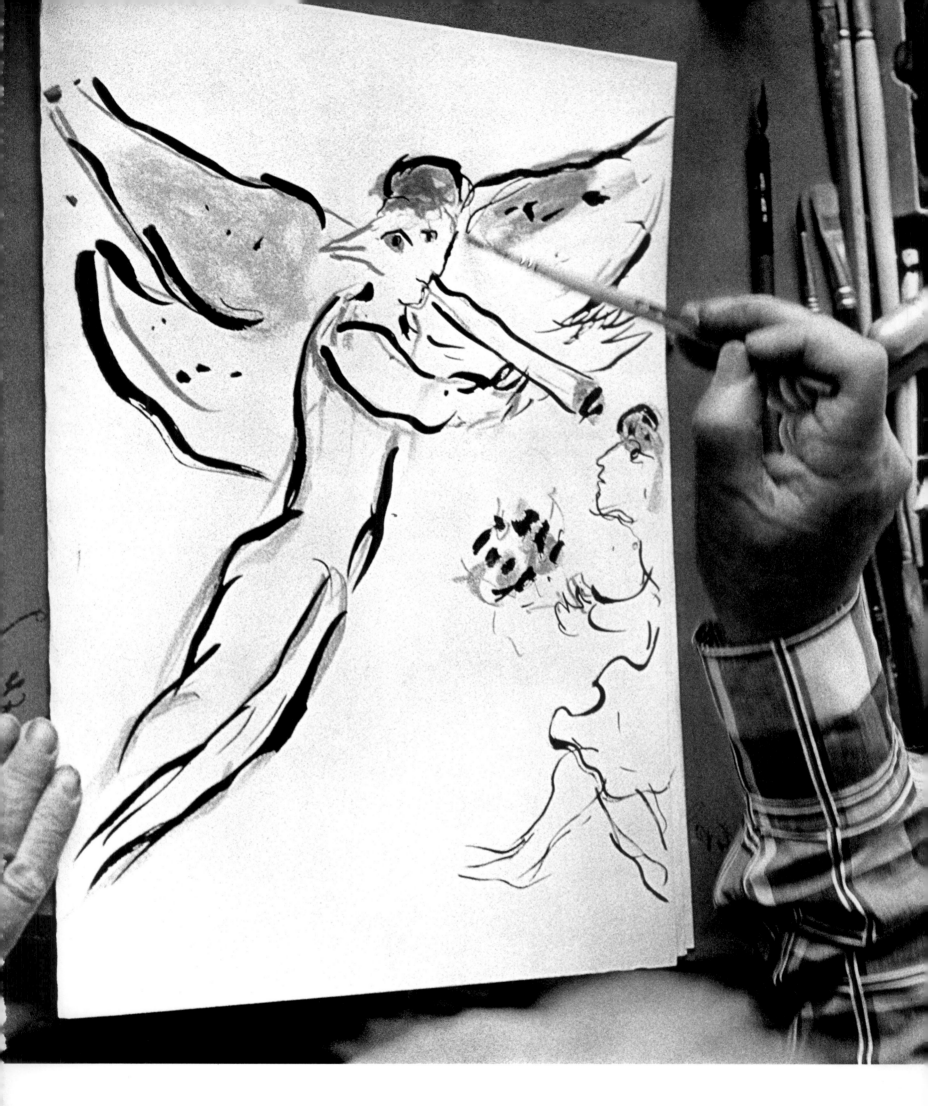

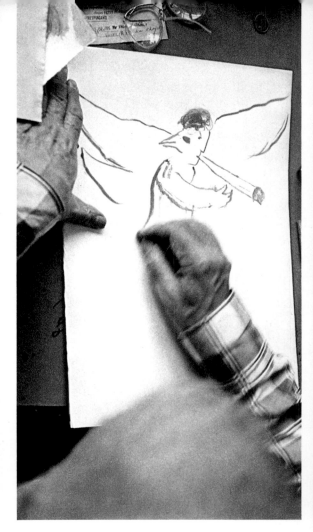

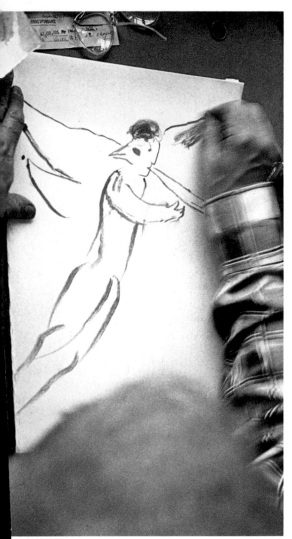

"*I had doubts about myself, about my work. Certain opinions only reinforced my doubts.... I doubted day and night.*"

The trumpeting, bird-headed, red-winged angel Chagall associates with the music of Mussorgsky underwent many subtle transformations—and some dramatic ones in terms of color— between its birth as a sketch in the Vence studio and its final form on a section of canvas in the Gobelins atelier in Paris (page 220). During these long months of work the Moscow under the angel's trumpet lost its Vitebsk crucifixion and acquired some fantastic details lacking in the maquette (pages 214–215) prepared in 1963.

217

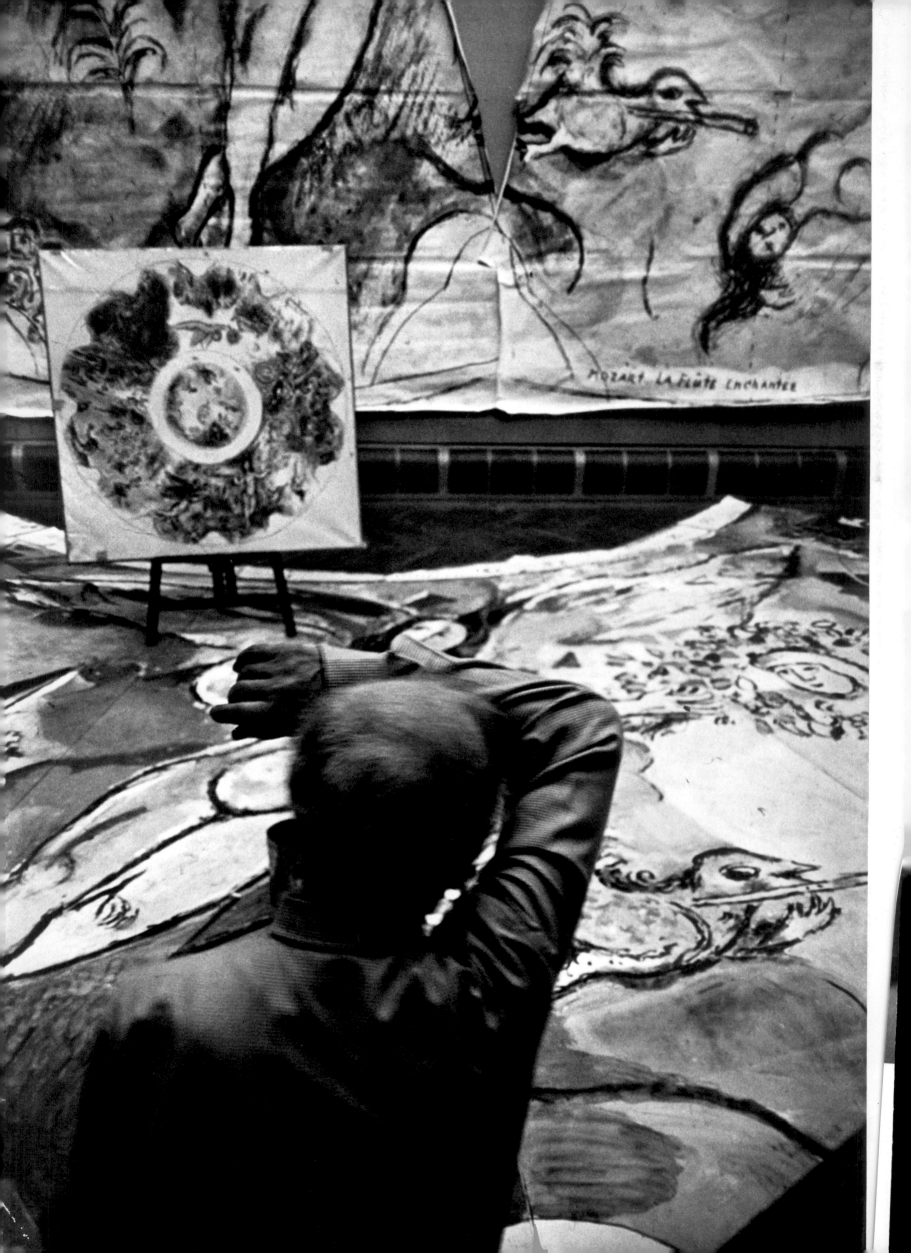

The "abstract" result of all this preparatory work can be seen, minus the center section, in the nearly finished canvas laid out on the floor at Meudon (pages 234-235). The composition is divided into five great wedges that radiate from a zone of light (intensified in the opera house by the great chandelier) in a way that is nicely consonant with the cabalistic and Hasidic theory of creation by emanation. Several prominent diagonal motifs echo at different angles the diagonals formed by the sides of the wedges and emphasize the fact that each wedge, allowing for some areas of transition on its borders, is a separate composition intended to be looked at from a fixed viewpoint and with the outer rim of the ceiling as a base—to see everything properly, one must walk about during the intermission, or reserve a different seat for each of five evenings. The picture space is cinematic, erotic, and for the most part extremely shallow. Each wedge has a dominant background color that is associated with two composers: green with Wagner and Berlioz, yellowish white with Rameau and Debussy, red with Ravel and Stravinsky, yellow with Tchaikovsky and Adam, and blue with Mussorgsky and Mozart. In this linking of color and music Chagall continues, in his own characteristically unsystematic fashion, a mode of thought, or of synaesthesia, that was often surprisingly systematic in Russia before the Revolution. Rimsky-Korsakov felt that green went with F major, white with C major, red with A major, yellow with D major, and blue with E major. Scriabin had an equally elaborate, although different, set of correspondences.

After he had made the important decisions concerning his colored substance, spatial organization, and basic shapes and structures, Chagall turned to his figurative iconographic program (pages 214-215). This combines scenes from operas and ballets with a private Chagallian collection of memories of places, people, birds, beasts, objects, and old pictorial motifs.

Thus in the Mussorgsky section of the ceiling (details on pages 217-218, 219-220, and 224) the royal figure is clearly Boris Godunov. The scene is the moving finale of the opera; he has called the boy Feodor to his side for a last admonition to rule wisely, and is singing "Farewell, my son, I am dying." The crowd to the right of the throne represents the Russian people, the real protagonist in nearly every Russian historical drama. Above the crowd is Moscow, and above Boris is a winged demon that can be interpreted, if one insists on precision about such creatures in Chagall's work, as the czar's evil spirit, as the angel of death, or as an allegory of Russian music. But the more one looks at the images

The artist had assistants to help with the physical labor of enlarging the maquette, but he had to answer the hard questions himself, and in the course of doing so he repainted every square foot of the canvas at least once. On the opposite page he is wrestling with the Mozart section in the Gobelins atelier, with the maquette far enough away to suggest an opera-goer's view of the work.

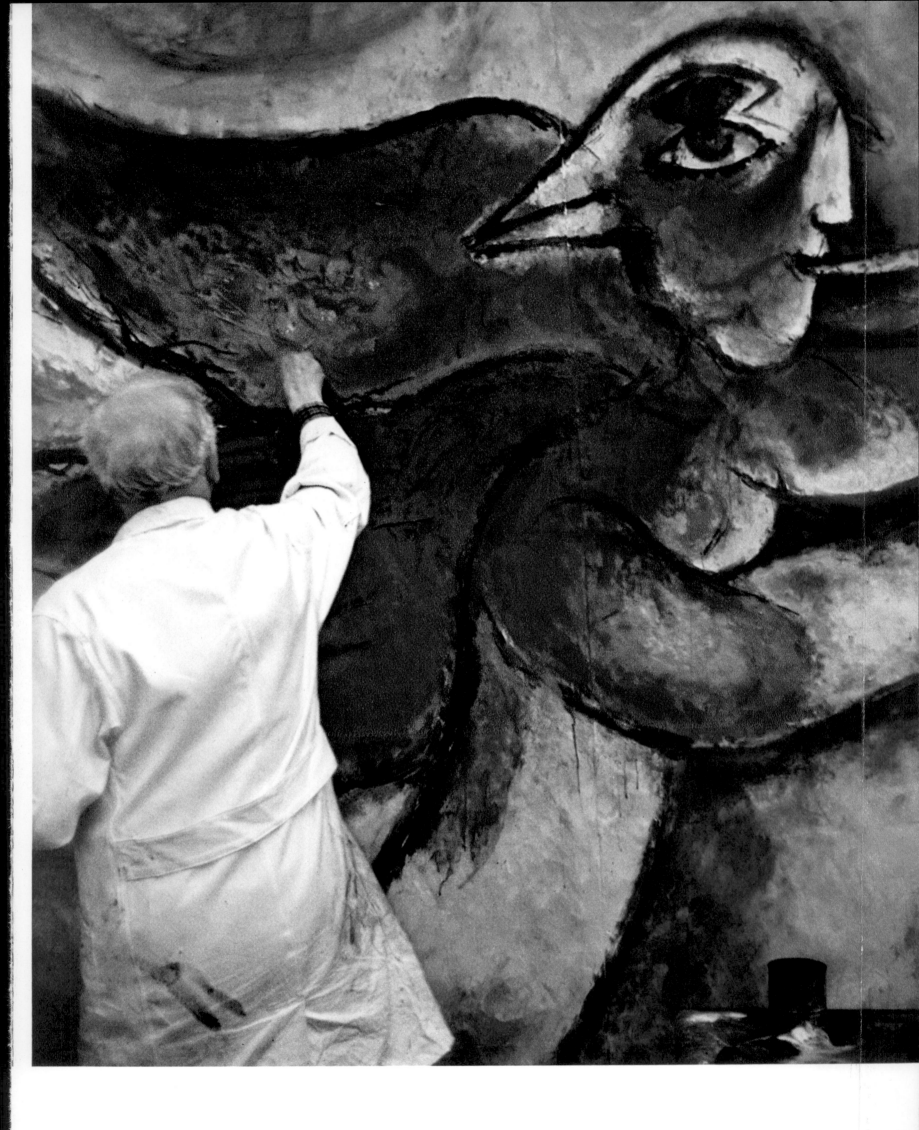

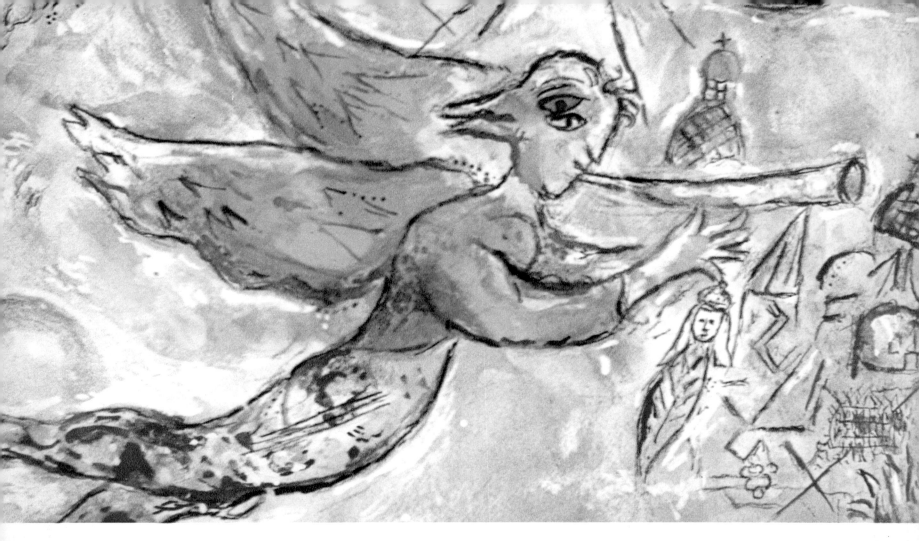
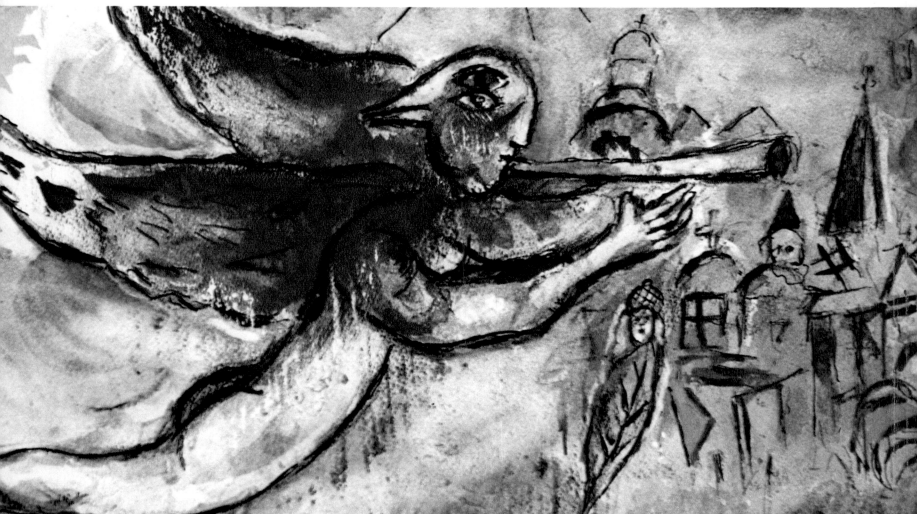

the more they seem to be the results of a dreamlike condensation and displacement of symbolic materials long resident in the artist's imagination. The throne and crown of Boris recall irresistibly the familiar wooden baroque case of the Chagall family clock. The sketched crucifixion (pages 214-215), which was eliminated in the final oil version, recalls the tiny yellow one in the center of *Red Roofs* (page 145) and helps to justify a suspicion that what seems to be Moscow may be merely one more disguise for the beloved Vitebsk. In such a context the human half of the winged demon's head does not need much contemplation in order to turn into one more self-portrait.

The images in the Mozart, Wagner, and Berlioz sections have only the vaguest sort of public illustrative purpose; they are the private symbols of what Chagall, in the ripeness of his long life, remembers and re-experiences when he thinks of the music of these composers (details on pages 216, 228, and 229). The aggressive little cock plays Mozart's magic flute in a flying, perhaps Freudian, love-making formation with the windblown nude, or Jungian anima, that floats above the dreamer of *Window in the Sky* (pages 38-39). A naked angel, obviously a sister of those in the erotic oneiric space of *Jacob's Dream* (page 20), carries a bouquet in which the head of Mozart replaces the usual Chagallian sweethearts (see page 161). Beyond the windblown anima the theme of happy sensuality yields to one of nostalgia and tragedy, in keeping with the music of *Tristan and Isolde* and of Berlioz's dramatic symphony *Romeo and Juliet*. The townscape is a cinematic montage of the Right-Bank monuments of Paris, the second Vitebsk; and in the middle of the Avenue des Champs-Elysées lies the tiny figure of the dead man Chagall painted in the first Vitebsk of 1908. The elongate sweeping form associated with the phantom of Bella and with the idea of resurrection is apparent in both the small Wagnerian couple (in the lower left corner) and the giant Berlioz pair. In fact, Romeo's lively, askew little horse is the only motif in this part of the ceiling that does not carry a hint of death.

The Rameau-Debussy wedge is relatively straight illustration (details on pages 207, 230-231, and 233). On the left is the Paris Opera itself; prominent in the foreground is a freely interpreted version of Carpeaux's *Dance,* the only acknowledged masterpiece among the pieces of sculpture on the facade. Above the roof, with a floral tribute extended toward the building, floats an angel that Chagall has said represents the long list of French opera and ballet composers for whom he did not have space. Below the angel are the gloomy castle and forest of Debussy's *Pelléas and Mélisande;* a humid yellow sun fails to penetrate them. King Arkel's head swims in the mist in front of the castle, Pelléas gazes pensively

The naked angel that flies between the Russian capital and The Magic Flute *stares with slightly cross-eyed intensity over the shoulder of Chagall as he arranges her hair.*

222

Overleaf: With Vava Chagall watching, the painter works on the Mozart section. The adjoining Mussorgsky section has been moved up on the wall, and so Boris Godunov and Moscow are temporarily united. ▷

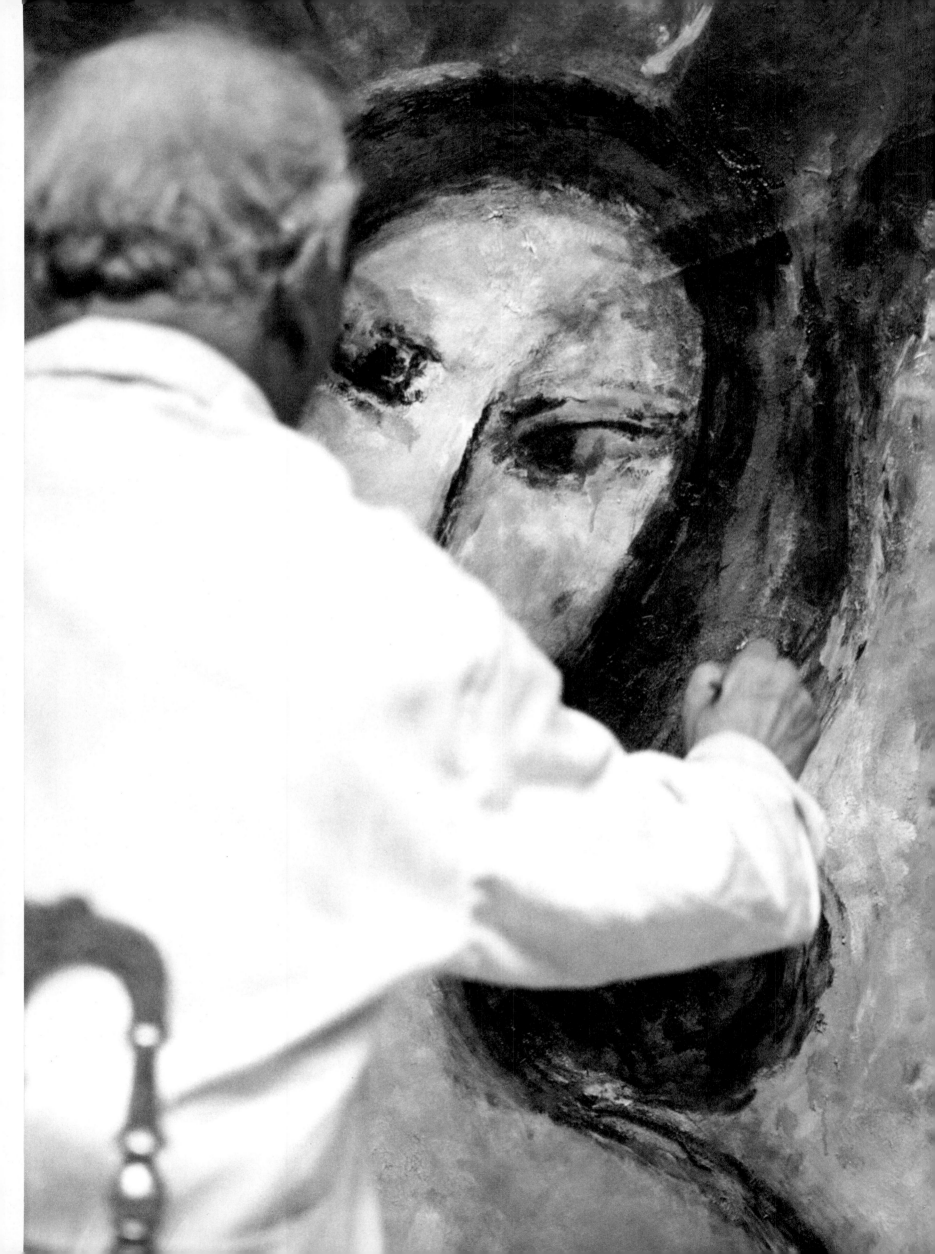

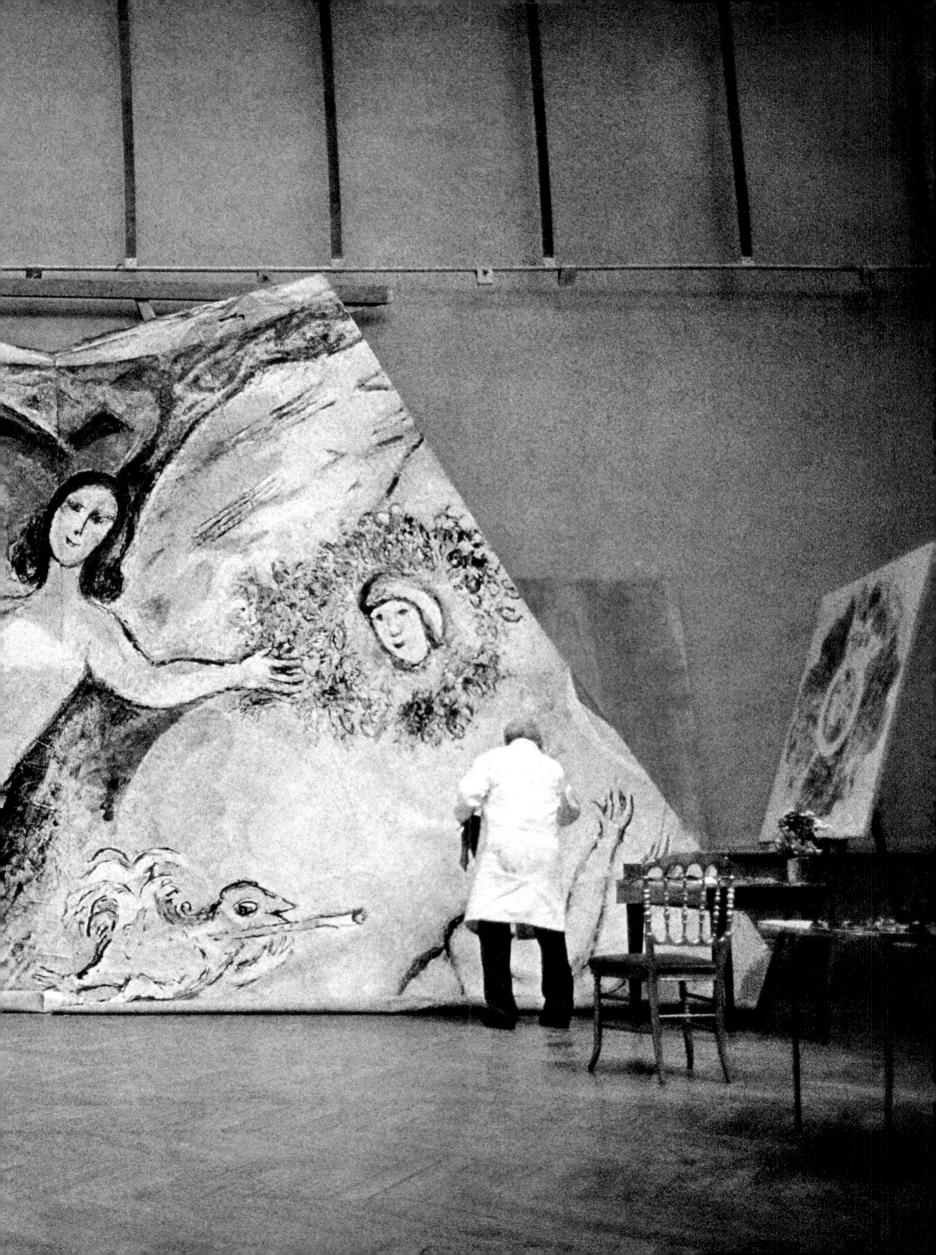

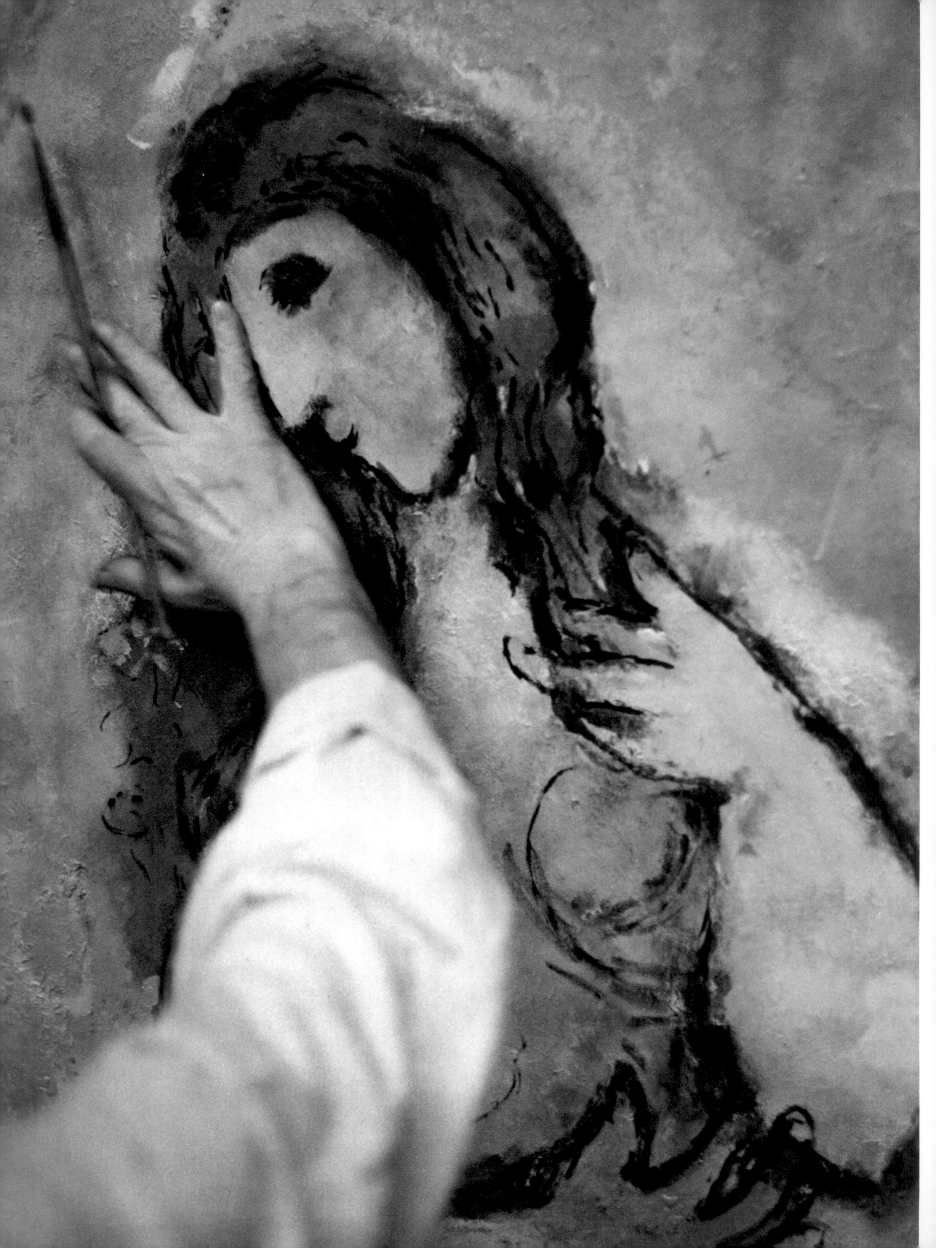

from a window reminiscent of those in the little wooden houses of Vitebsk, and Mélisande leans over part of the rim of the ceiling as if she were looking into the fountain in which she lost her ring by throwing it "towards the sun."

The Ravel-Stravinsky section (details on pages 229 and 232) is built around a giant, swaying, multicolored Eiffel Tower, the symbol of the move to Paris that cut Chagall off from his homeland and made him a French as well as a Russian artist. The left, or French, half of the composition is devoted to Ravel's *Daphnis and Chloe:* a flying version of the great god Pan, a flock of sheep, a Doric temple, and an agitated band of fauns, nymphs, and swains evoke the Greek pastoral atmosphere, while the literally united lovers soar above the ship of the pirates from whom Chloe has been rescued. On the Russian side of the tower Chagall himself, palette and brushes in hand, dominates the scene. Below him a Vitebsk rooster that is also the royal, shining creature of *The Firebird* (see page 202) embarks on a rooftop journey, the prince and the princess of the Stravinsky ballet are married under the red *chupah* of Marc and Bella, and the pines of a Russian forest drift down through a snowy area toward a zone of warm color in which a Mexican woman—from a gouache of 1942—appears with a basket of fruit on her head.

Two more ballets, Tchaikovsky's *Swan Lake* (detail on pages 10-11) and Adam's *Giselle* (detail on page 2), complete the cycle of compositions in the main, or outer, part of the ceiling. Although both contain plenty of Romantic incident in their stage versions, Chagall treats them as pure dance except for the scene in which Odette, the queen of the swan maidens, flutters back into her enchanted state after the unwitting infidelity of Prince Siegfried. Here the underlying "abstract" crescent shapes, the "chemistry" of the blues, yellows, and tinted whites, and the inherent poetry of the subject combine to form one of the most musical of the many motifs in this whole magically evocative work.

Although Lenepveu had left the space around the chandelier vacant, Chagall chose to fill it with lightly painted allusions to Gluck's *Orpheus and Eurydice,* Bizet's *Carmen,* Verdi's work as a whole, and Beethoven's *Fidelio* (pages 214-215). He was thus able to turn into a general tribute to European opera and ballet what would otherwise have been very largely a French and Russian affair. He was also able to add some personal associations; Beethoven's Leonore, for instance, resembles the frantic mother on the wagon in *Obsession* (pages 156-157), and in the bullring of Seville Carmen is being serenaded by a taurine straight from the fantastic world of Vitebsk.

Using his hand instead of his brush, the artist adds definition to the sad, archaic profile of Debussy's Mélisande. She is one of the few figures in the ceiling who appear, at least from a distance, to be looking down at the opera-house audience.

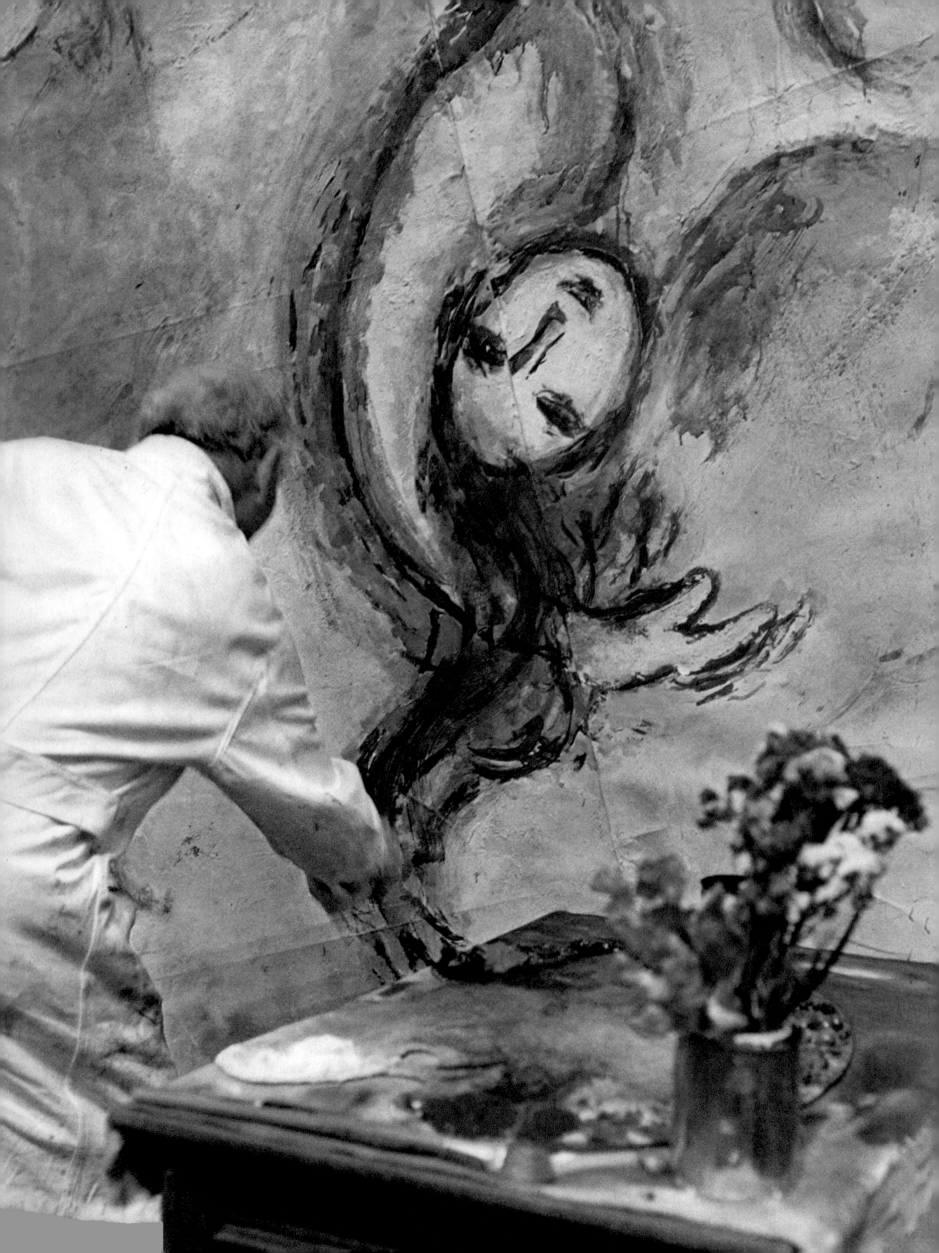

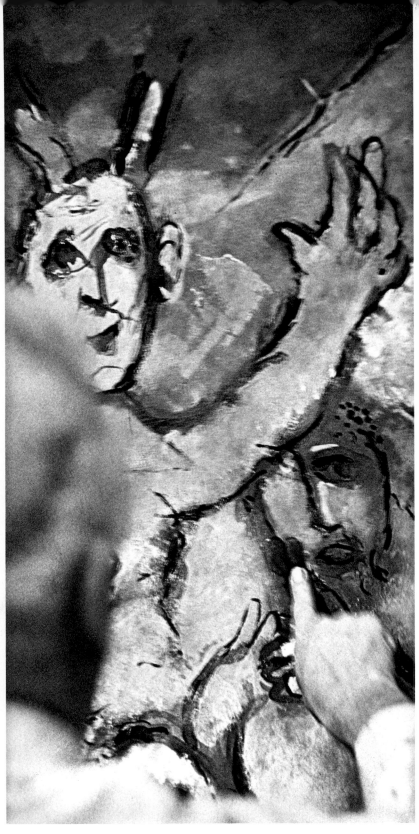

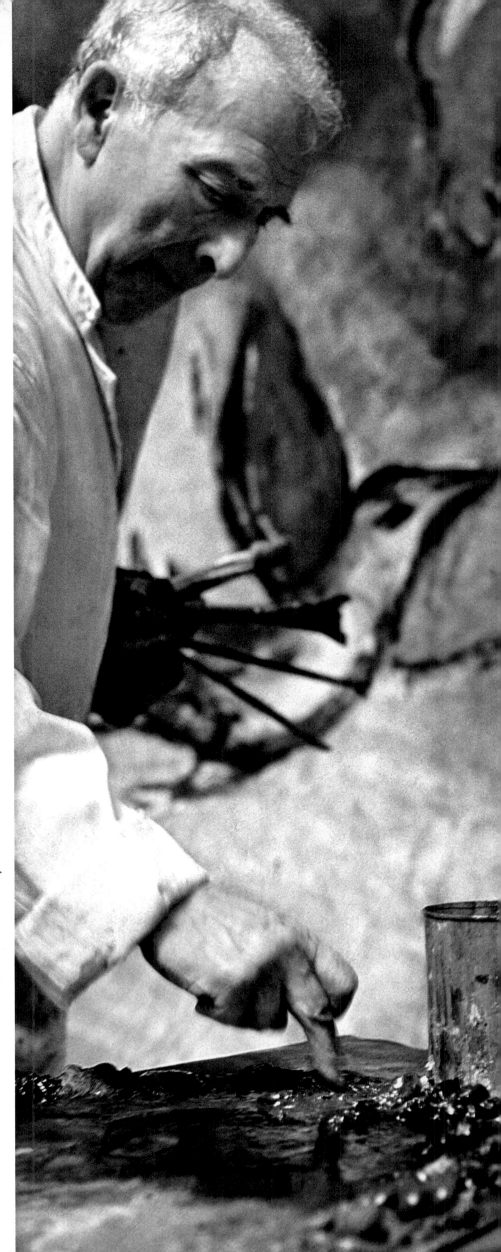

With flowers next to his palette to remind him of the organic "tissue" and "chemistry" of colors in nature, the painter adds tresses to the wind-blown nude he associates with The Magic Flute.

He uses his finger to massage color into a Daphnis and Chloe *satyr (above) and (right) the bird that appears below the angel in the Mozart section.*

Overleaf: July 7, 1964, his 77th birthday, is marked by the visit of his twin grandchildren, Bella and Meret Meyer, to the Gobelins. The angel above the Paris Opera offers flowers, as the first Bella did on the often-remembered July 7, 1915, in the Vitebsk studio. ▷

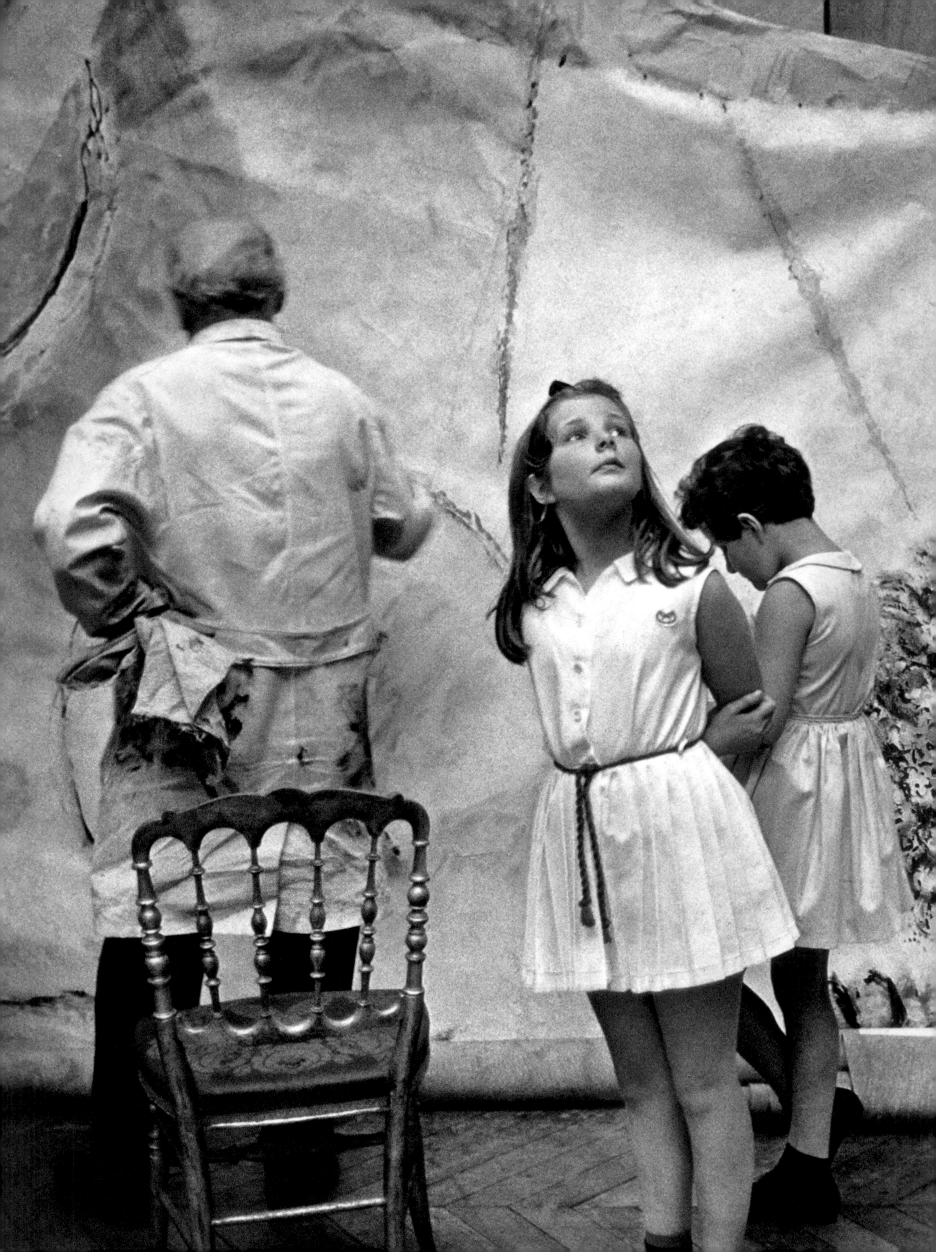

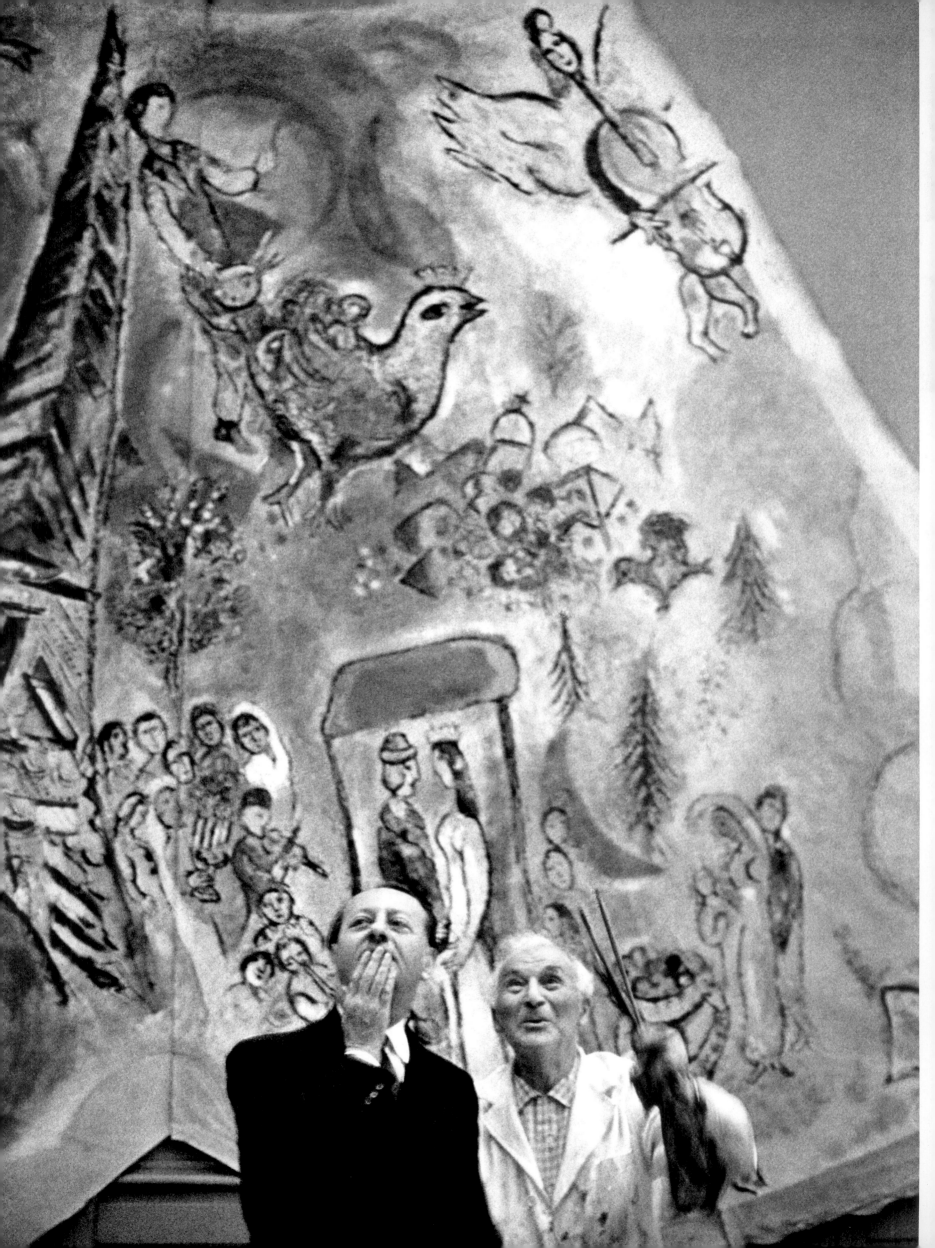

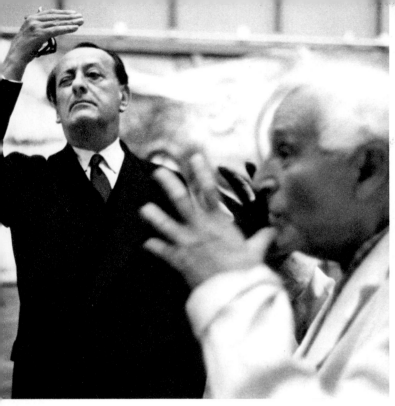

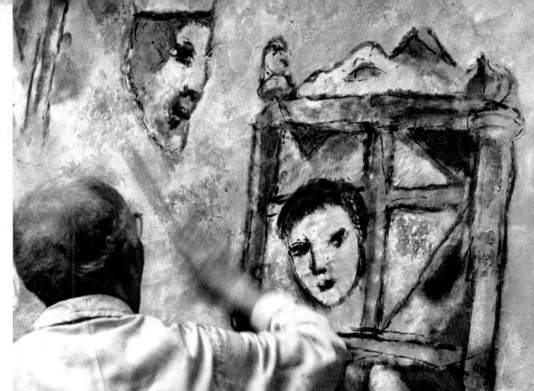

On a tour of the Gobelins atelier at the end of July, 1964, André Malraux and the painter become part of the Stravinsky section of the nearly completed work. The minister and art historian's verdict: "A day can come in the life of a painter when his genius explodes and leads him to sum up his entire life in a picture. That's what happened to Chagall with the Opera ceiling."

After the visit, Chagall turns Pelléas into a portrait of Malraux, in keeping with the medieval custom of depicting the patron.

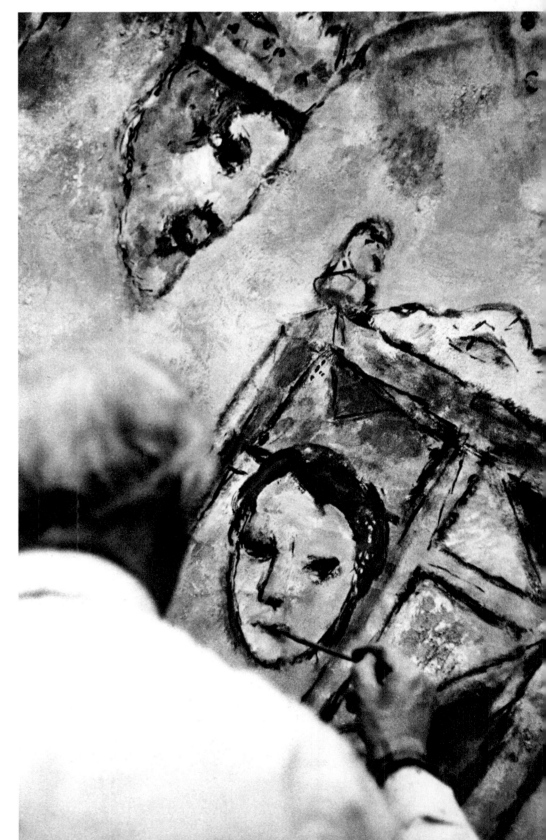

Overleaf: The sections of the ceiling laid out on the floor of the hangar at Meudon, with the artist visible (in the upper left section) as a tiny figure among the dancers of Swan Lake: the photograph was taken through a hole in the roof. ▷

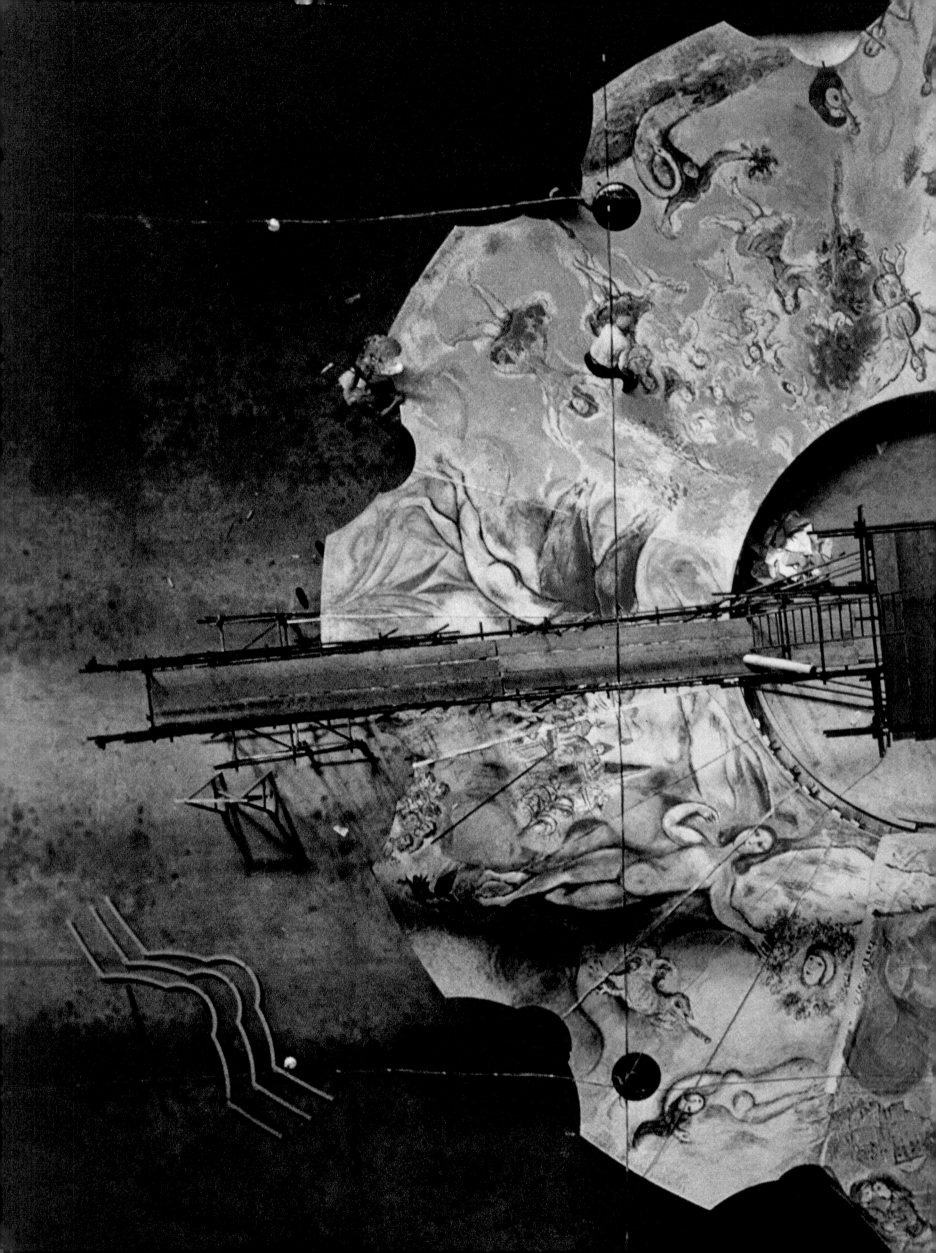

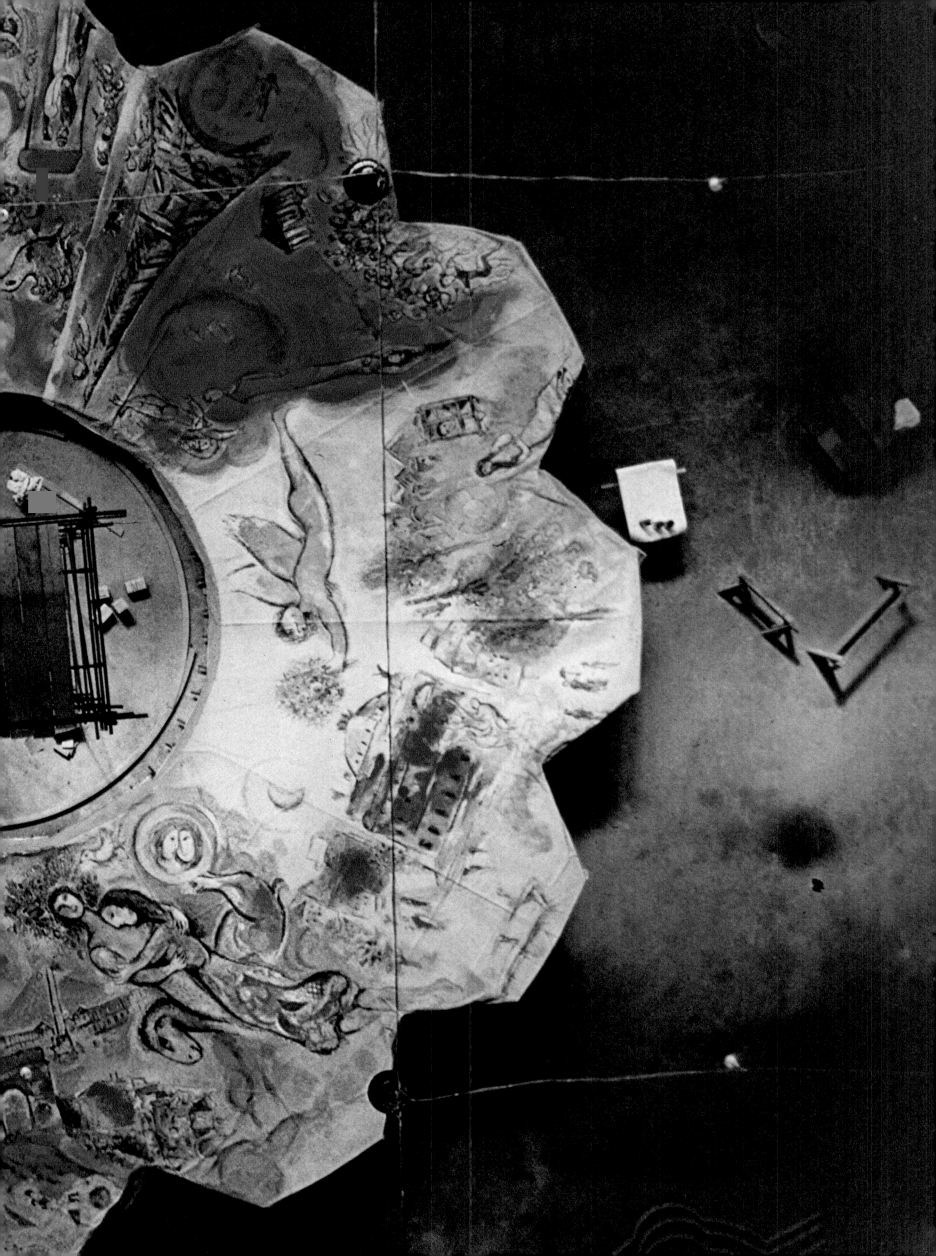

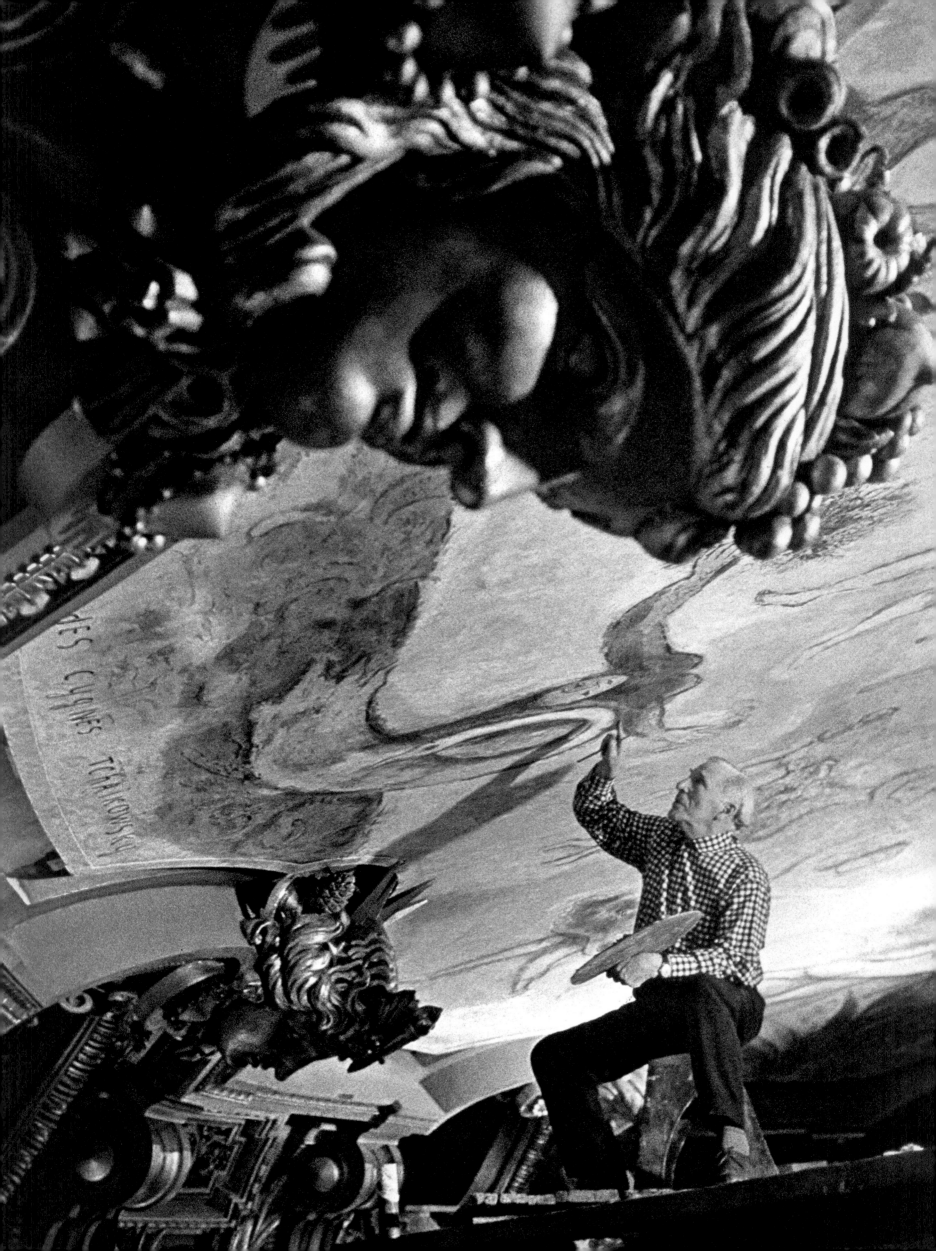

*"I wanted, as in a mirror up there on high,
to reflect a bouquet of the dreams and creations
of the actors and musicians...."*

With the canvas sections of the Gobelins and Meudon phases glued to a plastic shell and installed in the opera house a few inches below the 1870 ceiling of Lenepveu, Chagall returns for some retouching of seams, a deepening of tones, and a last look in private at his gift to the people of France—a gift proposed in the midst of controversy and created in an almost governmental secrecy, but ultimately welcomed with enthusiasm by all but a small minority of critics. The contrast between the 19th-century decoration and the swan maiden the painter is attending to is evidence that the controversy cannot be dismissed as merely a political quarrel; and in the tactful Chagallian color harmonies can be seen some of the several reasons for the final success of the project.

XIII *The Lincoln Center Murals*

The two 30-by-36-foot paintings commissioned by the New York Metropolitan Opera for its building on Lincoln Center Plaza are in many ways a sequel to the Paris Opera ceiling, for Chagall decided at the start that he should not try—beyond attending to such matters as scale and visibility—to integrate his style with that of the architect, Wallace K. Harrison, who was in charge of the New York project. He favored contrast over similarity. "You cannot resist the severe masses of modern American architecture," he said, "with something in the severe manner of Mondrian or Léger. You have to do it with the movement of lines and colors." He thought of the murals less as murals than as large easel pictures, and carried through his concept by insisting that they be provided with frames: half-inch bronze enclosures designed to separate the art of architecture from the art of oil painting and to remove from the latter any suggestion of it being subordinate.

The new works, entitled *The Sources of Music* and *The Triumph of Music*, are not, however, merely a continuation and development of ideas to be found in the Paris ceiling. They have their own quite independent subject matter. And they have an added quality—a nuance that may best be approached through some anecdotal history.

Chagall signed the canvases in the Gobelins ateliers in Paris on the morning of March 14, 1966, with the *Jupiter Symphony* coming this time from a portable

Chagall at work in 1964, in the Paris atelier of the state-owned Gobelins tapestry establishment, on a section of THE SOURCES OF MUSIC. *Under his brush is the harp of the central, Orpheus-David figure; further in the foreground, with a horse, are Romeo and Juliet (see the keys to the imagery of the murals on pages 242 and 243).*

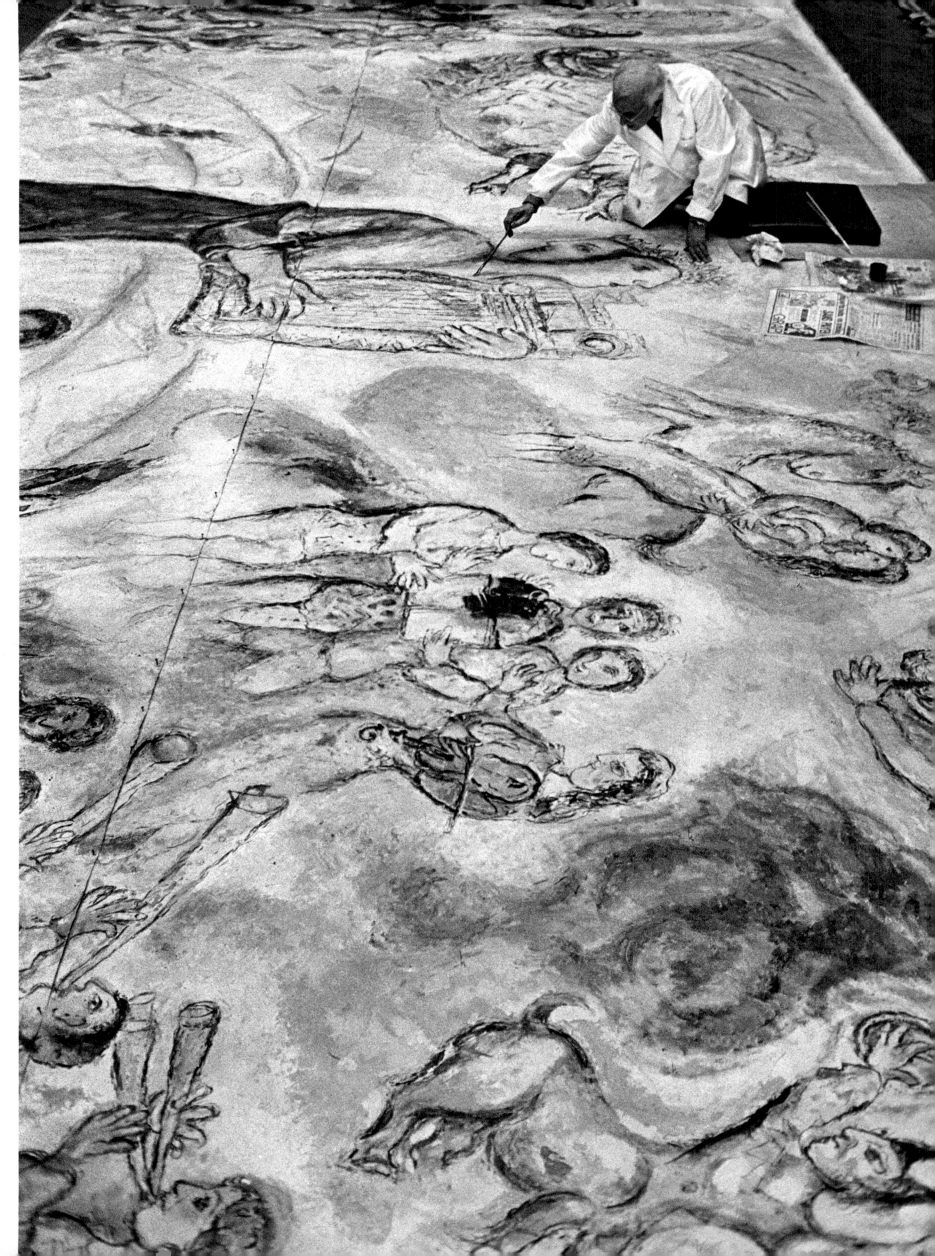

record player. There were champagne toasts and congratulations from his studio assistants, from his wife, daughter, and grandchildren, and from a small group of friends who had gathered to help him celebrate the successful conclusion of two years of hard work. The excitement was such that he painted an extra "a" into his name on one picture, and had to make some hasty repairs before uttering a triumphant "*Fini!*" Then, after a final inspection of the "chemistry" and the "tissue," he went back to his Seine-bank apartment to prepare for a return to Vence and some deserved rest in southern sunshine. The next morning, however, a postscript to the signing was being enacted when I came around to the atelier to have a last look at the 12 sections, which were to be shipped to the United States for combining and mounting. (The size of the compositions had made it impossible for them to be executed as single pieces.) Part of *The Sources of Music* was spread out on the floor, and the 78-year-old artist, in a white house-painter's coat and with his shoes off, was in the middle of it, intensifying the yellow around the faces of the Orpheus-David figure and calling at intervals for advice from Vava Chagall, who was perched on a tall stepladder to get perspective on the warmth of the tones. Eventually he cried "*Fini!*" once again, and tiptoed back through patches of wet paint to the unoccupied part of the floor. "It has got to have strong colors," he said. "It's a message for the people."

During the summer of 1966 in New York the paintings were assembled, retouched, and glued to the plaster walls of the Grand Tier (first balcony) of the Metropolitan Opera House in positions that allow them to be seen, through Harrison's round-arched, geometrically patterned glass facade, from the other side of Lincoln Center Plaza. When the building is lighted for an evening performance they glow toward the exterior like stained glass seen from inside a medieval church—in fact, many New Yorkers refer to them as "Chagall's windows." The red *Triumph of Music* is on the left, and so the large angel at the top of the composition appears to be directing its trumpet call toward the audience. But all this was not accomplished without friction. For instance, the reverse arrangement of the maquettes on pages 242 and 243 follows Chagall's original plan, which was dropped only after some warm controversy during the installation; in the building it would have permitted the angel to trumpet in the general direction of Central Park and the people of the world at large.

Preparatory sketches in pen and ink for some of the motifs in THE SOURCES OF MUSIC. *In the painting the nude emerged from inside the rooster to cling to its back (upper left corner of the maquette on page 242), the little cello-man was stationed to the right of the lovers representing "Homage to Verdi" (number 9 in the key), the angel with the violin was assigned to the lower left corner of the composition and given a bird's head, the Grecian profile became that of "The Angel Mozart" (number 7), and Orpheus gained substance at the expense of King David (number 1) in the upper part of the personage.*

THE SOURCES OF MUSIC

Maquette for the mural oil painting on the north wall of the Grand Tier, Metropolitan Opera House, New York.

1 *Orpheus and King David;* 2 *Beethoven;*
3 *Fidelio;* 4 *Bach and Sacred Music;*
5 *Romeo and Juliet;* 6 *Wagner (Tristan and Isolde);* 7 *The Angel Mozart;*
8 *The Magic Flute;* 9 *Homage to Verdi;*
10 *The Tree of Life;* 11-12 *New York.*

242

THE TRIUMPH OF MUSIC

Maquette for the mural oil painting on the south wall of the Grand Tier, Metropolitan Opera House, New York.

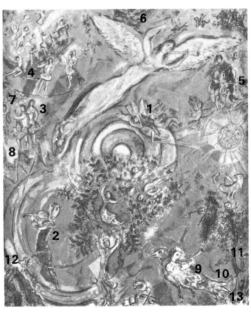

1 *The Song of the Peoples;* 2 *The Musician;* 3 *The Singers;* 4 *The Ballet;* 5 *Homage to American Music;* 6 *The Firebird;* 7 *Homage to French Music;* 8 *To Rudi Bing;* 9 *Russian Music;* 10-11 *Chagall and his wife;* 12-13 *New York.*

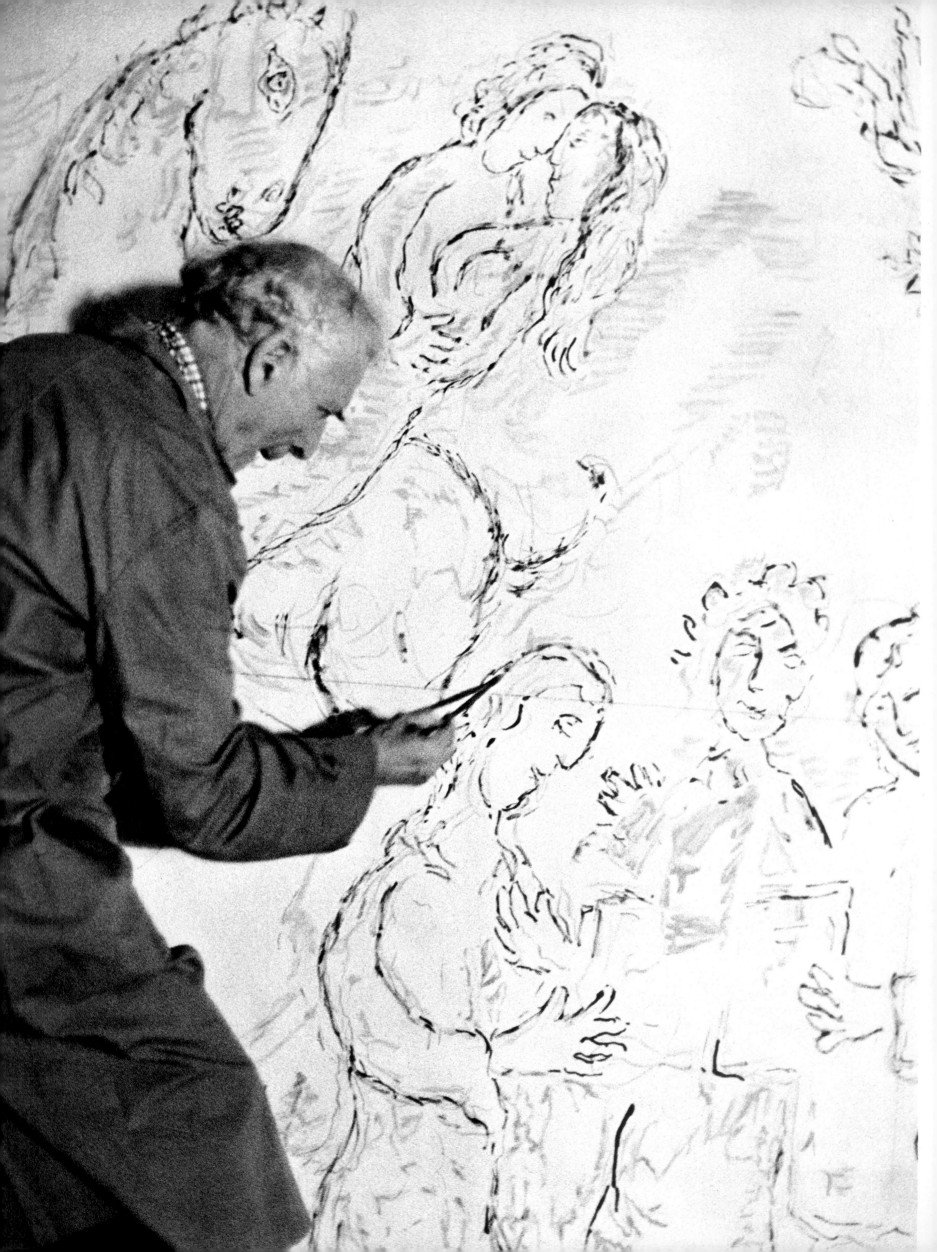

*"I am a painter, and allow me the expression
'I am an unconscious-conscious painter.'"*

After his maquettes were enlarged on canvas at the Gobelins atelier, Chagall went over each detail of the drawing, reinforcing it and giving it the fluency of his rapidly executed small-scale sketches. Here he unconsciously adopts the facial expression of the personage upon whom he is concentrating, a member of the group of singers in the upper right corner of THE SOURCES OF MUSIC. *Above his head are Romeo and Juliet and their horse (number 5 in the key for the imagery).*

Overleaf: With a studio assistant as audience, the artist attacks the chin line of "The Angel Mozart" in THE SOURCES OF MUSIC. *Variations on the motifs in this section of the Lincoln Center murals appear on the fore-curtain, or "overture drop," for* The Magic Flute. ▷

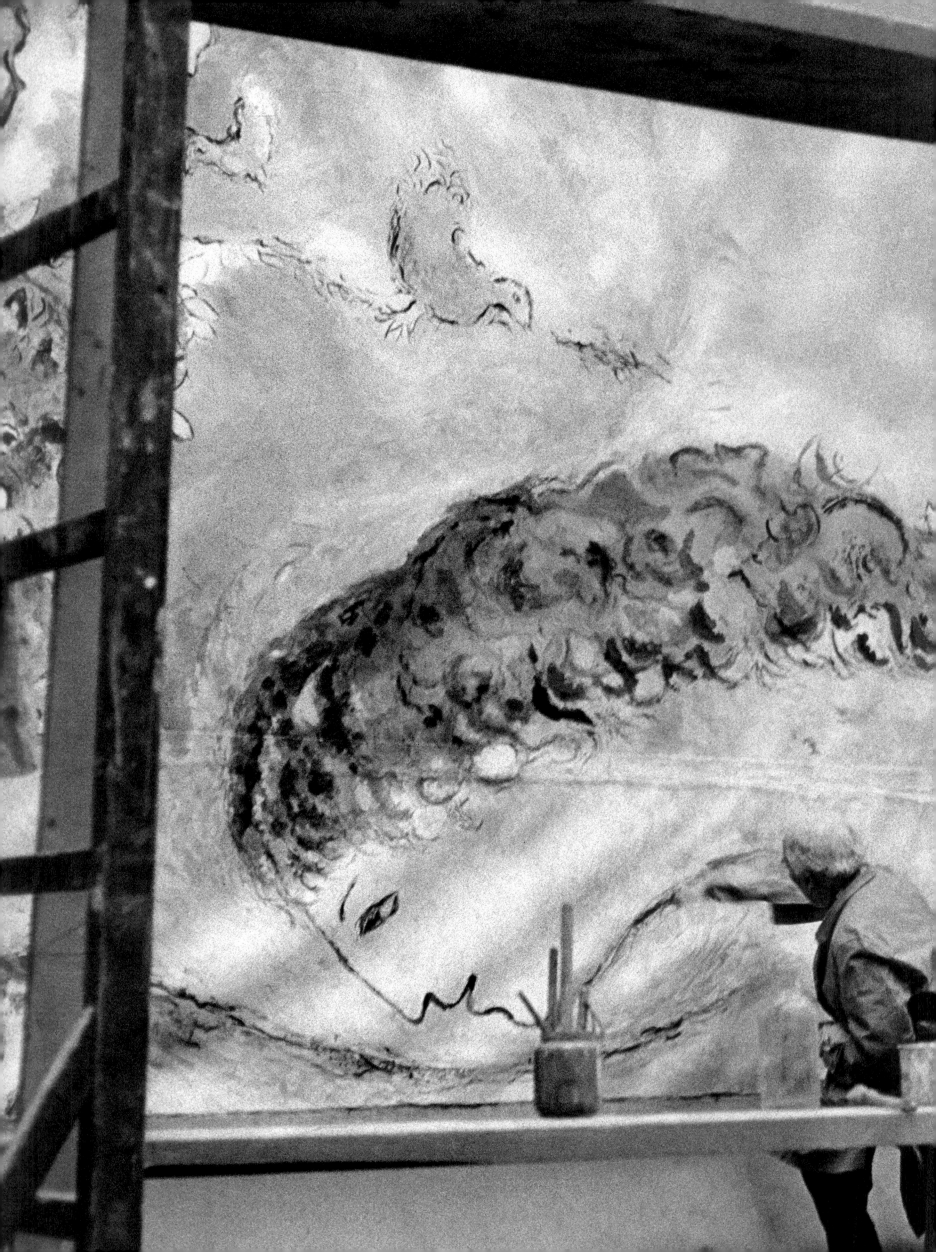

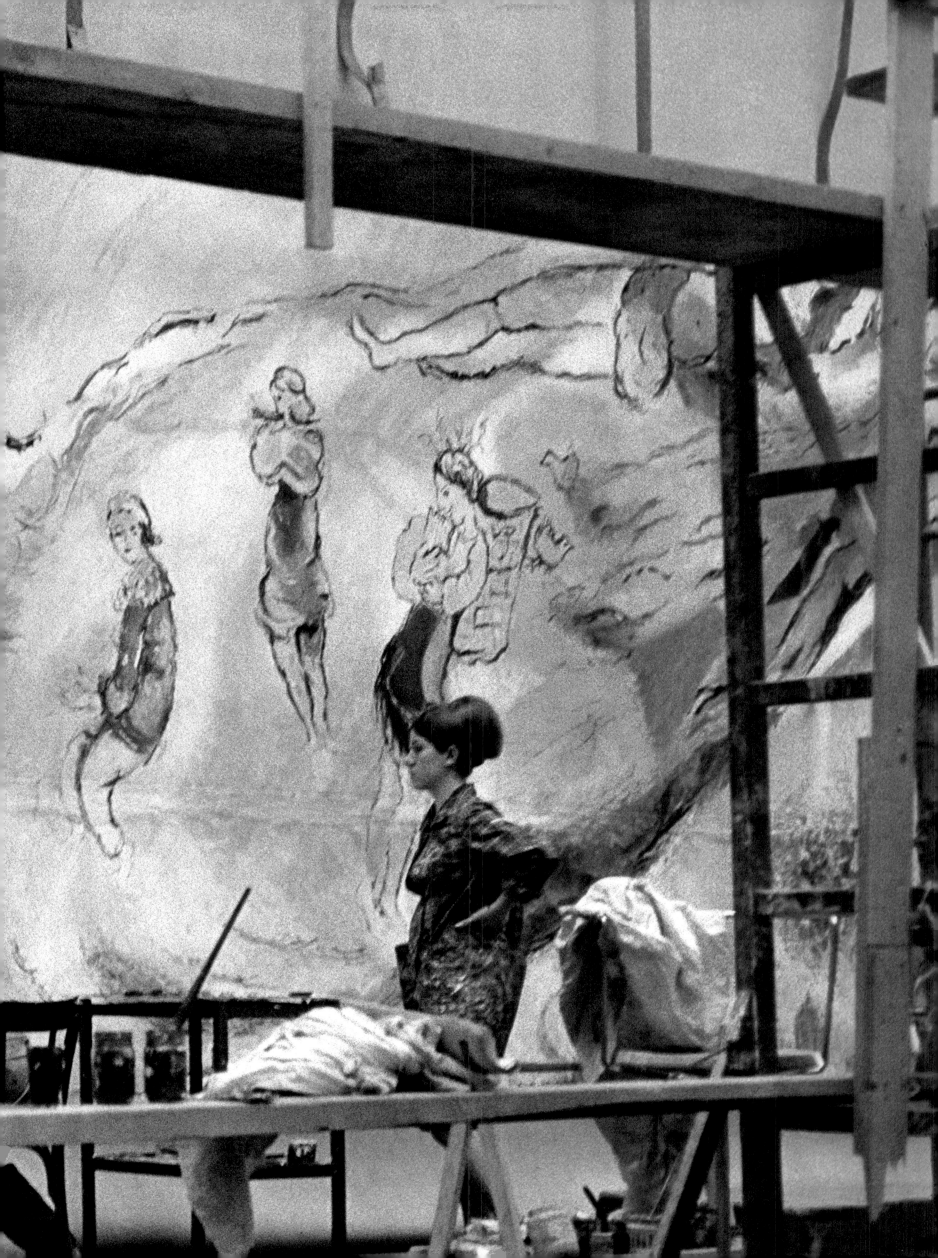

In sum, when one reflects on the creative process, on the dimensions, on the bold, unified colors, on Chagall's stated aims, and on the Lincoln Center location, it becomes apparent that these two paintings are public art to a degree that the Paris ceiling, along with most of the artist's work, is not. Like the facade paintings and mosaics once common in public squares in Italy, they are art that goes out to the man in the street and does not require him to visit a private collection, a museum, a church, a synagogue, or a theater. They might be called billboard or poster art, if the unwanted connotations could be overcome.

What do they announce? What "message for the people" did their author have in mind that March morning in Paris when he could not resist the impulse to come back and warm up the color once more? He would say, as would any authentic painter, that the message has to be grasped in the language of forms and colors instead of in words. But he has provided some labels for his imagery (pages 242 and 243), and with these as points of departure one can attempt to wind one's way into the depths where the untranslatable part of the significance can be experienced.

In *The Sources of Music* the central underlying structure, half embedded in the yellow background, is a curved band that recalls the round arches on the front of the new opera house and at the same time suggests something very ancient, covered with illegible hieroglyphics and strange pyramids. A personage in fur-trimmed royal robes stands in front of it, playing an instrument that combines features of the lyre, the harp, and also perhaps of the Hebrew *kinnor,* mentioned in the Old Testament. With his lifted, laurel-crowned Orpheus face and his pensive, bearded David face he symbolizes at one level of meaning both the Greek, or European, and the Semitic musical traditions. Like nearly every Chagallian image, however, he has more than one level of meaning. He is the inconsolable husband who, by the magic of his art, nearly succeeded in bringing his dead wife back from Hades; as such he has a profound personal meaning for Chagall (the form is the elongate sweeping one often associated with the phantom of Bella and the idea of resurrection) and great importance among the historical "sources of music"—his story having inspired the librettos for masterpieces by Monteverdi and Gluck and for Peri's *Euridice,* the first opera to survive. In the guise of David the shepherd boy he is a reminder of the healing power of music, for he "took an harp, and played with his hand" and thus caused "the evil spirit" to depart from Saul (1 Samuel XVI: 23). As David the king he is the founder of the united kingdom of Israel and Judah, the scourge of the Philistines, and a Messianic symbol. And as a Jewish musician he is a reminder of the fact that Jewish composers and performers constitute one of the important sources of Western music.

Flying below the Orpheus-David figure is a large and rather matronly seraphic creature (numbers 7 and 8 in the key on page 242, detail on pages

246-247) whose artistic ancestry might be traced back through angels in Russian and Byzantine icons to ancient representations of the cherubin on the Ark of the Covenant. It is labeled "The Angel Mozart" by Chagall, and is depicted, in the icon X-ray style of *Pregnant Woman* (page 157), as teeming with the characters of *The Magic Flute;* Papageno is on the right, sounding the five ascending notes on his Panpipe and failing to notice that two birds have escaped from the cage on his back. Above him, in the pose of a Venus by Titian or Giorgione, a draped nude reclines on the feathers of the angel and illustrates once again Chagall's tendency to associate the music of Mozart with happy sensuality. "Two of the marvels of the world," he remarked one day while at work on this canvas, "are the Bible and the music of Mozart. And a third, of course, is love."

Sensuality of a more strenuous kind is apparent in the image, above and to the left of Orpheus and King David, of the rooster with a crowned nude clinging to its back and a crescent-shaped little man blowing a shofar or horn in the fiery whirlwind of its tail feathers. No key to the meaning is provided in words; the viewer can guess that an allusion to Stravinsky's *Firebird* is intended, or he can simply let his imagination hover somewhere between the visions of Hieronymus Bosch and the insights of Freud.

These three major complexes of themes—the rooster with the nude, the Greek-Jewish harpist, and the Mozartean angel—are framed by a crowd of minor motifs, many of which Chagall did not choose to label and some of which he seems to have labeled on the spur of the moment, merely to satisfy a request or to amuse himself. All, however, are worth examining for their contributions to the total meaning of the picture.

In the upper left corner, below the Christlike figure of a martyr bound to a stake, a group of singers with eloquently uplifted arms represents Beethoven, *Fidelio,* and the place that music has occupied in the struggle for human liberty (numbers 2 and 3 in the key on page 242). The emphasis on singing continues further down this side of the composition, and then yields to an evocation of the power of music to calm the passions: beneath a palm tree straight out of the view from Chagall's studio window in Vence (page 31), a half-Oriental maiden plays a tune that has the same effect on wild animals as the magic flute of Mozart's Tamino. Below this charming glimpse of Eden there is a wreath of flowers that serves as a kind of floating bridal crown for the Angel Mozart; and then, at the corner, a bird-angel plays a violin solo.

Overleaf: Like a make-up man preparing an actor for a part, Chagall retouches the eye of the bird-woman that represents "Russian Music" in THE TRIUMPH OF MUSIC *(number 9 in the key). His interest in Etruscan art appears to have influenced the drawing of the inclined, listening head of the woman, although her instrument is almost a shofar.* ▷

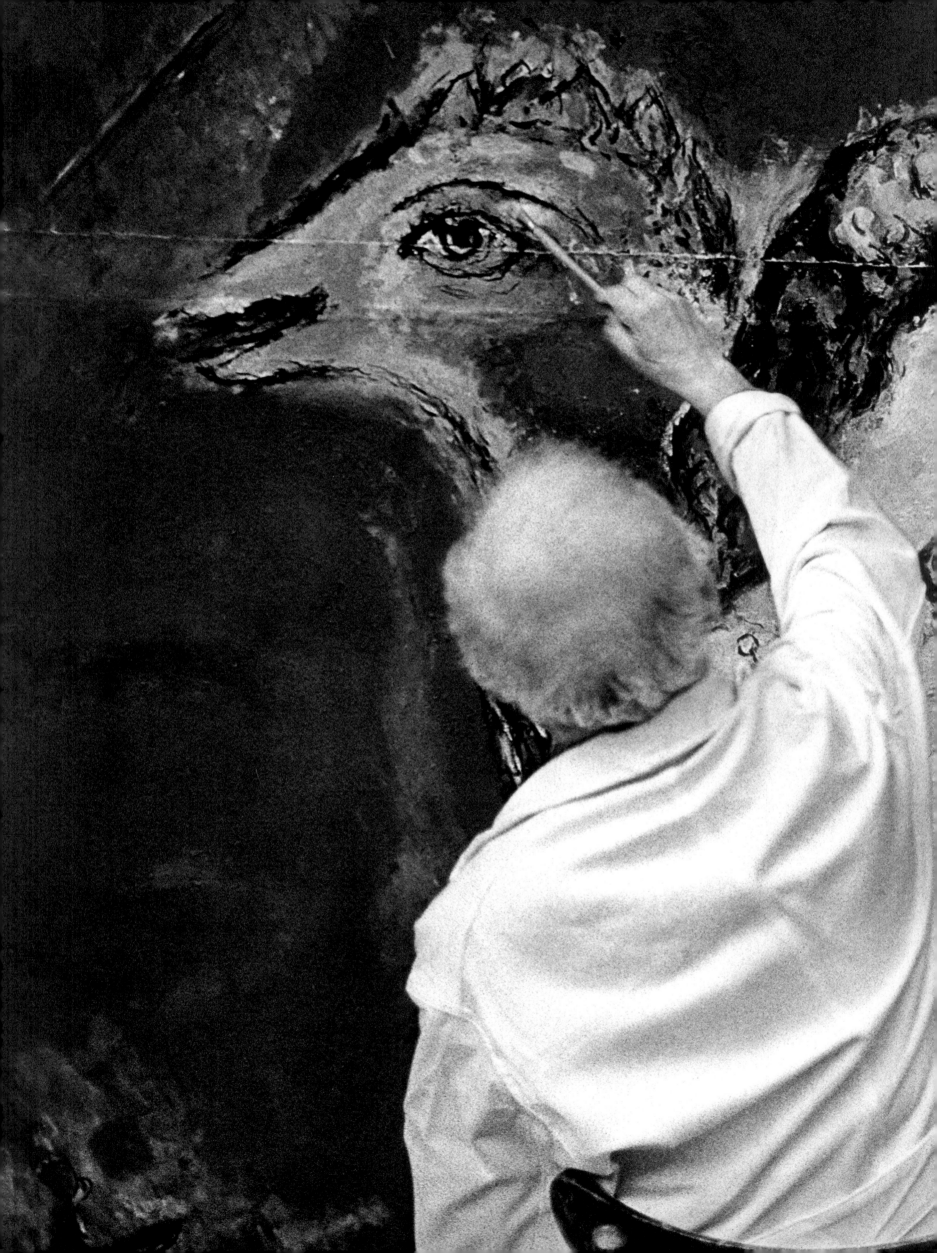

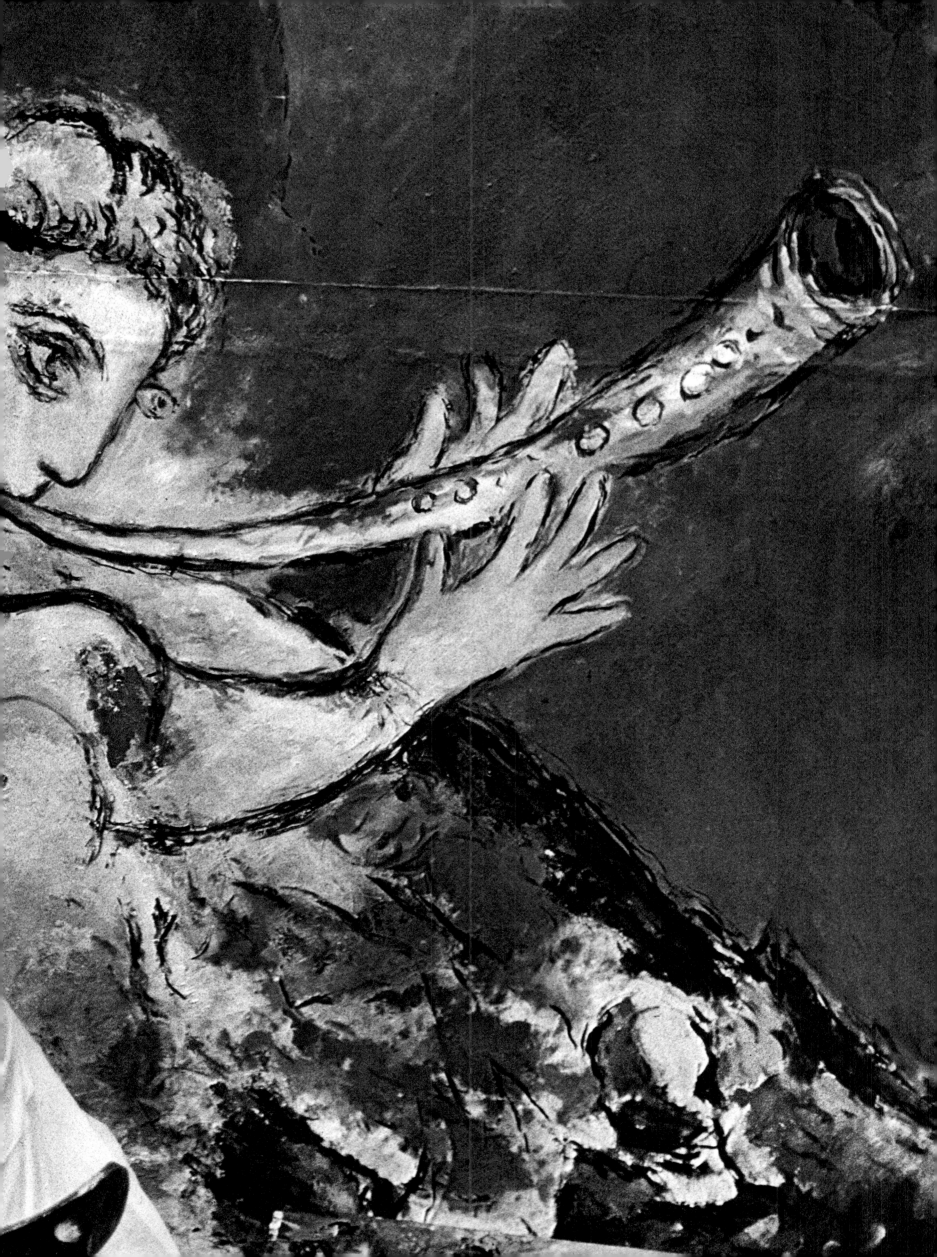

Since Chagall is a constant reader of the Bible, the "Tree of Life" (number 10 in the key) at the bottom of the painting can be safely linked to the one mentioned in Genesis III: 22, as a reason for the expulsion of Adam from Eden: "And the Lord God said, Behold, the man is become as one of us, to know good and evil: and now, lest he put forth his hand, and take also of the tree of life, and eat, and live for ever…" Here this symbol of the immortality from which we are excluded is floating in the middle of the Hudson, with birds huddling in its branches like shipwrecked souls on a raft and with the Manhattan skyline (number 11) in the distance under a crescent moon. (The scene is not merely symbolic. The painter happened to notice such a floating piece of foliage one evening while dining with New York friends on a terrace above the river.)

On the right side of the picture, below a generalized image of New York bridges (number 12), an allusive tribute is paid to various composers and compositions. An angel offers a Jewish candelabrum to a Romeo and a Juliet (number 5) who are presumably those of Berlioz, since the horse of the Paris Opera ceiling— this time with its legs in a normal position—also appears. A small portrait (number 6) and a relatively large image of Tristan and Isolde are devoted to Wagner; a singer and an instrumentalist, to Bach and sacred music (number 4); and a ballerina and a swan, to *Swan Lake*. In the lower right corner a pair of lovers is marked as a homage to Verdi (number 9); if we assume that the bouquet to the left of them is made up of camellias, they are the Violetta and Alfredo of *La Traviata*.

The "message for the people"? It is of the important kind that looks embarrassing in plain prose. It is simply that we must all—as Gentiles and Jews, as men and women, as human beings and animals—love one another, for we are all forbidden to live forever. Art can teach us to love passionately, and can keep the memory of love alive, but it cannot actually bring back the sensuous, warm presence of a lost Eurydice, Violetta, Isolde, Juliet, or Bella. Part of the force, along with much of the genuinely popular appeal, in the work of Chagall springs from his willingness to risk reaffirming such apparently, although not actually, banal truths.

Much the same message can be found in *The Triumph of Music*. But here the note of sadness and nostalgia that is sounded frequently in *The Sources of Music* is missing; the ancient tinkle of the Orpheus-David figure's lyre is replaced by angelic trumpet blasts; and delicate, greenish shades of yellow yield to waves of dense, furnace red. What was somewhat passive, languorous, feminine, and lunar becomes active, masculine, and solar. The circle replaces the crescent. The universal love we are now asked to contemplate is creative and cheerful—in a word, Hasidic.

A good place to begin to "read" the picture is the lower right corner. Here (number 10 in the key on page 243, detail on page 255), beneath a dancing blue

tree from which a human head and a pair of clumsy human feet emerge, Chagall himself is seated, deep in thought and apparently exhausted by his creative labor. On the other side of the tree, above the spires of New York's Cathedral of St. Patrick (number 13), Madame Chagall performs a tightrope act with the help of an old-fashioned parasol for balance (number 11). The two tiny figures provide scale for the vast, cosmic, dream space of the composition as a whole, and especially for the principal structures in this space: three large circles and a soaring diagonal slab of yellow (detail on pages 258-259).

The circle on the far right, a brilliant sun wheel that shoots yellow flames halfway across the cosmic space and turns the rooster above the blue tree gold, is clearly the center of energy; it can be read, in keeping with cabalistic and Hasidic theories, as a symbol of the divine essence, the creative godhead, in the universe. The bright core is a medallion occupied by a pair of lovers and a little horse that is perhaps the faithful animal of Vitebsk. (The lack of any definitive references to the artist's home town in these two paintings contributes to the "public art" impression I have mentioned.) From this core of mystical light and human and animal love the other great circles emanate through the hot, red "tissue"—each one being actually several concentric circles or halos; and as they advance toward the lower left foreground the light and love that they carry modulates into the sound of music—here Chagall may have been influenced by the old notion of the music of the heavenly spheres. What is labeled (in language that suddenly reminds one that the artist spent several years in revolutionary Russia) "The Song of the Peoples" (number 1) is represented by a group of angelic acrobatic horn players blowing in several directions with the abandon of a Dixieland jazz band. Further down, in a mass of incandescent foliage, a ballerina leaps into a Chagallian crescent to the accompaniment of a vigorous leg-beat. In the last great circle "The Musician" (number 2, detail on pages 254-255) appears, wearing a vaguely troubadour costume and holding a lute to his chin; his connection with the rest of God's creation, and with the medallion in the first circle of light and love, is emphasized by the animal face, or mask, on the back of his head. To the right of him an unlabeled royal personage in a golden costume turns into a baroque flame under the influence of the music.

Overleaf: The artist at work on the bottom section of THE TRIUMPH OF MUSIC, *under the dreaming regard of the self-portrait on his right. The colored substance is structured in a Cubist manner by the use of triangles and lozenges of contrasting hues, shadows, and highlights. Two of these shapes, the yellow triangle next to the flame-like royal personage and the green half-triangle on the leg of "The Musician" (number 2 in the key), clearly betray the fact that they were originally scraps of textile pasted on an early maquette. Chagall frequently practices this personal kind of collage in his sketches (see Papageno drawing on page 205).▷*

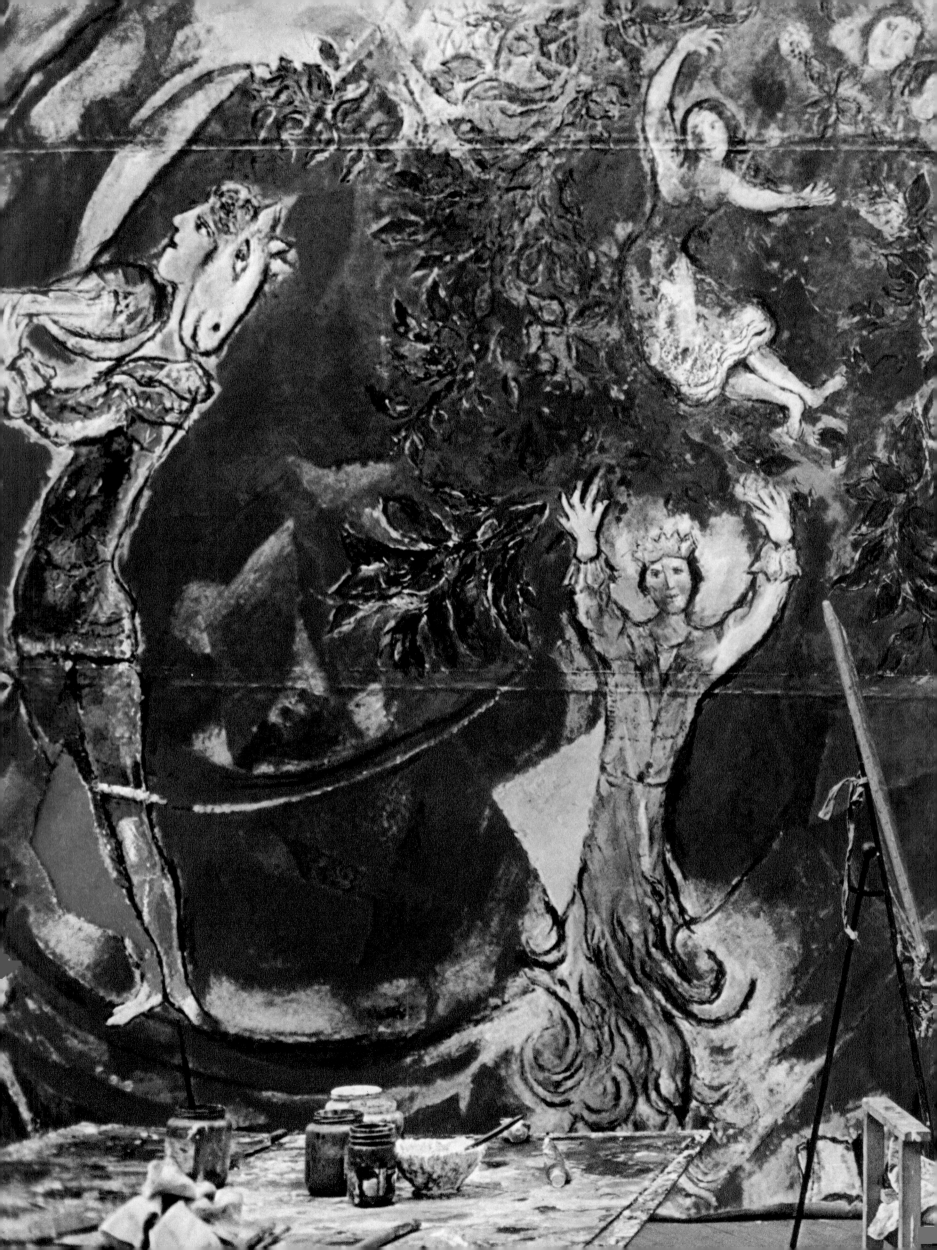

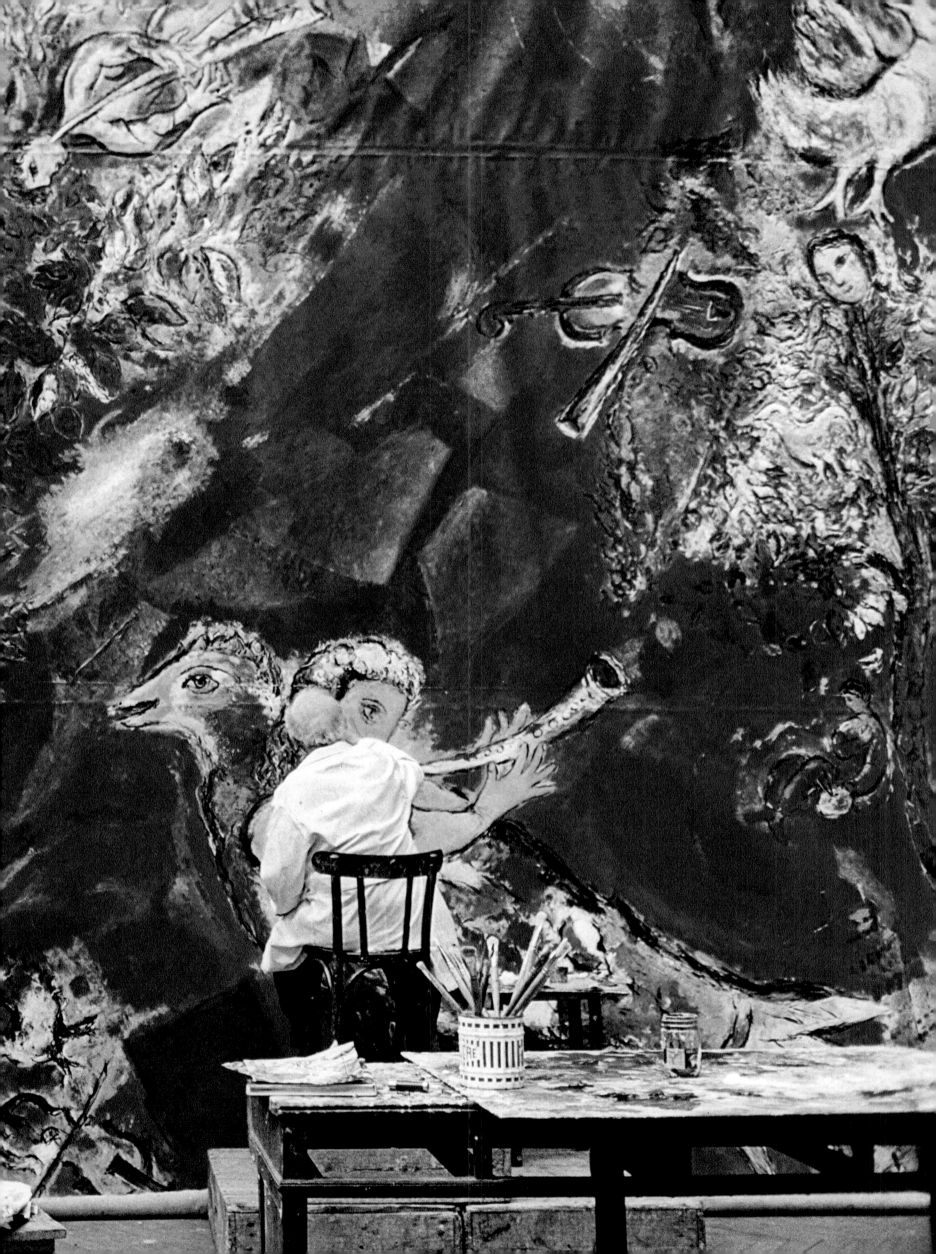

Above the circles soars the triumphant spirit of music, in the form of an angel blowing one of the flute-like trumpets with which Chagall equips most of his instrumentalists. (I described these horns in Chapter IX as being rather Romanesque and Gothic; here they seem to me to resemble the Hebrew trumpets depicted on ancient reliefs—in particular on the well known part of the Arch of Titus at Rome, which represents a triumphal procession after the fall of Jerusalem.) The idea of union in love is symbolized in the artist's characteristic manner: by the diagonal and by the linking of two personages at their lower extremities. Above the angel's right wing (number 6) a small motif turns out on close examination to be a version of the curtain (page 202) created for the New York production of Stravinsky's *Firebird* in 1945.

In the upper left corner of the composition something that is almost a fourth great circle is carved out of the colored substance, equipped with a core of light, and dedicated to "The Ballet" (number 4) in a detailed fashion that reveals the painter's familiarity with the basic positions of classical dance. Directly below the ballerinas is a group of three figures that constitutes one of the best and most amusing examples in the whole work, of Chagall's habit of giving his images multiple meanings (numbers 3, 7, and 8). At the general level of significance we are invited to think of the figures as simply "The Singers." At another level they are a "Homage to French Music," and it is clear from the costumes, the guitar-like instrument, and the bullring in the background that they are specifically a homage to Bizet's *Carmen*. And finally, for reasons of friendship rather than of iconographic appropriateness, the man in the middle represents Rudolf Bing, the general manager of the New York Metropolitan Opera.

The skyscrapers of New York are evoked in the lower left corner (number 12) in the company of a little rooster and a flying violin; next to the dancing blue tree, "Russian Music" is represented by an iridescent bird-woman (number 9) obviously related to the demon-angel of Boris Godunov in the Paris Opera ceiling; and—in what can be understood as a gesture of rebellion against too many demands for specific labels—a young cellist in Renaissance dress (number 5) is mysteriously designated as a "Homage to American Music."

Looking back now over the above paragraphs, I fear that they present *The Sources of Music* and *The Triumph of Music* too much as collections of allegories, symbols, and illustrations. These pictures are much more than that; they are "a message for the people" in the language of a colored substance that is one of the most eloquent in 20th-century painting. They are part of Chagall's answer to what he feels is a "moral crisis" in Western society and culture, a crisis brought on by too much science, too much analysis, too much rationalism, and not enough organic integration. In this connection I cannot do better than quote from a speech he made while on a visit to the United States in 1963:

"During recent years I have often spoken of an alleged chemistry of color

and matter as a thermometer for authenticity. A particularly sharp eye can see that an authentic color and an authentic matter contain automatically every possible technique as well as a moral and philosophical content. If there is a moral crisis, it is a crisis in the color, matter, blood, elements, words, sounds, and so forth with which we construct art as well as life. And if there are mountains of color on canvases, if you do or do not see objects in them, if there are lots of words and sounds, all that will not necessarily create authenticity. For me the color-matter alone of Cimabue provoked a change in Byzantine art.... I repeat, it is not a conception of the world, a literary and symbolic thing, which brings about change, but the blood itself, a certain chemistry in nature, in things, and even in human attention."

Overleaf: The middle section of THE TRIUMPH OF MUSIC *nears completion in the Gobelins atelier. Above the painter's head is the motif he calls "The Song of the Peoples" (number 1 in the key); above the bright sun wheel that contains the lovers and the horse is "Homage to American Music" (number 5). "The older I get," Chagall remarked during work on this vast composition, "the more at ease I feel in front of a big canvas."* ▷

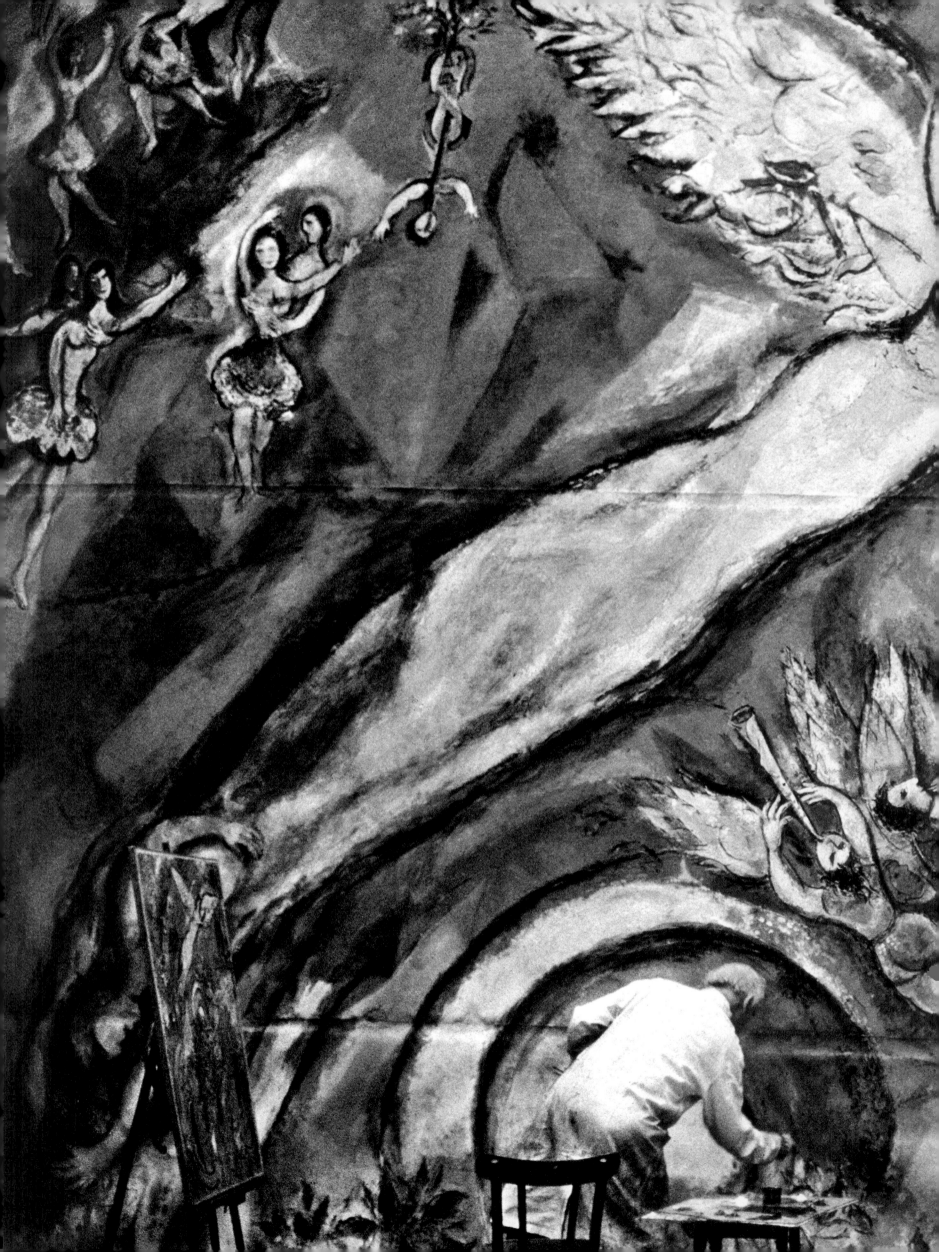

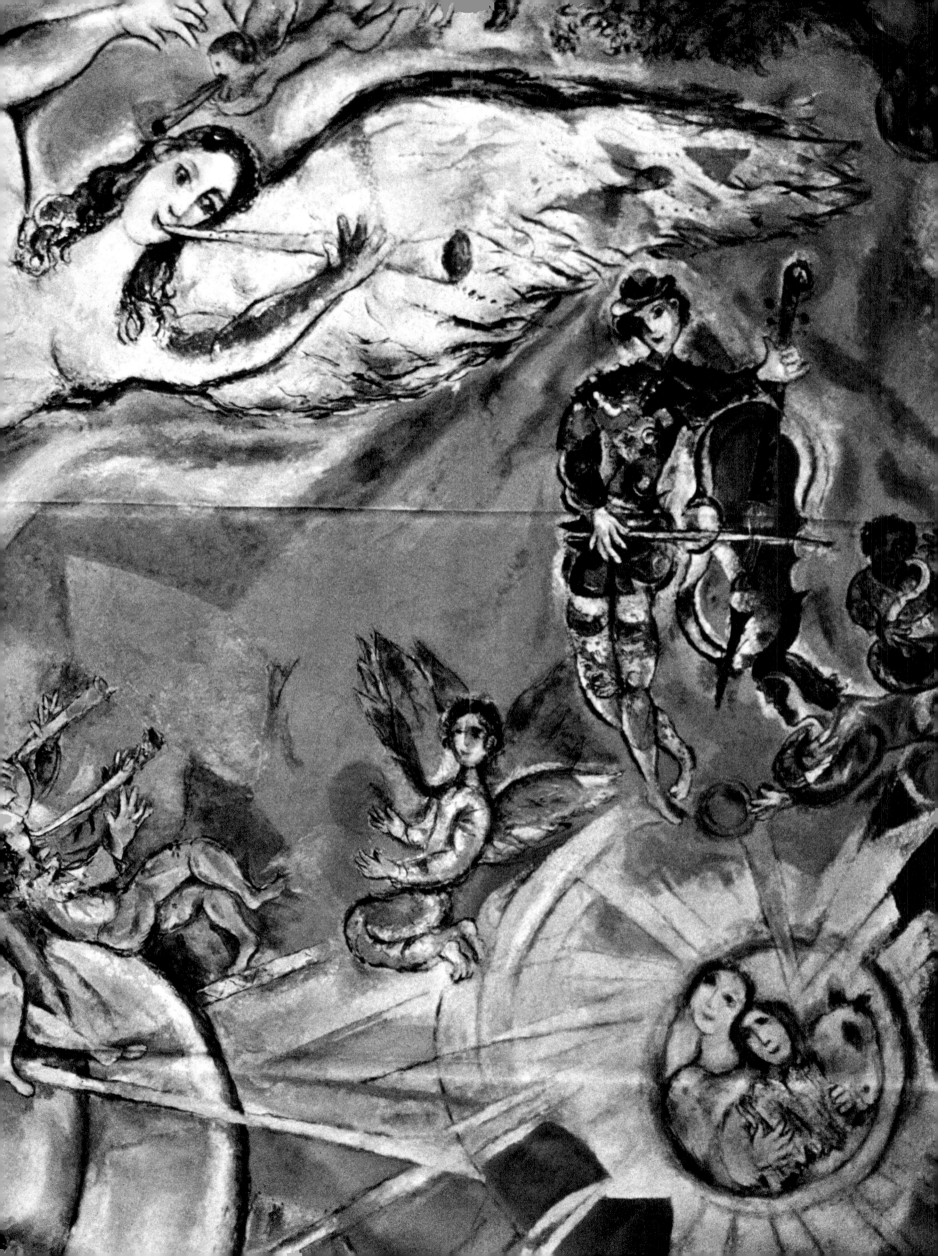

XIV *A Summing-up*

Chagall, as every gallery-goer knows, is not a solemn person. Unlike many 20th-century innovators, he has always frankly enjoyed performing the traditional functions of the artist in an affluent society—the functions of the professional entertainer, embellisher, and general life-enhancer. In many of the pictures in this book he can be seen returning overtly, although in his own manner, to the sentiment and sensuality of the European 18th century: to the attitudes that lay behind the production and appreciation of nymphs in porcelain, the *fêtes galantes* of Watteau, and the light-hearted serenades of Mozart. In other works he appears as an East European Yiddish humorist, a teller of Russian fairy tales, a prestidigitator and levitator, or an impresario of circus acts, vaudeville turns, village fairs, and the *commedia dell'arte*. He finds occasion to be diverting and decorative even in his religious paintings and in his stained-glass windows.

The tenderness, the hedonism, the whimsicality, and the fun are not, however, in any danger of going unnoticed, and so in these closing remarks I prefer to direct attention once more to two facts I have tried to stress in most of the preceding chapters. First, Chagall is a major artist in strictly painting terms—that is, without taking into account his figurative imagery. Second, beneath its charming and fantastic surface the "world" he has created during more than sixty years of extraordinarily consistent activity is essentially the world of a mystical moralist. To be aware of these two facts is not to be unmindful of his charm. On the other hand, not to be aware of them is automatically to misjudge his intentions and achievements; it is to make the kind of mistake made by people who ignore Watteau's or Mozart's tragic sense of life out of fear of spoiling the enjoyment of graceful silhouettes and delightful musical phrases. Moreover, the two facts are in a reciprocal causal relationship; the mystical moralist in Chagall has strongly influenced, especially in the last 20 years, the

artist's strictly painterly notions of color, space, and form, while the pure painter (and also the experimental artisan) has at the same time suggested insights to the mystical moralist. The bold, dense yellow and red of the Lincoln Center murals, to cite two examples we have recently considered, exist partly for metaphysical and ethical reasons—to help project the message for the people. They have, in the artist's view, "a moral and philosophical content." Such a view may be extremely arguable, but it ought not to be ignored. In art, intentions count.

An easy way to test the quality of Chagall as a strictly painterly artist is to imitate his own studio habit, which is also the procedure he has imagined for a demonstration of the "chemistry" and "tissue" in a collection of masterpieces (page 25). The reader has simply to turn this book upside down, perhaps squint a little to blur familiar outlines, and look at the color plates as if the compositions they reproduce were as purely abstract as those of Kandinsky and Pollock. The assumption will not hold up, of course, partly because Chagall may undermine it with motifs that were originally upside down, and largely because he is not, after all, an abstract artist. But I am confident that the outcome of the experiment will be the disclosure of an unsuspected variety of mysterious depths in the picture space, of a surprising eloquence in the "nonfigurative" shapes and structures, and of a virtuoso's richness, complexity, and radiance in color. An additional outcome may be the discovery, or the confirmation, of the fact that Chagall's style is recognizable without his lovers, flowers, clowns, clocks, roosters, and assorted quadrupeds. The "chemistry" is the man himself.

Chagall the mystical moralist concentrates primarily, as I have had many occasions to remark, on the problem of alienation—in the widest sense of the word. He is concerned about the to him unwarranted separation of one part of God's creation from another, about exile from a native land and a home town, about the estrangement of the artisan from the materials and the results of his labor, about the inability of man and woman to form a perfect union, about the anxiety consequent on being separated from the womb, about the alienation of the adult from the childhood self, and finally about the division between man's animal passions and his rational faculties, or between the unconscious and conscious minds. In general, the remedy proposed for all these varieties of alienation is love and the kind of imaginative sympathy in which affection, creation, and true knowledge become indistinguishable; this is frequently reinforced and raised to a cosmic significance by reminiscences of Hasidic and cabalistic doctrines. In painting the remedy appears abstractly as an insistence on an organic tissue of colored substance that is related both to the flesh of the artist's hand and to the "microbes of the universe." But it also takes the form of refusals to separate the bride, or her phantom, from the groom; the animal realm from the human; the sacred image from the profane; an inner, psychic reality from an outer one beyond a symbolic window; the image of the artist himself from the mirror-picture; and the exiled and bereaved husband from

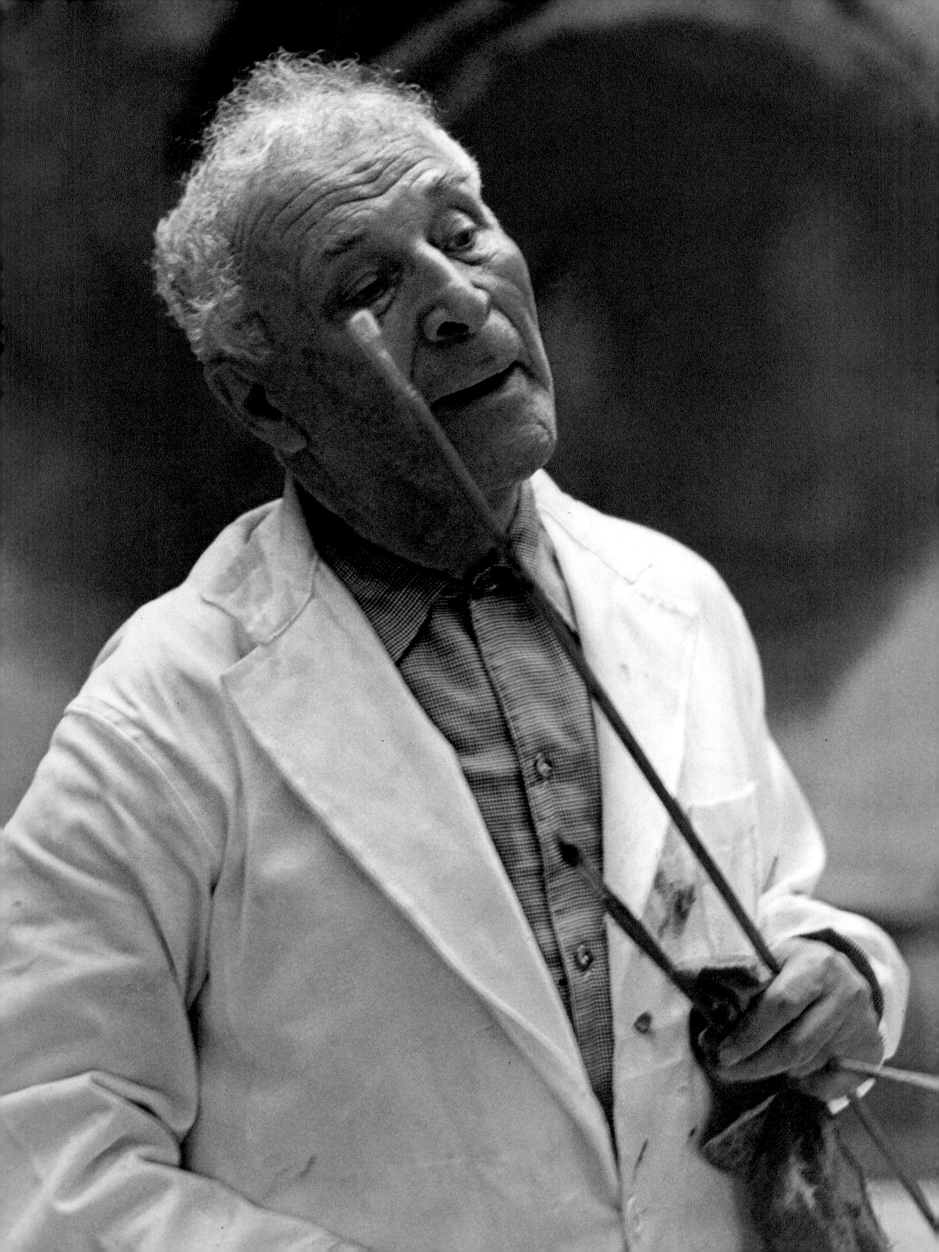

memories of Vitebsk, Paris, and Bella. The refusals are strengthened by an imaginative process and a systematic private mythology that together produce the powerful effect of a recurring dream, complete with such dream devices as condensation of symbols, displacement and concealment of emotional content, and the plastic representation of verbal metaphors.

In all this the strictly personal element is admittedly very strong: the art of Chagall cannot be fully appreciated without biographical information of a quite intimate sort. But this is not to say that it is merely a privately significant art, for the life of Chagall has followed a pattern familiar to millions of people in the 20th century. He is not alone in his yearning for an end to estrangement.

"Everything in art must spring from the movement of our whole life-stream, of our whole being—including the unconscious."

Bibliography

BERGER, RENÉ. *Chagall et la présence du mythe. XXe siècle,* No. 17, p. 67. Paris: 1961.

BERGGRUEN & CIE. *Hommage à Marc Chagall pour ses quatre-vingts ans. 250 gravures originales,* 1922–1967. Catalogue. Paris: 1967.

BUBER, MARTIN. *Hasidism and Modern Man.* Edited and translated by Maurice Friedman. New York: Harper & Row, Publishers, 1966.

CASSOU, JEAN. *Chagall.* Translated by Alisa Jaffa. New York: Frederick A. Praeger, Inc., Publishers, 1965.

CHAGALL, BELLA. *Burning Lights.* With 36 drawings by Marc Chagall. Translated by Norbert Guterman. New York: Schocken Books, Inc., 1962.

CHAGALL, MARC. *The Artist,* a lecture. English version arranged by Robert B. Heywood. In *The Works of the Mind.* Chicago: The University of Chicago Press, 1947.

CHAGALL, MARC. *My Life.* Translated from the French edition by Dorothy Williams. London: Peter Owen Limited, 1965.

COGNIAT, RAYMOND. *Chagall.* Paris: Flammarion, 1966.

DAMASE, JACQUES. *Marc Chagall.* Verviers, Belgium: Gerard & Co., 1963.

DIMONT, MAX I. *Jews, God and History.* New York: The New American Library, Inc., 1962.

EPSTEIN, ISIDORE. *Judaism.* Harmondsworth, Middlesex: Penguin Books Limited, 1959.

ERBEN, WALTER. *Marc Chagall.* Translated by Michael Bullock. London: Thames and Hudson, 1966.

FONDATION MAEGHT. *Hommage à Marc Chagall: œuvres de* 1947–1967. Catalogue of exhibition. Saint Paul, France, 1967.

GENAUER, EMILY. *Marc Chagall.* New York: Harry N. Abrams, Inc., 1956.

JUNG, CARL, and M.-L. VON FRANZ (editors). *Man and his Symbols.* London: Aldus Books Limited, 1964.

KRAWITZ, HERMAN E. *An Introduction to the Metropolitan Opera House, Lincoln Center Plaza.* New York: Saturday Review, Inc., 1967.

KUNSTHAUS, ZURICH. *Chagall.* Catalogue of retrospective exhibition, 1967.

LASSAIGNE, JACQUES. *Chagall.* Paris: Maeght Editeur, 1957.

LASSAIGNE, JACQUES. *Le plafond de l'Opéra de Paris par Marc Chagall.* Monte Carlo: André Sauret, 1965.

LEYMARIE, JEAN. *Marc Chagall, monotypes,* 1961–1965. With a catalogue by Gérald Cramer. Geneva: Gérald Cramer, Editeur, 1966.

LEYMARIE, JEAN. *Marc Chagall, Vitraux pour Jérusalem.* Monte Carlo: André Sauret, 1962.

METROPOLITAN OPERA PROGRAM, 1966–1967. Includes information on the new production of *The Magic Flute.* New York: Saturday Review, Inc.

MEYER, FRANZ. *Marc Chagall.* Translated by Robert Allen. New York: Harry N. Abrams, Inc., 1963.

MEYER, FRANZ. *Marc Chagall. The Graphic Work.* With documentation by Hans Bolliger. London: Thames and Hudson Limited, 1957.

MOLLESON, JOHN. *Chagall at the Met: God, Mozart, Color.* In the *New York Herald Tribune,* p. 32, February 20, 1966.

MOURLOT, FERNAND. *Chagall lithographe,* 3 volumes. Paris: 1960–1967.

MUSÉE DES ARTS DÉCORATIFS, Paris. *Marc Chagall.* Catalogue of the retrospective exhibition, 1959.

MUSÉE DES BEAUX-ARTS, Rouen. *Marc Chagall et les vitraux de Metz.* Catalogue of the exhibition, 1964.

MUSÉE DU LOUVRE, Paris. *Donation Marc et Valentina Chagall.* Catalogue of the exhibition *Le Message Biblique de Marc Chagall,* 1967.

NEUMANN, ERICH. *Art and the Creative Unconscious.* Translated by Ralph Manheim. London: Routledge & Kegan Paul, 1959.

PARINAUD, ANDRÉ. *Chagall.* Paris: Club d'Art Bordas, 1966.

SCHMALENBACH, WERNER. *Chagall.* Paris: Gibert Jeune, 1957.

SCHNEIDER, DANIELE. *The Psychoanalyst and the Artist.* New York: The New American Library, 1962.

SÜSSMAN, CORNELIA and IRVING. *Marc Chagall, Painter of the Crucified.* In *The Bridge, a Yearbook of Judaeo-Christian Studies,* p. 96. New York: Pantheon Books Inc., 1955.

SWEENEY, JAMES JOHNSON. *Marc Chagall.* New York: The Museum of Modern Art, 1946.

VENTURI, LIONELLO. *Chagall.* Geneva: Editions d'Art Albert Skira, 1956.

WEISSTEIN, ALLYN. *Iconography of Chagall.* In *Kenyon Review,* Ohio, Vol. 16, No. 1, p. 38, Winter, 1954.

Sources of Chagall Quotations

The listing is by pages. Remarks (©) Marc Chagall) not listed are from conversations with the authors. References are to the editions mentioned in the bibliography above. In some instances, where primary sources are not available, secondary ones are cited.

16 Musée des Arts Décoratifs catalogue, p. 88.
17 *My Life,* p. 63.
24 Chagall, *The Artist,* p. 24.
24 Damase, *Marc Chagall,* p. 16.
30 Chagall, *The Artist,* p. 26.
34 Musée des Arts Décoratifs catalogue, p. 210.
37 *My Life,* p. 44.
37 Second quotation. *My Life,* p. 46.
39 Musée des Arts Décoratifs catalogue, p. 168.
40 *My Life,* p. 84.
48 Meyer, *Marc Chagall,* p. 601.
50 *My Life,* p. 113.
53 *Ibid,* pp. 42–43.
59 Chagall, *The Artist,* p. 24.

64 Musée des Arts Décoratifs catalogue, p. 206.
72 *My Life,* p. 26.
74 *Ibid,* p. 73.
77 *Ibid,* p. 51.
78 *Ibid,* p. 95.
85 Translated by the author from Jacques Lassaigne's French version of the Russian original.
86 Chagall, *The Artist,* p. 35.
88 *My Life,* p. 87.
101 Sweeney, *Marc Chagall,* p. 7.
109 Meyer, *Marc Chagall,* p. 526.
110 Erben, *Marc Chagall,* p. 142.
112 *Ibid.*
113 *Ibid.*
122 Musée des Arts Décoratifs catalogue, p. 92.
123 *Ibid,* p. 418.
130 Musée des Beaux-Arts, Rouen, catalogue, p. 59.
139 *My Life,* p. 118. Second quotation. *Ibid,* p. 95.
142 Meyer, *Marc Chagall,* p. 608.

143 Meyer, *Marc Chagall,* p. 608.
144 *My Life,* p. 114.
146 Musée des Arts Décoratifs catalogue, p. 448.
148 Sweeney, *Marc Chagall,* p. 7.
158 *My Life,* pp. 9–10.
160 *Ibid,* p. 25 and p. 121.
162 Musée des Arts Décoratifs catalogue, p. 264.
171 Second quotation, *ibid,* p. 30. Third quotation, Rouen catalogue, p. 59.
173 Parinaud, *Chagall,* p. 55.
177 *Ibid,* p. 55.
180 *My Life,* pp. 40–41.
187 *Ibid,* p. 93.
194 Musée des Arts Décoratifs catalogue, p. 86.
201 *My Life,* p. 162.
217 *Ibid,* p. 89.
237 Lassaigne, *Le plafond de l'Opéra de Paris,* p. 89.
245 Chagall, *The Artist,* p. 21.
257 Cogniat, *Chagall,* p. 29.
263 Chagall, *The Artist,* p. 33.

Additional Data on the Illustrations

17 THE GREEN HORSE, oil, 37 3/8 × 29 1/2 inches, 1956. Private collection.

20 JACOB'S DREAM, oil, 49 1/4 × 43 1/4 inches, 1967. Private collection.

22 CLOWNS AT NIGHT, oil, 37 3/8 × 37 3/8 inches, 1957. Private collection.

26 FOR VAVA, gouache, 25 1/4 × 18 7/8 inches, 1955. Collection Vava Chagall.

28 Detail of PARADISE, oil, 1962. Dimensions of the whole: 72 7/8 × 113 inches. The painting is part of the collection "The Biblical Message," donated by the artist and his wife to the French national museums for eventual installation in a cultural center at Nice.

31 THE STUDIO WINDOW, monotype, 11 7/8 × 15 3/4 inches, 1963.

38 WINDOW IN THE SKY, oil, 28 3/8 × 36 1/4 inches, 1957. Private collection.

41 Colored etchings, 14 1/2 × 10 1/2 inches,
44 1958. Executed as illustrations for the
47 book De mauvais sujets, by Jean Paulhan, published by Les Bibliophiles de l'Union Française, Paris.

55 Untitled ink drawing, 1960. Private collection.

75 SELF-PORTRAIT WITH PARENTS IN PROFILE, pen drawing, 7 1/8 × 4 3/4 inches, 1911. Collection of the artist.

76 THE SEVEN DEADLY SINS, etching and drypoint, 6 5/8 × 4 5/16 inches, 1926. Frontispiece for Les sept péchés capitaux, a collection of texts by Jean Giraudoux, Paul Morand, Pierre Mac Orlan, André Salmon, Max Jacob, Jacques de Lacretelle and Joseph Kessel. Paris: Simon Kra, 1926.

78 BEHIND THE HOUSE, pen drawing, 8 5/8 × 7 inches, undated. Private collection.

79 A GENTLEMAN, pen drawing, 18 1/2 × 12 5/8 inches, 1920. Private collection.

80 MAN CARRYING STREET, ink drawing, 12 5/8 × 8 5/8 inches, undated. Private collection.

81 ABDUCTION, pen drawing with fabric impressions, 13 3/8 × 18 1/2 inches, 1920. In the upper left section, "Marc Chagall" in Hebrew letters. Private collection.

87 THREE ACROBATS, etching and aquatint, 13 1/2 × 14 1/2 inches, 1923.

90 LANDSCAPE WITH BLUE FISH, monotype, 11 7/8 × 15 3/4 inches, 1962.

93 EIFFEL TOWER, pastel and ink, 1954. Collection of the artist.

95 RUE DE LA PAIX, pencil drawing, 1953. Collection of the artist.

96 THE SUN, monotype, 11 7/8 × 15 3/4 inches, 1965.

97 EZEKIEL'S VISION, etching, 13 × 10 1/4 inches, Plate 104 of the Bible illustrations begun for Vollard and published by Tériade in Paris in 1956.

98 PEACE, monotype, 16 1/2 × 23 inches, 1963.

101 LIFE, oil, 116 1/2 × 159 7/8 inches, 1964. Fondation Maeght, Saint Paul, France.

103–5 Colored etchings as 41, 44, 47 above.

108 THE CROSSING OF THE RED SEA, lithograph, 19 3/4 × 14 1/2 inches, 1966.

111 Untitled vase, 18 inches high, 1962. Private collection.

122 FANTASTIC ANIMAL (left), bronze, 22 1/2 inches high. ROOSTER, bronze, 22 inches high. Private collections.

123 Relief sculpture in stone, 19 1/2 × 17 3/4 inches, 1965.

126 THE ENTRY INTO JERUSALEM, pencil and pen, 1963. Collection of the artist.

135 THE SEINE BRIDGES, lithograph, 6 1/2 × 9 1/2 inches, 1952. Both the lithograph and text, which is in Chagall's handwriting, appeared in Verve, Paris, No. 27–28.

143 OVER THE CITY, lithograph, 10 5/16 × 15 inches, 1922/1923.

145 RED ROOFS, oil, 86 5/8 × 83 7/8 inches, 1953. Collection of the artist.

151 PREGNANT WOMAN, pen drawing, 11 3/4 × 6 7/8 inches, 1913. Private collection.

152 THE ACTOR, pen drawing, 1916. Private collection.

153 HOMMAGE À APOLLINAIRE, oil, 42 7/8 × 78 inches, 1911/1912. Stedelijk van Abbe-Museum, Eindhoven, The Netherlands.

156– OBSESSION, oil, 30 1/4 × 42 1/2 inches,
157 1943. Private collection. The sketch and the passage from My Life in Chagall's handwriting are reproduced from Chagall ou l'orage enchanté, by Raïssa Maritain, Editions des Trois Collines, Geneva, 1948.

159 SELF-PORTRAIT IN CHECKED JACKET, lithograph, 25 1/4 × 19 1/4 inches, 1957.

161 THE PAINTER WITH THE BLUE BOUQUET, oil, 21 5/8 × 18 inches, 1964. Collection of the artist.

163 DONKEY WITH FLOWERS, pastel, 1963. Collection of the artist.

164, The dimensions of each of the stained-
168 glass windows for Jerusalem are 133 1/8 × 98 7/8 inches.

184 DAPHNIS AND CHLOE, gouache and watercolor sketch for a backdrop, 22 × 31 1/2 inches, 1958. Collection of the artist.

192 Watercolor and gouache sketch for the costume for Daphnis in the ballet Daphnis and Chloe, 1958. Collection of the artist.

200 Sketch for a stage set of Synge's The Playboy of the Western World, pencil and gouache, 13 3/4 × 20 1/8 inches, 1920. Collection of the artist.

202 Curtain sketch for The Firebird, pen drawing and wash, 19 5/8 × 25 1/2 inches, 1945. Collection of the artist.

205 Sketch for the costume of Papageno in The Magic Flute, watercolor and collage, 1965. Private collection.

241 Sketches in pen and ink for motifs in THE SOURCES OF MUSIC. Collection of the artist.

242, Maquettes for the Lincoln Center
243 murals, gouache, 37 × 43 1/4 inches, 1964. Collection of the artist.

Other Source Material

13 For a detailed biography of Chagall, see Meyer's Marc Chagall, to which the present writer is greatly indebted for facts and insights.

54 Bella Chagall, Burning Lights, p. 112.

64 Quoted in Saul Bellow, by Tony Tanner, pp. 7–8. Edinburgh: Oliver and Boyd Limited, 1965.

164 For a detailed description of the stained-glass windows for Jerusalem, see the Leymarie book listed in the bibliography.

206 For more details on the Paris Opera ceiling, see the study by Lassaigne listed in the bibliography.

Acknowledgements

The publishers would like to thank Monsieur and Madame Chagall and the following collectors, publishers, and institutions for permission to reproduce illustrations:

Société des Bibliophiles de l'Union Française, Paris; Galerie Cramer, Geneva; DuMont Presse, Cologne; Gebr. Rasch & Co., Bramsche; Verlag Gerd Hatje, Stuttgart; Madame Leale; Galerie Maeght, Paris; Imprimerie Murlot, Paris; Editions André Sauret, Monte-Carlo; Stedelijk Van Abbemuseum, Eindhoven; Editions Teriade, Paris; Verve, Paris.

Extracts herein cited are from the Authorized Version of the Bible. Quotations from My Life are from the English edition published by Peter Owen Ltd. © 1965, translated by Dorothy Williams.

If the publishers have unwittingly infringed copyright in any quotation or illustration reproduced they will gladly pay an appropriate fee on being satisfied as to the owner's title.

Index

Printed in Switzerland